THE POPULAR PRINT
IN ENGLAND

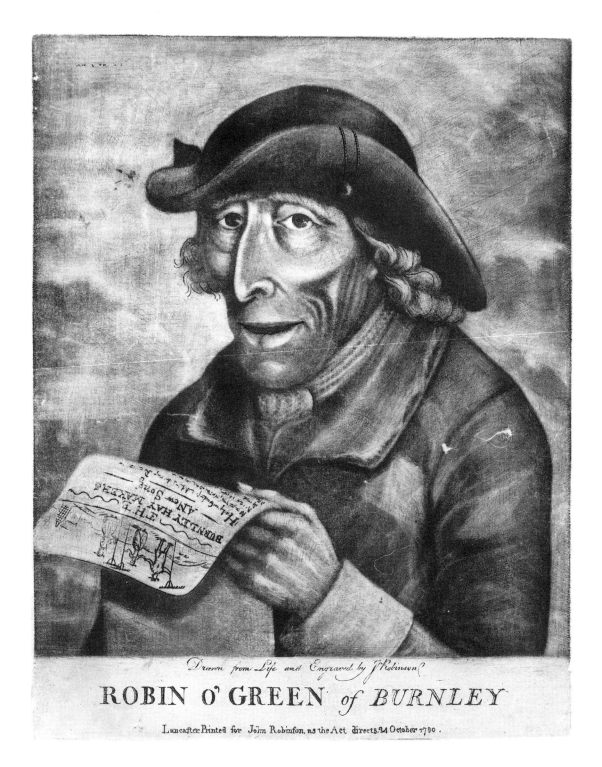

Robin o'Green of Burnley, 1780, a ballad-singer and seller.

THE POPULAR PRINT
IN ENGLAND
1550–1850

Sheila O'Connell

Published for The Trustees of

The British Museum by

BRITISH MUSEUM PRESS

© 1999 The Trustees of the British Museum

First published in 1999 by British Museum Press
A division of The British Museum Company Ltd
46 Bloomsbury Street, London WC1B 3QQ

A catalogue record for this book is available from
the British Library

ISBN 0–7141–2622–5

Designed and typeset in Sabon by James Shurmer

Printed in Great Britain by The Bath Press, Avon

Front cover
Detail of *The Portraiture of King Charles the First
on Horseback*, *c*.1745, after Anthony van Dyck
(see p. 153, fig. 6.2).

Back cover
Adam and Eve in Paradise, 1815 (see p. 253).

CONTENTS

Preface	page	6
Author's note		8
1 What is a popular print?		9
2 'All sorts of prints … '		16
3 The production of popular prints: publishers and printmakers		42
4 Popular themes and subjects		66
Religion and morality		68
Patriotism and the status quo		82
Crime and execution		89
Phenomena and freaks of nature		98
Marriage, cuckoldry and women		109
Drinking, good fellowship and temperance		120
5 The popular print and propaganda		129
6 The popular print and high art		152
7 The market for popular prints		167
8 The popular print and its development in England		181
9 Collectors and historiography		192
10 Nostalgic revivals		203
11 The Continental perspective		210
Notes		224
Abbreviations and bibliography		239
Author's acknowledgements		243
Checklist of illustrations		245
Index		254

PREFACE

There is no difficulty in finding good introductions to popular printmaking on the Continent. The shelves of libraries contain numerous studies on German, Italian, Dutch and – especially – French popular prints. But there is hardly any survey of the comparable phenomenon in this country. The absence of a general survey has been filled with many studies – often admirable – that study a part of the field, and occasionally mistake that part for the whole. Some books show a basic misunderstanding of what a popular print is. In particular, it must be made clear at the very outset that the great tradition of British political caricature has nothing to do with the popular print; these were expensive prints made for and bought by the political élite.

Two approaches have dominated the existing literature. The first is to study a particular category of print production. This might be street literature (a subject particularly associated with Leslie Shepard), the broadside, the fan, the playing card, games, the printed textile, publications for children, and so on. The second is to study particular types of subject that are deemed to represent popular taste. This would produce studies of the battle of the sexes, the anti-Catholic propaganda sheet, the ages of man, the land of cockayne (lubberland), and all the other themes that because they do not form part of high culture are rashly assumed to belong exclusively to popular culture.

In recent years a more profitable approach has begun to emerge as scholars have observed that certain publishers aimed their entire output at the bottom end of the market, and that the ways they devised to market their stock were different from those employed by mainstream print publishers. This has produced studies of a few archetypical popular print publishers such as the Diceys. But this too has its limitations, for many mainstream publishers also had lines of stock that competed directly with the Diceys and their ilk.

Nothing is less profitable than to argue about the definition of the popular print, and in order to make this survey as comprehensive as possible Sheila O'Connell has taken the simplest possible test: the prints that are the subject of this book are cheap prints, sold in very large numbers to a very wide public. This approach leads into the study of numerous prints that are recorded in early sources, such as the records of the Stationers' Company and print publishers' catalogues, but which do not survive. Recently Jan van der Stock has rewritten the history of early Antwerp publishing by using evidence of this kind about prints that have long been lost and whose existence has remained unsuspected. The survival of prints is in inverse ratio to the volume of their production. The expensive and exquisite has been treasured and guarded from the day it was made. The cheap and crude has been thrown away once it had served its purpose.

This has made the study of popular printmaking peculiarly difficult, and the material in this book has been assembled from many different collections. The British Museum's own holdings, although containing many pieces of interest (often lurking in the most out-of-the-way portfolios), proved disappointing. The founders of the collection concentrated on those prints that were works of art or served as documents of art or political history. So part of the lengthy research that lies behind this book, towards which Sheila O'Connell has been working for a long time, has been devoted to building up the collection in the Department of Prints and Drawings in the British Museum. Those who are interested will be able to recognize the new acquisitions from the dates in the register numbers provided in the checklist of illustrations.

Our initial intention was to write an exhibition catalogue, in which the weight of information would be given in the entries on each print. But we soon realized that this was inappropriate to such a subject, where the specimens exhibited were chosen because they were typical rather than exceptional. Too many of them were unique for us to be able to borrow them all for the exhibition, which has perforce become something rather different from the book, and I would like to offer my thanks to those who have so readily agreed to lend to our exhibition, as well as those who have given us permission to reproduce their prints here.

The scope of this book is restricted in two ways that might surprise some readers. There is so much to be said about the lower end of the print trade in the first 350 years of its existence that no attempt has been made to deal with the huge increase in the range of prints that resulted from Victorian technological developments after 1840, not least the invention of photography. Similarly, there is no discussion of issues relating specifically to print production outside London, whether in the English provinces or in Scotland, Wales or Ireland. How different this may prove to have been awaits further study, as do numerous other matters.

The intention of this book is to open up the subject for further research. In this respect it may been seen in the context of the revival of interest in British printmaking before the nineteenth century that has been a notable feature of the 1990s. It is not, I hope, improper to single out Timothy Clayton's pioneering study of *The English Print 1688–1802*, and Tessa Watt's remarkable *Cheap Print and Popular Piety 1550–1640*. The period that links them is the subject of the catalogue of an exhibition held in the British Museum last year, *The Print in Stuart Britain 1603–1689*.

I am confident that Sheila O'Connell's book will be seen as another foundation block for the future study of the British print. Much of the material has never been reproduced before, and most will be as much a revelation to other readers as it has been to me. It has required immense labours from the author to piece all this together in the intervals allowed by a pressured job in an over-stretched Department, and she has my warm thanks, and, I trust, the reader's too.

ANTONY GRIFFITHS
Keeper, Department of Prints and Drawings
British Museum

AUTHOR'S NOTE

Reproductions are chosen to illustrate points discussed in the text, but I have also taken the opportunity to publish rare English popular woodcuts in the British Museum: these include an indulgence of *c.*1490 (fig. 4.1), eight sixteenth-century woodcuts (figs 3.1, 3.3, 3.4, 4.21, 4.24, 5.1, 11.5 and colour pl. I), two of the early seventeenth century (fig. 5.2 and colour pl. IIA) and all eight woodcuts in the Department of Prints and Drawings published in the eighteenth century by the Dicey family and in Aldermary Churchyard (see index). I hope that this will help visitors to the Department who are often surprised that the collection contains so little of this sort of material. Chapter Nine indicates where the main collections can be found and gives references to such catalogues as exist.

English popular prints are often accompanied by large amounts of text and entire sheets have been reproduced in order to show images in the context in which they would originally have been seen.

Captions to illustrations give title and date only. The checklist (pp. 245–53) gives full details. Most makers of popular prints are long-forgotten and unless otherwise stated prints should be assumed to be anonymous. Reproduction of prints in collections other than the British Museum is by permission of the owners, whose names appear in the checklist.

I have followed the usual method of describing prints, using the term 'impression' for each printing from a plate or block. Some of the literature on popular prints, and especially on broadsides or ballads, uses the term 'copy' in the same sense that it would be used of a book; 'copy' is used here to indicate another version of a print: for instance, the large-scale copy of William Hogarth's *A Midnight Modern Conversation* published by John Bowles (fig. 4.53).

So as not to distract the reader from the content of quotations I have modernized capitalization, punctuation and – usually – spelling.

Prices translate into post-1971 decimal currency as follows:
1d. = 0.4p; 12d. = 1s. = 5p; 20s. = £1; one guinea = £1.1s. = £1.05.

CHAPTER ONE
WHAT IS A POPULAR PRINT?

The term 'popular print' was coined in the late eighteenth century by scholars who perceived native culture as disappearing in the face of growing industrialization. The imagination of Romantic writers such as Goethe, the Brothers Grimm and Walter Scott saw the spirit of the nations of Europe embodied not only in the ancient heroes but also in the lives of contemporary peasants and craftsmen. Popular culture became a matter for serious study.[1]

These scholars were writing at the time of a great development of the trade in cheap prints, which in England was dominated by James Catnach and other printers in the area around Seven Dials in London. Their ballads, execution sheets and pious or topical broadsides – illustrated with coarse woodcuts, often crudely

1.1 *Street criers, c.*1835.
George Scharf's drawings document life in the streets of London. Here men sell yard-long ballad sheets and large broadsides of the latest public execution.

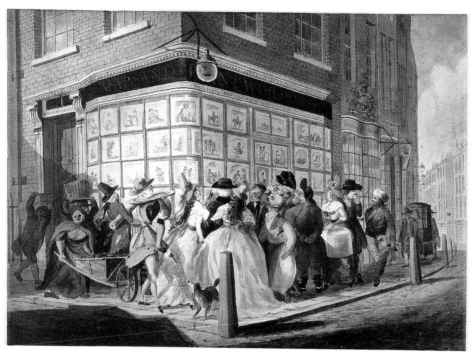

1.2 *A crowd outside a print shop*, 1790. Printsellers' window displays made a wide range of prints familiar to those who would not have been able to afford to buy them. The crowd includes people from all walks of life: young ladies in muslin, elegant gentlemen, an old apple-seller with a wheelbarrow, a chimney-sweep and a sailor in striped trousers. Among the portraits, landscapes and sporting prints, the prints that are probably the focus of attention show *The Monster*, a man who was causing great anxiety with random knife attacks on attractive young women, but who also provided the satirists with yet another way to caricature the politicians of the day (see BM Sat 7647, with further references).

coloured – were sold by street criers and were familiar throughout the country (fig. 1.1). It has often been assumed that the Seven Dials productions were the latest in a more or less unchanging tradition of naive prints beginning with the woodcut indulgences sold before the Reformation (fig. 4.1). The facts are less straightforward: prints, like other forms of popular culture, were far from immune from the effects of commerce and industry.

A few general points need to be made before looking at the popular print itself. It is necessary first to consider the nature of the print. The print, as dealt with in this book, is a pictorial image on paper or cloth produced by transferring ink from a prepared woodblock, copperplate or other printing surface by exerting pressure by means of a press; multiple impressions of the same image can be produced from a single surface.[2] No matter how crude the printed image might be it is not an example of 'folk art'. Printing is an industrial process; it requires the co-ordination of a number of crafts and a considerable amount of capital. Painting, drawing, sculpture or ceramics can be produced by artists working as individuals and are to be found in the most primitive societies, but even the

simplest woodcut requires the woodcutter or printer to work in co-operation with the paper- or cloth-maker, the ink-maker and the manufacturer of a printing press. The production of multiple images, moreover, presupposes a process by which they are to be distributed. Printmaking is essentially an urban and commercial phenomenon; it developed to serve the needs of a population which was congregated in towns.

The term 'print' covers a huge range of objects – from an etching by Rembrandt, where he has experimented with variations in the inking of his plate and chosen different types of paper so that each impression is unique, to a modern advertising poster produced in many thousands of impressions by an advanced industrial process. The first is aesthetically sophisticated but technically simple, while the opposite applies to the latter.

The types of print that have usually been collected, and so survive in the greatest numbers, are, paradoxically, those that were produced in the smallest numbers: luxury items for connoisseurs, such as prints by Rembrandt or the German Little Masters; vanity publications of society portraits; etchings by amateurs produced for circulation among friends. The political and social satires that were such an important aspect of eighteenth- and early-nineteenth-century

1.3 *Sawney in the Boghouse*, c.1745. This print, although hardly to be taken as reliable evidence of eighteenth-century custom, may be accurate in indicating that popular prints could end their days in privies. Those attached to the wall include a bellman's sheet, an elegy, a military broadside and a print of a racehorse. *Sawney in the Boghouse* was one of many prints published in response to English anti-Scots feeling following the Jacobite Rebellion of 1745. The satire was initially aimed at an audience which would take snobbish delight in the portrayal of an ignorant Scot who does not understand city life, but its coarse humour had a wide appeal and many copies were made. Versions reappeared in the early 1760s as part of the furore over the Earl of Bute's influence over the young George III, and the image appeared even on a punchbowl made in China for the export trade.

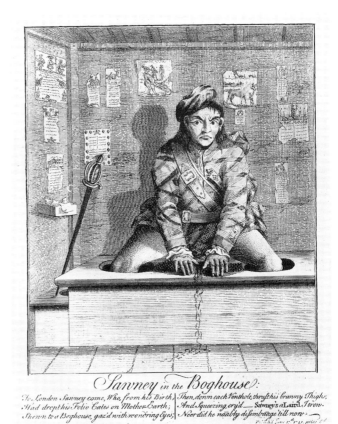

Sawney in the Boghouse:

British printmaking – and are sometimes thought of as popular prints – were similarly exclusive. They were made for a knowing audience that was *au fait* with current political intrigues and would be amused by depictions of the behaviour of those less well-bred or intelligent than themselves. The prints of Hogarth, Rowlandson, Gillray and clever amateurs like George Townshend, 4th Viscount and 1st Marquess, were not aimed at the ordinary person in the street – although some satirists were able to combine political barbs with a broader humour that appealed to the wide public who saw their work in print shop windows (figs 1.2 and 1.3).

Prints aimed at a limited market are necessarily expensive. If the initial cost of creating the printing surface can be spread over a large number of impressions then the price per print falls. Since the beginnings of printmaking in the fifteenth century publishers have seen printing primarily as a method of producing multiple impressions. Most prints have been relatively simple, cheaply produced images answering the tastes and needs of the time. Publishers are driven by commercial imperatives and prints have served a wide range of more or less utilitarian purposes: advertisement, decoration, education, entertainment, information, religious or political propaganda and titillation. It is with this mass of cheap print production that this book is concerned.

But within this huge range of material there are prints that might not readily be regarded as popular. Prints produced by the Seven Dials publishers are identifiable as popular because they were deliberately aimed at the lowest end of the market, even if members of higher classes sometimes bought them. Other prints are not so easily categorized.

It might seem that popular prints are necessarily the work of anonymous artists, and that prints after known designers or printmakers, particularly if they are revered Old Masters, cannot be called popular. But this rule cannot always be applied. Marcantonio Raimondi's engravings after Raphael's designs are respected works of art, but cheap copies of Raphael are another matter – in 1729 J. Farrell published the Sistine Tapestry Cartoons as the border of a childrens' writing sheet (fig. 2.16), and William and Cluer Dicey's cheap print catalogue of 1754 included reproductions both as engravings printed from copperplates, in two sizes, and as woodcuts. Bernard Baron, an urbane Frenchman who built up a thriving business in prints after paintings in the most distinguished English collections, made an elegant engraving after Van Dyck's equestrian portrait of Charles I for which he charged 9s.;[3] that print was not popular, but Dicey's woodcut version of Van Dyck's painting (front cover and fig. 6.2), sold at 1d., certainly was.[4] Benjamin Smith's *The Hen Peckt Husband*, a print whose main purpose is to mock an unhappy couple, gives incidental evidence that prints after Old Masters might be displayed in a relatively humble home (fig. 1.4).

The context in which a print was published affects the way it is categorized. Early impressions of a high-quality print are regarded quite differently from impressions made decades later when the plate was worn or the woodblock

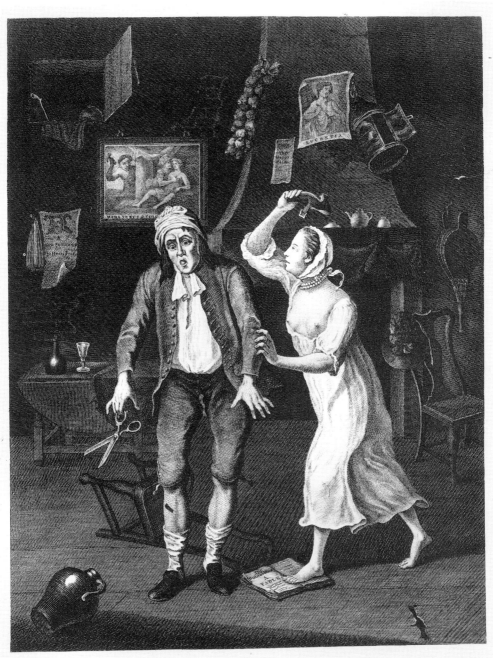

The HEN PECKT HUSBAND.

Publish'd as the Act directs, Jan.ʳ 1ˢᵗ 1768, by Jnᵒ Smith Nᵒ 35 in Cheapside, & Robᵗ Sayer, Nᵒ 53 in Fleet Street, London.

1.4 *The Hen Peckt Husband*, 1768. The prints on the wall (a ballad with a horned cuckold, *Vulcan Surprising Venus and Mars*, *The Suicide of Lucretia*) are intended to make it clear that the tailor who is being belaboured by his half-dressed wife has been cuckolded. They also indicate the random mix of prints after Old Masters and popular ballads – framed or pinned directly to the wall – that might be displayed in a craftsman's home.

worm-eaten. An extreme example is a fine sixteenth-century German woodblock of a classical hero that found its way to Aldermary Churchyard, London, in the middle of the eighteenth century where it reappeared under a new identity as a decidedly popular print of *Saint George, the Chief Champion of England* (fig. 1.5).

Price is obviously relevant to the market level of a print, but it is not a clear way of defining whether or not it is popular. Until well into the eighteenth century any print was a relatively expensive commodity. The population was small and the vast majority had little money to spare for non-essentials. The market was simply not large enough to sustain a trade in cheap prints that would depend on large print-runs to keep costs down. It was not until the second half of the eighteenth century that the market had developed to the extent that a distinct trade in cheap prints could emerge. But this is not to say that many earlier prints would not have had a wide appeal. They would have been familiar – pinned on tavern walls or offered for sale in the streets – even to those who could not afford to buy them and would have formed part of the common experience of city life.

It is also important to stress that these popular prints were not of interest only to those who would not appreciate more sophisticated prints. The Romantic use of the term 'popular' is misleading in suggesting an aspect of culture exclusive to the uneducated sections of the population. The audience for popular prints was an inclusive one. There is evidence of the penetration of popular imagery to all levels of society. This is especially clear in the work of artists – particularly the satirists mentioned above – who borrowed traditional motifs from a common visual language.[5] 'Popular' is used in this book in the sense defined by Ronald Paulson as 'read or seen by almost everybody; [and therefore] part of the consciousness of the learned or educated as well as the uneducated'.[6]

The following chapters approach the popular print in England via a number of different routes: by considering genres and functions of prints that were not produced as fine art; by looking at the work of publishers and printmakers who produced cheap prints, and at subjects and themes that recurred frequently in such prints. The relationship of popular imagery to propaganda and to high art will be discussed, as will the market for cheap prints and the development of the print trade in England from the beginnings of printmaking until the first half of the nineteenth century. Later chapters look at the changing approaches of collectors, historians and artists to what they saw as popular prints, and at English popular prints in relation to their Continental counterparts.

At the end no final definition of the popular print will be made. This book seeks to draw the reader's attention to the huge range of prints that was familiar to a large proportion of the population – at least in towns – even before the explosion of mass production in the mid nineteenth century. By bringing together material that has not previously been seen in the same context its aim is to stimulate the reader to consider the role of prints in settings far beyond the collector's cabinet.

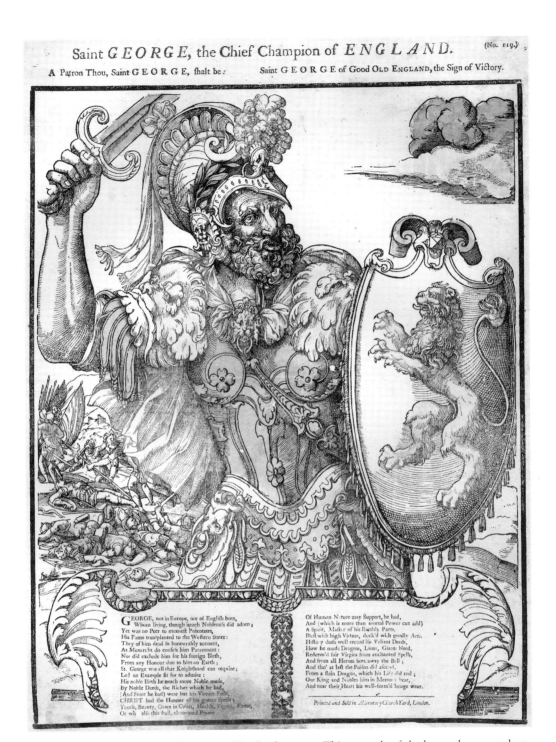

Saint *GEORGE*, the Chief Champion of *ENGLAND*.

(No. 119)

A Patron Thou, Saint *GEORGE*, shalt be: Saint *GEORGE* of Good OLD ENGLAND, the Sign of Victory.

GEORGE, not in Europe, nor of English born,
 Whom living, though much Noblenefs did adorn;
Yet was no Peer to meaneft Potentate;
His Fame tranfplanted to the Weftern States:
They of him dead fo honourably account,
As Monarchs do confefs him Paramount:
Nor did exclude him for his foreign Birth,
From any Honour due to him on Earth;
St. George was all that Knighthood can require;
Lo! an Example fit for to admire:
His noble Birth he much more Noble made,
By Noble Deeds, the Riches which he had,
(And Store he had) were but his Virtues Folk,
CHRIST had the Honour of his gotten Spoils:
Youth, Beauty, Grace in Court, Health, Vigour, Fame,
Or wh else this frail, elemented Frame

Of Human Nature may Support, he had,
And (which is more than mortal Power can add)
A Spirit, Mafter of his Earthly Parts,
Bleft with high Virtues, deck'd with goodly Arts.
Hiftory doth well record his Valiant Deeds,
How he made Dragons, Lions, Giants bleed,
Redeem'd fair Virgins from enchanted Spells,
And from all Heroes bore away the Bell;
And tho' at laft the Poifon did afcend,
From a flain Dragon, which his Life did end;
Our King and Nobles him in Memory bear,
And near their Heart his well-form'd Image wear.

Printed and Sold in Aldermary Church Yard, London.

1.5 *Saint George, the Chief Champion of England, c.1750.* This example of the large, cheap woodcuts which enjoyed enormous popularity in the mid eighteenth century uses a sixteenth-century woodblock that must have appeared originally in a more dignified context – and probably portrayed a classical hero rather than St George. The subject reflects the bellicose nationalism of the period of the Seven Years War and the Jacobite Rebellion.

CHAPTER TWO
'ALL SORTS OF PRINTS...'

This chapter takes as its title a phrase with which eighteenth-century print publishers introduced lists of their stock. It deals with some of the many categories of prints that can be called popular, and with their functions, history and appearance. Categorizing prints by function raises other problems of definition. Prints found in such popular publications as almanacs, chapbooks and children's books might elsewhere be discussed as book illustrations; prints used for amusement (such as anamorphic or glass prints) might be relatively sophisticated in technique or subject matter. The only broad category of print that is deliberately excluded is the Old Master print sold by auctioneers, or by dealers in what were called 'old prints', who catered to connoisseurs; popular prints – ephemeral by nature – only rarely reach a second-hand market.

Evidence about prints comes not only from surviving examples but also from advertisements and print publishers' catalogues, from literary descriptions, and from visual information in the form of images of printsellers and of interiors where prints are on display. The most important publications on specific categories (where any exist) are given.

The archetypal popular print throughout Europe is a simple woodcut, about 350 × 250 mm or larger, crudely hand-coloured, with a title in letterpress and perhaps a small amount of other text. From the seventeenth century at least such prints were pinned or pasted on the walls of taverns and cottages as decoration or as religious or patriotic icons. In the early Victorian period Smith, Steam Printer, of Brick Lane, Spitalfields, London, T. Bloomer, at the Cheap Traveller's Warehouse, Birmingham, and rivals all over the country published boldly coloured prints of this type for a market in the expanding cities (fig. 2.1). In the mid eighteenth century the Dicey family of London and Northampton (see pp. 55–60) was the best known of several publishers of large simple woodcuts sometimes printed from blocks that were already more than a hundred years old. In the seventeenth century these woodcuts had been published by Allde, Trundle and the 'ballad partners', Thomas Pavier and John Wright[1] (see below and Chapter Three).

As we move back in time it becomes harder to gain a clear picture of the range of print production in England. The Stationers' Registers for 1554 to 1708[2] give titles of publications that often suggest popular subject matter but they offer no clue as to style, or even whether the item registered was a print or an unillustrated broadside or book. Tessa Watt searched assiduously for surviving

single-sheet prints published in England between 1550 and 1640 and found only half a dozen large-size religious woodcut 'pictures' (as opposed to broadsides or ballads which might have had small illustrations) of the sixteenth century. She found a further twenty-two sixteenth-century woodcuts of secular subjects.[3] There were no systematic collectors of such material and the rate of survival is doubtless less than the one in twelve that Watt calculates for ballads of the period,[4] but on that reckoning fewer than four hundred single-sheet woodcuts would have been published in England in the sixteenth century.

The most common category of popular print in England before the nineteenth century was the ballad illustrated with simple woodcuts. There is a long history of ballad-collecting; many examples survive and the literature is exhaustive. Samuel Pepys's collection, now at Magdalene College, Cambridge, has been fully catalogued and indexed by Helen Weinstein and the ballads are reproduced in a series of five volumes.[5] See Chapter Nine for other major collections, most of which were catalogued during the nineteenth century.

It is not only survival that indicates the importance of the ballad in England. Its predominance among categories of popular prints is confirmed by visual and literary evidence. Ballads appear more often than any other form of popular print

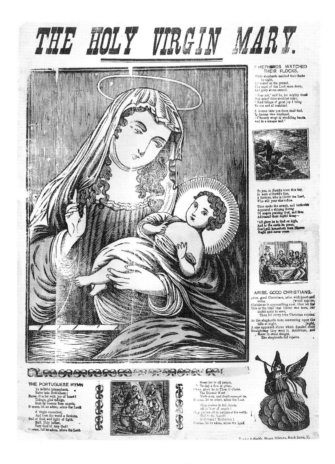

2.1 *The Holy Virgin Mary*, *c*.1840. This crudely cut and brightly coloured block is an example of a type of religious print that appeared in England in the nineteenth century. Images that might be construed as icons had been avoided since the Reformation but a more tolerant attitude to Roman Catholicism brought with it cheap devotional imagery of a kind that was ubiquitous in southern Europe.

as 'prints within prints' (figs 1.4 and 4.15) and, similarly, they are the subject of the vast majority of literary references to prints in taverns and on cottage walls: Isaak Walton's Piscator takes his friend to an 'honest ale-house, where we shall find a cleanly room, lavender in the windows, and twenty ballads stuck about the wall';[6] in 1709 Jonathan Swift wrote of 'ballads pasted on the wall / Of Joan of France, and English Moll, / Fair Rosamund and Robin Hood, / The little Children in the wood';[7] Thomas Holcroft, the dramatist, spent his childhood in the 1740s and 1750s travelling around England and recalled that 'Even the walls of cottages and little alehouses ... had old English ballads, such as *Death and the Lady* and *Margaret's Ghost*, with lamentable tragedies, or *King Charles' Golden Rules*, occasionally pasted on them. These were at that time the learning, and, often, no doubt, the delight of the vulgar';[8] in 1770 George Smith described the sunlight moving across the wall of a room in the course of a day:

See on the kitchen wall, with ballads gay,
The early sunbeams quiver through the spray;
Now Rosamund they leave, and sink apace
To tremble on the lines of Chevy Chase,
Tis five exactly when they yield the tack
That holds the corner of the Almanack.[9]

The contrast with the Continental preference for the image with little or no text must be explained by the comparatively high levels of literacy at all strata of society in England. Research in the last few decades makes it clear that literacy in Britain was much higher than has often been thought: the remarkable level of nearly forty per cent adult male literacy was reached in the third quarter of the seventeenth century.[10] The majority of the popular prints discussed in this book were produced to accompany text.

Most surviving ballads recount traditional tales of adventure or bawdy exploits, but governments recognized their potential as agents of subversion and from 1533 successive measures were introduced to control their production and sale. From 1557 ballads were required to be registered by the Stationers' Company[11] after authorization by the Archbishop of Canterbury. In 1586 a decree of the Star Chamber[12] in response to the activities of clandestine presses imposed rigid control and required unregistered material to be licensed retrospectively; 237 ballads were registered in the following year.[13] Watt gives an account of the ballad as a means of religious propaganda in the late sixteenth century and demonstrates how in the Jacobean period that role was taken over by the pamphlet and printed sermon while ballads moved down-market.[14] The year 1624 saw the formation of the 'ballad partners', a voluntary arrangement between members of the Stationers' Company who registered (and thus acquired joint copyright of) all the most popular ballads for the remainder of the century; surviving ballads of the period usually carry a joint publication line naming between two and four partners. A list of publications issued in 1689 by one of the later partners, William Thackeray, included 301 ballads.[15] The chief contribution

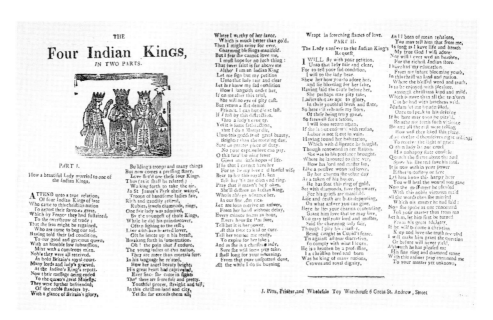

2.2 *The Four Indian Kings, c.*1820. This early-nineteenth-century ballad follows the traditional horizontal format. It tells a fanciful story of the love of an 'Indian King' for an English beauty. It derives from the visit of four Iroquois sachems to England in 1710 (see p. 108), but is illustrated by a woodblock of the three kings of the Nativity which the publisher would have had in stock.

of the ballad partners was the initiation of a distribution network that took cheap printed material to all parts of the country.

Sixteenth-, seventeenth- and eighteenth-century ballads were printed horizontally on a half-broadside or pot sheet (about 250 × 300 mm). By 1700 'black-letter' (gothic) type had given way to modern 'white-letter' – a century after it had gone from other printed matter. In the early nineteenth century a variety of new formats were used: quarto sheets (about 250 × 175 mm), printed vertically often with more than one song; slip ballads (about 270 × 100 mm); 'garlands', collections of songs on sheets folded to form small chapbooks about 150 × 100 mm; and 'long-song' sheets, about 750 × 150 mm, that could be cut up and pasted together by the ballad-sellers to form dramatic streamers proclaiming their wares (figs 2.2, 2.3, 2.4). No figures exist to indicate the proportion of ballads that were illustrated, but simple woodcuts are commonly found on surviving ballads from all periods.

Christmas carol sheets were a distinct form (fig. 6.4). They appeared in the stock book of John Dorne of Oxford in 1520 (see p. 181) and were still obtainable, although not easily, in the first decades of the nineteenth century. In 1823 William Hone feared that they would soon die out altogether: 'This collection [of carol sheets] I have had little opportunity of increasing except when in the country I have heard an old woman singing an old carol, and brought back the carol in my pocket.'[16]

A
GARLAND
OF
NEW SONGS.

Young Love among the Roſes.
My Nanie, O.
God ſave the King.
Rule Britannia.
Dear is my little Native Vale.
General Wolfe's Song.

Newcaſtle upon Tyne
Printed by J. Marſhall, in the Old Fleſh-Market.
Where may alſo be had, a large and curious Aſſortment
of Songs, Ballads, Tales, Hiſtories, &c.

2.3 *A Garland of New Songs*, early nineteenth century. This collection of songs – including *Rule, Britannia* and *God Save the King* – is printed and folded in the form of a chapbook. The woodcut illustration, from an old block that would have been part of the publisher's stock, bears no relation to any of the songs save that it includes a king. It shows a scene from a favourite ballad subject, the story of Fair Rosamond, mistress of Henry II, who, according to popular legend, was murdered by Queen Eleanor. Marshall, the publisher, worked in Newcastle and Gateshead from about 1801 to 1831.

2.4 *The Champion*, c.1825. The 'long-song' ballad sheet was designed to attract attention. A Victorian writer remembered seeing them offered for sale in Carlisle: 'The Long-song sellers pasted three yards of songs together, and carried their wares about suspended from the top of a tall pole, crying "Three yards a penny, songs, beautiful songs, nooest songs"' (see p. 174).

Many of the woodcuts used to illustrate ballads also appeared in chapbooks. These were little books of sixteen or twenty-four pages made by folding a sheet or a sheet and a half of poor-quality paper and sewn together without covers. They were priced at about a penny and were sold throughout the country by chapmen or pedlars. Chapbooks first appeared in the last quarter of the seventeenth century and were overtaken early in the nineteenth century by technical advances and the demand for higher quality. Most were produced in the City of London, but as the eighteenth century progressed piracies were published in Newcastle and elsewhere in the British Isles.

Most surviving chapbooks contain traditional tales such as *The Children in the Wood*, *Dick Whittington*, *Robin Hood* or *Tom Thumb*. More than a hundred are reproduced, in whole or part, in Ashton, but unfortunately his illustrations were made from drawings rather than photographs of the woodcuts and they are deceptively tidier than the originals. This not only gives a false impression but can also cause confusion in any study of the re-use or copying of blocks. For a thorough survey of the subject with an excellent critical biography see Neuberg 1977.

Another class of publication that sold in huge numbers – and often included pictorial prints – was the almanac. Almanacs combined calendars with astronomical, astrological and other useful information. They could take the form of small books, like modern pocket diaries, or illustrated broadsides intended for display (see George Smith's verse above, and fig. 2.5). The most thorough accounts of early almanacs are Bosanquet and Capp.

It was their astrological content, rather than their utilitarian features, that caused almanacs to sell in enormous numbers – in the seventeenth century outstripping even the Bible.[17] An interest in astrology, which in the Middle Ages had been confined to court circles, became widespread. *Merlin Anglicus Junior, The English Merlin Revived*, published annually by the leading almanac writer William Lilly from 1644 until his death in 1681, sold out its first edition in a week. In 1648 Lilly was sent to Colchester to encourage the besieging parliamentarian army with predictions of victory.[18] John Evelyn complained that the almanac writers had stirred up anxiety that the eclipse of 29 March 1652 was evidence of divine wrath.[19]

Prognostications were a convenient vehicle for political propaganda, and proclamations of 1568–9 against seditious pamphlets restricted the publication of almanacs. For the whole of the seventeenth and eighteenth centuries the production and wholesaling of almanacs was largely in the hands of the 'English Stock', an organization run by the Stationers' Company in the City of London, but their profitability meant that the monopoly was continually challenged. Cambridge and Oxford Universities obtained permission to publish almanacs respectively in 1623 and 1637 but the Stationers bought out their rights until the 1670s. Competition from individual publishers was similarly eliminated by a combination of legal sanctions and financial encouragement.

At the end of the eighteenth century half a million almanacs were produced every year – at a time when the population of London was only about a million, and that of the whole of England less than ten million. In 1794 the Stationers advertised a wide range: Wing's Sheet Almanack, Cambridge Sheet Almanack and a number of County Almanacks for 8d. each; London Sheet Almanack and Goldsmith's Almanack for 9d. each; The Gentleman's Diary, The Ladies' Diary, Francis Moore's Almanack, John Partridge's Almanack, Poor Robin's Almanack, Season on the Seasons, Tycho Wing's Almanack and Rider's British Merlin at 10d. each; and White's Coelestial Atlas and The Free-Mason's Calendar at 1s. But the variety of titles diminished and by 1802 nearly all of the Company's £3000 profit came from Francis Moore's *Vox Stellarum*. Moore died in 1715, but 'Old Moore's Almanack' continued in production. At the time of the French Revolution its editor Henry Andrews (1744–1820) introduced illustrations symbolizing millennial ideas and promoting political radicalism (fig. 2.5).

Newspapers were not commonplace until well into the eighteenth century and were rarely illustrated before the Victorian period. In earlier times events of public interest were reported on broadsides or, in the case of official publications, in the form of proclamations that would be pasted up in public places. The sixteenth and seventeenth centuries were periods of fierce government control of the dissemination of news, but newsbooks or *corantos* with translations of foreign news (particularly of what was to be the Thirty Years War) appeared intermittently from 1620.[20] Newsbooks and pamphlets of all sorts proliferated during the Civil War and Commonwealth, but after the Restoration censorship returned and remained in force until 1695. *The London Gazette*,[21] published continuously from 1665, received government sanction. The Stamp Act of 1712 required newspapers and other ephemeral publications to be licensed and taxed. It remained in force until 1855 and by pushing up retail prices effectively hindered the opposition press.

Large numbers of publications dealing with current events in the seventeenth century survive thanks to two collectors, George Thomason and Narcissus Luttrell (see pp. 192–4). Both men aimed to build up narratives of life in their times by keeping such ephemeral material and so, incidentally, provided a record of changing styles and formats. Luttrell's late-seventeenth-century broadsides are far more likely to be illustrated than those that Thomason collected a generation earlier.[22]

Long after newspapers had taken a central role in the dissemination of news the execution broadside remained a mainstay of print production at the cheaper end of the trade. From the beginning of the eighteenth century the prison chaplain, or 'Ordinary', of Newgate prison sold accounts of executions.[23] The earliest of these were pious tracts accompanied by advertisements for published sermons,[24] but in the second decade of the century they began to include simple woodcuts of Newgate and the 'triple tree' – the three-sided gallows – and more varied letter-press, including black-letter for emphasis.[25] This elaboration coincides with

2.5 *Moore's General Almanack for 1835*. This sheet almanac contains a calendar and factual information about eclipses, hackney coach fares and so on, but the woodcut illustration (signed by the satirical printmaker Charles Jameson Grant) depicts the chaotic state of the nation at this time of political reform.

increased length, and the chaplain's exhortations are enhanced with details of the criminal histories of the condemned.

By the middle of the century these earnest publications, which appeared immediately after the execution, were supplemented by more sensational broadsides that made 'dying words' available for purchase while the felon was still being dragged through the streets. About 1760 Thomas Kaygill of Russell Court, Drury Lane, advertised, among prints, books and stationery for sale, 'Plays, Sessions Papers [i.e., lists of cases put down for trial], and Dying Speeches sold, or lent out to read'.[26] In 1779 the *Malefactor's Register*, a five-volume compilation of Ordinaries' accounts and other criminal biographies, was published; its success led to a series of expensively produced *Newgate Calendars* aimed at the growing middle-class market for moralizing literature.[27]

2.6 *An Elegy on … Prince Rupert*, 1682. Rupert, nephew of Charles I, is celebrated as leader of the Royalist army in the Civil War and for his inventions of military hardware – 'at once the Mars and Vulcan of the war'. Narcissus Luttrell bought the elegy for 1d. on 1 December 1682, two days after Prince Rupert's death.

(*Facing page*)
2.7 *London's Loud Cryes to the Lord by Prayer*, 1665. This broadside lists the numbers of those dying each week during successive plagues from 1591 onwards. It was published on 8 August 1665 and shows that more than eight hundred people had died of the plague in London during the previous week. The sheet also includes appropriate biblical texts and a receipe for a herbal remedy.

Londons Loud Cryes to the Lord by Prayer:

Made by a Reverend Divine, and Approved of by many others: Most fit to be used by every Master of a Family, both in City and Country. With an Account of Several modern Plagues, or Visitations in *London*, With the Number of those that then Dyed, as well of all Diseases, as of the *Plague*; Continued down to this present Day *August*, 8th. 1665.

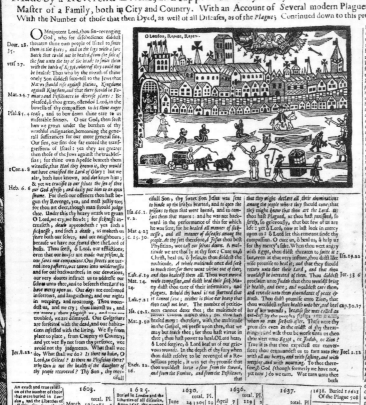

O London, Repent, Repent.

Most surviving execution broadsides, illustrated with stock woodcuts of Tyburn, and later Newgate or Horsemonger Lane Gaol, were produced by the mass popular print publishers James Catnach and his contemporaries who developed the market to an extraordinary degree from the early nineteenth century onwards (fig. 3.20). A number of the woodcuts from these nineteenth-century broadsides are reproduced, with a useful introduction, in Gretton.

The other perennially popular broadsides were elegies announcing the deaths of well-known people and recording their achievements. Dates noted on elegies in Narcissus Luttrell's collection show that they were published very rapidly, and the texts, like modern newspaper obituaries, would have been prepared in advance. Elegies were normally illustrated by *memento mori* woodcuts with figures of Death and Time, and surrounded by simple black strips that might include

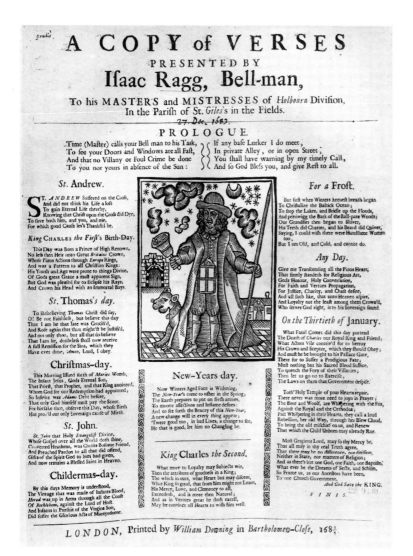

2.8 *A Copy of Verses presented by Isaac Ragg, Bell-man, 1683.* This sheet was given to Narcissus Luttrell 'gratis' on 27 December 1683 in an attempt by Ragg, the bellman or night watchman, to solicit a New Year gift.

funereal symbols such as skulls, bones and hour-glasses (fig. 2.6). The disastrous plagues of 1665 and earlier were documented by broadsides bearing these same emblems (fig. 2.7).[28]

Erasmus recorded in 1506 that the habit of distributing gifts at New Year was already long established. By the late seventeenth century it was customary for bellmen, night watchmen, and other tradesmen to present broadsides or smaller handbills as a way of soliciting such gifts (figs 2.8, 2.9). These were large sheets with a series of verses on pious and topical subjects surrounded by woodcuts. The most prominent image was the bellman patrolling the night-time streets with his lamp and dog. Bellmen's sheets are sometimes referred to as Christmas Sheets but that term is avoided here in order to prevent confusion with children's writing sheets (see below).[29]

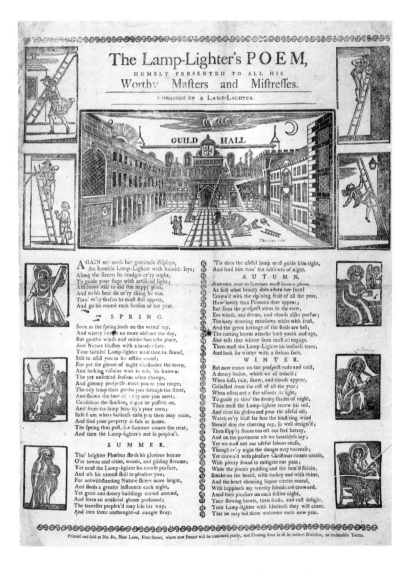

2.9 *The Lamp-Lighter's Poem*, c.1800. A variation on the bellman's verse is this sheet for a lamp-lighter. The scenes showing the lamp-lighter falling from a ladder remind citizens of the risks that are run in order to keep the streets lit at night. In contrast to most bellmen's sheets the publisher has not named a specific lamplighter or given a date – the sheet could do duty for several years. Lamp-lighters had a lower status than bellmen and are often shown in prints as comic figures absent-mindedly pouring oil on the heads of passers-by (see fig. 5.20).

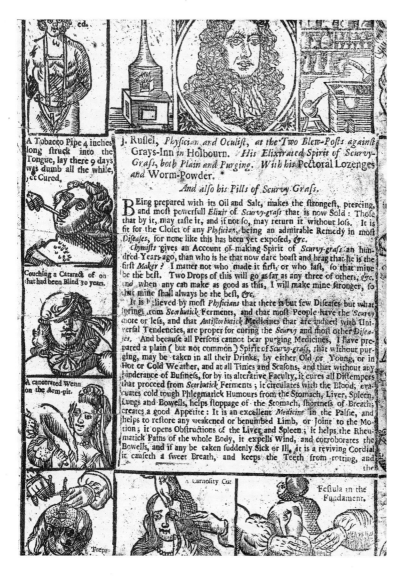

2.10 *Advertisement for J. Russel's Elixtrated Spirit of Scurvy-Grass, c.1665.* This handbill, with its alarming woodcuts of medical treatments, lists the benefits of a number of remedies sold not only by Russel, a physician and oculist, but also by Millner, a stationer. It was common for medicines to be sold by suppliers of printed materials, presumably so that they could take advantage of the network of hawkers or chapmen who carried small goods all over the country.

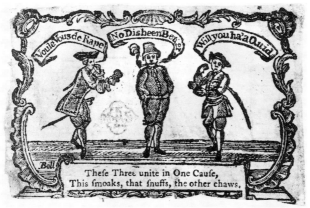

2.11 *Tobacco wrapper, c.1760.* The wrapper links national stereotypes (a favourite English joke) to tobacco consumption, showing an elegant snuff-taking Frenchman, a stocky pipe-smoking Dutchman and a Scot chewing tobacco. The print was cut by J. Bell, one of the few popular printmakers to be identified (see p. 65).

Also distributed free of charge were handbills with advertisements of all sorts, from invitations to view exotic creatures 'lately arrived' (figs 4.36, 4.37) to announcements of medicines that would cure all diseases (fig. 2.10). Many such handbills can be included in the category of the trade card. These were small sheets used as advertisements by eighteenth-century tradesmen. They usually show the sign by which the tradesman's premises was identified (street-numbering began to be used in England only in the 1750s) and provide an incidental record of such signs that has been of great interest to historians.[30] The images on trade cards range from elegant engravings to unpretentious accumulations of goods for sale (fig. 2.12). The British Museum's collection of over fifteen thousand trade cards came chiefly from the collections of Sarah Sophia Banks and Ambrose Heal.[31] In recent times the term 'trade card' has been used to describe the mass-produced cigarette, bubblegum or tea cards given away with goods to encourage sales; that type of print is beyond the scope of this book.

Tobacconists have a long history of advertising. By the early eighteenth century small packets of tobacco were printed with advertisements often incorporating the kind of jokes or riddles with which smokers might amuse themselves in the tavern (fig. 2.11). In the 1790s Radical tavern keepers used tobacco wrappers

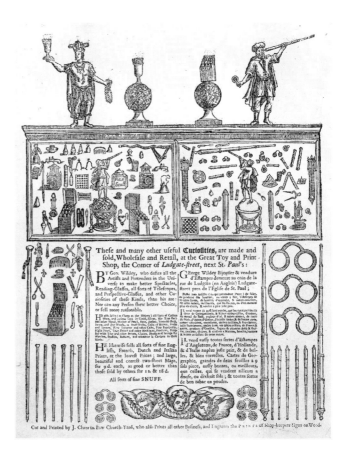

2.12 *Trade card of George Wildey, c.*1720. This card, published by the woodcut specialist John Cluer, shows a marvellous array of the goods sold by Wildey (fl. 1707–37): spectacles, telescopes, cutlery, jewellery, as well as English, French, Dutch and Italian prints, large maps and 'all sorts of fine snuff'.

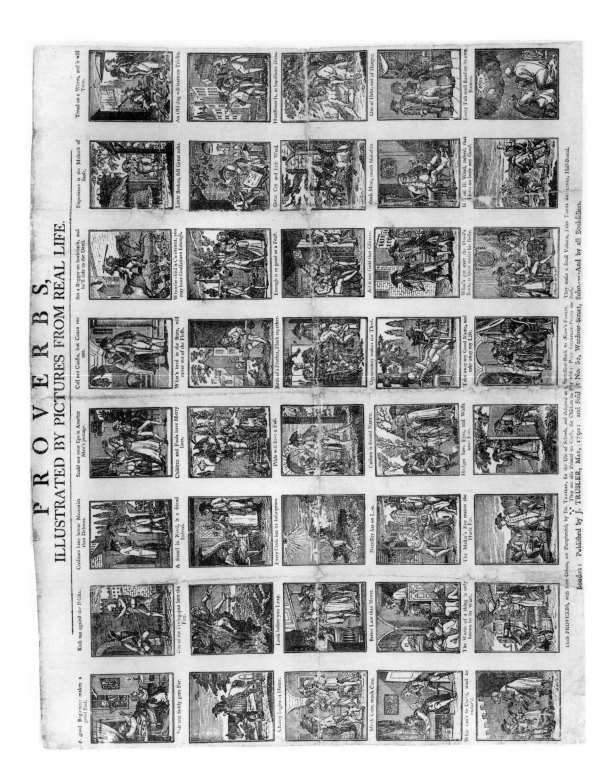

PROVERBS, ILLUSTRATED BY PICTURES FROM REAL LIFE.

as a vehicle for propaganda, printing them with riddles that gave anti-royalist messages (see p. 143).

The small size of tobacco wrappers called for detailed work, and printmakers often used small blocks of boxwood, which is very hard, cut across the grain.[32] The evidence for the use of boxwood comes not only from surviving prints but also from an advertisement of a printmaker of the early years of the eighteenth century:

At the Bible in Pannier Alley in Paternoster Row, all sorts of fine prints, are cut and engraved on box or pear tree [wood], for booksellers, printers, tobacconists, haberdashers, &c. Also, such stamps, or marks, cut on brass or wood, as are used at the Post Office, Excise Office, Stamp Office, &c. at reasonable prices, by William Pennock. At whose shop, ready money may be had for any large or small parcel of books, pamphlets, pictures, prints, or drawings. And books lent to read.[33]

Pennock's contemporary Isaac Bedbury, of Sea Coal Lane near Fleet Ditch, seems also to have used boxwood; according to his advertisement his prints were 'so fine in wood, that hundreds have taken them for copperplates ... One wooden print will wear out ten copperplates'.[34]

Prints were not always intended to appear in only one guise. In 1679 Thomas Dawks advertised a series of small scenes depicting events in the 'Popish Plot'. The prints were available in a range of formats:

so contrived that they will be made up in a pack of cards, and wrapped in a printed paper, which will assist the reader's understanding of them: or, they may be kept together in one view, in two large sheets of paper, making a complete ornament for a small almanac, this having only in place of an almanack, a journal of the [Popish] Plot. There was lately published a large sheet, called Sir Edmundbury Godfrey's murder made visible; ... wherein the several cruelties of the Papists, in the said Godfrey's Murder, are lively represented in a copperplate, which may be had plain, or painted and with rollers, being a neat ornament for gentlemen's houses.'[35]

Dawks's prints, after designs by Francis Barlow, sold extremely well at a time of high anxiety over alleged Roman Catholic plots to overthrow the government; several packs of cards survive.[36] Large sheets were much more vulnerable, whether prints, like the representation of Sir Edmundbury Godfrey's murder, or maps, 'plain, or painted', backed with linen and attached to rollers. They are often seen in views of seventeenth- or eighteenth-century interiors; Samuel Pepys, for instance, had a large map of Paris on the wall of his library.[37]

The flexible arrangement whereby the same prints could be issued in different formats was not unusual. The probate inventory of the publisher Charles Tias (d. 1664; see p. 175) lists large numbers of titles for sale as broadsheets or as books in several formats.[38] In 1790 John Trusler published a set of proverbs aimed at children illustrated with wood-engravings by John Bewick

(*Facing page*) 2.13 *Proverbs Illustrated by pictures from Real Life*, 1790. John Bewick (1760–95) was commissioned by John Trusler to design and cut wood-engravings to illustrate familiar proverbs – 'Better Late than Never', 'Custom is second Nature', etc.

that could be bought as packs of cards, bound as small books or as large sheets (fig. 2.13).[39]

Books and prints for children began to appear in the late seventeenth century, although horn books were commonplace from the late sixteenth century. These were children's primers printed on a single sheet protected by a thin sheet of transparent animal horn and mounted on a tablet of wood with a handle, but the term might be extended to more conventional books for children. An illustrated hornbook sheet first published *c.*1660 survives in a late seventeenth-century impression in the British Museum (fig. 2.14). In 1712 John Locke, the philosopher, devised educational toys in the form of cards with letters and pictures for the young son of the Earl of Shaftesbury.[40] A similar teaching method appears in the earliest known English children's book, *A Little Book for Children* by 'T. W.' published about the same time. About 1750 John Newbery published a game called 'Squares' based on Locke's design. The cards were printed with simple woodcuts and sentences with a moral tone still familiar in publications for small children: 'F was a Fool, and cou'd not read a word'; 'K was a King, who was honest and good'; 'L was a Lion, both stately and strong'.[41]

Newbery (1713–67) was the first publisher to develop the children's market as a major part of his business. His books were attractively bound in coloured floral boards; their small format would have appealed to children, but their quality and price – up to 1s. for a book of eighty to 150 pages – were far higher than those of the chapbooks hawked around the country for a penny. They were clearly aimed at the middle and upper classes who would come to one or other of the Newbery shops near St Paul's Cathedral. Other members of the family followed in Newbery's footsteps (although his stepson Thomas Carnan moved on to specialize in almanac publication after lengthy litigation with the Stationers' Company). Roscoe's bibliography is the basic text on the juvenile publications of the Newbery family.

Prints specifically aimed at children increased in numbers in the last decades of the eighteenth century, but the emphasis was still on 'playing them into a knowledge of the letters, figures, &c.'. This phrase appears on the title page of *A Little Lottery Book for Children*, published by Newbery in 1767[42] for 3d. The book consists of the letters of the alphabet illustrated with woodcuts of familiar subjects beginning with each letter (M for Magpie, etc.). At about the same time Thomas Kaygill of Russell Court, Drury Lane (see above), advertised a 'variety of little books for the instruction and amusement of children'.[43]

Printsellers' catalogues throughout the century include entries for prints for children. The most popular seem to have been sheets of small images called 'lotteries' (fig. 2.15).[44] Henry Overton's catalogue of 1717 offers, on p. 22, 'About 500 more several sorts of small plates for children to play with, both coloured and plain'; Carington Bowles's catalogue of 1786 describes these prints, on p. 198, as:

Lotteries. 400 different sorts, far superior in goodness to any extant, being a new and large collection of small pictures and hieroglyphics, intended to divert and instruct children in

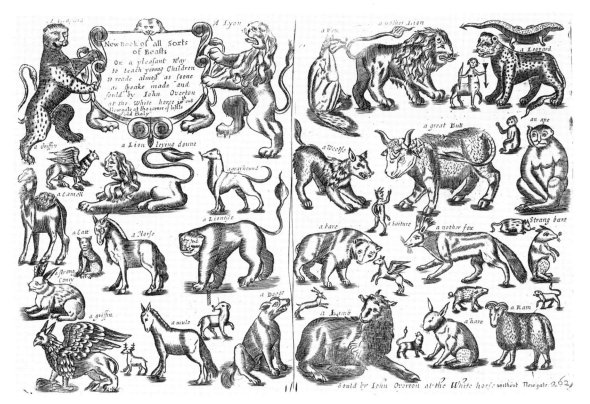

2.14 *A New Book of all Sorts of Beasts*, c.1660, this impression c.1670. This is a very early survival of an illustrated aid to the teaching of reading. It was first described in Peter Stent's catalogue of 1662 as a 'horn book', and was probably intended to be cut in half and attached to either side of a small panel of wood that a child could handle easily.

their most tender years, containing the several dignities, stations and conditions among men and women; the various kinds of beasts, birds and fishes; trees, fruits and plants; the seasons of the year, sports, diversions, humours, trades, caricatures; the ways of life, etc.

Bowles's wholesale price for lotteries was 1s. 10d. a hundred plain, 3s. 8d. a hundred coloured.

These little prints clearly had great appeal. Children doubtless swapped them and competed for them in the same way that later generations treated stamps and cigarette cards. One game involved pushing a pin into a book containing small prints: the child who pushed the pin into an opening containing a print would keep it.[45] There seems to have been no direct connection with lotteries as a commercial form of gambling.

It is worth mentioning at this point the large amounts of ephemeral material – occasionally illustrated – that were published in connection with the state lottery.[46] In the 1790s £36,000 a year was spent on advertising by the lottery contractors.[47] There are collections of lottery-related material in the Guildhall Library, London, and in the British Library.

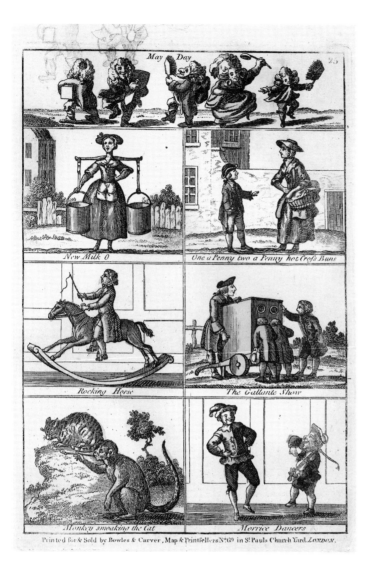

2.15 *Lottery sheet, c.1750*, this impression *c.*1800. The 'lottery sheet', an early type of print specifically aimed at children, was made up of small images that could be cut out and coloured. The images on this sheet include familiar sights on eighteenth-century streets: a milk seller, a hot cross bun seller, a peep-show, morris dancers. The dancers celebrating May Day are depicted as dwarf or Callot figures (see pp. 159–61).

Explicitly educational prints for children included writing sheets. These were large sheets printed with a pictorial border and a central area left blank for children to fill with specimens of their handwriting in order to impress their parents (fig. 2.16). They were usually presented at Christmas time and are often referred to as Christmas Sheets: the term is also sometimes used for the bell-men's sheets presented to householders at the same time of year (see above). A group of writing sheets with calligraphic borders designed about 1690 by John Smith, writing master at Christ's Hospital School, are early examples.[48] Commercially produced sheets were published throughout the eighteenth and nineteenth centuries, but most surviving examples date from about 1780 to 1830. Like other material produced for children the images and associated text are frequently of a didactic or moralizing nature.

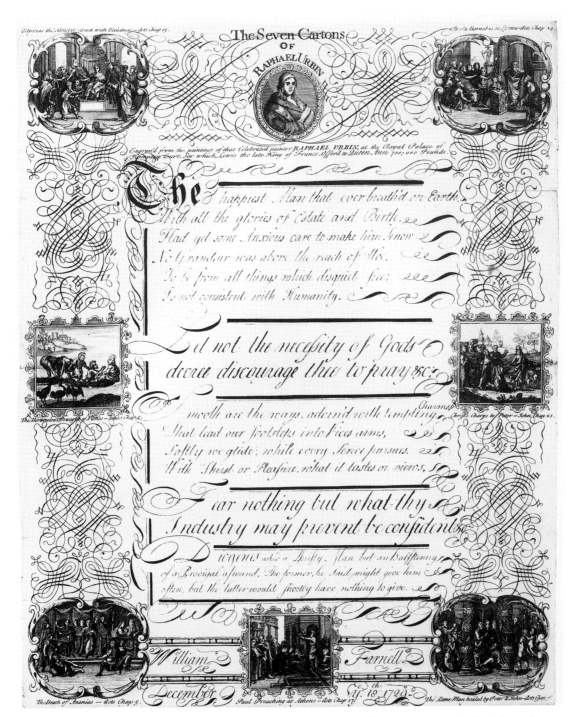

2.16 *Writing sheet, c.*1729. This is an early example of a type of print that was common in the eighteenth and nineteenth centuries. Sheets were printed with pictorial borders and large blank central areas that children filled with examples of their handwriting. The border to this sheet includes engravings after Raphael's famous tapestry cartoons, then at Hampton Court and only recently engraved for the first time – and thus brought into public view.

A type of children's print that enjoyed a vogue from about 1765 was the Harlequinade or 'turn-up' (fig. 2.17).[49] It was based on theatrical performances and consists of a folded sheet in four sections each with two flaps that alter the image and continue the story. Harlequinades remained popular for a long period: an impression of *Mother Shipton Part 2, or Harlequin in the Dumps*, first published by Robert Sayer in 1771, was printed on paper watermarked 1818.[50]

The popularity of theatrical subjects led publishers of popular prints to produce toy theatres. Actors, scenery and proscenium arch were printed on paper to be coloured, pasted on to board and cut out by children who would then perform their own versions of stage productions. The first English print publisher to specialize in toy theatres was William West (1783–1854), who developed them

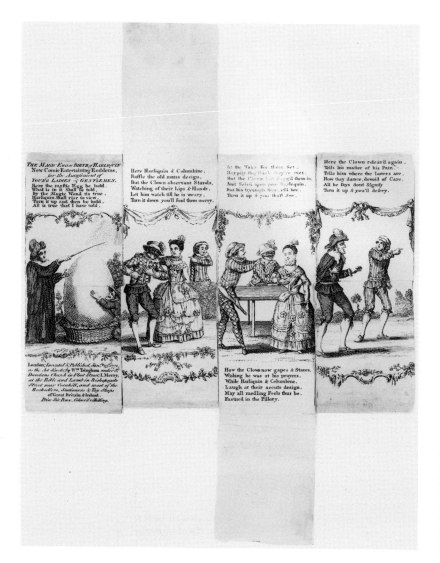

2.17 *Turn-up*, 1771. 'Turn-ups' appeared in the 1770s and their descendants are still a feature of books for children. A story is told in words and pictures which change as flaps are turned up or down. Harlequinades with clowns, pretty girls and foolish old men were favourite subjects.

around 1811[51] from prints of actors in famous roles. In 1851 West told Henry Mayhew that the new idea 'went like wildfire among the young folks'; he went on to make elaborate wooden theatres with lighting, movable scenery and special effects – his best-selling 'The Miller and his Men' ended with the explosion of the mill.[52] From the 1830s the quality, and price, of toy theatres went down but they remained popular until the 1860s when the melodramatic plays on which they were based went out of fashion. In an article entitled 'A Penny Plain and Twopence Coloured'[53] Robert Louis Stevenson recalled his delight in buying toy theatres as a boy in Edinburgh around 1860 and discussed their connection with the more general popularity of romantic tales. Stevenson's article initiated a revival of the genre, and the last Victorian publisher Benjamin Pollock (1856–1937) continued in business at his shop in Hoxton, London, until just before the Second World War. The British Museum has an important collection of early toy theatre prints (fig. 2.18). Pollock's Toy Museum, Scala Street, London, has a good collection of toy theatres and sells modern versions. For a thorough account of the toy theatre see Speaight.

Board games can also qualify as popular prints. They appear in the oeuvre of a wide variety of printmakers, including artists as celebrated as Stefano della Bella

2.18 *William Barrymore as Hamet Abdulcrim in El Hyder*, 1823. Toy theatre prints enjoyed great success in the first half of the nine-teenth century. This example shows a famous actor as a swaggering character from a typical melodrama. Entire productions were printed – characters, scenery and proscenium arch – to be assembled and performed at home.

and Giuseppe Maria Mitelli. They were produced by all the major English cheap print publishers on large sheets that would have been pasted on to board and varnished; when not in use they might be propped against the wall and serve as ornaments. In 1762 Oliver Goldsmith described a room in an alehouse:

The humid wall with paltry pictures spread;
The royal game of goose was there in view
And the twelve rules the royal martyr drew;
The seasons fram'd with listing found a place
And brave Prince William shew'd his lamp-black face.[54]

The royal game of goose (fig. 2.19) was an internationally popular board game, long established by Goldsmith's time. It takes its place in the alehouse beside *King Charles's Good Rules* (see p.18), a set of the four seasons surrounded by a border made of cloth, and a portrait of William, Duke of Cumberland.[55] Goldsmith mentions the game again in another country inn: 'The pictures placed for ornament and use, / The twelve good rules, the royal game of goose'.[56]

Playing cards – the most popular of all printed games – should not be forgotten. They are among the earliest prints. Playing cards, like much of English printing and printmaking, suffered from the restrictive practices of manufacturers, and the finest examples of Continental playing cards have no comparisons in this country. They were always a price-sensitive commodity: an advertisement at the foot of a murder newsheet printed in London for Joseph Grimes, near Ratcliff-Cross in 1708, gave:

Notice to all persons, that at a printers, next door to the pump in Half Paved Court in Salisbury Court, turning in by the sign of the Dog, is sold the best of super-fine cards, two-pence half-penny a pack, and by the dozen cheaper, being as good as those which are sold in some places for a groat or six-pence.[57]

There is much specialist literature on playing cards but the most useful general text is Mann.

Other prints served as amusements and pastimes rather than strictly speaking as games. The rules of perspective fascinated artists and viewers from the time of their codification in the Renaissance. Two particular types of print exploiting these rules achieved much popularity: the anamorphic print and the *vue d'optique*.

The anamorphic print was developed in Germany in the early sixteenth century.[58] The rules of perspective are used to create images that are unintelligible when looked at in the conventional way, but which make sense when viewed from a particular angle. Prints of this type appear in Henry Overton's catalogue of 1734 on p.41: '1. A George on horseback drawn in perspective so that it does not appear what it really is [fig. 2.20]. 2. A horse after the same manner. 3. Head of Charles I after the same manner'.

A particular type of view drawn with exaggerated perspective, and usually known as the *vue d'optique*, was popular in the second half of the eighteenth

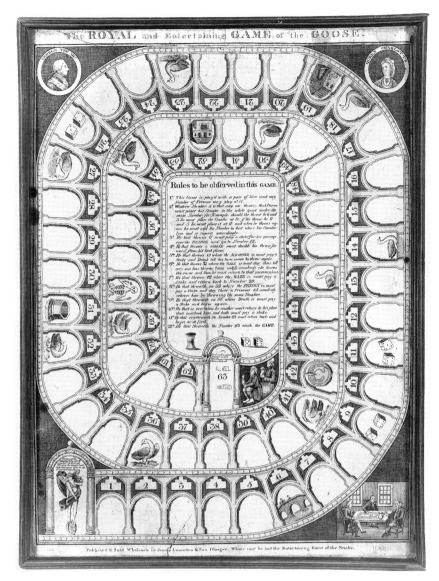

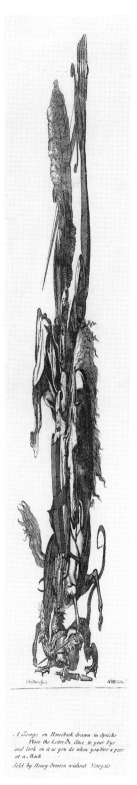

2.19 *The Royal and Entertaining Game of the Goose*, c.1800. This Scottish publication is a rare sheet by John Lumsden & Son of Glasgow, best known for their children's books. The game of goose, played with dice, was popular throughout Europe. Sheets were coloured, pasted on board and varnished; this example has a contemporary frame backed with green baize.

2.20 *A George on Horseback*, c.1710. Anamorphic images play with the rules of perspective so that they can be read only when viewed from a certain angle. The lettering below this print advises the viewer to 'Place the Letter A close to your Eye and look on it as you do when you Fire a piece at a Mark'; the crease in the paper at the letter A shows that this instruction was followed.

The Lord Mayor's Mansion House. *Publish'd according to Act of Parliament Dec.11.1751.* Le Palais du Lord Mayor *ou premier Magistrat*
Showing the Front of the House & the West Side. *de la Ville de Londres.*
Printed for John Bowles at the Black Horse in Cornhill.

2.21 *The Lord Mayor's Mansion House, London,* 1751. This view of the newly built
Mansion House in the City of London is a *vue d'optique* designed with deliberately
exaggerated perspective so that it could be used in a viewing apparatus that gave an effect of
three-dimensionality. Such prints had an international market and were often published with
bilingual titles.

century throughout Europe (fig. 2.21). It was designed to be seen with the aid of
an apparatus containing magnifying lenses, mirrors and candles that created
an illusion of three-dimensionality. Surviving impressions are, as often as
not, brightly coloured with bold bands of blue in the sky. The print publisher
Carington Bowles's catalogue of 1784 includes on p. 70: 'Perspective Views ...
for viewing in the diagonal mirrors, or optical pillar machines, in which method
of looking at them, they appear with surprizing beauty, and magnify almost to
the size of the real building'. Titles are often published in two languages in order
to encourage international trade; they are often reversed to allow for a mirror-
image. *Vues d'optique* occupy the middle ground in the print market: at 1s., or
2s. coloured, they are too expensive to be properly classed as popular, and
yet they were clearly bought for amusement rather than as works of art for
connoisseurs.[59]

Making 'glass prints' was a favourite pastime for young ladies in the seven-
teenth and eighteenth centuries (fig. 2.22). They would paste a mezzotint face
down on to a sheet of glass and carefully scrape and rub away the paper until only
the printing ink remained. They would then colour the image by painting the

2.22 *Painting*, from a series of allegories of the arts, *c*.1750. A mezzotint has been pasted on to a sheet of glass and the paper rubbed away so that only the ink remains. The resulting 'glass print' was then coloured from behind. Making glass prints was a favourite pastime for young ladies in the late seventeenth and eighteenth centuries, but they were also sold ready-made as decoration.

glass. There was no need to paint with great care or skill because the modelling of the forms was provided by the printed image. Print publishers also produced ready-made glass prints. For an account of the process see Massing.

A type of print production that was particularly popular in the 1820s was the printed handkerchief, roughly 470 x 630 mm, usually recording major events or famous people. Fine prints had appeared on silk since the seventeenth century[60] but it was the industrial development of printing on cotton in Lancashire that brought the medium to a wider market. Many surviving printed handkerchiefs depict subjects connected with the Radical movements of the 1820s (fig. 5.16). There is a collection of over a hundred printed handkerchiefs in the Museum of London.[61]

CHAPTER THREE

THE PRODUCTION OF POPULAR PRINTS: PUBLISHERS AND PRINTMAKERS

The first prints published in England were the woodcuts illustrating William Caxton's *Mirror of the World* in 1481. The production and publication of prints and of books were inseparable in the first decades of printing. (For illuminating accounts of the early years of printing in England see Plomer, Blagden 1960 and Bennett.) The new trade was officially encouraged at first, and the 1484 Act restricting aliens working in England specifically exempted those involved in printing. In the early years a large import trade developed, and high-quality books and prints, as well as many skilled practitioners, came to England from established printing centres in France, Germany, Holland, Italy and Switzerland. Evidence of international co-operation even at the lower end of the market is provided by a broadside jointly published in 1531 by Niclas Meldeman of Nuremberg and Peter Treveris of Southwark (fig. 3.1).[1]

But the situation was soon to change. The printed word played too important a role in the Reformation for political and religious interests to allow the new trade to develop unhindered. At the same time the Stationers' Company was determined to maintain the powerful position it enjoyed before the introduction of printing, and it provided the perfect vehicle for government control. The government was mainly concerned to prevent the publication of potentially subversive literature; the Stationers wanted the right to publish profitable material, mainly certain religious texts and almanacs (see pp. 21–3). Both aims were satisfied in a series of proclamations and Acts of Parliament from 1523 onwards that wiped out such trade as existed in the provinces and severely regulated printers working in London. In 1557 the Stationers' Company was granted a charter stating that all printers in the kingdom must be members unless licensed by the Crown – and membership, as with other guilds, could be achieved only by patrimony, by apprenticeship or by redemption, which required influential sponsorship and cash. The Company policed the trade with swingeing rights of search and seizure, and was allowed to imprison defaulters for three months without trial.

In the short term the Stationers reaped the profits of monopoly status, but the combination of their restrictive practices and government censorship stifled the development of printing, and thus of printmaking, in England. Control focused on the printed word but all printed matter was subject to the same legislation, and the restrictive atmosphere did nothing to encourage the print trade. While printing and printmaking flourished on the Continent it was more

than two hundred years before the British print trade became an international one.[2]

For historians there is, however, a small compensation in that the Stationers' Registers list every book, pamphlet, broadside and print licensed by them and so provide important evidence, especially for the early period when few of the minor publications survive. These registers were published between 1875 and 1914 (see Arber) and provide records of the publication of many prints that survive only in later impressions or have been altogether lost.[3] It should be noted, however, that many publications that do survive are not listed; the regulations were not enforced with equal vigour at all times, and in slacker periods publishers avoided registration.

Current knowledge of the print trade in sixteenth-century England suggests that it remained too small for a clear division between the upper and lower levels to develop, but one publisher stands out as a forerunner of those who in later generations produced woodcuts for a popular audience. He was Gyles Godet,

3.1 *This Horryble Monster...*, 1531. This broadside describing the birth of conjoined piglets in a German village is an extraordinary example of international co-operation at the bottom end of the print trade. The front and back views of the piglets and the German text describing them were published by Niclas Meldeman in Nuremberg; the blank area that he left in the centre of the sheet was completed with an English text by the Southwark printer Peter Treveris. Within a few years such enterprise would have been impossible. Government censorship and guild regulations imposed by the Stationers' Company combined to restrict not only foreign imports but also provincial printing within the British Isles.

3.2 *A genealogy of the Kings of England*, 1562. This is a section of a series of English monarchs extending back into prehistory, published by Gyles Godet in the early years of Elizabeth's reign. The kings and queens from William the Conqueror to Henry VIII are based on a series of woodcuts made in Antwerp in 1534, probably by Dirk Vellert, and the verses are English versions of the Dutch originals.

a Frenchman who came to London around 1547, became a member of the Stationers' Company and was in business in Blackfriars from c.1562 until 1568. He was connected with the Parisian woodcut publishers of the Rue Montorgueil (see p. 213), and few English woodcuts of any period reach the standard of those he published. Early in 1563 he registered twenty-seven prints,[4] including two that survive with his imprint: a *Genealogy and Race of all the Kings of England from the Flood of Noah and Brutus* (fig. 3.2) and *The Picture of Queen Elizabeth*.[5] Two other entries in the Stationers' Register are also identifiable with surviving prints: *The Anatomie of the Inwarde Partes of Man and Woman* (fig. 11.5),[6] and *A Christian Exhortation of the Good Householder to his Children* (see fig. 3.3). Other prints with Godet's address survive in the Bibliothèque Nationale, Paris.[7]

What happened to Godet's woodblocks after his death is not clear. In 1584 English kings from his genealogy were published by Roger Ward as the 'Nine Worthies' (heroes from the ancient world, the Old Testament and medieval history), with a moralizing text by Richard Lloyd.[8] *The good Hows-holder* was

published in Blackfriars some twenty years later, perhaps by a member of the French community there.[9] By the time of the Commonwealth some at least of Godet's stock seems to have passed to Thomas Warren who, in 1656, registered woodcuts with very similar titles, in particular, *The Good Householder, The Anatomy of Man and Woman* and *A Roll of All the Kings of England since the Conquest.*[10]

An impression of another woodcut that Warren registered in 1656, *The Image of the Life of Man, by Apelles, in 9 Large Sheets*, is a particularly fortunate survival (fig. 3.4). Prints of this size (930 × 1562 mm) are vulnerable to damage. They would have been intended as wall decorations to be replaced after a few years, but this example must have gone straight into a collector's album and within a hundred years found its way to the British Museum. It is clearly printed from sixteenth-century blocks cut on the Continent and if prints on this scale and of this quality were being published in Elizabethan England (it is possible that the blocks were imported in the seventeenth century) then there must have been a well-developed print industry.

3.3 *The good Hows-holder*, 1564–5, this impression 1607. The image of the venerable old man is probably identifiable with *A Christian Exhortation of the Good Householder to his Children* registered by Gyles Godet in 1564–5. The figure is an example of a type that was well known in the mid sixteenth century. It is very similar to both *Le Divin Philosophe*, published in Antwerp by Israel Silvestre (*c.*1536–42), and *Le Viellard Discrest*, published in Lyon by Ian le Maistre and Anthoine Volant (*c.*1570–2). Godet's blocks were passed down from one publisher to another and some remained in use for over a century.

The Popular Print in England

From the beginning of the seventeenth century woodcuts moved down-market.[11] Survivals are extremely rare, but there is evidence of their production in the Stationers' Registers and elsewhere. Publishers, as we have seen, continued to use old blocks, but others that deal with contemporary events also survive. The Society of Antiquaries has a number of large woodcuts of the period, and the names of two publisher/printers recur: Edward Allde and John Trundle.

Allde's career began as early as 1584. From 1612 to 1624 he had been one of the limited number of printers authorized to print ballads, and his name is often associated with those of the ballad partners (see pp. 18–19). He used the same woodcut architectural frame (suggesting that the prints were intended for display) for *The Subjects Joy for the Parliament* (1621), with a fine woodcut portrait of James I, and for *Prince Charles welcome to the Court*, celebrating the return of the future Charles I after the abortive Spanish marriage of 1623.[12] Allde's most striking surviving woodcut is the misogynist *Fill Gut, & Pinch belly* of 1620 (fig. 3.5).

On 8 January 1606 John Trundle (fl. 1603–26) registered *The Picture of Nobody* and on 12 March 1606 *Nobody and Somebody*. The image was well known: Trinculo, the jester in *The Tempest* (1612), hears the invisible Ariel playing a tune on tabor and pipe and exclaims, 'This is the tune of our catch, played by the picture of Nobody.'[13] 'Nobody', as the person responsible for crimes and misdemeanours, appears in literature as far back as Homer, and he was familiar throughout Europe in many visual forms (see fig. 9.1). In English publications the opportunity for a visual pun is often taken by showing Nobody as a figure whose legs are joined to his shoulders (fig. 3.6).[14] Trundle used the sign of Nobody as the address of his shop in the Barbican and it illustrates the unsophisticated nature of the work he published. Watt classified eleven news-books published by Trundle as 'sensational'.[15] This leaning towards what might be called the popular market is apparent also in Trundle's broadsides in the Society of Antiquaries: *Mistress Turner's Farewell to all Women*, an account of the execution in 1615 of Anne Turner, the Countess of Essex's accomplice in the murder of Sir Thomas Overbury; an elegy for Ludovick Stuart, Duke of Richmond and Lennox, James I's favourite whose funeral in 1624 was preceded by a magnificent procession from Holborn to Westminster Abbey; *England and France, Hand in Hand* celebrating the marriage of the future Charles I with Henrietta Maria in 1624; *A School for Young Soldiers*, a guide to drilling with the pike and musket; *The Penitent Son's Tears for his Murdered Mother*

(Facing page) 3.4 *The image of the lyfe of man … by Apelles, c.*1560. This huge print was published in 1656 from woodblocks that must have been cut about a hundred years earlier. Its subject is the *Tabula Cebetis* – a painting known only in literary descriptions – by the great classical artist Apelles: the heavenly city is surrounded by a series of walls beyond which are vices that can lure the traveller from the true path. Prints of this size were used as wall decoration and rarely survive; this one does so only because it was preserved in the collection of Hans Sloane.

3.5 *Fill Gut, & Pinch belly*, 1620. At a time when women were stereotyped as domineering scolds Edward Allde and Henry Gosson would have appealed to a broad audience with this gloriously misogynistic print. The fat monster is well fed on men who are bullied and cuckolded by their wives, but the other creature starves because she can eat only wives who are good. The motif has Continental precedents in both art and literature (see p. 111).

and the Much-afflicted Mother's Tears for her Drowned Daughter, a criminal broadside illustrated with figures of the murderers kneeling by the bodies of their victims.[16]

Engravings on copper are usually accorded a higher status than woodcuts, but there are a great many cases where the quality of execution makes it clear that prints were not expensive and their subjects can be categorized with those of Allde and Trundle as being of wide interest; in other words they could be classed as 'popular prints'. The first English copperplate print publisher for whom any listing survives is Peter Stent (fl. 1642–65), whose catalogues and advertisements from 1654 to 1663,[17] together with those of his successor John Overton up to c.1690, are analyzed in Globe. Globe also provides a catalogue raisonné of 623 prints. Prints of traditional motifs that were later to be identified with a clearly

defined popular taste were *The Cats Castle*, *The Contented Cuckold* and *Lubberland* (figs 3.7, 4.46 and 4.54).[18] All are printed on 'pot-sheets' (about 390 x 300 mm) from coarsely engraved plates copying Continental prototypes.

Stent died of the plague in 1665 and his shop at the sign of the White Horse (changed from 'The Crown' during the Civil War) near Pye Corner was taken over by John Overton (1640–1713) only to be destroyed in the Great Fire of 1666. Overton took the sign to temporary premises nearby in Little Britain, but in 1669 settled at the White Horse without Newgate, which was to be the address of one of the great City of London print publishing dynasties for another century. About 1672 Overton published a broadside catalogue that gives an indication of the market for the decorative and practical which he served: he offered books, prints and maps 'neatly cut in copper, being very pleasant ornaments for houses, studies, and closets, and also extraordinary useful for goldsmiths, chafers, [en]gravers, painters, carvers, embroiderers, drawers, needle-women, and all handicrafts'. The text continues with a statement that brings the print trade of the period to life:

3.6. *No-Body his Complaint*, 1652. 'Nobody' complains that he is always blamed for what 'Somebody' has done. For an English audience he can be portrayed, as in this example, in the form of a visual pun: a man without a body whose legs join on to his shoulders.

The following text appears within the image:

THE CATS CASTLE BESIEGED AND STORMED BY THE RATS

vp you goe M.r pufs

Master Tybet prince of Cats

Nigro Musell prince of Ratts

printed and Sould by Iohn Ouerton

3.7 *The Cats Castle, c.*1660, this impression after 1665. This cheap print appears to be the earliest English survival of a subject that was popular throughout Europe from around 1500 until the early nineteenth century (see p. 124). It portrays an upside-down world where the hunted turn on the hunter.

John Overton ... scorns to sell any thing pitifully done, and he hath more than ten times the choice and stock that R[obert] W[alton] hath, though he vapours that he is the oldest man. It was formerly Mr Peter Stent's shop, the ancientest and chiefest of that way in England. If any booksellers or others in the country desire to have any of these to sell, if they send but a line to John Overton ... he will take as exact care to furnish them as if they were present, and at as cheap prices.[19]

The rival printseller Robert Walton had reproached Overton for reissuing out-of-date maps, and had remarked that, although Overton had acquired Stent's plates and tools, they would not teach him how to print or colour.[20] Overton's huge stock included many plates that dated back to the beginning of the century; Globe calculated that he published as many as 1753 copperplates both singly and in books.[21] Plates that had been made for relatively discerning clients moved to the cheaper end of the market as they became worn and began to appear old-fashioned.

Overton became a household name. In 1716 John Gay described the downward slide of the area around the Strand, where a hundred years before Arundel House had housed the 2nd Earl's great art collection:

Here Arundel's fam'd structure rear'd its Frame,
The Street alone retains an Empty Name:
Where Titian's glowing Paint the Canvas warm'd,
And Raphael's fair Design, with Judgment charm'd,
Now hangs the Bell-Man's Song, and pasted here,
The Colour'd Prints of Overton appear.[22]

In 1720 the humorist Tom Brown predicted that after his death he would be remembered in portraits 'most curiously engraved in wood, by honest John Overton, to adorn the walls of every coffee-house in Drury Lane'.[23]

For the purposes of this study it is convenient to divide London print publishers of the eighteenth century into those who continued to trade in the square mile of the City and those who catered to the more fashionable clientele of the West End. From the later part of the seventeenth century ambitious print publishers had followed the market into the new squares and broad streets, first of Covent Garden and then of Soho and Mayfair. William Hogarth epitomized this westward movement: he was born in the City, near the medieval church of St Bartholomew the Great, but established himself in a house in Leicester Square, still so newly developed that it retained the name Leicester Fields until long after he had settled there in the 1730s.

The most important of the print publishers who remained in the City were the Overtons, the Bowleses and the Diceys, and their successors. As we have seen, John Overton had transferred Peter Stent's stock to the White Horse without Newgate in the late 1660s. His son Henry (1676–1751) took over the business in 1707 and flourished to such an extent that he left a fortune of £10,000. His nephew, Henry Overton II, succeeded to the business. Philip Overton (c.1680–1745), brother of Henry Overton I, traded at the White Horse, Fleet Street, changing the name of his premises to the Golden Buck in 1708. His widow, Mary, ran the business for three years after his death before selling it to Robert Sayer (1725–94). Sayer joined forces with John Bennett (d. 1787) in 1774; by then street-numbering had been introduced and the address was 53 Fleet Street. By 1786 the firm was trading as Sayer & Co. At Sayer's death in 1794 it was taken over by his assistants Robert Laurie and James Whittle (c.1757–1818). Robert Laurie retired in 1812 and his son Richard Holmes Laurie succeeded to the business which was renamed Whittle & Laurie. After Whittle's death it was known as R. H. Laurie, and as late as 1858 as R. M. Laurie.

The Overton-Sayer-Laurie dynasty was paralleled by that of the Bowles family.[24] Thomas Bowles I was in business in St Paul's Churchyard from about 1691 to 1721. His son Thomas Bowles II (before 1695–1767) ran the shop from about 1715. His nephew Carington Bowles (1724–93) took over c.1763. The business passed at his death to his son (Henry) Carington Bowles II (1763–1830)

who went into partnership with Samuel Carver (b. *c*.1755); trading seems to have ceased in 1832.[25] John Bowles (1701?–79), younger brother of Thomas Bowles II, ran a print shop at Mercers' Hall, Cheapside, from 1723 and moved to the Black Horse, Cornhill, in 1733. In 1752 or 1753 his son Carington became a partner and for the next ten years the firm traded as John Bowles & Son, until Carington took over his uncle's business (see above). The shop was damaged by fire in 1766 and the business moved back temporarily to Mercers' Hall; in 1768 it was trading at 13 Cornhill. John Bowles died a rich man and his stock was taken over by Robert Wilkinson.

Although these businesses (and that of the Dicey family – see below) expanded they remained essentially unchanged, publishing prints whose conservatism brands them as popular in contrast to the innovative prints produced by those who appealed to a more demanding market. For the City publishers Hogarth's prints were best-sellers that could be pirated rather than models for a new pictorial approach to satire. The refinement of the mezzotint by McArdell and the Dublin group or later by Valentine Green and John Raphael Smith might not have happened as far as they were concerned; mezzotint remained no more than a

3.8 *Lucipher's new Row-Barge*, 1721. This satire on the financial speculations of the South Sea Bubble was still appearing in publishers' catalogues in 1764.

(*Facing page*)
3.9 *The Happy Marriage*, c.1690, this impression c.1750.
The costume worn by the happy family suggests a date at the end of the seventeenth century, but the letterpress indicates that this impression dates from some fifty years later. A state in the Victoria and Albert Museum differs only in the letterpress of the title and the verses below the image; it is numbered '144', corresponding with entries in the Dicey catalogues of 1754 and 1764, and carries the address 'No. 4 Aldermary Church Yard, Bow Lane, London'. The subject was produced in several formats and was usually paired with the contrasting *Unhappy Marriage* (see fig. 4.44).

The HAPPY MARRIAGE.

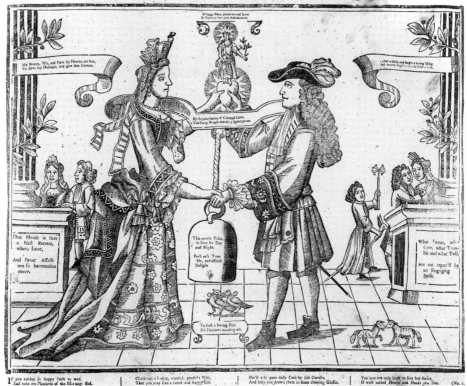

quick and therefore cheap way of producing simple compositions. Technical
innovations were for the most part ignored: aquatint, stipple engraving and
soft-ground etching find no place in the City publishers' catalogues.[26] Old plates
were reprinted for decades: satires on the South Sea Bubble of 1721 still appeared
in Dicey & Marshall's catalogue in 1764 (fig. 3.8),[27] battle scenes from
Marlborough's campaigns in the first decade of the century were still being
published by Carington Bowles in 1784,[28] and seventeenth-century woodblocks
were pressed into service with new letterpress even when they were worm-eaten
and cracked (fig. 3.9). Designs were copied in different formats and in the case of
the Overtons and Diceys on both copperplate and woodblock. The same titles
appear in the catalogues of all the major publishers; surviving impressions
indicate that this was normally because they copied each other's designs rather
than – as might well be assumed – because they shared stock.

One area of print publishing that was developed by the Bowleses and the
Overtons was the cheap mezzotint. Drolls based on Dutch precedents are the best-
known examples of this particular genre, but portraits and other readily saleable
subjects also appeared (fig. 3.10) and remained highly successful throughout the
century. John Bowles's catalogue of 1728 included five pages of mezzotints; in
1731 he listed 172, and in 1753 249. Four catalogues issued by Carington Bowles

The production of popular prints: publishers and printmakers 53

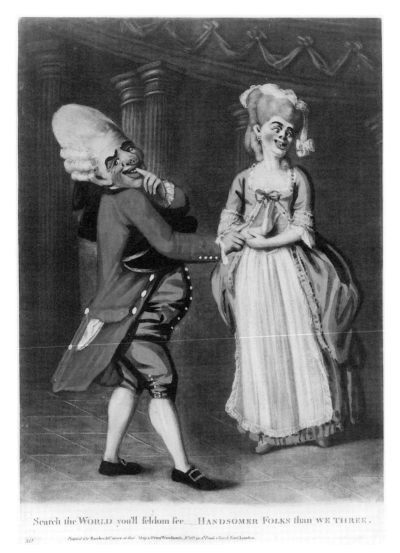

Search the WORLD you'll seldom see HANDSOMER FOLKS than WE THREE.

Printed for Bowles & Carver, at their Map & Print Warehouse, N° 69 in S! Paul's Church Yard, London

3.10 *Search the World, you'll seldom see, Handsomer Folks than We Three, c.*1795. Garishly hand-coloured mezzotints were extremely popular from the 1770s onwards and often portrayed traditional humour. Here the viewer makes up the third member of the group of 'handsome folks'. For other examples of this ancient joke see pp. 122–3.

and Bowles & Carver between 1784 and 1795 have separate sections listing hundreds of mezzotints, including many humorous subjects. The same titles appeared year after year, and plates would have been quickly reworked as they wore down. These boldly hand-coloured mezzotints were relatively expensive at 1s. plain and 2s. coloured, but their coarse humour and even coarser colouring must have been intended to appeal to popular taste. The Overtons produced similar prints: three pages of mezzotints appear in Henry Overton II's catalogue of 1754, and many of the same subjects are listed in the almost identical catalogues published in 1753 and 1755 by Robert Sayer who had acquired the stock of Overton's brother Philip. The 1795 catalogue of Laurie & Whittle (successors to Sayer and John Bennett) indicates that the market for cheap mezzotints went beyond the metropolis: the heading to a section of 'quarto drolls' offered

wholesale describes them as 'well calculated for the shop windows of country booksellers and stationers ... the greatest variety of whimsical, satirical and burlesque subjects (but not political)'.

While the Overton and Bowles dynasties aimed at the middle level of the market the most active publishers at the cheaper end were the Diceys. The known facts of the history of the firm were clearly outlined by Victor Neuberg in 1969, but he was concentrating on their trade in chapbooks and there is still more to be discovered about other aspects of their business.[29] The earliest-known member of the family was William Dicey, who seems to have moved from London to Northampton in 1720. He set up a printing office there with Robert Raikes, who in the previous year had started *The St Ives Postboy* about forty miles away in Huntingdonshire; on 2 May 1720 they published the first issue of *The Northampton Mercury*.[30] This was the period after the relaxation of censorship when newspapers were springing up around the country and publishers could exploit the distribution network ('the men that carry this news') to sell all sorts of printed material – ballads, pictorial prints and chapbooks – as well as other easily transported goods such as medicines. In Dicey's case the sale of Dr Bateman's Pectoral Drops was an important part of his business. A Raikes & Dicey ballad of 1720 carries a list of stockists:

Matthias Dagnel in Aylesbury and Leighton, Stephen Dagnel in Chesham, William Ratten in Coventry, Thomas Williams in Tring, Booksellers; Nathan Ward in Sun Lane in Reading; William Royce in St Clements, Oxford; Paul Stephens in Bister; Anthony Thorpe at the White Swan in St Albans; Mr Franks in Wooburne; William Peachy near St Benet's Church in Cambridge; Chururd Brady in St Ives; at all which places are sold all sorts of ballads, broadsheets, and histories [chapbooks], with finer cuts, better print, and as cheap as at any place in England.[31]

Trade flourished to the extent that in 1733 William Dicey was able to buy a house on Market Hill, Northampton, costing over £500.

By this time William's son Cluer Dicey, who would have been about twenty, had become a partner in the business. He was named after his uncle John Cluer whose family had run a printing office at the Maidenhead, Bow Churchyard, London, since the end of the previous century (fig. 3.11).[32] Like other print publishers the Diceys developed their business by acquiring the stock of competitors: *The London Evening Post* of 27–30 May 1732 carried a report that the widow of the Stamford printer and bookseller William Thompson had 'disposed of all effects in trade to Cluer Dicey, eldest son of Mr William Dicey of Northampton'.[33] The most important acquisition was that of John Cluer's business. After his death in 1728 Cluer's widow carried on trading alone for three years until she married Thomas Cobb, John Cluer's foreman. In 1736 Cobb transferred the business to his brother-in-law William Dicey (fig. 3.12). On 11 November 1736 the Diceys announced in *The London Evening Post* that they would carry on the business and that 'Shopkeepers may have curiously engraved as well as printed sign plates, bills of parcels in wood and copper'.

William ran the London and Northampton printing offices in tandem for another twenty years until his death in 1756. He left Cluer the premises in Bow Churchyard, all the printing presses and equipment used in London and a one-third share of the rights in Dr Bateman's Pectoral Drops.[34] The firm also sold the famous Daffy's Elixir that John Cluer had advertised in 1724 as being 'in great Use these fifty Years'.[35] 'Daffy's Cordial, warm and spicy / Sold in Bow Church Yard by Dicey' was advertised in sheets issued as far apart as Salisbury (1784) and Thetford (1786) and, together with Bateman's Drops, in a chapbook printed in Tewkesbury c.1795.[36] The shop was a City landmark: James Boswell indulged in a fit of nostalgia in 1763 when he went there to buy a group of chapbooks 'having when a boy been much entertained with Jack the Giant Killer'.[37]

Two Dicey catalogues survive: published in 1754 by William and Cluer Dicey of Bow Churchyard, and in 1764 by Cluer Dicey and Richard Marshall of Aldermary Churchyard.[38] By the latter date the company was offering for sale over three thousand ballads (with 'new ones out daily'), one thousand prints and 150 chapbooks.

Dicey's partnership with Richard Marshall and the new address in Aldermary Churchyard have caused some confusion. It is often assumed that prints bearing

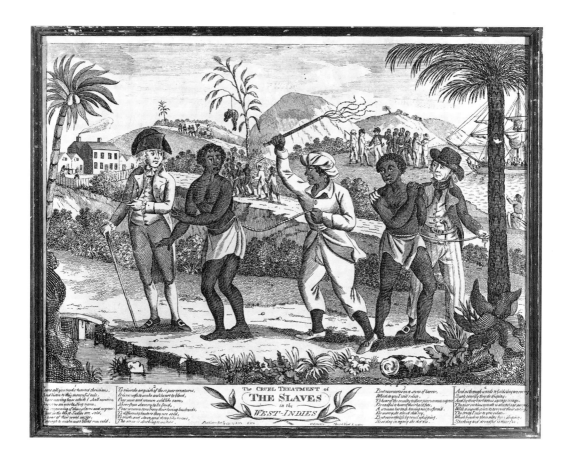

The engraving caption within the image reads:

The CRUEL TREATMENT of
THE SLAVES
in the
WEST-INDIES

3.13 *The Cruel Treatment of the Slaves in the West Indies*, 1793. In the politicized years around the turn of the century popular print publishers produced prints supporting both progressive and conservative causes (see Chapter Five). The provocative presentation of semi-naked black women in this print would no doubt have found a market beyond the abolitionist movement. John Marshall used a technique that appeared in many cheap prints of the period – a deeply bitten broad etching style that would have produced thousands of impressions and would have been far quicker to produce than woodcut.

(*Facing page*)

3.11 *An Hymn To be sung at the Parish Church of St Clement Eastcheap*, 1714. The sheet, published by John Cluer of Bow Churchyard, London, announces two sermons on Sunday 17 January 1714, one of which was to be given by the Lord Bishop of Lincoln 'for the benefit of ninety poor children'. It only narrowly escaped the fate of most ephemeral publications and its bad condition is explained by the manuscript note in the left-hand margin: 'London. Found under a staircase Bishops Walk, Lambeth January 1819 John Simons carpenter'.

3.12 *Trade card of William & Cluer Dicey*, 1736–56. The Diceys took over the printing office in Bow Churchyard in 1736 and this trade card must have been used at some time before William's death in 1756. It is an unusually elaborate example of their work and was doubtless intended to advertise the quality of engraving that the firm was able to provide. There is no mention of the range of printing available, but two different presses are shown: a book press for printing letterpress and woodcut (with typesetters at work in the background) and a rolling press, which could exert the additional pressure necessary for printing from copperplates.

no publisher's name but the address 'Aldermary Church Yard' or 'No. 4 Aldermary Church Yard' (the latter after the introduction of street-numbering *c*.1760) were published by the Diceys. It seems more likely that these were earlier imprints, perhaps Marshall's. The partnership was a temporary one: the names of both Dicey and Marshall or the imprint of Cluer Dicey & Company appear only on prints published around 1764 at 4 Aldermary Church Yard. Dicey continued to trade from Bow Churchyard[39] and a generation later 4 Aldermary Churchyard was the address of John Marshall (fig. 3.13), best known for his Cheap Repository Tracts (see pp. 140–2).[40]

Although Marshall is not an uncommon name it is likely, in this age of family businesses, that all Marshalls active in the London print trade were related. Joseph and William Marshall were in business at the Bible, Newgate Street, from

3.14 *The Glory of Man's Redemption*, *c*.1714–24. The print is datable by the reference to William Dawes, Archbishop of York, but the block – fretted with worm-holes – was clearly an old one that would have passed through several publishers' hands.

(*Facing page*)
3.15 *Miss Fanny Murray* and *The Careless Maid*, *c*.1760. The woodcut portrait of the courtesan Fanny Murray (d. 1770) is based on a mezzotint by James McArdell after Henry Morland. The verses hint at her notoriety, but the image alone could easily be taken by modern eyes to be a straightforward portrait of a perfectly modest well-dressed woman. The second print, in which the young woman ties her garter while staring provocatively at the viewer, is more explicit – and the text is even more so in describing how English women were taking up the loose behaviour of their French counterparts.

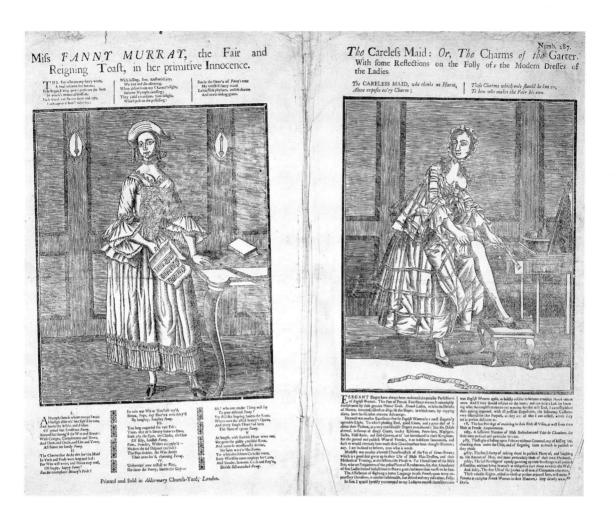

1679 to 1725, and John Marshall in Gracechurch Street in 1708, where he sold 'Chapmen's books, broadsides ... at the very lowest prices'; the woodblocks for these may have passed to Richard Marshall. Dicey doubtless saw the partnership as a means of acquiring access to more stock. The Aldermary Churchyard business clearly owned a number of old blocks: the address is found on several prints where letterpress indicates an eighteenth-century publication date but the blocks, often worm-eaten, were older (fig. 3.14). The 1764 catalogue contains fifty-five more 'Wooden Royals'[41] than the catalogue of 1754 – that is, more than twice as many. Some would have been newly cut, like the portrait of the courtesan Fanny Murray (fig. 3.15; no. 287 in the 1764 catalogue) based on a mezzotint by James McArdell after a painting by Henry Morland, but others would have been old blocks pressed into service. A wholesale price list in the 1764 catalogue includes 'Wood Royals, plain, 26 to the quire' at 1s. 2d. per quire, and coloured at 1s. 4d. These prints would probably retail at 1d. plain, but it was normal practice to double the price for a coloured impression.

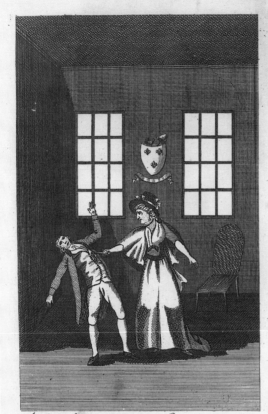

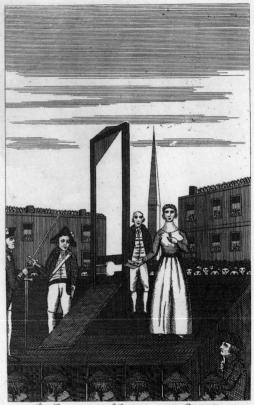

The death of MARAT *at* PARIS *Who was stabbed by* CHARLOTTE CORDE *of* CAEN *Sunday* July 14. 1793.

Publish'd Oct.r 21 1793 by I. Evans Long Lane

The Execution of CHARLOTTE CORDE *at* PARIS JULY 17. 1793.

Publish'd Oct.r 21 1793 by I. Evans Long Lane

3.16 *The Death of Marat* and *The Execution of Charlotte Corde*, 1793. This is a particularly crude example of the etchings published by John Evans. It appeared three months after the event and is indicative of the widespread nature of English interest in the French Revolution.

In 1775 Cluer Dicey died a prosperous man, with property in Little Claybrooke, Leicestershire, and Stoke Newington, and shares in both the Bow Churchyard and the Northampton sides of the business, the latter having been run by his brother Robert (1721–57) and after his death by Cluer's son Thomas (b. 1742). Although Dicey did not take over the Aldermary Churchyard firm an amicable relationship evidently continued: Marshall and his wife were mentioned in Dicey's will and when Marshall himself died four years later he left money for mourning rings to Dicey's son Thomas and his wife. Thomas Dicey took over the Bow Churchyard office after his father's death and in 1798 he and Francis Benyon, who had also been mentioned in Cluer's will, took a twenty-one-year lease on two houses in Bow Lane at £40 per annum.[42] The business continued well into the nineteenth century, and the Dicey family owned the *Northampton Mercury* until 1885.

3.17 *An Elegy to the Memory of our Illustrious and Lamented Queen Caroline of England*, 1821. John Pitts has used the format of a traditional elegy for a propagandist print. Caroline's dispute with George IV made her a popular heroine and her cause was exploited by the Radicals in their campaign for political reform. The scandals of the royal marriage and finally Caroline's death provided a wealth of subjects for print publishers.

3.18 *The Perpetual Almanack*, *c*.1813. This early broadside by James Catnach differs little in quality from those of his competitors: the paper is rough and the design is much less imaginative than those of later publications (see fig. 3.19). The subject is a traditional one telling how a soldier explains the fact that he has a pack of cards in church by claiming that he uses the cards as a bible, almanac and prayer book.

In the last decades of the eighteenth century the old woodblocks must finally have seemed out of date and there was a growing market for prints of current events as the political atmosphere heightened in the aftermath of the French Revolution.[43] Publishers at the lower end of the market began to produce etchings drawn in a simple, open style that were more deeply bitten than usual so that they could yield thousands of impressions. The new technique is seen in prints published by John and Thomas Evans and G. Thompson, all of Long Lane, West Smithfield, and John Marshall, the successor to Richard Marshall at 4 Aldermary Churchyard. In the early nineteenth century a group of twenty of these coarse etchings published by John Evans was stitched together to make an album[44] that

forms an epitome of subjects for popular prints: most are traditional moralizing and religious subjects (*The World Turned Upside Down*, *The Various Ages and Degrees of Human Life*, *The Prodigal Son*, *The Great Tribunal*, etc.), but there are also topical prints of the death of Jean Marat and the execution of Charlotte Corday (fig. 3.16), and of the British fleet preparing to set sail under Earl Howe in 1794.

A longer-lasting innovation in what had become the market in cheap prints was achieved by James Catnach (1792–1841). His father, John Catnach, was a printer in Newcastle-upon-Tyne who moved to London in 1812 to avoid his creditors. He set up a press in Wardour Street but died after a few months. James Catnach was to develop the business to the extent that the name of Catnach and the area of Seven Dials near Covent Garden where he settled became synonymous with popular printmaking. Charles Hindley's memoir of Catnach (1878) remains the only monograph on this very important figure.

Although Catnach's earliest prints were of a quality indistinguishable from those of his older-established rival in Seven Dials, John Pitts (1765–1844; for an account of the career of Pitts and much further information on the popular print trade of the period, see Shepard 1969), his standards improved and he developed a style that clearly differentiated the popular print from prints produced for other markets (figs 3.17 to 3.20). They were no longer poor-quality versions of more expensive prints. He differed from earlier print publishers in concentrating on woodcut to the exclusion of copperplate techniques. He introduced a type of paper that, although thin, was white and smooth so that it would take print well. His designs were an attractive combination of bold images with text and ornament, accurately set and produced with due care to their arrangement on the sheet. Catnach's training in Newcastle must have been influential. The northeast was one of the leading provincial publishing centres of the late eighteenth century, and standards were high. It was in producing woodcuts, or wood-engravings, for local publishers that one of the greatest of English printmakers, Thomas Bewick (1753–1828), developed the art of wood-engraving to an extraordinary degree.[45]

Catnach's prints covered the whole range of popular print subject matter (see Chapter Four) from plagiaries of more up-market publications (fig. 3.19), to politics and, in particular, execution broadsides of which he sold millions (see pp. 97–8). He retired in 1838 and his sister Ann Ryle ran the business with James Paul until the 1850s when William Fortey took over. Other publishers in Seven Dials and elsewhere[46] continued to publish broadsides and ballads during this time, but by the middle of the century cheap illustrated newspapers had begun to take over as the chief source of popular imagery.

So far this chapter has discussed only the entrepreneurs who were the owners of the publishing houses producing cheap prints. These men would have taken an active role in printing and often also in designing prints, writing texts, cutting woodblocks and etching and engraving copperplates (the widows and sisters who

3.19 *Life in London; or, the Sprees of Tom and Jerry*, 1822. Pierce Egan's book, and the subsequent play, about the adventures of two young country gentlemen in London were tremendously popular. James Catnach plagiarized the book's illustrations in this broadside, but ironically prints a claim to copyright over the designs. The main scene shows a tavern in the 'Holy Land' of St Giles, only a few hundred yards from Catnach's shop.

The production of popular prints: publishers and printmakers 63

sometimes inherited firms usually took charge of financial matters),[47] but the bigger firms would also have employed specialists for all these tasks.

In the late 1770s Carington Bowles bought paintings from John Collet on which to base prints at the more expensive end of the popular print range (fig. 4.51), and in the 1780s and early 1790s he commissioned designs for prints from Robert Dighton.[48] The cheapest prints, on the other hand, often copies, were probably designed by the largely forgotten men who cut the blocks or engraved the plates. Thomas Bewick, writing in the early nineteenth century about the familiarity of large woodcuts in the 1750s, pointed out that the 'immense numbers of impressions ... so cheaply and extensively spread over the whole country, [must] have given employment to a great number of artists, in this inferior department of wood cutting'.[49] His tone suggests that even someone who

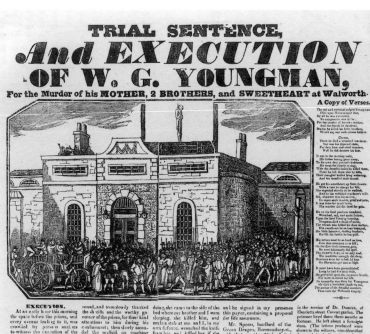

3.20 *Trial, Sentence, and Execution of W. G. Youngman*, 1860. This broadside shows the gallows erected on the roof of Horsemonger Lane Gaol in Southwark. The same woodcut could be used for any execution – a section being inserted with additional hanging figures if necessary. By 1860 the Catnach Press was being run by William Fortey but the name of its famous founder still appeared in the address.

had worked in the print trade all his life knew little of the modest printmakers of a generation or two earlier.

The occasional name survives: in the early years of the eighteenth century Isaac Bedbury of George Yard in Sea Coal Lane near Fleet Ditch, London, advertised that he cut 'the finest prints in wood, for printers, booksellers, stationers and tillet-painters';[50] a hundred years later George Steevens, the editor of Shakespeare and cataloguer of Hogarth, acquired a print from 'old Mr Hodson of Clerkenwell, a cutter of woodblocks'.[51] A contemporary of Hodson known only by his initials is 'RM', who produced charming, but very crude, woodcuts for chapbooks published by the Dunn family in Whitehaven, Cumberland, during the last years of the eighteenth century.[52] His work is usually based on illustrations to chapbooks or ballads produced by other publishers.[53]

The only woodcutter of the period who might be described as well known is J. Bell: but details of his biography, and even his christian name, remain to be discovered. Bell owes his posthumous reputation to two woodcuts that he made for William Hogarth in 1751: *The Third Stage of Cruelty* and *Cruelty in Perfection*. These are versions of the last two prints in Hogarth's *Four Stages of Cruelty*. The series was one of a number of works of the period that Hogarth aimed at a wider audience than was usual for him,[54] perhaps seeking to exploit the market in popular woodcuts that the Diceys and others were developing. Hogarth's copperplates would probably have produced two thousand impressions before needing any reworking, but woodcut versions of his designs would yield many thousands of impressions. He employed J. Bell to copy the last two prints in the series,[55] but for reasons that have never been satisfactorily explained the first two blocks were not cut. The quality of Bell's cuts is far superior to that of any other surviving large woodcut of the period, and this may have been part of the problem. Bell was obviously a highly skilled craftsman and the prints were large and complex; the initial cost would have been high and recouped only if very many impressions were sold. Hogarth may not have wanted to risk the cost of Bell's fee when he could sell prints from the copperplates that he would have worked fairly rapidly himself. He might also have found difficulties in printing from woodblocks, which are normally printed on flat book presses rather than the rolling presses used for copperplates. In the event the woodcuts were not published successfully until long after Hogarth's death, when they were acquired by the great print-publishing entrepreneur John Boydell and printed as collectors' items.

Bell's few other signed works are all on a much smaller scale but demonstrate his great control of the technique. He signed the headpieces of two newspapers of the 1720s, *The Weekly Journal* and *Appleby's Journal*,[56] and the illustrated title page of an undated edition of Lily's Latin Grammar.[57] A tobacco wrapper (fig. 2.11) was published about 1760, and small woodcuts appear in, and on the cover of, books published by John Newbery between 1752 and 1784, some of which must have been published posthumously.[58]

CHAPTER FOUR
POPULAR THEMES AND SUBJECTS

4.1 *Christ as the Man of Sorrows, c.*1490. The text below
the image offers an indulgence of 26,000 years to those that kneel
before it and 'Devoutly say v. pater nostar & v. Avees'
(five Lord's Prayers and five 'Hail Marys').

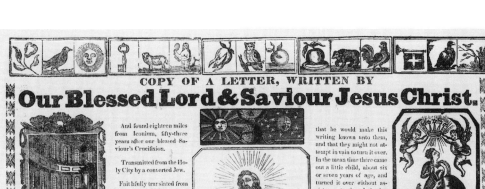

COPY OF A LETTER, WRITTEN BY
Our Blessed Lord & Saviour Jesus Christ.

And found eighteen miles from Iconium, fifty-three years after our blessed Saviour's Crucifixion.

Transmitted from the Holy City by a converted Jew.

Faithfully translated from the original Hebrew copy, now in the possession of Lady Cuba's family, at Mesopotamia.

This letter was written by JESUS CHRIST, and found under a great stone, round and large, at the foot of the Cross.

Upon the stone was engraved, "Blessed is he that shall turn me over." All people that saw it, prayed to God, earnestly, desiring

that he would make this writing known unto them, and that they might not attempt in vain to turn it over. In the mean time there came out a little child, about six or seven years of age, and turned it over without assistance, to the admiration of every person who was standing by. It was carried to the city of Iconium, and there published by a person belonging to the Lady Cuba.

On the Letter was written the commandments of Jesus Christ.

Signed by the Angel Gabriel, seventy-four years after Our Saviour's birth.

King Agbarus's Letter to Our Saviour, and Our Saviour's Answer; also His Cures and Miracles. Likewise Lentulus's Epistle to the Senate of Rome, containing a Description of the Person of Jesus Christ.

A Letter of Jesus Christ.

WHOSOEVER worketh on the Sabbath-day shall not prosper; I command you all to go to church, and keep the Lord's day holy, without doing any manner of work. You shall not idly spend your time in bedecking yourselves with superfluities of costly apparel and in vain dresses, for I have ordained it to be a day of rest. I will have it kept holy that your sins be forgiven you. You shall not break my commandments, but observe and keep them, write them in your heart, and stedfastly observe what is written and spoken with my own mouth. You shall not only go to church yourself, but also keep your men-servants and your maid-servants, and observe my words and commandments. You shall finish your labour every Saturday in the afternoon by six o'clock, at which hour is the preparation of the Sabbath. I advise you to fast five Fridays every year, beginning with Good Friday, and continue the four Fridays immediately following, in remembrance of the five wounds which I received for all mankind. You shall diligently and peaceably labour in your respective callings, wherein it hath pleased God to place you. You shall love one another with brotherly love, and cause them that are baptised to go to church and receive the sacraments, baptism and the Lord's supper, and to be made members of the church; in so doing, I will give you a long life and many blessings; and your land shall flourish, and your cattle bring forth in abundance; and I will give unto you many blessings and comforts in the greatest temptations, and he that doth to the contrary shall be unprofitable. I will also send hardness of heart upon them till I see them, but especially upon the impenitent and unbelieving. He that hath much, by giving to the poor shall not be unprofitable. Remember, he that hath a copy of this letter, written with my own hand, and spoken with my own mouth, and keepeth it without publishing it to others, shall not prosper, but he that publisheth it to others shall be blessed of me; and though his sins be in number as the stars in the sky, and be truly believe in me, they shall be pardoned; but if he believe not in me and my commandments, I will send my own plagues upon him, and consume both him, and his children, and his cattle. And whosoever shall have a copy of this letter, and keep it in their houses, nothing shall hurt them—neither lightning, pestilence, nor thunder; —and if a woman be in labour, and a copy of this letter be about her, and she firmly puts her trust in me, she shall safely be delivered.

Christ's Cures and Miracles.

He cleansed a leper by touching him; he healed the Centurion's servant afflicted with the palsy; Peter's mother-in-law of a fever; several possessed of devils; stilled a most violent tempest; cured a man sick of the palsy; raised a man from the dead; restored two blind men to sight; cured a dumb man who was possessed of a devil; fed about 5000 with five loaves and two fishes; walked on the sea; cured the diseases of Genesaret by the touch of his garment; cured a woman of a devil; multitudes of lame, blind, dumb, maimed, &c. and fed 4000 with seven loaves and three small fishes.

King Agbarus's Letter to Christ.

I have heard of thee and the cures wrought by thee without herbs or medicines; for it is reported thou restoreth sight unto the blind, maketh the lame to walk, cleanseth the leper, raiseth the dead, and healeth those that are tormented with diseases of long continuance; having heard all this of thee, I was fully persuaded to believe one of these two things, either that thou art very God, and comest down from heaven to do such miracles, or else thou art the Son of God and performest them; wherefore I have now sent these lines intreating thee to come hither and cure my distemper. Besides, having heard that the Jews murmur against thee, and contrive to do thee mischief, I invite thee to my city, which is little indeed, but exceeding beautiful, and sufficient for us both.

Our Saviour's Answer.

Blessed art thou Agbarus for believing in me whom thou hast seen not; for it is written—that they who have seen me should not believe, & they who have not seen me should believe and be saved; but as to the matter thou hast wrote about, these are to acquaint thee, that all the things for which I am sent must be fulfilled, and that I shall be taken up, and returned to him that sent me; but after my ascension I will send one of my disciples who shall cure thy distemper, and give life to thee and all them that are with thee.

Lentulus's Epistle to the Senate of ROME.

There appeared in these our days a man of great virtue, called Jesus Christ, who by the people is called a prophet; but his disciples call him the Son of God. He raised the dead, and cures all manner of diseases, a man of stature, somewhat tall and comely, with a reverend countenance, such as the beholders both fear and love. His hair is the colour of chesnut all ripe, and is plain almost down to his ears; but from thence downward, waving about his shoulders; in the middle of his head is a seam or parting, like the Nazarites. His forehead very plain and smooth. His face without either wrinkle or spot, beautiful with a comely red; his nose and mouth so formed that nothing can be reprehended; his beard thick, the colour of the hair on his head; his eyes grey, clear and quick. In reproving he is severe; in counselling he is courteous; he is of a fair-spoken, pleasant and grave speech; never seen by any one to laugh, but often seen by many to weep; in proportion to his body, he is well-shaped and strait; and both arms and hands are very delectable. In speaking he is very temperate, modest and wise. A man for singular beauty far exceeding all the sons of men.

Printed and Sold by R. BOND, Herald Office, Whimple-street, Plymouth.

4.2 *Copy of a Letter, written by Our Blessed Lord & Saviour Jesus Christ*, c.1840. This collection of apocryphal texts was known in medieval England. Until the Victorian period it continued to claim almost the status of a pre-Reformation icon, promising that 'whosoever shall have a copy of this letter, and keep it in their houses, nothing shall hurt them'.

This chapter discusses six groups of topics that dominate English popular prints: religion and morality; patriotism and the status quo; crime and execution; phenomena and freaks of nature; marriage, cuckoldry and women; drinking, good fellowship and temperance.[1] These categories are loosely based on those by which Samuel Pepys organized his collection of 1775 ballads.[2] They range from the deeply serious to the humour of the bar room. Popular imagery expresses abstract ideas in visual terms that are designed to be understood by those with little knowledge of the language of emblem: there is no room for subtlety. Moralists remind sinners of the imminence of death and retribution with skeletons, skulls, crossbones and the fiery mouth of Hell, or with gaols, whips and the gallows; patriotism is encouraged by images of royalty, scenes of military triumph and portrayals of foreigners as figures of fun; the strange and exotic – whether animal or human – is offered up to feed the curiosity of the moment; relations between the sexes are battlegrounds; and men dream of a world where there is nothing to do but eat, drink and make merry. In somewhat different guises the same subjects remain the focus of the mass media today.

Religion and Morality

Among the earliest prints in England, as elsewhere, were simple woodcut indulgences sold at pilgrimage sites and offering thousands of years' reprieve from suffering in Purgatory to those who recited certain prayers in front of them (fig. 4.1). Only about twenty English indulgences are known to have survived the Reformation.[3] Images of the Crucifixion, the Virgin and other saints remained the typical popular prints of France and other Roman Catholic countries – attached to the walls of humble homes to keep their occupants from harm – but from the 1530s onwards traditional religious imagery was rare in England. The Reformation saw widespread destruction of images, and hostility to what was seen as Romish idolatry haunted the relationship between religion and the visual arts long after the first rage of iconoclasm.[4]

The word was pre-eminent and publishers found a flourishing market for religious texts in the form of both books and broadsides. The high level of literacy in England by the late seventeenth century (see p. 18) meant that many broadsides could be deliberately aimed at the lower end of the market, but imagery, where it existed at all, was usually limited to a portrait of the author – or supposed author. The homilies of John Dod, a puritan Oxford don (1549?–1645), were still to be seen pasted on the walls of cottages more than a century after they had been written, and an old woman told James Granger that 'she should have gone distracted for the loss of her husband, if she had been without Mr Dod's "Sayings" in the house'.[5] Benjamin Franklin sold thousands of copies of *The Way to Wealth*, a collection of aphorisms from the preface to *Poor Richard's Almanack* reprinted as a broadside in 1757, and *King Charles's Good Rules* were current into the reign of Queen Victoria.[6] *A Letter of Jesus Christ*

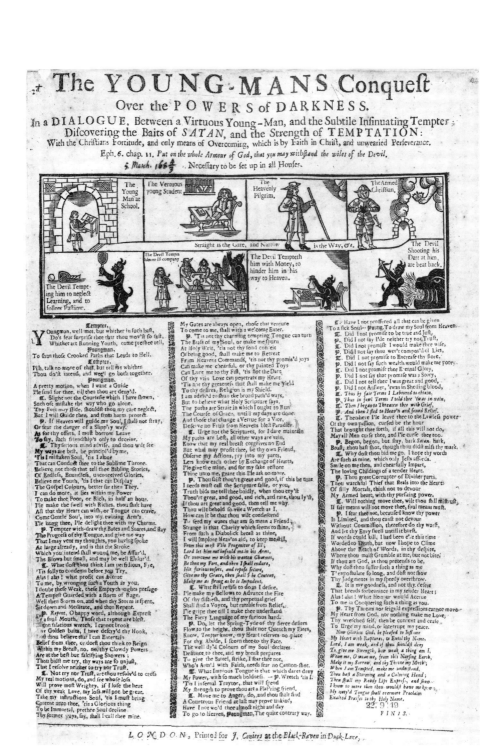

4.3 *The Young-Man's Conquest Over the Powers of Darkness*, 1684. This schematic illustration of the choice between the paths leading to Heaven or Hell is headed 'Necessary to be set up in all Houses'. It may be noted that the first temptation is to play tennis, recalling Polonius's anxiety that his son might find his way – among other evils – to 'falling out at tennis' (*Hamlet*, Act II, scene i). The broadside was purchased by Narcissus Luttrell for 2d. on 5 March 1684.

and other pious epistles supposed to date from the first century (fig. 4.2) were probably invented around the year 300; they were known in medieval England and survived the Reformation to be published continuously until the middle of the nineteenth century.[7]

The most important prescriptive text was, of course, the Ten Commandments, displayed since the Reformation in place of painted altarpieces. Large multi-sheet prints showing the tablets supported by Moses and Aaron would be painted and varnished to do duty in chapels and country churches.[8] Watt discusses (and reproduces) other examples of didactic broadsides where imagery is used to support text: *Some Fyne Gloves Devised for New Yeres Gyftes to Teche Yonge Peop[le to] Knowe Good from Evyll* (1559–67) employs the device of a pair of gloves with one of the Ten Commandments printed at each fingertip and virtues and vices

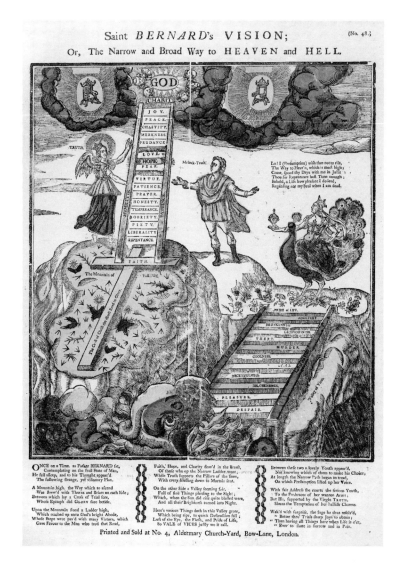

4.4 *Saint Bernard's Vision*, c.1700, this impression c.1750. This depiction of the 'Narrow and Broad Way to Heaven and Hell' is based on a seventeenth-century German broadside (Coupe, pl. 108); it follows the medieval tradition in which the devout were granted visions that allowed them to convey the Word of God to their fellows.

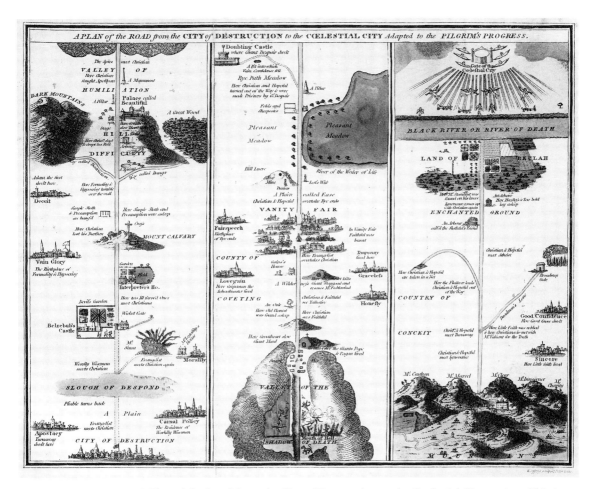

4.5 *A Plan of the Road from the City of Destruction to the Coelestial City, c.*1800. This is an example of many similar maps directly or indirectly derived from John Bunyan's *Pilgrim's Progress* (1678) that provided an accessible visualization of the spiritual journey of the devout Christian. It was part of the huge collection of prints and drawings belonging to George Cruikshank (mainly by himself) that was bequeathed to the British Museum by his widow.

listed on either palm; *The Map of Mortalitie* of 1604 uses simple emblems – the cock 'Awake from sinne, that sleepe therein', the swan 'A conscience pure', a skull 'Remember thine End'.[9] These were elaborate productions made for comparatively wealthy households; a down-market moralizing broadside of the early nineteenth century uses as a mnemonic device a pack of cards: the Ace standing for the one true God, the three court cards standing for the Trinity and so on (fig. 3.18).[10]

Reminders of the inevitability of death were common, appearing on simple elegies for the dead with figures of time and death, and skulls and crossbones (figs 2.6 and 2.7), but also in more elaborate arrangements as, for instance, in one of the most popular of all images, *The Stages of Life*, which is discussed in Chapter Eight.

The value of the image in reinforcing the word was not forgotten, and icono-graphers – who did not have the option of using the lives of saints as moral exemplars – struggled to develop a language of emblem that could be easily under-stood.[11] A favourite subject was the spiritual journey towards heaven and the temptations to be resisted if the goal was to be reached. The basic text was Christ's exhortation from the Sermon on the Mount to 'enter ye in at the strait gate: for wide is the gate, and broad is the way, that leadeth to destruction',[12] which could be represented in schematic illustrations of 'the broad and narrow way'[13] (figs 4.3 and 4.4). The publication of John Bunyan's *Pilgrim's Progress* in 1678 provided an accessible model for the wider audience, and maps were produced showing the route to the heavenly city through the Slough of Despond, Vanity Fair and so on (fig. 4.5 and pl. 11B).

A more complex iconography combined the broad and narrow ways with the 'Tree of Life', whose fruits represent virtues,[14] and 'the holy city, new Jerusalem'[15] represented – like the classical *Tabula Cebetis* (fig. 3.4)[16] – as an edifice sur-rounded by a series of walls protecting it from vice and corruption. The combination appears in a rather clumsy composition entitled *An Epitome of Gospel Mystery*, published by Joseph Marshall, c.1700 (fig. 4.6). What was to become a standard treatment seems to derive from a print by Hieronimus Wierix of c.1600:[17] Christ crucified marks the choice between the road leading towards the holy city which is travelled by decorous figures and the wider path where revellers ignore a looming Hell-mouth.[18] As iconoclastic ways of thinking subsided in the early eighteenth century, emblematic motifs could be placed in everyday contexts. A series of prints from about 1740 onwards combine emblem with naturalism: Christ crucified hangs on the Tree of Life beneath the triangular symbol of the Trinity against a landscape where conventional rules of perspective apply; in the foreground a crowd of sinners who could have come from any London street ignore the preaching of John Wesley and George Whitefield and make their way along the Broad Way to the Bottomless Pit where devils stoke the fires (figs 4.7 and 4.8).[19]

The lasting popularity of this type of composition is attested by its use, in the form of a large painting, as a preaching aid by Gawin Kirkham in his Open Air Mission from 1869 to 1892[20] and as the frontispiece (also sold separately) to General Booth's *In Darkest England*, 1890, where the heavenly city is replaced by a carefully planned 'Colony over the Sea' that will provide salvation for the poor.

Moralists saw the value of visual reminders of the wages of sin, and prints are often lettered with phrases such as 'a useful table to be set up in all families' or 'Necessary to be set up in all houses' (figs 4.3 and 4.10). Such prints should not, however, tempt the viewer with the portrayal of the vices that they warned against. The use of emblems not only avoided the naturalistic images which reformers abhorred, but also avoided such risks. *The Prodigal Sifted* (figs 4.9 and 4.10)[21] shows parents sieving out their son's sins. Sieving was a metaphor for the transformation of an errant character, removing unacceptable elements in the

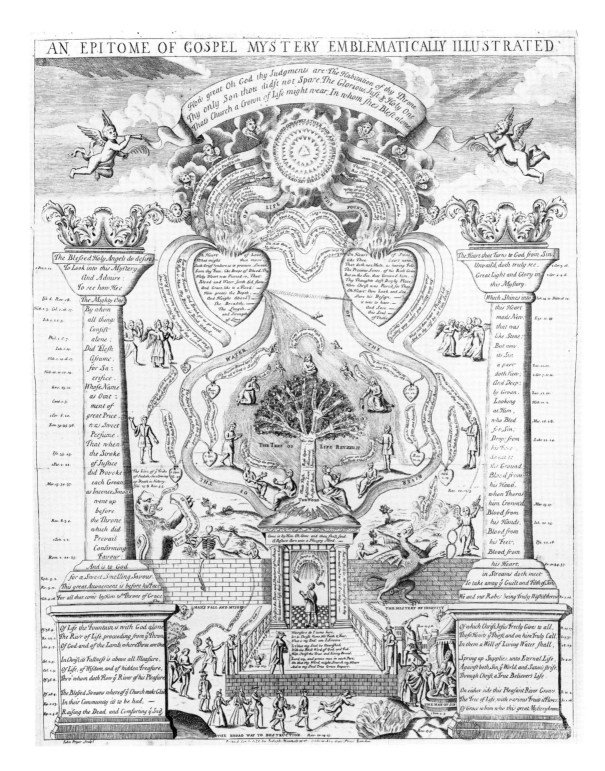

4.6 *An Epitome of Gospel Mystery Emblematically Illustrated*, c.1700. This confused and wordy composition is a precursor of the image shown in figs 4.7 and 4.8.

same way that sieving separates coarse from fine particles or grinding refines coarse material.[22] The symbols of most of the son's misdeeds can be easily understood – dice, cards, fashionable dress, bastard children and so on – but in one of the background pictures showing scenes of his debaucheries is a traditional emblem that is no longer immediately recognizable: 'the horn of suretyship'. 'To stand surety' is to take responsibility for another's debts, a means by which naive young men could be relieved of their fortunes. The horn hangs at a moneylender's door; a young man enters easily into the wide mouth but is squeezed thin by the time he escapes from the narrow end.[23]

A small version of the composition was used on two ballads in the Pepys collection, both of which subvert the moral intention of the image: in *A Looking-Glass for Lascivious Young Men: or, The Prodigal Son Sifted* attention is

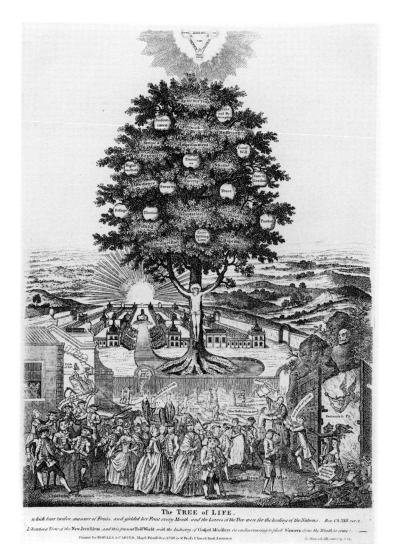

4.7 *The Tree of Life*, c.1750, this impression c.1800. By the middle of the eighteenth century traditional emblems were combined with conventional perspective to create a coherent composition which became extremely popular. Recognizable figures include the famous preachers John Wesley and George Whitefield, who are ignored by sinners following the Broad Way to the Bottomless Pit.

(Facing page)
4.8 *The Tree of Life*, c.1825. This woodcut version of fig. 4.7 is aimed at an even wider market.

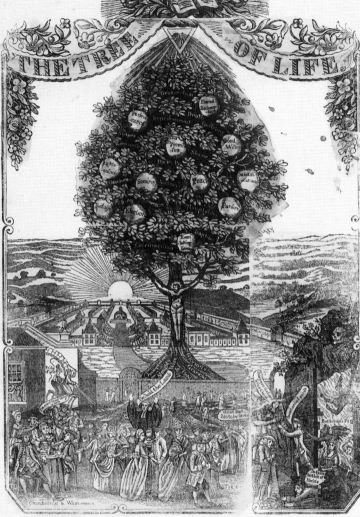

Tree of Life.

SON of God! thy blessing grant,
Still supply our ev'ry want,
Tree of Life thine influence shed,
With thy sap our spirits feed!

Tend'rest branch, alas! am I
Wither without thee, and die;
Weak as helpless infancy—
O confirm our souls in thee!

Unsustain'd by thee we fall!
Send the strength for which we call!
Weaker than a bruised reed
Help we ev'ry moment need.

All our hope on thee depend,
Love us! save us to the end!
Give us the continuing grace,
Take the everlasting praise!

CHRIST

Worshipped by all his Creatures.

YE servants of God,
Your Master proclaim,
And publish abroad
His wonderful Name,
The Name all victorious
Of Jesus extol;
His Kingdom is glorious,
And rules over all.

God ruleth on high,
Almighty to save,
And still he is nigh,
His presence we have.
The great congregation
His triumph shall sing,
Ascribing salvation
To Jesus our King.

Salvation to God,
Who sits on the throne:
Let all cry aloud,
And honour the Son.
Our Jesus's praises
The angels proclaim,
Fall down on their faces,
And worship the Lamb.

Then let us adore,
And give him his right,
All glory and pow'r
And wisdom and might;
All honour and blessing,
With angels above,
And thanks never ceasing,
And infinite love.

GIVE to the Father praise,
Give glory to the Son,
And to the Spirit of his grace
Be equal honour done.

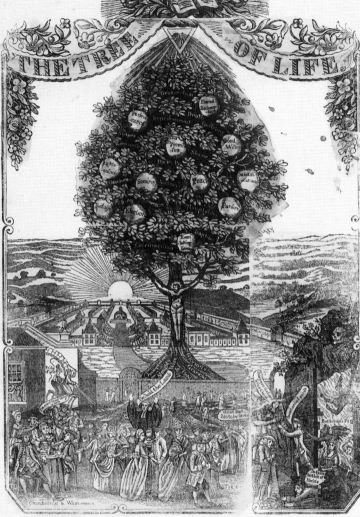

THE TREE OF LIFE

THE TREE OF LIFE,

Which bear twelve manner of Fruits, and yielded her Fruits every Month, and the Leaves of the Tree were for the healing of the Nations.---*Rev.* ch. xxii. v. 2.
Likewise a View of the New Jerusalem, and this present Evil World, with the industry of Gospel Ministers in endeavouring to pluck Sinners from the wrath to come.---*Mat.* ch. vii.

A Prospect of Heaven
MAKES DEATH EASY.

THERE is a land of pure delight,
Where saints immortal reign;
Infinite day excludes the night
And pleasure banish pain.

There everlasting springs abides,
And never with'ring flow'rs;
Death like a narrow sea, divides
This heav'nly land from ours.

Sweet fields beyond the swelling flood
Stand dress'd in living green,
So to the Jews old Canaan stood
While Jordan roll'd between.

O could we climb where Moses stood
And view the landscape o'er,
Not Jordan's stream, nor death's cold
flood,
Should fright us from the shore.

DISMISS as with thy blessing,
Lord,
Help us to feed upon thy Word;
All that has been amiss, forgive,
And let thy truth within us live.
Tho' we are guilty, thou art good,
Wash all our works in Jesu's blood,
Give ev'ry letter'd soul release,
And bid us all depart in peace.

finish'd—was his latest voice;
These sacred accents o'er,
He bow'd his head, gave up the ghost
And suffer'd pain no more.
Tis finish'd—The MESSIAH dies
For sins, but not his own;
The great redemption is complete,
And Satan's pow'r o'erthrown.
Tis finish'd—All his groans are past;
His blood, his pain, and toils,
Have fully vanquished our foes,
and crown'd him with their spoils.
Tis finish'd—Legal worship ends,
and gospel ages run;
All old things now are past away,
and a new world begun.

THE CRUCIFIXION.

BEHOLD the Saviour on the
A spectacle of woe! (cross,
See from his agonizing wound
The blood incessant flow;
Till death's pale ensigns o'er his face &
and trembling lips were spread;
Till light forsook his closing eyes,
And life his drooping head

J. Catnach,

Printer, 2, Monmouth-court, 7 Dials, London.

O MAY the grave become to me
The bed of peaceful rest,
Whence I shall gladly rise at length,
And mingle with the blest!
Cheer'd by this hope, with patient mind
I'll wait Heavens high decree,
Till the appointed period come,
When death shall set me free.

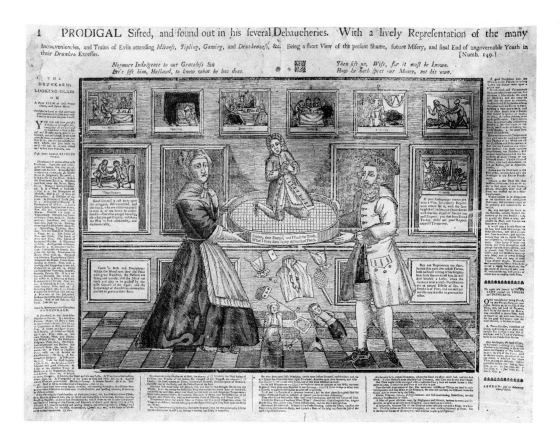

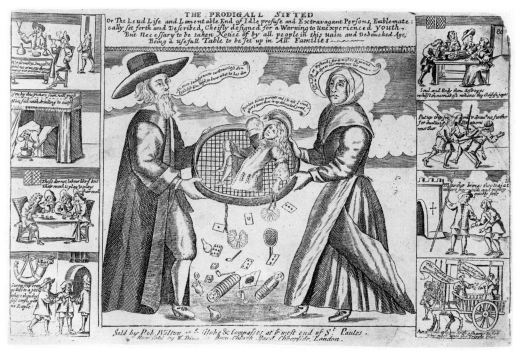

distracted by the salacious description of the 'strapping Whore, her name it was bouncing Bess' and the 'young Bastard ... a perfect bubble of farts'; *The Buxome Maids of Yoel* uses the block simply because the – decidedly bawdy – ballad concerns a sievemaker.[24]

Keep within Compass (fig. 4.11), a pair of decorative prints of which there are several late-eighteenth-century versions,[25] warning young men and women to 'Fear God' and avoid excess, might appear to have an ambiguous attitude to the vices they warn against. However, Samuel Lines (1778–1863), the Birmingham painter and art teacher, recalled that in his childhood the subject was 'a great favourite, and frequently to be seen on the walls of farm houses and cottages' and went on to say that the motto had been 'a useful lesson to me'.[26] Versions of the composition appear as transfer prints on Staffordshire ware of the early

(Facing page)

4.9 *The Prodigal Son Sifted*, c.1700. Parents sieve their son to remove his sins (card-playing, fashionable clothes, smoking, drinking and fathering bastard children) and around them are images of his misdeeds: 'Drunkeness', 'Spewing', 'Debauchery', 'Gaming' and so on. The print appears as no. 149 in the Diceys' catalogue of 1754.

4.10 *The Prodigal Sifted*, 1677, this impression c.1740. This etched version of the subject shown in fig. 4.9 was sufficiently popular for William Dicey to re-publish it some sixty years after it first appeared.

(Right)

4.11 *Keep within Compass*, c.1790. This very popular subject was usually published as a pair to a similar composition warning a young man to 'Fear God'.

4.12 *Our Lord's Passover eaten, and the Betrayer, Judas Iscariot, foretold, c.1750.*
While images of saints disappeared from English popular religion at the Reformation, biblical
narratives remained acceptable.

(*Facing page*)

4.13 *Flight into Egypt, c.1810.* Small crudely coloured etchings of this type normally would
have been close-framed and hung from one nail. They illustrate the huge early-nineteenth-
century market for cheap biblical and moralizing prints.

4.14 *A cottage interior, 1883.* This detail of a photograph by A. E. Emslie shows prints
massed on a cottage wall. Some are framed and hanging from a nail (see fig. 4.13) while others
are pinned directly to the wall. They include a large sheet almanac and a pious motto: 'Watch
and pray'.

FLIGHT into EGYPT.

nineteenth century. The image of a figure standing beneath a mathematical compass has a precedent at least as early as 1619 when it appeared on the title page of a book published by John Trundle entitled *Keepe within Compasse: or, The Worthy Legacy of a Wise Father to his Beloved Sonne* that was reprinted several times over the next ten years.[27]

Biblical narratives were less problematic than images of saints and even appeared from time to time in the seventeenth century.[28] Nativity scenes appear in surviving broadsides of 1631[29] and *c*.1713, the latter re-using an old worm-eaten block (fig. 3.14). The eighteenth-century popular print publishers' catalogues (see Chapter Three) contain numerous biblical subjects. A woodcut of the Last Supper, probably based on a Venetian source, is one of the survivals from Aldermary Churchyard (fig. 4.12). The parable of the prodigal son survives in many 'modern dress' versions. In *The Mill on the Floss* (1860) George Eliot had Maggie Tulliver visiting Luke Moggs's cottage where she 'stood on a chair to look at a remarkable series of pictures representing the Prodigal Son'.[30] In 1844 Dickens had Martin Chuzzlewit stop at an inn where he saw 'highly-coloured scripture pieces on the walls'. By this time there was a market for brightly coloured woodcuts of the Crucifixion or the Virgin and Child (fig. 2.1) and for small cheap images of bible stories that could be exploited with simple coloured etchings to be framed and hung from one nail on cottage walls (figs 4.13 and 4.14). The former would have found their way into the homes of poor Irish immigrants, largely Roman Catholic, who began to settle in the industrial cities in greater numbers after the Act of Union of 1800. Only a few hundred yards from Seven Dials was the notorious 'rookery' of St Giles, described in 1845 as the home of 'the poorest of the poor, the worst paid workers with thieves and the victims of prostitution indiscriminately huddled together, the majority Irish, or of Irish extraction'.[31]

(Facing page)

4.15 *Cobler's Hall*, *c*.1750, this impression *c*.1800. The framed print of the Duke of Cumberland hanging above the fireplace recalls Thomas Bewick's childhood memory of cheap prints of 'Duke Willy'. Other popular prints and ballads are pinned to the wall.

4.16 *A Loyal Song*, 1746. Overton's engraving with its rapidly set verses and decorative book ornaments would have been rushed out to cash in on the rejoicing over the defeat of the Young Pretender's army in 1746. Overton has inserted an advertisement for his warehouse: 'where all country shopkeepers, or travellers, &c. may be served with the greatest variety of sorts, at the best hand, there being above 400 different Kinds, of this size and price; of which there are above 50 Sorts of maps; likewise, above 100 different sorts of two sheet maps, and prints, &c. All at the lowest prices.'

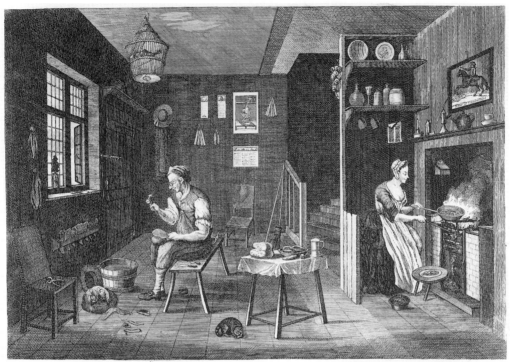

COBLERS HALL.

Printed for & Sold by BOWLES & CARVER, at their Map and &c. Print Warehouse, Nº69 in Sᵗ Pauls Church Yard. LONDON.

Patriotism and the Status Quo

Popular prints were aimed largely at a politically naive public, and images of the sovereign, or of national heroes and their famous victories, served as a means of reinforcing patriotic feelings. It is a common misapprehension to suppose that radical or anti-establishment values are normally to be found in popular imagery. The deliberate appropriation of techniques and imagery familiar from popular prints by political propagandists of the late eighteenth and early nineteenth centuries will be discussed in Chapter Five. Far more typical were the nationalistic prints of 'the rebel lords' and 'Duke Willy' remembered by Thomas Bewick (1753–1828) on the cottage walls of his childhood[32] (fig. 4.15). William, Duke of Cumberland, son of George II, now remembered as 'the Butcher of Culloden', was celebrated in English popular prints for his victory over the Young Pretender and

4.17 *The Royall Line of Kings, Queenes, and Princes, c.*1613. This variation of the traditional royal chronology (see fig. 3.2) shows a century of the English monarchy from Henry VII to the family of James I. The verses are emphatically anti-Roman Catholic.

4.18 *The Great Champions of England … Sir Thomas Fairfax*, 1646. The equestrian portrait of the Civil War general illustrates a broadside listing the Lords and Members of Parliament who supported the Parliamentary cause.

the Jacobites in 1746 (fig. 4.16). The marketing opportunity afforded by this event was exploited throughout the country at a time when most printing was still concentrated in London (see Chapter Three). Two ballads on the subject of Culloden were printed in Sheffield in 1746, the Pretender's army having reached nearby Derby the previous year.[33] Prints of 'the rebel lords' – Scottish noblemen who took part in the uprising – and of their executions were produced in quantities, the best-remembered being Hogarth's *Simon, Lord Lovat*, said to have sold ten thousand impressions, even at the high price of 1s.

Such prints were not official publications. Most were produced for purely commercial motives: while successive British monarchs and governments censored publishers (see p. 42) there is no evidence of a pro-active government role in print

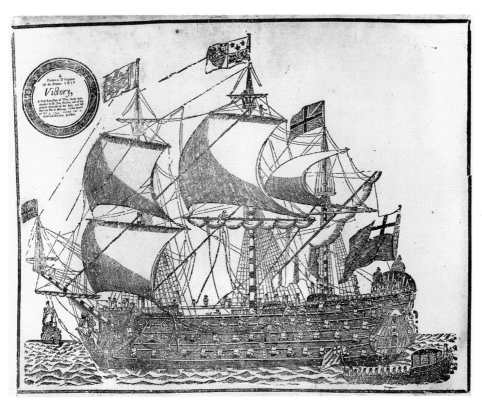

4.19 *A Particular Description of the Famous Ship Victory ...*, 1744. The *Victory* went down with eleven hundred men in 1744 when it was caught in an October storm in the Channel after defeating a French squadron off the coast of Spain. The tragedy evidently caught the public imagination: Thomas Bewick recalled seeing a print of the *Victory* on the wall of his schoolroom about 1760. This example was made from an old worm-eaten block, pressed into service to illustrate a topical event. Newly set letterpress was inserted in place of the original text.

propaganda before the 1790s. But portraits of royalty always find a ready market and have been a staple of print production since its beginnings. In 1563 Gyles Godet (see pp. 43–5) registered woodcuts with the Stationers' Company that included not only a genealogy tracing the lineage of the kings of England back to Noah, but also 'The picture of King Henry the Eighth', 'The picture of King Edward the VI' and 'The picture of Queen Elizabeth'. In 1656 Thomas Warren (who seems to have acquired a group of Godet's blocks) registered genealogies of the Saxon and post-Conquest kings, and large sheets of Henry VIII, James I, Anne of Denmark and 'Lady Elizabeth' (presumably James's daughter who became Elizabeth of Bohemia) and – this being in the middle of the Commonwealth – 'His Highness the Lord Protector on horse back'.[34] A large woodcut in the Society of Antiquaries collection shows the royal succession from Henry VII to the children of James I in the form of a group portrait (fig. 4.17).[35]

The British Museum's huge collection of portrait prints includes thousands

of examples of English royalty ranging in quality from Blooteling's luscious mezzotints after Peter Lely[36] to crude woodcuts like Dicey's *Portraiture of King Charles the First, on Horseback* (fig. 6.2) or *The whole Life, Birth, Glorious Actions, and Last Dying Words, Of Queen Anne*, 1714.[37] All the major publishers of the seventeenth and eighteenth centuries issued series of historical as well as contemporary royalty. Richard Westbrooke registered twenty-one engraved portraits of royalty with the Stationers' Company on 24 March and 3 April 1656. Overton's 1717 catalogue lists 'Head of Charles II, big as life by Vanderbank' and 'Six other very fine large heads ... by Vanderbank' that can be identified as engravings originally published between twenty and forty years earlier by Peter Vandrebanc (1649–97) himself.[38] They had passed after Vandrebanc's death to Christopher Browne (active 1688–1712) and by 1717 were showing signs of wear – slipping down from the top of the market towards an audience that was more interested in acquiring large portraits of monarchs than in appreciating fine prints.

Dramatic images for popular consumption were provided by portraits of military heroes like Sir Thomas Fairfax (fig. 4.18), the Duke of Cumberland (see above) or General Blakeney who defended Minorca after Admiral Byng had deserted it.[39]

4.20 *Captain Thomas Coram* (1668?–1751), after 1740. Coram became a national figure through his work to establish the Foundling Hospital for abandoned children. This woodcut is based on William Hogarth's painting.

4.21 *The Ark Royal, c.1588*. This rare sixteenth-century survival is thought to show the ship made famous in the defence against the Spanish Armada. The large woodblock, made from three separate sections, must have been difficult to print; the vertical joints are clearly visible.

(Facing page)

4.22 *The Glorious Victory ... on June the 1, 1794*. The wars following the French Revolution spawned large numbers of prints aimed at every level of the market. This popular example is unusually large and would have been intended to be placed above a fireplace or door. More sophisticated prints of the same North Atlantic battle present it in the form of a heroic composition full of abstract idealism, but the emphasis here is on the ordinary sailor – both in the action in the foreground of the image and in the reference in the text to 'the magnanimity of the British Tars'.

4.23 *The Honour of a London Prentice*, 1690s. This patriotic ballad tells of the adventures of a young Elizabethan whose courage convinced the King of Turkey that 'no land / like England may be seen / No people better governed / by vertue of a Queen.'

The text under the engraving is largely illegible due to the ornate typeface and resolution.

THE GLORIOUS VICTORY obtained by the BRITISH FLEET under the command of the Right Hon. ADMIR... HOWE over the FRENCH REPUBLICAN FLEET on June the 1 1794.

The Honour of a LONDON PRENTICE.

Being an Account of his matchless Manhood and brave Adventures done in Turkey, and by what means he married the King's Daughter, &c.

To the Tune of, All you that love Goodfellows, &c.

Of a worthy London Prentice,
my purpose is to speak,
And tell his brave adventures,
done for his Country sake;
Seek all the world about,
and you shall hardly find,
A man in valour to exceed
a prentice gallant mind:

He was born in Cheshire,
the chief of men was he,
From thence brought up to London,
a prentice for to be;
A merchant on the bridge,
did like his service so,
That for three years his factor,
to Turkey he should go.

And in that famous country,
one year he had not been,
Ere he by tilt maintained
the honour of his Queen;
Elizabeth the Princess,
he nobly did make known,
To be the Phenix of the world,
and none but she alone.

In armour richly guilded,
well mounted on a steed,
One score of Knights most hardy,
one day he made to bleed;
And brought them all to ground,
who proudly did deny,
Elizabeth to be the Pearl
of Princely Majesty.

The King of that same country
thereat began to frown,
And will'd his son, there present,
to pull this youngster down;
Who at his father's words,
these boasting speeches said,
'Thou art a traitor, English boy,
'and hast the traitor plaid:

'I am no boy nor traitor,
'thy speeches I defie,
'For which I'll be revenged
'upon thee by and by:
'A London Prentice still
'shall prove as good a man,
'As any of your Turkish Knights,
'do all the best you can.

And therewithal he gave him
a box upon the ear,
Which broke his neck asunder,
as plainly doth appear:
'Now know proud Turk, quoth he,
'I am no English boy,
'That can with one small box o'th' ear
'the Prince of Turks destroy.

When as the King perceived
his son so strangely slain,
His soul was sore afflicted
with more then mortal pain;
And in revenge thereof,
he swore that he should dye,
The cruel'st death that ever man
beheld with mortal eye.

Two lyons were prepared
this Prentice to devour,
Near famish'd up with hunger
ten days within the tower,
To make them more fierce
and eager of their play,
To glut themselves with human gore
upon this dreadful day.

The appointed time of torment
at length grew near at hand,
Where all the noble Ladies
and Barons of the land
Attended on the King,
to see this Prentice slain,
And buried in the hungry maws
of these fierce lyons twain.

Then in his shirt of cambrick,
with silk most richly wrought,
This worthy London Prentice
was from the prison brought;
And to the lyons given
to stanch their hunger great,
Which had not eat in ten days space
not one small bit of meat.

But God that knows all secrets,
the matter so contriv'd,
That by this young man's valour
they were of life depriv'd;
For being faint for food,
they scarcely could withstand
The noble force, and fortitude,
and courage of his hand:

For when the hungry lyons
had cast on him their eyes,
The elements did thunder
with the eccho of their cries;
And running all amain
his body to devour,
Into their throats he thrust his arms,
with all his might and power;

From thence by manly valour
their hearts he tore in sunder,
And as the King he threw them,
to all the peoples wonder:
'This have I done, quoth he,
'for lovely England's sake,
'And for my Country's Maiden Queen
'much more will undertake.

But when the King perceived
his wrothful lyons hearts,
Afflicted with great terrour,
his rigor soon reverts;
And turned all his hate
into remorse and love,
And said, 'It is some angel
'sent down from heaven above.

'No, no, I am no angel,
the courteous young man said,
'But born in famous England,
'where God's Word is obey'd;
'Assisted by the heavens,
'who did me thus befriend,
'Or else they had most cruelly
'brought here my life to end.

The King in heart amazed,
lift up his eyes to heaven,
And for his foul offences,
did crave to be forgiben:
Beliebing that no land
like England may be seen,
No people better governed
by vertue of a Queen.

So taking up this young man,
he pardon'd him his life,
And gave his daughter to him
to be his wedded wife,
Where then they did remain,
and live in quiet peace,
In spending their happy days
in joy and love's encrease.

London Printed by and for W. O. and sold by the Booksellers of Pye-corner and London-bridge.

Bewick described:

prints, which were sold at a very low price, [and] were commonly illustrative of some memorable exploits – or perhaps the portraits of eminent men who had distinguished themselves in the service of the country, or in their patriotic exertions to serve mankind ... representations of remarkable victories at sea, and battle on land, often accompanied with portraits of those who commanded, and others who had born a conspicuous part in these contests with the enemy – the house in Ovingham, where our dinner poke was taken care of, when at school, was hung around with views or representations of the battles of Zorndorf and several others – with portraits of Tom Brown, the valiant Grenadier – Admiral Haddock – Admiral Benbow and other portraits of admirals – a figure or representation of the Victory man-of-war of 100 guns [fig. 4.19], commanded by Admiral Sir John Balchen, and fully manned with 1,100 picked seamen and volunteers, all of whom and this uncommonly fine ship were lost – sunk to the bottom of the sea ... Some of the portraits, I recollect, were now and then to be met with, which were very well done in this way on wood. In Mr Gregson's kitchen one of this character hung against the wall many years – it was a remarkably good likeness of Captain Coram [fig. 4.20][40]

The prints mentioned are testimony of the longevity of popular prints. Bewick was born in 1753 but many of the prints he remembered from his childhood must have been published well before his birth: the portraits of the 'rebel lords' and Cumberland would have dated from 1746; Tom Brown was a hero of Dettingen in 1743; Admiral Benbow died in 1702; Admiral Nicholas Haddock died in 1746;[41] the *Victory* went down in 1744; and the 'likeness' of Captain Coram (1668?–1751) would have been based on Hogarth's painting of 1740.[42] The battle of Zorndorf took place in 1763 when Bewick was nine years old.

Prints of military and naval victories were always popular. The great *Ark Royal* that led the English fleet against the Spanish Armada in 1588 (fig. 4.21) appeared in a fine contemporary woodcut. The series of simple engravings entitled England's Glory published by William Rayner in 1738 and 1739 showed naval exploits of thirty years earlier in order to encourage support of the current war with Spain.[43] Prints of the most celebrated victories continued to be issued for decades. By the end of the century there was a new class of coarse etchings designed to sell cheaply (see p. 190). A large contemporary print of the victory on 1 June 1794 (fig. 4.22) – in which six French ships were captured, and no British vessel was lost – has a text glorifying the magnanimous British 'Tars' who are shown helping their French counterparts floundering in the water.

Patriotic prints might also deal with mythic characters such as the 'Valiant London 'Prentice' (fig. 4.23). The 'Prentice is thrown to the lions by the Turkish King but the brave young Englishman overcomes the wild beasts by thrusting his arms into their gaping mouths; the symmetrical image of the youth with a lion on each hand identifies the story in ballad and chapbook versions until the late eighteenth century when it is replaced by a more naturalistic representation of the scene.[44] The traditional image can be clearly seen attached to the wall of the weaving room in plate 1 of Hogarth's *Industry and Idleness* where it foretells a fine future for the industrious young Francis Goodchild.

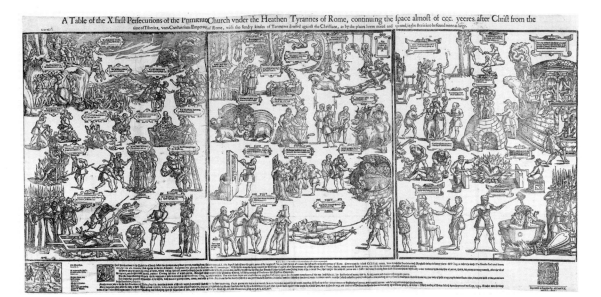

A Table of the X. first Persecutions of the Primitiue Church vnder the Heathen Tyrannes of Rome, continuing the space almost of ccc. yeeres after Christ from the time of Tiberius, vnto Constantinus Emperour of Rome, with the sundry kindes of Tormentes deuised against the Christiane, as by the places herve noted and quoted,in the storie is to be found more at large.

4.24 *A Table of the X First Persecutions of the Primitive Church*, 1570. John Foxe's *Book of Martyrs* was primarily an account of the persecution of Protestants during the Reformation, particularly those executed during the reign of Mary I. It was widely distributed in numerous editions from 1554 up to the nineteenth century and the illustrations of torture and death were widely known. This print – the largest in the book and added to the 1570 edition – shows scenes of the martyrdom of early Christians and was also displayed separately. Individual scenes are based on prints by Dürer and other German printmakers.

Crime and Execution

The earliest prints of executions were those of religious martyrs. The most familiar to English audiences would have been the woodcuts in John Foxe's *Actes and Monuments*, his 'Book of Martyrs', which appeared in eleven illustrated editions between 1559 and 1684.[45] Parish churches had chained copies of the book, and both the text and illustrations – including two separate sheets – were widely known (fig. 4.24).[46] These sheets, or copies of them, continued to be published throughout the seventeenth century: Robert Walton's print catalogue of 1666 listed the highly disturbing *Ten Persecutions of the Primitive Church* (a version of fig. 4.24): 'a convenient table for ornament of every good christian house, to stir them up to stand to the faith'.[47]

Precursors of the execution broadsides that were to become a staple of popular print production appear in the Society of Antiquaries collection: *The unfaigned retraction of Fraunces Cox which he uttered at the pillery in Chepesyde*, 1561, has an elaborately decorated initial letter but no illustration relevant to the text (Cox narrowly escaped punishment of death for practising astrology); *A declaration of the death of John Lewes a most detestable and obstinate Hereticke, burned at Norwich*, 1583, gives a verse account of Lewes's atheism and consequent

❧ A proper newe Ballad, declaring the substaunce of

all the late pretended Treasons against the Queenes Maiestie, and Estates of this Realme, by

sundry Traytors: who were executed in Lincolnes-Inne fielde on the 20. and 21.daies of September. 1586. To Wilsons newe tune.

When first the gracious God of heauen, by meanes did bring to light:
the Treasons lately practised, by many a wicked wight.
Against their Prince whose life they sought, & many a noble Peere:
the substance of whose treasons strange, you shal most truely heare.

O Lord preserue our noble Queene long maintaine:
Confound her foes and graunt her grace in health to rule and raigne.

Their Treasons once discouered, then were the Traytors sought:
some of them fled into a Wood, where after they were caught.
And being broughte vnto the Tower, for ioye the Belles did ring:
and throughout London Bonefiers made, where people Psalmes did sing

O Lord preserue our noble Queene, &c.

And set their Tables in the streetes, with meates of euery kinde:
where was preparde all signes of ioye, that could be had in minde.
And praysde the Lord most hartely, that with his mightie hand:
he had preserued our gracious Queene, and people of this Land.

O Lord preserue our noble Queene, &c.

Which thing was taken in good parte, by our renowned Queene:
who by her Letters gaue them thankes, as playnly may be seene.
Assuring them that all her care, was for their safetie still:
and that thereby she would deserue, their loue and great good will.

O Lord preserue our noble Queene, &c.

The Traytors well examined, (whom God himselfe bewrayed:)
their Treasons knowne, then were they straight to Westminster conuaied,
Whereas they all indited were, of many a vile pretence:
seauen pleaded guiltie at the Barre, before they went from thence.

The maner how they did begin, herein will playne appeare:
their purposes in each respect, you shall most truely heare.
Herein vnto you will be seene, if they had not bene foylde:
our Realme, our Realme, yea rich and, poore together had bene spoylde.

One Sauidge lurking long in Fraunce, at Rheames did there remaine:
whom Doctor Gifford did perswade, great honor hee should gaine.
If that he would goe take in hand, (these matters very straunge:)
first to depriue our gracious Queene, Religion for to chaunge.

And then for to inuade the Realme, by troupes of foraine power:
to ouerthrowe the gouernment, and kill her in her Bower.
Or forceably to dispossesse, the Queene of Englands Grace:
and to proclaime the Scottish Queene, and set her in her place.

Which matter Sauidge promised, his full performance too:
so that he might see warrant with, safe Conscience so to doo.
The Doctor vowed by his Soule, and bad him vnderstand:
it was an honourable thing, to take the same in hand.

When Sauidge heard that merites were, to him therby so rise:
he vowed for to doe the same, or else to lose his life.
And shortly into England hyed, and did imparte the same:
to Babington of Darby shire, a man sure voyd of shame.

And tolde him how that he had vowed, to doe it or to dye:
desiring him of helpe and ayde, and that immediatly.
A Iesuit Priest whom Ballard hight, came ouer to that end:
he came also to Babington, and dayly did attend.

Still to perswade him that he would, attempt and take in hand:
this vilde and wicked enterprise, and stoutly to it stand.
And tolde him that he should haue ayde, of fortie thousand men:
that secretly should landed be, and tolde him how and when.

And in respect of all his paines, he truely might depende:
that it was lawefull so to doe, Renowne should be the ende.

But let all Traytors nowe perceiue, what honor he hath wonne:
whose trayterous head and wicked heart, hath many a one vndone.
This proude and hautie Babington, in hope to gaine renowne:
did stirre vp many wilfull men, in many a Shire and Towne.
To ayde him in this deuilish act, and for to take in hand:
the spoyle of our renowned Prince, and people of this Land.

Who did conclude with bloodie blade, a slaughter to commit:
vpon her Counsell as they should, within Star Chamber sit.
Which is a place wheras the Lordes, and those of that degree:
peeldes Iustice vnto euery man, that craues it on their knee.

Yea famous London they did meane, for to haue sackt beside:
both Maior and Magistrates therin, haue murdered at that tide.
Eache riche mans goodes had beene their owne, no fauour then had serued:
nought but our wealth was their desire, though wee and ours had starued.

Besides these wicked practises, they had concluded moe:
the burning of the Nauie and, the cheefest Shippes in store:
With fire and swoorde thy vowed, to kill and to displace:
eache Lord Knight and Magistrate, true subiects to her Grace.

They had determinde to haue cloyde, and poysoned out of hand:
the cheefe and greatest Ordinaunce, that is within this Land.
And did entend by violence, on rich men for to fall:
to haue their money and their Plate, and to haue spoild them al.

The Common wealth of England soone, should therby haue bene spoylde:
our goodes for which our Parents and, our selues long time haue toylde.
Had all bene taken from vs, besides what had ensued:
the substaunce proueth playnely, to soone u ee all had rewed.

Those were the Treasons they conspyde, our good Queene to displace:
to spoyle the states of all this Land, such was their want of grace:
But God that doth protect her still, offended at the same:
Euen in their young and tender yeares, did cut them of with shame.

These Traytors executed were, on Stage full strongly wrought:
euen in the place where wickedly, they had their Treasons sought.
There were they hangde and quatered, there they acknowledged why:
who like as Traytors they had liued, euen so they seemde to dye.

O wicked Impes, O Traytors vilde, that could these deedes deuise:
why did the feare of God and Prince, departe so from your eyes.
No Rebelles power can her displace, God will defend her still:
true subiectes all will lose their liues, ere Traytors haue their will.

How many mischiefes are deuisde, how many wayes are wrought:
how many vilde Conspyracies, agaynst her Grace is sought.
Yet God that doth protect her still, her Grace doth well preserue:
and workes a shame vnto her foes, as they doe best deserue.

O heauenly God preserue our Queene, in plentie health and peace:
confounde her foes, maintaine her right, her ioyes O Lord increase.
Lord blesse her Counsaile euermore, and Nobles of this Land:
preserue her Subiects, and this Realme, with thy most mightie hand.

FINIS.

execution and is illustrated by a coarse woodcut of a figure tied to the stake; two broadsides celebrating the death of the Babington plotters executed in 1586 for conspiring to overthrow Elizabeth I are illustrated with different groups of seven pairs of woodcut heads (fig. 4.25).[48]

Many execution broadsides – mostly, still, vehemently anti-Roman Catholic – are included in the seventeenth-century collection of Narcissus Luttrell (see Chapter Nine). Most are without illustrations or with only simple *memento mori* woodcuts. Luttrell also owned a number of sheets, again unillustrated, giving sensational accounts of murders, for instance, *Murder by James Shelben of Mrs Bartlet and wounding of Mrs Chethen in a bawdy-house in Lemon Street, Goodman's Fields 22 March 1691* which Luttrell bought the day after the crime was committed. His annotation suggests that he followed such events closely: 'this

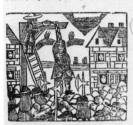

(*Facing page*)
4.25 *A proper newe Ballad, declaring the substaunce of all the late pretended Treasons against the Queenes Majestie*, 1586. This early example of an execution broadside describes the plot of Anthony Babington and his associates to assassinate Elizabeth I and to crown Mary, Queen of Scots, in her place. The plotters were hung, drawn and quartered before a great crowd in Lincoln's Inn Fields.

(*Right*)
4.26 *The Disobedient Son and Cruel Husband*, c.1700. This ballad tells a sensational story of a man who was executed for murdering his family. The woodcuts appeared on several ballads and do not relate specifically to the events described.

is now no less than the fifth Murther that has been committed within these six Months past, in five several B[awdy] Houses ... in and about London'.[49]

Lurid accounts of murders and executions appeared in late-seventeenth-century ballads, but they seem to have been intended as entertainment and make no real attempt at veracity. An example is *The Disobedient Son and Cruel Husband* (fig. 4.26), crudely illustrated with two small woodcuts, a version of one of which was used in *The Downfall of William Grismond*[50], an account of a murder committed in 1650, to be sung to the tune of *Where is my Love*.[51] *The Golden Farmer's Last Farewell*, 1690, to the tune of *The Rich Merchant Man*, and *Francis Winter's Last Farewell*, 1693, to the tune of *Russel's Farewell*,[52] present accounts of the careers of notorious robbers.

By the middle of the eighteenth century the execution broadside had become established in the form in which it was to remain familiar for over a century (see figs 3.20 and 4.32–4.33): a woodcut of the execution with an account of the crime, the 'Last Dying Speech' of the condemned and a description of his or her death. Famous executions clearly provided opportunities for large sales of

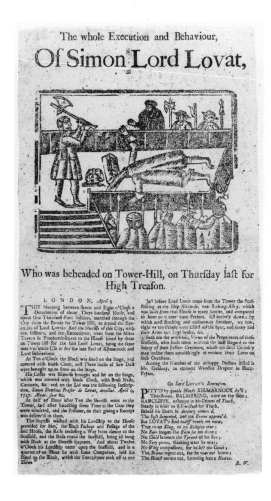

4.27 *The whole Execution and Behaviour of Simon Lord Lovat*, 1747. Much of the text is taken up with a description of the collapse of one of the viewing stands erected near the scaffold and the deaths of a number of spectators. It may have been interest in this disaster that the publisher wished to exploit when he, unusually by that date, issued the sheet after the execution. The damaged woodblock, showing figures in seventeenth-century dress, would have been made originally to illustrate the execution of Charles I.

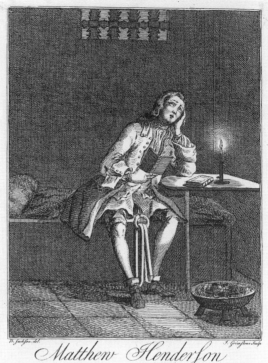

4.28 *Henry Rogers*, 1735. Rogers barricaded his house when a Decree in Chancery went against him, and he shot five men dead before being arrested. He attempted another murder while in gaol and it is most unlikely that the print is, as it purports to be, an accurate likeness drawn in the prisoner's cell. It was sold for 6d.

4.29 *Matthew Henderson*, 1746. The market for criminal portraits extended to those with genteel tastes, and Henderson, reading by candlelight in his cell, looks more like a Guido Reni saint at prayer than the 'inhuman' teenage murderer described beneath the print. It sold for 6d.

broadsides, and old woodblocks were pressed into service by printers wishing to cash in. An early example is a handbill issued immediately after the execution in April 1747 of Simon Fraser, Lord Lovat, beheaded for his part in leading the 1745 Jacobite Rebellion; the illustration is taken from a badly damaged seventeenth-century block showing the execution of Charles I (fig. 4.27).

A market developed also for portraits of notorious criminals. Horace Walpole wrote in 1750: 'You cannot conceive the ridiculous rage there is of going to Newgate, the prints that are published of the malefactors, and the memoirs of their lives set forth.'[53] Criminals might be shown in the prison cell, like Christopher Layer, a Jacobite executed in 1723,[54] Jack Shepherd, painted by

James Thornhill in 1724,[55] Sarah Malcolm, painted by Hogarth in 1733, Henry Rogers, a Cornish mass murderer (fig. 4.28), or Matthew Henderson, who in 1746 murdered the lady to whom he was in service (fig. 4.29). They might also appear in conventional settings, and prints can be indistinguishable, at first glance, from formal portraits of respectable sitters. James Lowry, a murderous sea captain, is shown in 1752 posing on the sea shore – although his portrait is said to have been 'Drawn from the Life in Newgate' – and it is only by reading the text below his feet that his evil character is made apparent (fig. 4.30). A similar setting is used for a portrait of Richard Parker, executed for leading the mutiny of the Nore in 1797.[56] A fashionable portrait of Mary Blandy, a young lady from Henley, was used as the basis for a number of prints when she was condemned in 1752 for murdering her father (fig. 4.31); in one version her embroidered gown is

CAPTAIN JAMES LOWRY

Late Commander of the Molly Merchantman, bound from Jamaica to London, who was try'd and condemn'd by a High Court of Admiralty at the Old Bailey, on Tuesday February 18.th 1752. before S.r Tho.s Salusbury K.t Judge of the said Court &c. for inhumanly Whipping to Death Kenith Hossack, Foremast-man on board the said Ship, December the 24.th 1750. in Latitude 49 Degrees 50 Min.ts * A Stick which he cruelly beat his Men with.

Published according to Act of Parliament March 7, 1752. by R. Bennett, Engraver at the Back in Blackmoor Street Clare Market; Sold by the Printsellers of London & Westminster &c. Price 6d plain.

4.30 *Captain James Lowry*, 1752. Lowry is shown against a seascape, in a pose and setting conventional for a naval man. It is only from reading the text that we learn that the stick he holds is the one with which he cruelly beat his crew, and that he whipped one of his men to death. The print sold for 6d. plain and 1s. coloured.

(*Facing page*)
4.31 *The Female Parricide*, 1752. In 1751 Mary Blandy poisoned her father so that she could run off with an army officer who was already married to a wife in Scotland. According to the caption the illustration is based on a study from life 'by an eminent Limner in the Year 1750'; an etched version of the same portrait, published by Dickinson on 3 February 1752, purports to have been 'Taken from the life in Oxford Castle', and has shackles on Blandy's ankles.

The Female PARRICIDE.

Being a Circumstantial Relation of the cruel Poisoning of FRANCIS BLANDY, Gent. late Town-Clerk of *Henley-upon-Thames*, in the County of *Oxford*, by his only Daughter *Mary Blandy*; as it was prov'd against her at the Assizes held at *Oxford*, on *Tuesday, March* 3, 1752, where she was found guilty of the same, and received Sentence of Death; and executed at *Oxford* on *Monday* the 6th of *April* following.

To which are added, A Letter from a Clergyman to Miss *Blandy*, after receiving Sentence of Death, and her Answer thereto; as also an Account of her Behaviour at the Place of Execution.

YE blushing Virgins view a Woman's Shame.
A Spider came ; he flatter'd and betray'd :
With *Father's* Guilt, he shook her tender Frame,
And to a Monster turn'd th' indulgent Maid.

And, ye gay Tribes, who bloom in Beauty's Pride,
Attend her Fate ; her piteous Story learn :
O set too much in lavish Pride confide !
For ah ! the Perjures of faithful Man.

Shun Flattery's Lure, fair Beauty's cruel Bane !
The doors deluſt Virtue's ſelf to wed.
Want that the Stage not with immodeſt Paſs,
Yet her fair Shade are with Deſtruction ſled.

A rather bleeds, ſtruck by a Daughter's Hand,
New Vengeance threatens, rigid juſtice calls ;
Blood bred for Blood, in Nature's juſt Demand !
The Law remits not, and a Daughter falls.

THE TRUE EFFIGIES OF Miss Mary Blandy,

As drawn from the Life, by an eminent Limner, in the Year 1750.

unchanged, but there are shackles around her ankles. The woodcut was copied as a portrait of Fanny Davies, executed at Chelmsford, in a chapbook of 1785.[57]

Where criminals caught the public imagination there might be a number of portraits, usually based on a single prototype, and stories with a particular fascination could appear in a succession of prints as further details emerged. Elizabeth Canning's alleged kidnapping was an unusually long-running story told in a series of prints, broadsides and eventually satires.[58]

Crime and execution appeared not only in popular broadsides and single-sheet prints but also as a subject for illustrated chapbooks. The story of Elizabeth Brownrigg, who was executed in 1767 for abusing her three apprentice girls, appears in *The Cries of the Afflicted*.[59] The woodblock showing her arrest reappeared in *The Life and Death of Christian Bowman*.[60] The tales are told in a

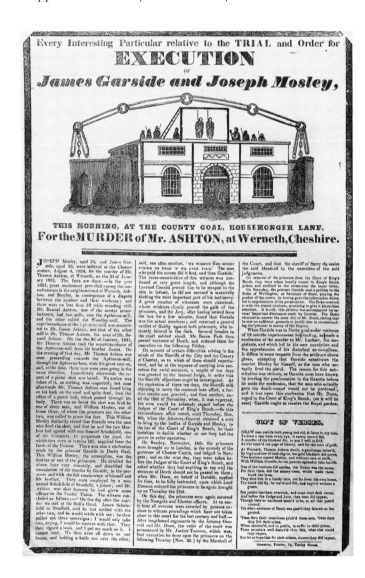

4.32 *Execution of James Garside and Joseph Mosley … at the County Gaol, Horsemonger Lane*, 1834. The image of the gaol is a simplified version of the standard view used in fig. 3.20.

4.33 *Life, Trial, and Execution of Christian Sattler*, 1858. Sattler, a German who had fled England after committing a felony, was hanged at Newgate for murdering the detective who was bringing him back to stand trial. The broadside is illustrated with a standard woodcut showing the Old Bailey in which a separate block of the hanging man is inserted; extra figures could be added for multiple hangings.

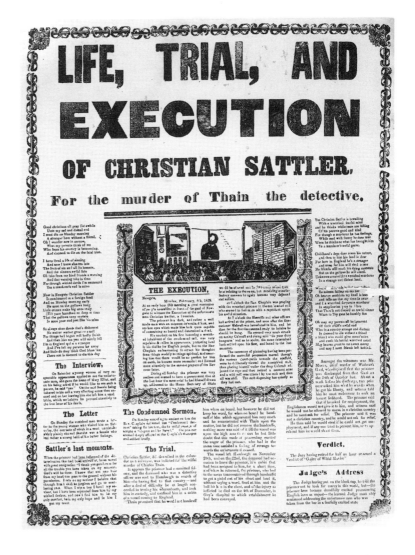

simple moralizing tone apparently aimed at children. The developing moralistic and educational aspect of the execution print is apparent in *The Last Dying Speech and Confession of John Pallett*, a broadside of 1823: the usual account of trial, confession, imprisonment and execution – describing the felon's demeanour, his suffering at the end, and the size of the crowd – is followed by a 'Moral' advising the reader to avoid anger, feelings of revenge, swearing and drunkenness, to read the Bible and to 'spend the Sabbath as its precepts direct'. A line of bold type at the foot of the sheet exhorts: 'Read this to your Children and Preserve it.'[61]

Most surviving execution broadsides were produced by the mass popular print publishers James Catnach and his contemporaries, who developed the market to an extraordinary degree from the early nineteenth century onwards (see Chapter Two). In 1849 the Catnach Press sold more than two and a half million broad-

sides of the executions both of James Rush in Norwich[62] and of George and Maria Mannings in Southwark; this was at a time when the population of the country was less than twenty million.[63]

Catnach's development of the popular print was echoed by printers in every provincial town who produced broadsides of local, and sometimes more distant, crimes and executions. The tradition of re-using woodblocks continued: J. Marshall of Newcastle used the same old block of a beheading for broadsides describing four separate hangings – John Worthington's of 1815, Matthew Clarke's of 1816, James Lewis's of 1819 and Thomas Brown's of 1820[64] – even though the account of Worthington's execution dwells at gory length on the incompetence of the hangman, and the last execution by beheading in the country had been in 1747.[65]

Execution woodcuts usually followed one of a small number of familiar patterns, often designed with a separate block for the gallows itself so that the number of hanging figures could be changed to suit the circumstances. The hanging of Hogarth's *Idle 'Prentice* continued to provide a model for illustrations even after the actual place of execution had moved from Tyburn to Newgate in 1783.[66] Another standard image was Horsemonger Lane Gaol in Southwark, built in the 1790s with the scaffold clearly visible on the prison roof (figs 3.20 and 4.32). It appeared in a number of variants, each with the same cart loaded with spectators and the same boy climbing the lamp-post. The prototype was probably an etching of the execution of Colonel Edmund Despard and six associates in 1803, published by G. Thompson.[67]

The execution broadside (fig. 4.33), with its crude woodcuts, bold lettering and formulaic accounts of crime and punishment, suited the Victorian taste for melodrama. The market disappeared in 1868 when executions ceased to be public, but the taste for crime in the mass media continued.[68] By then popular illustrated newspapers were well established, and publications such as *The Illustrated Police News* fed the appetite for sensational images with whole-page wood-engravings depicting scenes of violent crime.

Phenomena and Freaks of Nature

Trinculo in Shakespeare's *Tempest*, coming across the hideous Caliban, describes the English fascination with exotic creatures:

A strange fish! Were I in England now, as once I was, and had but this fish painted, not a holiday fool there but would give a piece of silver. There would this monster make a man; any strange beast there makes a man; when they will not give a doit to relieve a lame beggar, they will lay out ten to see a dead Indian.[69]

The word 'monster' derives from the Latin *monere*, to warn, and originally signified a divine portent. German Reformation prints of strange animals, and of phenomena such as earthquakes, eclipses and comets, usually portray them as warnings from God.[70] Although such beliefs did exist in England,[71] it was usual

·Imprinted at *London*, and are to be sold by *M. Sparke, Iunior*. 1636.

4.34 *The Three Wonders of this Age*, 1636. This broadside describes a number of ancient and contemporary figures of very tall or very small stature or of great age. The etched illustration by George Glover contrasts the seven-foot William Evans with the tiny Jeffrey Hudson and shows the 'very old man', Thomas Parr, who lived to the age of 153.

for such publications to appear as straightforward news items – a monster was simply something to marvel at. An account of a malformed pig born in Germany was jointly published in Nuremberg and London in 1531 (fig. 3.1) but the bilingual text simply describes the two hearts, eight feet and so on, making no supernatural inference; a broadside of 1552 showing a pair of conjoined twins born in Oxfordshire (pl. 1) carries a verse drawing a parallel between their malformed bodies and the way that Satan had made monsters out of men, but the main body of the text is a detailed description of their birth and parentage, their bodies, and the first days of their lives.[72] So few sixteenth-century English prints survive that it is not possible to estimate the relative popularity of any one type of subject with any accuracy, but the fact that a group of fifteen broadsides of

MISS ANGELINA MELIUS *the celebrated* **GIANTESS** *from the* UNITED STATES *19 Years of Age & nearly* **7** Feet high. *Attended by her* **PAGE** SEÑOR DON SANTIAGO *de los* SANTOS *from the Island of* MANILLA. *55 Years of Age &* **2** Feet *2* Inches high.

4.35 *Angelina Melius and Santiago de los Santos, c.* 1820. The comparative sizes of the tall woman and very small man are exaggerated to an extent which takes the image into the realm of fantasy.

4.36 *Three Wonderful Phoenomena*, 1787. The sheet advertises an exhibition of three small South Americans each with a goitre or 'Monstrous Craw' who could be seen for a shilling. They had been exhibited throughout Europe and were admired for their 'most endearing Tractableness and respectful demeanour towards all Strangers, as well for their unparallel'd and natural, chearful, lively, and merry Disposition'. Their fame was such that the description 'monstrous craw' was given to the exaggerated cravats worn by dandies of the period. James Gillray used the same term in the title of a print satirizing the reconciliation of George III, Queen Charlotte and the Prince of Wales after Parliament voted to pay the Prince's enormous debts and to increase his annual income; they are shown gorging themselves on guineas (BM Sat 7166).

PRICE REDUCED.

To the Nobility, Gentry, and the Curious for infpecting moft Extraordinary Human Beings, of the wild Species born.

Juft Arrived from Abroad,

And to be Seen at Mr. Becket's, *Trunk Maker*, No. 31, HAY-MARKET,

From Ten o'Clock in the Morning, till Nine in the Evening,

Three Wonderful Phœnomena,

Wild Born, of the Human Species :

THESE are Two Females and a Male, of a very SMALL STATURE, being little lefs or more than *Four Feet High*;

Each with a Monftrous CRAW

under the Throat, containing within, fome Three, fome Four, fome Five BALLS or GLANDS, more or lefs big than an Egg each of them, and which play upwards and downwards, and all ways in their *Craws*, according as incited and forced, either by their Speaking, or Laughing. Thefe Three

Moft wonderful wild born Human Beings,

whofe Country, Language, and Native Cuftoms are yet unknown to all Mankind, it is fuppofed ftarted in fome Canoes from their Native Place (believed to be fome ftill unknown remote Land of South America) and being after Wrecked, were picked up by a Spanifh Veffel, which in a violent Storm, was alfo loft off Triefte, in Italy, when thefe Three People, and another of the fame kind, fince Dead, were providentially faved from perifhing; though, it is imagined, there were more on board of their Species.—At that period they were of a dark Olive Complexion, but which has aftonifhingly, by degrees, changed to the colour of that of Europeans.

Thefe Three *truly-furprifing* Beings, have attracted to themfelves the moft minute Attention, and great Admiration of all the Princes, celebrated Anatomifts, and Naturalifts, to whom they have been prefented in Europe, for their Rare, and yet Unknown Species; and not lefs indeed, for their moft apparent and furprifing Happinefs, and Content among themfelves; moft endearing Tractablenefs and refpectful demeanour towards all Strangers, as well for their unparallel'd and natural, chearful, lively, and merry Difpofition, Singing and Dancing (in their moft extraordinary Way,) at the will and pleafure of the Company

Admittance, One Shilling Each:—

'monstrous creatures' of the 1560s makes up over a third of surviving large-scale secular woodcuts published in England between 1550 and 1640 may confirm Shakespeare's account of English taste.[73]

On 23 November 1637 Robert Milbourne registered with the Stationers' Company 'a picture of the Italian young man with his brother growing out of his side with some verses thereunto'. The same phenomenon was the subject of a ballad entitled *The Two Inseparable Brothers*, concerning a young Italian 'who hath an imperfect (yet living) Brother growing out of his side ...', published by Thomas Lamb at the sign of the Horseshoe, Smithfield.[74]

A broadside of 1636 (fig. 4.34) gives an account of a number of very tall and very small men as well as those who lived to a great age; the illustration by George Glover shows William Evans, 'whose stature is seven foot and upwards', Jeffrey Hudson, Queen Henrietta Maria's dwarf, and Thomas Parr, 'the very old man'.[75] Glover's print emphasizes the contrasting stature of Evans and Hudson by placing them together in a way which was typical of prints of such subjects.

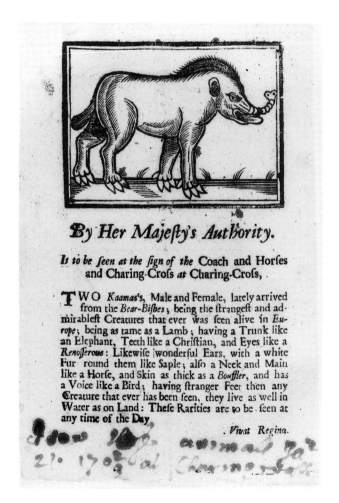

By Her Majesty's Authority.

It is to be seen at the sign of the Coach and Horses and Charing-Cross at Charing-Cross,

TWO *Kaamas's*, Male and Female, lately arrived from the *Bear-Bishes*; being the strangeft and admirableft Creatures that ever was feen alive in *Europe*; being as tame as a Lamb; having a Trunk like an Elephant, Teeth like a Chriftian, and Eyes like a *Renofferous*: Likewife wonderful Ears, with a white Fur round them like Saple; alfo a Neck and Main like a Horfe, and Skin as thick as a *Bouffler*, and has a Voice like a Bird; having ftranger Feet then any Creature that ever has been feen, they live as well in Water as on Land: Thefe Rarities are to be feen at any time of the Day.

. *Vivat Regina.*

4.37 *Hartebeest*, 1702. This handbill advertises two kaamas or hartebeest (South African antelopes). It is inscribed in an educated hand: 'I saw these animals Jan 21 1702/3 at Charing cross'.

(*Facing page*)
4.38 *A Trew Draught of the Whale as he was seen at Blackwall Dock*, c.1690. This etching, showing fashionable visitors arriving by boat to see the whale washed up on the bank of the Thames east of London, would have been produced to exploit the souvenir market. The text was etched quickly with little attention to spacing or spelling. For other whales recorded in the Thames see Altick, p.38. The print appeared in the British Museum inventory for 1837 in a volume containing other prints of phenomena and freaks of nature that seems to have belonged to Hans Sloane.

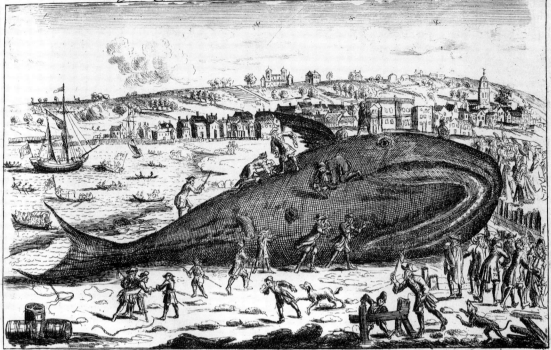

A Trew Draught of the Whale as he was seen at Blackwall-Dock.

This Monsterous Fish is 57 foot in Lenght & near 40. foot About, he is more in hight, then in breath, and is taken to be a matter of 50:Tunn in Wight, He was first discover'd near the Bowy of the Nore Where he was fier'd at by a Kings Youth so received sum Wound, & made toward the Shoure so came along by ye Hoop & beat himselfe upon ye Sand after that he was Harpoond & Taken, then Bought by a Quator. etc. Sold by Iohn Drapentier Ingraver in St Martins Legrand:

A broadside of 1664 advertises:

The true and exact effigies of a giant born in Germany and lately seen at Ipswich, his stature nine foot and half in height, and the span of his hand a cubit compleat; he goes from place to place with his wife, who is but of a very ordinary stature and takes money for the show of her husband, she intends to be at London with him at next Bartholomew Fair.

The etched illustration shows a man and a woman barely reaching the giant's chest and he demonstrates his enormous hand span stretching from the tip of the smaller man's finger to his elbow.[76] 'Mr Bamfield, the Staffordshire Giant' appears with 'Mr Coan the Norfolk Dwarf' in a print of 1771 by James Roberts based on models of the two men exhibited by a Mr Rackshaw.[77] An early-nineteenth-century print of the seven-foot Angelina Melius exaggerates her size by showing her as seven times the height of Santiago de los Santos who is said to be two foot two inches tall (fig. 4.35).

Probably the most famous of all the human 'phenomena' ever exposed to public view were the Siamese twins, Chang and Eng (c.1810–74), purchased from their mother by an American entrepreneur in 1829 and exhibited around the

world.[78] Their obituarist writing in the *Daily News* on 22 January 1874 refers to 'a taste essentially vulgar' for exhibitions of 'pig-faced women, dog-faced men, children with two heads, Norwegian giantesses, Circassian beauties, and six-fingered boys', and points out that the fame of such people depended less on their physical peculiarity than on the manner in which they were publicized – the dwarf Tom Thumb, for instance, owed 'his reputation far less to his small stature than to the cleverness, and energy, and showmanlike qualities of Mr P. T. Barnum'.

Many of the surviving prints of human phenomena were produced by showmen as publicity for exhibitions, but the fascination existed long before the time of Chang and Eng. The *London Gazette* for 13 April 1682 carrried an announcement reminding 'such as make shew of motions and strange sights' that, like mountebanks, rope-dancers and ballad-singers, they had to obtain a licence from the Office of the Revels in Whitehall, which since 1546 had regulated public performances.[79] Hans Sloane, eminent physician and founder of the British Museum, was one of many gentlemen of his time who visited exhibitions of human and animal phenomena. He collected a number of advertisements for such shows,[80] several of which claim veracity for the exhibits by noting that the King, the Queen and Sloane himself had seen them.[81] On 14 October 1714 Ralph Thoresby, the Leeds antiquary, recorded that he 'walked into Southwark to see the Italian gentleman with two heads; that growing out of his side has long black hair. I bought his picture, which is with the printed ticket.'[82] A handbill of 1784 advertised that a 'satyr, or real wild-man of the woods' described as having come from the East Indies, and probably an orang-utan, was 'to be seen alive at no. 99 Holborn Hill'[83] where 'foreign birds, beasts, &c. [were] bought and sold'. Three years later a similar handbill (fig. 4.36) advertised 'Three Wonderful Phoenomena' who could be seen for a shilling 'at Mr Becket's, Trunk maker, No. 31, Haymarket' – these were three small South Americans each of whom had a goitre or 'Monstrous Craw'. Becket appears to have made a speciality of curiosities: in 1789 he distributed bills advertising Margery Gasson, who had been pregnant for six and a half years, and at around the same time 'the Learned Goose' who could read letters printed on cards.[84]

Unusual animals were treated with the same fascination as human phenomena. A handbill advertising a pair of hartebeest (fig. 4.37) to be seen in London is annotated in an educated hand: 'I saw these animals Jan 21 1702/3 at Charing cross'. Other prints of strange creatures, merely report sightings: whales washed up on the shore are always worthy of note (fig. 4.38).[85]

Many exhibitions were simply of people of remarkable appearance or extraordinary physical abilities. Bernardo Gigli, an eight-foot-tall Italian, clearly carried his own advertising material with him: the etched lettering on his portrait (fig. 4.39) is in Italian, but is supplemented by bold English letterpress below the image. Some exhibits were extremely fat people, like Daniel Lambert,[86] Jacob Powell or Christopher Bullock (figs 4.40 and 4.41), or those who were extremely tall, like Charles Byrne (O'Brien), the 'Irish Giant' whose skeleton measuring

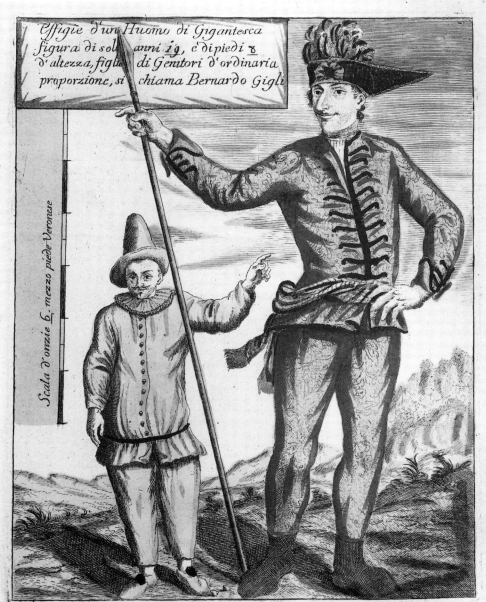

The EFFIGY of

BERNARDO GIGLI, (*an* Italian)

A Gigantic Man, only Nineteen Years of Age, who is Eight Feet high, and the Talleſt and Beſt Proportion'd Man ever ſeen, and whoſe FATHER and MOTHER were of a common Size. [Price One Shilling.]

4.39 *The Effigy of Bernardo Gigli, (an Italian)*, mid eighteenth century. The etching, with its lettering in Italian, must have accompanied the 'gigantic' Gigli on his travels. The English text was overprinted in letterpress.

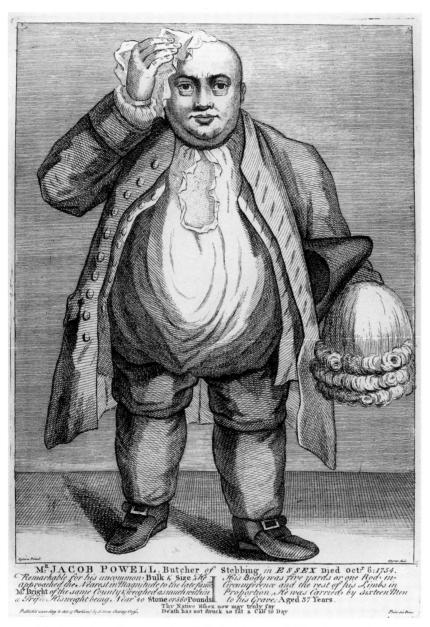

4.40 *Mr. Jacob Powell, c.1754.* Powell died at the age of thirty-five weighing 560 pounds.

(*Facing page*) 4.41 *The Suffolk Wonder, 1755.* The woodcut of Christopher Bullock is a direct copy of a portrait of Jacob Powell (fig. 4.40). The text describes Bullock as being three feet six inches tall and measuring seven feet 'round his Body'. It continues with mention of a woman of Diss who was three feet tall, and of famous men in Suffolk history, and ends with a note of market days and distances from London of towns on the road to Yarmouth. The original price of '3d' is written at the foot of the sheet, but a note on the verso records that at some time before it was acquired by the British Museum in 1851 it was sold for £1 11s 6d.

The *Suffolk* WONDER:
OR, THE
Pleasant, Facetious, and Merry DWARF of *Bottesdale*.

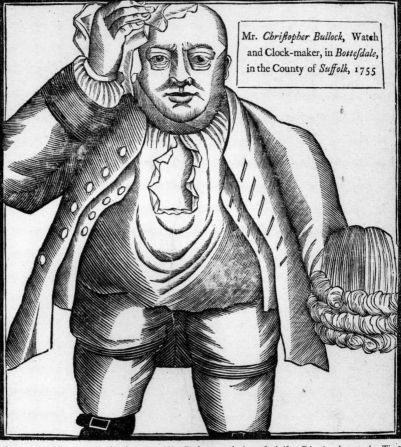

Mr. *Christopher Bullock*, Watch and Clock-maker, in *Bottesdale*, in the County of *Suffolk*, 1755

THIS Surprizing Little Man exceeds by far the remarkable and weighty Mr. *Edw. Bright*, of *Much-Waltham* in *Essex*, both in Activity, and also in Bulk, considering his Height; for although he measures but three Feet and six Inches from the Sole of his Foot to the Crown of his Head in Height, yet is he no less than seven Feet round in his Body: His Limbs are all proportionably thick; yet he moves with as much Activity, and as light, as any Man of his Age, which is this Year Forty-seven. He has had by his Wife (who was born at *Whymondham* near *Norwich*, and is a small, but hale, and thick, strong Woman) four Children, three of which are now living. He was born at a Village called *Lavenham*, in the County of *Norfolk*, and is really the Wonder of the World. When he came of a fit Age, he chose for himself the Trade of a Clock and Watch-maker, by which he maintains his Wife and Family in a genteel and creditable Manner, and is esteem'd, employ'd, and and respected by all the Gentlemen round him.

This County is not only remarkable for the above living Dwarf and his Wife, as well as for one Miss *B-t-c-b-r* of *Diss*, no more than three Feet high, but also for the many Noblemen and Gentlemen of Learning and other most excellent Atchievements, born within the same; but must be remember'd to the latest Date of Time for the gallant Exploit of *John Cavendish*, Esq; who, in the Reign of *Richard* the Second, *Anno* 1381, when the infamous Rebel, *Wat Tyler*, play'd the King in *London*, and being angry that Sir *John Newton*, Sword-Bearer to the King, (then in Presence in *Smithfield*) devouring his Distance, nd not making his Approaches mannerly enough unto him, much Bustling arising therefrom, Sir *William Walworth*, Lord Mayor of *London*, arrested *Wat Tyler*, and with his Dagger wounded him, who being well stricken in Years, wanted not Valour, but Strength and Vigour, to dispatch him quite, was Seconded by this Gentleman, who mortally wounded him. Hereupon the Arms of *London* were augmented with a Dagger; and, to divide the Honour of this over-grown Rebel's Destruction equally betwixt them, to *Walworth* belong'd the Haft, and to *Cavendish* the Blade and Point. ------- As also Sir *Thomas Cook*, Knight, and Sir *William Chapell*, Knight, the first born at *Lavenham*, the other at *Stoke Neyland*, both Natives and Neighbours of this County, and both Lord Mayors of *London*; and, by God's Blessing on their Industry, attain'd great Estates. The latter is reported to have made a sumptuous Entertainment for King *Henry* the Seventh, and making a large Fire, burnt many Bonds, of which the King stood Surety (a

sweet Perfume, no doubt, to so thrifty a Prince) and at another Time drank a dissolved Pearl, of many hundred Pounds Value, in an Health to the King.

The Road to *Bottesdale*, although but a small Market Town in itself, carries you from *London* through many beautiful Towns of Note, and Trade, and is as good, if not the best Road in *England*, for the Number of Miles; and brings you to the famous Sea-Port Town of *Yarmouth*, so remarkable all over *Europe* for the Beauty and Safety of its fine Key.

The following is a Description of the measured Miles and Market Days.

From *London* to	M.	M.D.		M.	M.D.
Rumford	12	W	Bury St. Edmund.	72	W.
Brentwood	18	Th.	Ixworth	78	F.
Ingatston	23	W.	Bottesdale	87	Th.
Chelmsford	29	F.	Schole-Inn	94	
Braintree	40	W.	Harleston	101	W.
Halstead	47	F.	Bungay	108	Th.
Sudbury	56	S.	Beccles	114	S.
			Yarmouth	128	W. S.

seven feet ten inches remains on show at the Royal College of Surgeons.[87] William Joy, 'the English Samson', demonstrated his great strength before the royal family in 1699.[88] Artists who do not have hands exert a lasting fascination: Mrs Morrell (fl. *c.*1770) was renowned for cutting watch-papers with her toes; Thomas Inglefield (fl. *c.*1789) taught himself to draw and etch.[89]

People from distant lands were frequently portrayed as curiosities by publishers: the four Iroquois sachems who visited Queen Anne in 1710 appeared in numerous cheap prints – as well as in other media – and became the subject of a popular ballad that was current for over a hundred years (figs 2.2 and 4.42).[90] Prints of Sartje Bartmann, 'the Hottentot Venus', demonstrate even more forcefully the distance from modern sensitivities: she was shown in pseudo-scientific exhibitions in England and France from 1810 to 1824.[91]

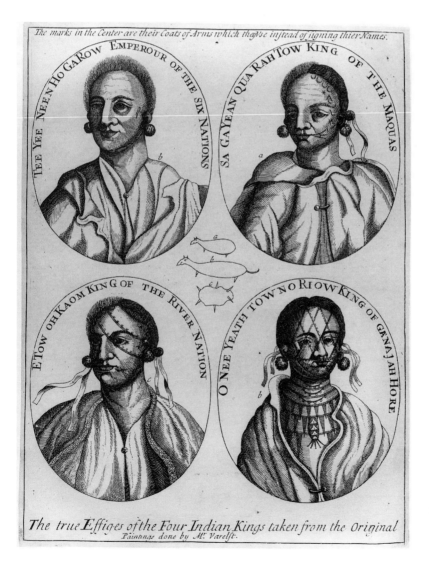

4.42 *The true Effigies of the Four Indian Kings*, 1710. The Iroquois sachems were respected visitors to the court of Queen Anne and were painted for her by John Verelst, but they also appeared as exotic curiosities in many cheap prints.

4.43 *A Good Housewife*, c.1600, this impression c.1750. The industrious wife and mother in her well-ordered home is shown beneath a picture of Time who prepares to crown her with a laurel wreath. The verse below the print, however, undermines the image of admirable womanhood by claiming that 'such Wives … are wondrous rare'.

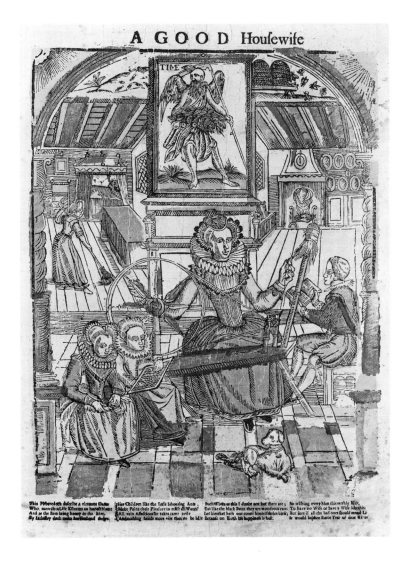

Marriage, Cuckoldry and Women

A major and continuing theme in popular prints is marriage or, more specifically, cuckoldry. The point of view is inexorably male, and for most of the period dealt with in this book women are shown as shrewish adulteresses. Even a rare image of an admirable woman, *A Good Housewife* of c.1600, includes in the verse accompanying an early-eighteenth-century impression (fig. 4.43)[92] the cynical lines: 'Such Wives as this I doubt not but there are; / But like the black Swan they are wondrous rare.' *The Happy Marriage* (fig. 3.9), a large late-seventeenth-century woodcut, depicts a model relationship, but the image originally appeared as a pair to *The Unhappy Marriage*. The double image survives in an engraving (fig. 4.44); according to the verse, death is the only escape for the man 'yoked with a brawling shrew'. Harsher still in its attitude to women is the image of the *Good*

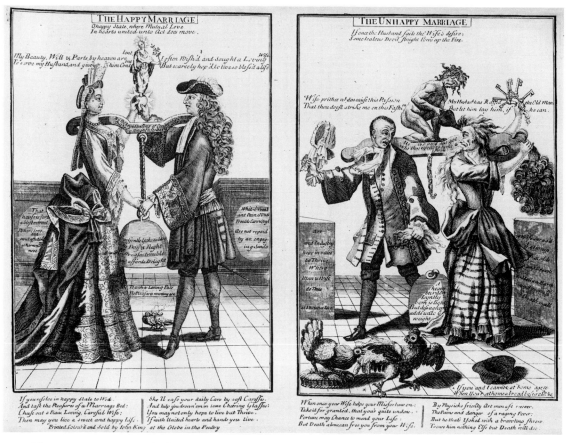

4.44 *The Happy Marriage* and *The Unhappy Marriage*, *c.*1690. This pair of images continued to appear in a number of versions until the late eighteenth century (see fig. 3.9 for a woodcut of *The Happy Marriage*).

(or Silent) *Woman* without a head, known from its use as a trade card and shop sign.[93]

English women escaped some of the oppression to which their counterparts in Roman Catholic countries were subjected under Canon law, especially as it related to adultery and fornication. But if the law of the land was less punitive than elsewhere, popular judgements could be harsh. The Skimmington, an English version of the French Charivari, punished contraventions of the social code by raucous parading of effigies of an adulterous couple, or henpecked husband and shrewish wife, with horns and petticoats held aloft accompanied by 'rough music' of bones and butchers' cleavers. Pepys saw such an event on 10 June 1667: 'Down to Greenwich, where I find the street full of people, there being a great riding there to-day for a man, the constable of the town, whose wife beat him.' Such popular manifestations, which at their most extreme could involve tarring and feathering or other such torments, and even lead to death, continued until recent times.[94] There are references in printed imagery to this sort of popular censure, the best-

known English example being Hogarth's *Hudibras and the Skimmington*, 1726, but the filter of publication – screening out the cruelty of spontaneous mass demonstrations – tends to present a refined version of what in reality could be terrifying events.

Traditional images of Socrates and Xanthippe or Aristotle and Phyllis,[95] the fight for the breeches (fig. 4.45) and variations on the theme of the horned cuckold are widespread throughout Europe. The image of Bigorne and Chicheface, which contrasts the fat monster who feeds on good men with the emaciated one who can eat only good women, was also familiar in the post-Reformation period;[96] Chicheface is mentioned in Chaucer's *Clerk of Oxenford's Tale*[97] but the monsters appear in English prints as *Bulchin and Thingut*[98] or *Fill Gut and Pinch Belly* (fig. 3.5). While in real life English women did not escape the witch-hunts of the post-Reformation period, there do not appear to have been English equivalents of German scare-mongering witch images. Hags with pointed hats flying on broomsticks do not become a commonplace of popular imagery until the middle of the eighteenth century, by which time witch-burnings were a thing of the past.[99]

Many images of cuckoldry show the husband as complacent. An example is *The Contented Cuckold*, which was published in two sizes by John Overton, *c.*1670 (fig. 4.46). A husband is shown sorting pieces of jewellery and counting

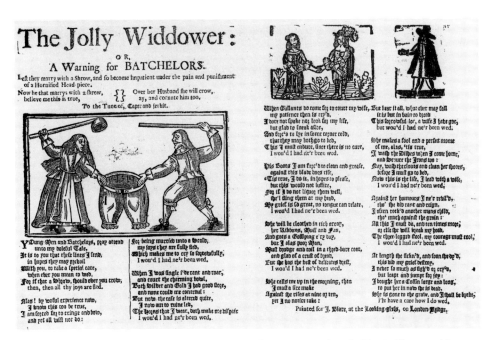

4.45 *The Jolly Widdower*, *c.*1690. This ballad telling a story of cuckoldry is illustrated by a woodcut of 'the fight for the breeches', a popular image throughout Europe in which husband and wife tussle over who is to 'wear the trousers'. The woodcut does not relate precisely to the story and it is probably recycled from another ballad.

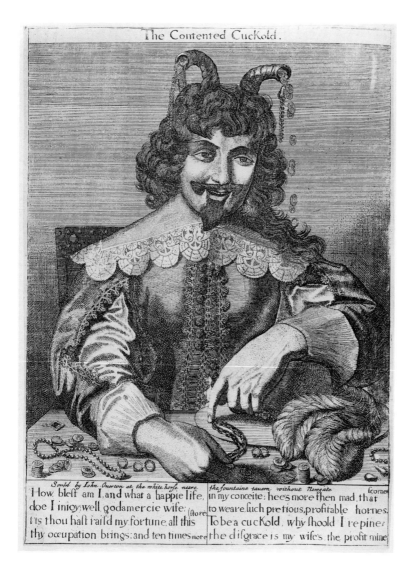

The Contented Cuckold.

Sould by John Overton at the white horse neare the fountaine tauern without Newgate [corne

How blest am I, and what a happie life, in my conceite; hees more then mad, that
doe I inioy; well godamercie wife: (store to weare such pretious, profitable hornes.
tis thou hast rais'd my fortune, all this To be a cuckold, why shoold I repine;
thy occupation brings: and ten times more the disgrace is my wifes, the profit mine

4.46 *The Contented Cuckold,*
*c.*1660, this impression *c.*1670.
Either this print or a smaller
version (Library of Congress,
Washington, D.C.) is identifiable
with *A silly contented Cuckold,*
no. 419 in John Overton's
catalogue of 1673. The plate
would have been acquired by
Overton as part of the stock of
Peter Stent, in whose catalogue
of 1662 a print of the same
subject appeared as no. 375
(see pp. 48–50).

piles of money acquired from his wife's lovers; he is content 'to weare such
precious, profitable hornes'. The print is closely based on a French prototype, *Le
Cornard Contant* (fig. 11.6), whose title punningly describes the cuckold as both
content and counting.[100] The image appears also in the form of a small woodcut
illustrating a ballad conveying the same sentiments entitled *The Dyer's Destiny*
(fig. 4.47). For reasons which I have not been able to ascertain, the association of
the trade of dyer with cuckoldry appears to have been traditional.[101]

The popular delight in punning appears in visual form in a woodcut of a horned
cuckold holding up a horn book[102] used to illustrate a mid-seventeenth-century
ballad entitled *Rocke the Cradle John.*[103] What appears to be the same block,
though now much worm-eaten and having lost both the horn book and the upper
parts of the cuckold's horns, was used on a number of other ballads, such as *My*

Wife will be my Master and *a Cuckold by Consent*, ballads of the 1680s published by Clarke, Thackeray and Passinger.[104]

Allied to cuckolds are men who are impotent, and thus open to jibes about their masculinity and the paternity of their children. *The Fumblers Club*, where a group of gullible city merchants gather around a cat that they imagine to be the child of one of their number, appeared in a mid-seventeenth-century etching and in a woodcut version that was still being published in the eighteenth century.[105]

Marriage often appears as a form of captivity for men: an oversize bird trap is used as *Cupid's Decoy, or an emblem of the state of matrimony*,[106] *The Disconsolate Cuckold or the Miseries of Wedlock* shows a husband in a pillory labelled 'Matrimony'[107] and, as the campaign against gin strengthened in the mid

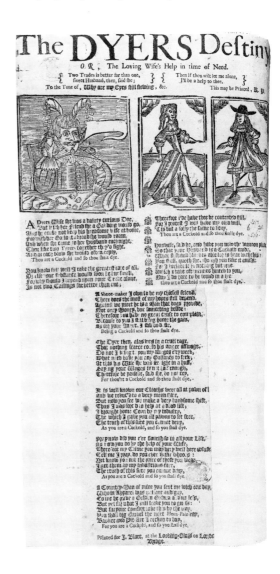

4.47 *The Dyers Destiny*, c.1690. The woodcut of the cuckold counting money and jewellery is copied from fig. 4.46. The ballad sheet has been cut in two and mounted in an album. A ballad entitled *The Dyer Deceived* (Pepys, IV, 126) has a similar illustration.

eighteenth century (see p. 126), *Wedlock* takes the form of a padlock securing a harassed husband to a drunken wife (fig. 4.48).

There are exceptions to the rule of antagonism towards women. *The May-Morning Ramble* (c.1690)[108] describes 'Robin and Kate, Will and Prue's pleasant pastime amongst the woods and groves'; rustic *double entendres* about gathering may blossom are illustrated with a block showing dancers and musicians beneath a garland. The block was re-used some decades later to illustrate *The Cullies Invitation*, a similarly light-hearted ballad for 'merry, merry Souls'.[109] The rare occasions where women who are guilty of sexual transgression are treated sympathetically are where they are the abused mistresses of powerful men. Jane Shore, mistress of Edward IV, became a figure of popular mythology, and the story of Fair Rosamond, Henry II's mistress murdered by Queen Eleanor, engendered its own iconography extending to between two and four scenes. Rosamond was kept in a country house outside Woodstock and the king is shown visiting her there; in a later scene the queen has found Rosamond and forces her to drink a cup of poison (fig. 2.3).[110]

A more relaxed attitude is evident by the later eighteenth century in the prints of the mass-publishers Bowles, Dicey, Overton and their successors (see pp. 48–60), and at the same time the new middle-class gentility has begun to portray women as passive and naive. 'Prentices from London [and] Their Sweethearts' are shown disporting themselves in *Greenwich Park*, a simple etching of 1786.[111] More suggestive is *The Sudden Explosion in Fording the Brook*, in which a soldier's musket is shown shooting into the air as he carries an attractive young woman across a stream.[112] Anti-papist sentiments are combined with titillation in prints of lascivious priests confessing young women.[113] Prostitutes are shown without any apparent condemnation in, for instance, *A St James' Beauty – A St Giles' Beauty*,[114] and what may appear to be straightforward portraits of young women would have been recognized by contemporaries as showing notorious courtesans (fig. 3.15).[115]

Sexual innuendo is stronger in texts than in images: a composite figure[116] of a servant girl *Moll Handy* (fig. 4.49), made up from kitchen utensils, uses a cracked porridge pot for her genitals and the 'Letter of Recommendation' at the foot of the sheet explains that 'She had the misfortune by a fall to be cracked and is become pot bellied, but as this small fault is so common in our sex ...'.[117] From the earliest days depictions of street cries were given bawdy overtones: the town-crier in an early-seventeenth-century woodcut *Cries of London*[118] asks for tidings 'Of a maidenhead lost on Saturday last / Twixt blanket and featherbed in great haste: / Bring word where the owner may't regain / And she'll reward you for your pain'; another seventeenth-century sheet has the town-crier asking for 'tidings of a little maiden child of the age of 24 years'.[119]

Blatant pornography appears to have been absent from popular imagery, or at least has not survived in the same way as it has in cheap literature. Bawdy ballads are generally illustrated with woodcuts of fully clothed couples in decorous

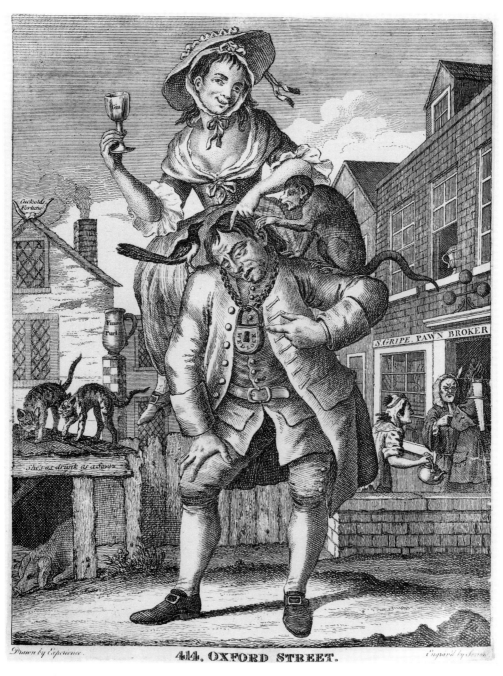

4.48 *Wedlock*, *c.*1751. This is one of several versions of this image produced at the height of the gin scare. The motif of a drunken woman riding on her husband's shoulders – literally weighing him down – derives from a print by Daniel van den Bremden after Adrien van de Venne in Jakob Cats, *Spiegel van den ouden ende nieuwen tijdt* (1635), while elements of the background are taken directly from Hogarth's *Gin Lane* (fig. 6.13). The essentially light-hearted flavour of the image is underlined by the fact that it was believed to have been used, under the title *The Load of Mischief*, as the sign for a public house in Oxford Street, London (see J. Larwood and J. C. Hotten, *English Inn Signs*, London, 1866 (new edn 1951), pl. 16).

settings, although the occasional nude appears re-used from some classical story. The block illustrating *The Female Ramblers or, The Three Buxome Lasses of Northampton-shire* goes further than most in showing the young hero in bed with one of his three seductresses, but we see no more than two heads peeping over the covers in a curtained four-poster; variants of a woodcut showing a fully clothed couple embracing on a bed appear in a number of Pepys ballads in the category 'Love Pleasant'.[120] A woodcut designed to illustrate the moral tale of *A Looking-Glass for Lascivious Young Men: or, The Prodigal Son Sifted* (see p.74) was used – simply because it includes a sieve – as the headpiece of *The Three Buxome Maids of Yoel*, a coarse ballad telling the story of three drunken young women who find themselves in trouble after 'pissing in the sieve'.[121] Two late-seventeenth-

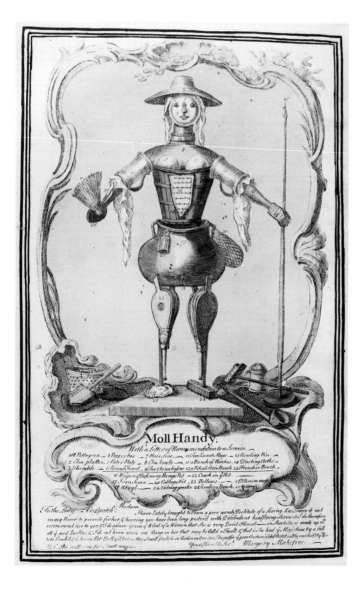

4.49 *Moll Handy*, *c*.1750, this impression *c*.1800. This is one of a series of figures made up from the tools of their trades. The archetypal kitchen maid has become pregnant and lost her job.

Love in a Miſt ;

'A loving Couple once together met, | A Miſt before my eyes I have, quoth ſhe,
And changing words, a Paſſion did beget : | What doſt thou mean, my Boy, to do with me:
To the Tune of, *Hey boys up go we.*

[Ballad verses in blackletter follow in multiple columns]

Printed for I. Deacon, at the Angel in Guiltſpur-ſtreet.

4.50 *Love in a Mist*, late seventeenth century. Like most bawdy ballads this one is illustrated with woodcuts that are far more decorous than the text. Publishers of such cheap material did not bother to ensure that illustrations matched the verses, and in this case one of the embracing couples could scarcely be more incongruous: the block is a fifteenth-century Visitation of the Virgin and St Elizabeth, in which they both rejoice that they are soon to give birth.

century ballads published by J. Deacon, *Love in a Mist* (fig. 4.50) and *The Jovial May-pole Dancers*,[122] include among their illustrations a woodcut that is surprisingly incongruous even by the careless standards of cheap ballad publishers. It is a small fifteenth-century woodcut of the Visitation; presumably the iconography of the Life of the Virgin was by then so unfamiliar that the image went unnoticed.

When not portrayed as sexually voracious, women can still be viewed critically as wasting their time with gossiping, gin drinking (fig. 4.48) and fashion. A late-sixteenth-century woodcut, probably Dutch in origin, shows groups of women gossiping and fighting while at church, at the conduit, at the alehouse, washing clothes and so on. This print is known in two impressions: one from the mid seventeenth century, entitled *The Several Places Where You May Hear News*,[123] and the other from the mid eighteenth century, entitled *Tittle-Tattle; or, the several Branches of Gossipping* (pl. 11A). The composition is closely based on a large French etching of c.1560, *Le Caquet des Femmes*,[124] which was also used as the basis for an etching by Wenceslas Hollar illustrating a German broadside entitled *Schaw Platz*.[125]

A fondness for fashion is another female weakness. *Prides Fall*, a late-seventeenth-century ballad that survives in several editions, tells the story of the birth of a child with two heads and strangely shaped hands as a warning to women against pride and loose morals. The illustration – only vaguely related to the text – shows a nude figure of a woman with two heads.[126]

Prints can show fashion-conscious women as simply vain, silly and, of course, wanton,[127] but there is often the added anxiety that fashionable dress can disguise a woman's social class. Extravagant head-dresses appear as a subject for satirical representations of women from the late seventeenth century, when heads were crowned with the high *fontange* or 'Top-Knot'. A ballad of *c.*1690, *Advice to the Maidens of London: To Forsake Their Fantastical Top-Knots*,[128] complains that 'Every draggle-tailed country girl' is dressing up her hair with expensive ribbons

4.51 *The Feather'd Fair in a Fright*, 1779. Exaggerated fashions were always a popular subject for mockery. In this example the verse makes it clear that the young women are servants who are aping their mistresses' taste for elaborate wigs. The print was based on a painting by John Collet commissioned by the publisher Carington Bowles.

4.52 *John Bull running down Crinoline*, c.1850. W. H. J. Carter published a series of lithographs satirizing the fashion for crinolines in the 1850s. This example uses the opportunity of showing a young woman terrified by a bull to make an additional jibe at the recent papal bull to reintroduce the Roman Catholic hierarchy to England (see fig. 5.11).

London, W. H. J. Carter, Bookseller, Bookseller &c 12, Regent Street, Pall Mall.

JOHN BULL RUNNING DOWN **CRINOLINE.**

Wynka. *Bless me They thats a Bull, Well whether from Rome or elsewhere, I always dread a Bull, Let us Run dear.*

so that 'you scarce can know Joan from my lady', and, nearly a century later, *The Feather'd Fair in a Fright* (fig. 4.51) criticizes two servant girls of the 1770s for aping the upper-class fashion for huge powdered wigs.[129]

Petticoats were familiar from the Skimmington as symbols of the threat of female power to the unguarded male. The fashion for hooped petticoats that appeared around 1710 provided fodder for sexual innuendo. Addison (*Spectator*, 16 July 1711) would not accept that hoops were worn because they were cool and comfortable: 'it is well known we have not had a more moderate summer these many years, so that it is certain the heat they complain of cannot be in the weather'. An etching of 1721, *The Three Grand Temptations*, warned that churchmen and princes may be powerful, 'But mighty love, more absolute than they, / Makes every power the petticoat obey'; it remained in print for more than fifty years.[130] The mid-nineteenth-century fashion for the crinoline brought forth more genteel satires on the subject: a series of thirty-eight lithographs published by W. H. J. Carter at 2s. 6d. each included such examples as *The Comic Act of Parliament against Crinoline* and *John Bull Running down Crinoline* (fig. 4.52).

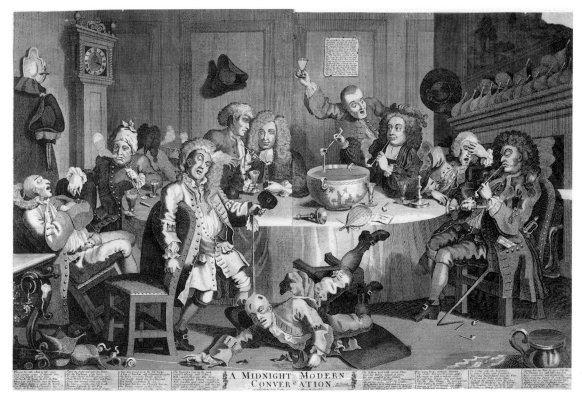

4.53 *A Midnight Modern Conversation*, c.1733. This two-sheet version of Hogarth's print was published by John Bowles and is an example of the piracies that led Hogarth to campaign for a copyright act for engravers.

Drinking, Good Fellowship and Temperance

Popular prints were commonly sold at the fairs held periodically in cities and market towns. Fairs provided a period of respite from the hard drudgery of daily life for the mass of the people. They were a time of indulgence in excess: bear-baiting, cock-fighting, gambling, sexual permissiveness and, especially, heavy consumption of alcohol. It is not surprising that a particular genre of prints exists which reflects such hedonism and would have been aimed at impulse buyers whose purse-strings were loosened by alcohol.

The Land of Cockaygne, or Lubberland as it was known in seventeenth-century England, is an idyllic world-turned-upside-down where idle men find

(*Facing page*)

4.54 *The Mapp of Lubberland or the Ile of Lasye*, c.1660. This cheap etching is based on one by Pieter Baltens which is closely related to the painting by Pieter Bruegel (see fig. 11.9).

4.55 *The Old Man, his Son and his Ass; or, Anything to please You*, 1793. The figures travelling on the winding lane illustrate the impossibility of pleasing everyone: no matter whether the old man, the boy or neither ride, they meet with disapproval, and when they carry the ass between them they are mocked most of all.

THE MAPP OF LUBBERLAND
or the Ile oF Laſye

Gallants when you this peece haue rightly Scand Capons Piggs Geese come ready rosted there If you loue rest there is your only keeping
Then know it is the Mapp of Lubberland Lye all alonge you cannot want good chaire Where thay haue in ponce nery day for Sleeping
Orth Ile of Laſye name it which you please And for your entrance that askes no great Shudding This Ils is in the Clime cald any Whore
Where none doe laboure all doe Liue at ease. Tis only tVatd aboute with a haſty Pudding As eaſye to be found as Cuckoldsheire.

THE OLD MAN, HIS SON, AND HIS ASS; OR, Any THING to pleaſe YOU.

This Tale's of a Matter that happen'd to Paſs, Why you two ſilly Fools, is not one of you weary, And dame ſhe mounts the poor boy as he ſat. And you like a lumber'd old Raſcal muſt ride, Old Daddy, will you diſmount e'en et there.
Between an Old Fellow his Son, and his Aſſe When people are tired, an Aſs is no bad ride. Why you Gallants crying they was not breeze at that, Let the Boy get behind you old Gentleman do, Think how with ill ſcal Reproer breaks de-cente.
The Female thro were good to Swine was the Weather, Either ride him yourself, or elſe let the Lad ride, See there your poor Father who incerely can maddle, Hes the devil do't, for that can't I carry two. If Sinners the Lord To none of your con-
And as Chuck he Jant they all Iout ſlem together, True ſays the old Man my Bones feet are tender, And you muſt Sadd therewith your ſ...on a Saddle, Nor enjoy the old Man you we dinott ſhall tthem vinced Hate is Sar'd th'll Man willlee Mehoel giue
Through a ſmall Market Town & twas Market day, And ſo a great weight as he is but ſlender, Then Humphry got off, and the Father got on, Gout ſite him a ſlit, and out him behind me Let us know what they I oye n'es catry the gat,
Save Humpher was Mounted when up comes a ſtry When dame but ſtory ſhort was their hird ſcene, When claſs but ſtory ſhort was their hird gone, Such themuſt who came by releas. So have you Which no ſooner there did but the Mob ſolle ſolle
What the firſt that they met, put to dem this, Derry, Imperial moſt like them the hundreds of Drury. Ere ſmithy-ayrd pheer muſt be walk he your ſide got theree. the new cave d'Old Man, he olleve last Shealter.

Pub'd Nov'r Jaary 17 by Robert N.H London inc Paw dode'sold.

ready-roasted pigs wandering around with carving knives in their sides, cottages tiled with tarts, and wine flagons emptying themselves into thirsty mouths.[131] There were several sixteenth-century representations on the Continent, the best known being the painting by Pieter Bruegel of 1567 (fig. 11.9);[132] a version of the composition was published in London as a cheap print c.1660 (fig. 4.54). A satire on Richard Cromwell called him the Prince of Lubberland (pl. III) and the fantasy has had a long life in popular literature and song.[133]

The connection with Bruegel is a reminder of the influence of Netherlandish imagery in England,[134] and in particular on the English popular print. Overton's catalogue of 1734 (pp. 27–8, nos 43–8) includes 'Six Dutch drolls, each an Elephant sheet, and are very proper for a drinking room'. It is not surprising that large prints designed for drinking rooms do not survive, but there are many smaller-scale copies or English reprints of Dutch tavern scenes portraying the companionable joys of a simple life lubricated by plentiful quantities of beer.[135]

English versions of such subjects are also not uncommon. Hogarth's *Midnight Modern Conversation* (1733) is the best known of a type of print (and painting) showing a group of men indulging in an evening's drinking – most of which depict an earlier stage in the proceedings. Like all Hogarth's work this print is open to interpretation at a number of levels but in the context of a discussion of popular imagery it has to be seen as an urban version of Lubberland, its inebriated protagonists arranged around a central focus and, just as in Bruegel's composition, a flask of wine held aloft and emptying itself on to a man who has already drunk so much that he cannot rise. Piracies issued by the major popular print publishers in England and abroad (fig. 4.53), as well as copies on tankards, punch-bowls, snuff boxes and other tavern paraphernalia, attest to the subject's appeal.[136] A scene of more respectable enjoyment in a well-appointed tavern had appeared as a woodcut illustrating, among other ballads, *The Joviall Crew*, a ballad of the 1680s that takes a relaxed attitude to the amoral 'trade of a bonny bold Beggar'.[137]

The world of drinking and good fellowship is one which delighted in fables, proverbs and puns. The fable of the old man, his son and his ass (fig. 4.55) remains a subject for prints throughout the period covered in this book: an old man riding his donkey while his son walks beside him is jeered at by drinkers outside a country tavern; he lets his son ride instead, and at the next tavern is mocked again; he mounts behind his son, and is accused of overburdening the ass; father and son carry the ass and cause further merriment; finally they both walk and are laughed at again. The moral is to ignore 'the sentiments of the vulgar who it is impossible to please'.[138] Another favourite joke that appears throughout Europe from at least the sixteenth century is *We Three* or *We are Seven*, where a group of foolish figures numbers one fewer than the title so that the viewer makes up the total (fig. 4.56).[139]

The well-known 'world-turned-upside-down' subjects that show such scenes as the rabbit roasting the man, the cart before the horse, or the boy beating his father

(fig. 4.57) might seem to advocate social upheaval, but recent scholars tend to the opinion that contemporary audiences would have seen these images as light-hearted jokes that reinforced the status quo by showing how ridiculous such upturning of the natural order would be.[140] Once again popular imagery favours the conservative viewpoint. The world-turned-upside-down appears in prints throughout Europe (and in other media during the Middle Ages) and by the seventeenth century had settled into a 'comic-strip' format, usually beginning with an image of an inverted globe held by two men. The earliest recorded British example is a woodcut licensed to Francis Leach in the Stationers' Register, 12 March 1656.[141]

The Cat's Castle – again familiar since the Middle Ages – shows an army of rats storming the castle of King Cat.[142] And again, rather than encouraging the

4.56 *The Seven Oddities, c.1820.*
Which is the oddest? The fool, his ass, his owl, the child with a boot on his head, the country bumpkin, his pig – or the person who spends time looking at them? The image has retained its popularity for over a century. This print is almost directly copied from a mezzotint by Cornelis Dusart (1660–1704).

THE SEVEN ODDITIES.

Of all the Oddities under Heaven
Which is the greatest of us SEVEN.

J. Sherratt. Lithog. 14. Wellington Terrace. Waterloo Bridge

THE FOLLYS OF MANKIND EXPOS'D OR THE WORLD UPSIDE DOWN

population to rise up against the government it gives the opportunity to envisage such a revolution, and then to see how ridiculous it would be. As in carnival and feasts of misrule, temporary licence is given in order to demonstrate that role reversal is the stuff of fantasy. *The Cat's Castle* goes back to the early days of printmaking: two versions were recorded in the collection of Hernandez Colon, son of the discoverer of America, who died in 1531.[143] A woodcut of *c.*1500 in Gotha[144] shows that the iconography of the subject, which was to remain in use until the nineteenth century, was established at an early date.[145] The earliest known English version is a cheap engraving of the mid seventeenth century published by John Overton (fig. 3.7), the plate for which would have been acquired with the stock of Peter Stent (see p. 48).[146] The subject was popular at the end of the eighteenth century and versions were published by G. Ash, Bowles & Carver and G. Sheppard.[147]

In puritanical England visual jokes and scenes of merry company are less common than warnings against the dangers of excess. A broadside of 1652, *A Looking-Glasse for a Drunkard* (fig. 4.58) – 'very needful to be set up in every house' – listing the social, physical and spiritual evils of drunkenness is more

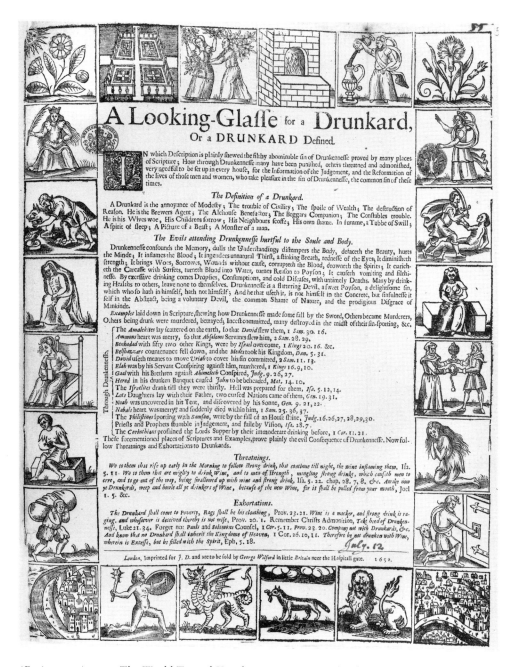

(*Facing page*) 4.57 *The World Turned Upside-Down*, c.1790. The 'folly' of the topsy-turvy world dates back to the Middle Ages. Even this version, published at the time of the French Revolution, has no political overtones and treats as merely amusing the images of horses riding their masters or hogs taking the man's blood to make black pudding.

(*Above*) 4.58 *A Looking-Glasse for a Drunkard*, 1652. A list of the negative effects of drunkenness is surrounded by a series of small prints previously used in *Wit's Laberynth: or, The Exercise of Idlenesse*, printed by Thomas Purfoot and sold by John Budge in 1610; some of these emblematic figures are relevant to the text – Temperance, Calamity, Theft, Melancholy – but most seem to be merely decorative.

typical of prints on the subject of drinking. Strict regulations governing the manufacture of spirits were lifted at the end of the seventeenth century, and by 1732 it was said that one in six houses in London sold alcohol. The social effects of mass drunkenness led to campaigns to curb alcohol consumption.[148] Prints – most famously Hogarth's *Gin Lane* (1750; fig. 6.13) – played their part in influencing public opinion.

The temperance movement began in America in the early nineteenth century. The British and Foreign Temperance Society was set up in 1831, and the next two decades saw the movement at its height. Prints were much used as weapons of temperance propaganda (figs 4.59 and 4.60). According to Mayhew, George Cruikshank was the one printmaker known by the very poorest Londoners:[149] his series *The Bottle* (fig. 4.61) was very much admired even by illiterate costermongers and appeared in a range of editions at different prices.[150]

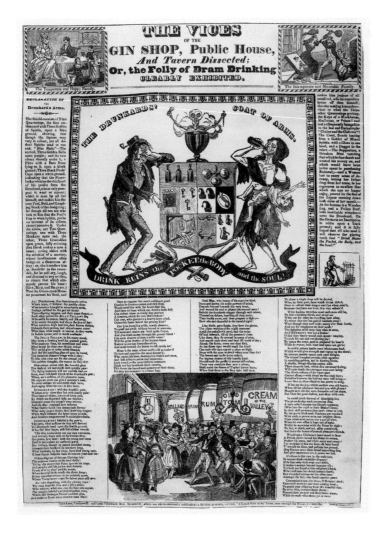

4.59 *The Vices of the Gin Shop, Public House, and Tavern Dissected*, *c.*1833. This temperance broadside uses the popular motif of a mock coat-of-arms – here that of the Drunkard.

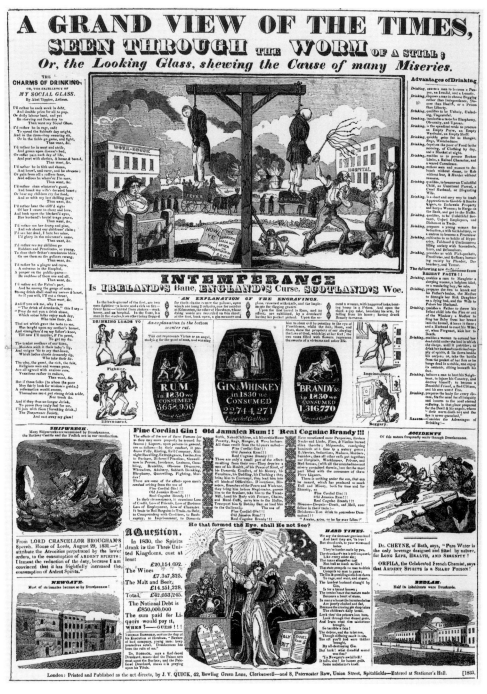

4.60 *A Grand View of the Times, Seen through the Worm of a Still*, 1833. The designer has, like many of his generation, used motifs from Hogarth's moralizing prints: the flogging scene is taken from *The South Sea Scheme*, and the woman beating hemp from *A Harlot's Progress*. A group of burning ricks in the background of the main woodcut implies that current rural unrest had its origins in public drunkenness, and places the temperance message in a reactionary political context.

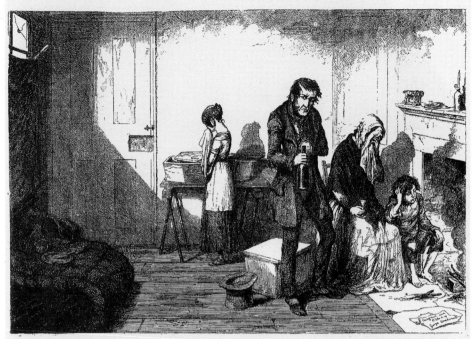

THE BOTTLE.

PLATE V.—COLD, MISERY AND WANT DESTROY THEIR YOUNGEST CHILD: THEY CONSOLE THEMSELVES WITH THE BOTTLE.'

4.61 *The Bottle: Plate V*, 1847. This is one of the plates from the cheap version of George Cruikshank's highly successful series showing the disastrous effects of alcoholism. In order to reduce the cost of production he adopted the technique of glyphography, in which a drawing on a metal plate was converted into a relief printing block from which many thousands of impressions could be printed. The technique does not allow the subtle variation of texture produced by etching and Cruikshank's most popular prints are aesthetically far less satisfying than his more expensive work.

(*Facing page*) COLOUR PLATE I

Conjoined twins born in Middleton Stoney, 1552. This broadside, which is an extremely rare early English example, shows a pair of conjoined twins born in Oxfordshire in 1552. It came to the British Museum at its foundation with the collection of Hans Sloane. This impression is trimmed at the bottom of the sheet, but another impression in Zürich retains the publication line recording that it was printed by John Day of Aldersgate, London. (See Chapter Four, p. 100.)

(*Overleaf*) COLOUR PLATE II

IIA *Tittle-Tattle; Or, the several Branches of Gossipping*, c.1600, this impression published c.1750. By the time that this impression was printed the woodblock had sustained a considerable amount of damage. The letterpress was reset, revising the title and modernizing spelling, as well as adding a final verse: 'Then Gossips all a warning take, / Pray cease your tongue to rattle; / Go knit, and sew, and brew, and bake, / And leave off tittle-tattle.' (See Chapter Four, p. 117.)

IIB *Pilgrim's Progress*, 1813. Bunyan's famous story of the Christian's struggle to conquer sin provided the model for many pious prints (see Chapter Four, p. 72). This hand-coloured example, published by John Pitts, was made using the new style of deeply bitten etching that became common towards the end of the eighteenth century (see p. 190).

got een kynt steyf de 17/
ader ander styf den 18/
augusto 1552

anno 1552
11 augusti vna puer mortuus
& alter puer 18 &c

Quisquis in hanc flectis mirantia lumina chartam
Antonite paulùm discute mentis onus,
Hæc est altisoni divina potentia Iovæ:
Hec tibi ut vivæ virga timenda manus,
Ne fias animo qui non es corpore monstrum
Mensue sit horrendis contaminata notis.
Iam sæpe, monstrosâ fugiendo relinquito vitam,
Atque mas niuis dirige mente tuas.

Such as we be, such is thisage
Behold and you shall se.
So far in vice, do men outrage
That monsters they may be.
Our bodies growe, al out of kinde
Our shape is straunge to syght,
So God hath drawne mas monstrons mynd
from God, from truth andsight.
Whordom no more, make straight your wales
Stand fast and feare to fall,
The Lorde hath sent us in these dayes,
An Image for you all.

Hou shalte understande (Christen Reader) that the thyrde daye of August last past. Anno. M.CCCCC.LII. betwene the houres of x. and xi. at after noone in a towne called Myddleton stonye. viii. miles from the Universite of Oxforde at the In, called the sygne of the Egle. There the good wyfe of the same, was delivered of thys double Chylde, begotten of her late housbande John Kenner whyche is dyseased. The forme and shape of the same Children, both of the fore partes and hynderpartes, is above shewed, & are yet livyng, having. ii. heades, ii. bodyes. iiii. armes. iiii. hands of good and parfit shape & fashion, welfavoured and faire of visages lyke unto other children, but with one onely belly, one navel and one only fundiment, at which they voide both uryne & ordure. Then have they. ii. legges wyth the feete on one syde of good reasonable forme and shape, & on the other syde but one legge wyth. ii. feete having but. ix. toes, monstrous both legge and feete, as ye maye perceive by the Pycture. They were fedde. ii. dayes wyth Cow milcke, and did not sucke of a woman til the thyrd day. They are of good lyking and in good possibilitye (by all mens judgementes that have sene them) to lyve. The face of the one wyll shewe a chersull countenaunce on suche as looke uppon them, when the other is fast a slepe, and either of them doth syldom cry. And as thei report which kepe the Children, thei never slepe both at once, but whyle the one slepeth, the other is wakynge. The lengthe of them was at the thyrd day after their byrth. xx. ynches. And ther bredth was the. vi. ynches. And also these sayde Chyldren were Baptised by the Mydwyfe and named John Johane, and after brought to the Church, alowed also by the Curate, and receyved by him into the Congregacion according to the order of th

Tittle-Tattle; Or, the several Branches of Gossipping.

AT Child-bed when the Gossips meet,
Fine Stories we are told,
And if they get a Cup too much,
Their Tongues they cannot hold.

At Market when good Housewives meet,
Their Market being done,

Together they will crack a Pot,
Before they can get Home.

The sick-house is a Place you know,
Where Maids a Story hold,
And if their Mistresses will prate,
They must not be control'd.

At Alehouse you for how Jovial they lie,
With every one her Noggin;
For till the Skull and Belly be full,
None of them will be Jogging.

To Church fine Ladies do resort,
New Fashions for to spy;

And other go to Church sometimes
To shew their Bravery.

...-house makes a rough Skin smooth
...doth it beautify.

Fine Gossips oft it every Week,
Their Skins to purify.

At the Conduit striving for their Turn,
The Quarrel it grows great,
That up in Arms they set it all,
And one another beat.

Washing at the River's side
Good Housewives take Delight;

But scolding Sluts cant not be dumb,
Like wrangling Queens they fight.

Then Gossips all a Warning take,
Pray curb your Tongue to rattle;
Go home, and sew, and Brew, and Bake,
And leave off TITTLE-TATTLE.

THE PILGRIMS PROGRESS

Or Christian's journey from the City of Destruction in the evil WORLD to the CELESTIAL CITY in the WORLD that is to Come.

COLOUR PLATE II

His Highnesse *Hoo. Hoo. Hoo.* Protector of *Lubberland,* and chief Captain of the night Guards.

I am resolved to ride in State,
Not caring what the small Birds prate.
I'le keep my Seat without controul,
If once I flinch they'l call me Owle.

London *Printed by* Tho Leach, *at the sign of the Golden Faulcon in* Shooe-lane.

THE STAGES OF LIFE

The various Ages and degrees of Human Life explained by these Twelve different Stages from our Birth to our Graves.

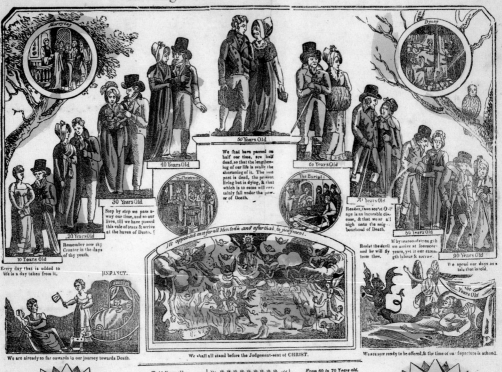

Marriage

Dying

50 Years Old

40 Years Old

60 Years Old

30 Years Old

70 Years Old

20 Years Old

10 Years Old

80 Years Old

90 Years Old

100 Years Old

The Creation *The Burial!*

We shall have passed on half our time, are half dead, so that the lengthening of our life is really the shortening of it. The true present living but is dying, & that which is to come will certainly fall under the power of Death.

Step by step we pass away our time, and so our lives, till we have passed this vale of tears & arrive at the haven of Death.

Remember now thy Creator in the days of thy youth.

Reader, thou see'st Old age is an incurable disease, & that we are nigh unto the neighbourhood of Death.

Resist the devil and he will fly from thee.

If by reason of strength years, yet is our strength labour & sorrow.

We spend our days as a tale that is told.

Every day that is added to life is a day taken from it.

INFANCY.

It is appointed once for all Men to die, and after that, to judgment.

We are already so far onwards in our journey towards Death.

We shall all stand before the Judgement-seat of CHRIST.

We are now ready to be offered, & the time of our departure is at hand.

To 10 Years old.
HIS vain delusive thoughts are fill'd
With vain delusive joys—
The empty bubble of a dream,
Which waking change to toys.

From 10 to 20 Years old.
His heart is now puff'd so,
He scorns the tutor's hand,
He hates to meet the least control,
And glories to command.

From 20 to 30 Years old.
There's nought here that can withstand
The rage of his desire;
His wanton flames are now blown up,
His mind is all on fire.

From 30 to 40 Years old.
Look forwards and repent
Of all thy errors past,
That so thereby thou may'st attain,
True happiness at last.

PRINTED BY
J. CATNACH,
Monmouth Court, 7 Dials,
LONDON.

From 40 to 50 Years old.
At fifty years he is
Like the declining sun,
For now his better half of life
Man seemeth to have run.

From 50 to 60 Years old.
His wasted taper now,
Begins to lose its light,
His sparkling flames doth plainly show
'Tis growing towards night.

From 60 to 70 Years old.
Perplex'd with slavish fear,
And unavailing woe,
He travels on life's rugged way
With locks as white as snow.

From 70 to 80 Years old.
Infirmity is great
At this advanced age,
And ceaseless grief and weakness
Now vent their bitter rage.

From 80 to 90 Years of age.
Life's "Vital spark" the soul,
Is hovering on the verge
Of an eternal world above
And waiting to emerge.

From 90 to 100 Years old
The sun is sinking fast,
Behind the clouds of earth,
O may it shine with brighter beams,
Where light receiv'd her birth.

THE DYING PILGRIM.

COME on my brethren in the Lord,
Whose hearts are join'd in one,
Lift up your hearts with courage bold,
Your race is almost run.

Above the clouds behold him stand,
And smiling, bids you come,
And angels whispering you away
To your eternal home.

A pilgrim on his dying bed,
With glory in his soul,
Lifts up his longing eyes on high,
Towards the blissful goal.

While friends and children weep around,
And loth to let him go,
He shouts with an expiring breath,
And leaves them all below.

Go on my brethren in the Lord,
I'm bound to meet you there,
Altho' we tread enchanted ground,
Be bold and never fear.

Fight on, fight on, ye valiant souls
The land appears in view,
Hope to gain sweet Canaan's shore,
And there to meet with you.

Farewell, my brethren in the Lord,
Until we meet again,
Perhaps in time, or as we rise
Above the fiery main.

We'll join the royal armies bright,
In presence of the Lamb,
We'll tune our harps, & sing free grace,
To love's eternal flame.

Hymn,
Composed by a converted Negro.

IN de dark wood, no Indian nigh,
Den me look heben & send up a cry
Upon my knee so low;
Dat God on high in shining plain,
See me in night will scarcy face,
My priest do tell me so.

Jso send he angel take me care;
Is came himself and hear me pray,
(If Indian heart do pray,)
In one me more, he know me more,
Is say poor massa do swear fear,
Me bless will rise night and day.

So me tuk God with inside heart,
Ie fight for me, he take my part,
And save my life before.
Jes, God tuk Indian in de wood,
to hold me up, and do he good;
Me pray him two does more.

THE PILGRIMS PASS THE RIVER.

A PRAYER.

O Jesus, my Saviour and Friend,
On whom I rest all my care,
Let thy love be still my delight
And hold thou still close to me here,

My trust is in what thou hast done,
Thy sufferings & death on the tree,
No merit I plead of my own
No righteousness, Lord, but in thee.

HYMN.

YONDER see the Lord descending,
Mark thy chariot drawing nigh,
Flaming troops descend the sky.
Turn to the Lord and seek salvation,
Sound the praise of his dear name!
Glory, honour, and salvation,
Christ the Lord is come to reign.

Heav'n is shaking, earth is quaking,
Mountains fly before his face,
See the graves their dead forsaking,
Nature sinking in a blaze.
Sing to the Lord hallelujah,
Hark, the herald angels sing,
Hail him christians, hail him christians,
Yonder's your victorious King.

Now behold each shining warrior,
Rising from their dusty beds
Fly to meet their blessed Saviour,
Glittering crowns upon their heads.
Hear them tell their pleasant story,
To their smiling, lovely King,
Glory, glory, glory, glory,
Glory, is the song they sing.

Now he's crowned with a rainbow,
Brighter than the sardine stone,
Coming through the clouds of heav'n,
Sitting on the great white throne.
Once a bleeding on the mountain,
There his precious blood did run,
Now he's brought us to the fountain,
Springing from his Father's throne.

Dies iræ, dies illa.

THAT day of wrath, that direful day,
Shall all the world in ashes lay,
As David and Saint James doth say.
How shall poor mortals quake with fears
When their impartial Judge appears,
Who all their causes strictly hears.

His trumpet sounds a dreadful tone,
The noise through all the graves is blown
And calls the dead before his throne.
Nature and death shall stand at gaze,
When creatures shall their bodies raise,
And answer for their ill-spent days.

The clear-writ book of conscience show
Sins black indictment shall be known,
And every soul its guilt shall own,
So when the Judge shall sit on high,
All hidden crimes shall open lie,
No sin shall from doom escape by

I as a guilty person grown,
My faults are in my blushes known,
Pity dear Lord, thy suppliant's moan
My worthless prayers deserve no hire,
But thou, dear Lord, thy grace inspire,
To save me from eternal fire.

Amongst the sheep grant I may stay
Far from the goats condemned band,
Securely set it on thy right hand.
Jesus! whose breast condoles
Preserve us from eternal foes,
When death our weary eye-lids close.

COLOUR PLATE IV

CHAPTER FIVE

THE POPULAR PRINT AND PROPAGANDA

Popular prints were perfect vehicles for propaganda. They were designed for wide distribution at low cost. Their imagery was simple and direct, and subjects were chosen to have wide appeal. Those who wished to impress their ideas on the public at large used ballads, chapbooks, broadsides and other popular forms. Traditional images – and others newly minted – were constantly repeated until they gained the status of popular emblems, instantly recognized by literate and illiterate alike. This chapter will focus on two areas where print propaganda directed at a very wide public was heavily used in England: anti-Roman Catholicism, and the period of political reform from the 1780s to the 1830s.

In the post-Reformation period religion and politics were inseparable. Tessa Watt records a number of anti-Roman Catholic woodcuts, most of which were probably printed from imported blocks (figs 5.1 and 5.2),[1] but the images that must have had the strongest impact were the fearsome illustrations of Protestant martyrdom in successive editions of John Foxe's ubiquitous *Book of Martyrs* (fig. 4.24).[2] British Reformers also take centre stage in a composition that was known throughout Protestant Europe: Luther is seated at a table surrounded by Reformers while a cardinal, a devil, the pope and a monk attempt to blow out a candle in the centre of the table. It is usually given as a title the stirring words that appear on the image: *The candle is lighted, we cannot blow [it] out*. The phrase comes from the Apocrypha, Second Book of Esdras, XXIV, 25: 'And come hither, and I shall light a candle of understanding in thine heart, which shall not be put out, till the things be performed which thou shalt begin to write', but English anti-papist audiences would have remembered Latimer's echoing of the phrase on 16 October 1555 when he and Nicholas Ridley were about to be burned at the stake in the middle of Oxford: 'We shall this day light such a

(*Previous page*) COLOUR PLATE III

His Highness Hoo, Hoo, Hoo, 1659. This caricature portrays Richard Cromwell as a foolish owl. A woodblock with an equestrian figure has been doctored with an owl mobbed by birds replacing the upper part of the rider. Cromwell was said to be seriously demoralized by discovering that this print was being sold on the streets. The Commonwealth fell a few months later. (See Chapter Seven, p. 168.)

(*Facing page*) COLOUR PLATE IV

The Stages of Life, c.1830. Catnach's decorative lettering, neatly symmetrical design and bright colouring distinguish his work from the carelessly designed broadsides of his predecessors. (See Chapter Eight, p. 191.)

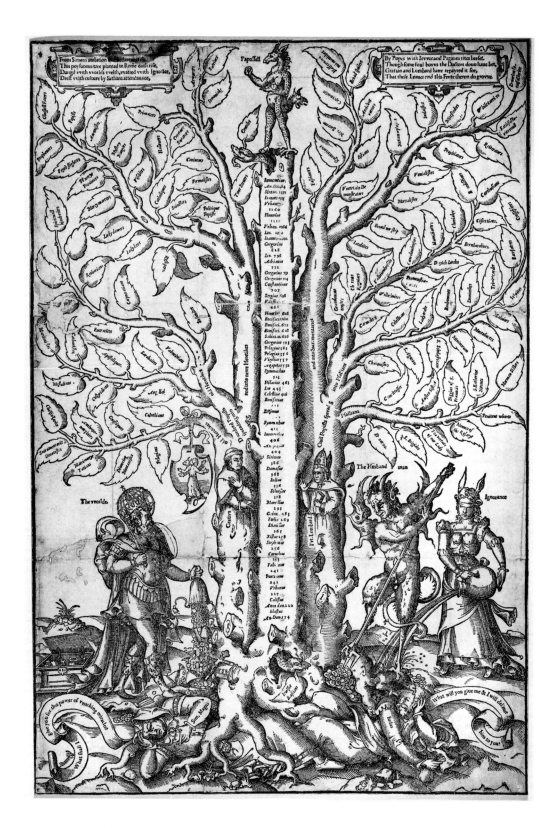

candle by God's grace in England, as I trust shall never be put out.' Impressions of several engraved versions survive[3] including one published by Thomas Jenner (fig. 5.3). It appears in its simplest form as a woodcut illustrating a broadside of 1680 in which the focus is on the martyrs of Protestantism, and William Tyndale is identified in the group around Luther (fig. 5.4).

Specifically English anti-Roman Catholic imagery emerged in the reign of James I.[4] A surprising number of woodcuts survive of the marriage in 1613 of Princess Elizabeth to Frederick, Elector Palatine. The subject – ostensibly simply patriotic – would have had an anti-Roman Catholic undertone. Frederick was seen as a Protestant bulwark against the Catholic Habsburgs. The Society of Antiquaries collection includes not only a bold woodcut chronology of English sovereigns from Henry VII to Princess Elizabeth and Frederick (fig. 4.17) but also two broadsides with woodcuts celebrating their marriage and proud ancestry.[5] In 1619 Frederick was offered the crown of Bohemia but held the country for only a few months before being driven out by Catholic forces. The following decade saw an outpouring of prints at all levels in response to anxieties over the political and military revival of the Catholic states of Europe in what was to become the

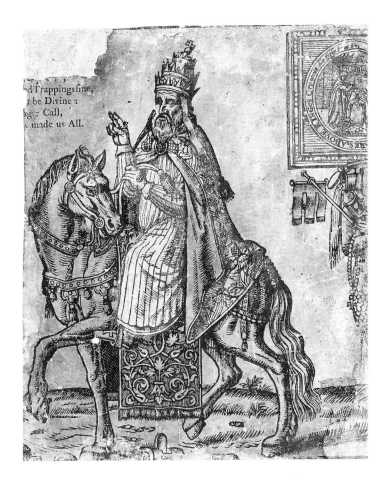

(Facing page)
5.1 *The Poysonous Tree, c.*1580. The Roman Catholic Church is represented as a tree tended by ignorance and the devil and fed by worldly wealth. Standing at the top is the papal ass – part-ass, part-woman, part-dragon – warning of divine wrath like the prodigies of nature in popular broadsides (see p. 9 8); the ass was also used in prints in Italy and Germany, and this woodblock may well have been imported from the Continent.

(Right)
5.2 *The pope on horseback, c.*1620. This damaged print is based on a German engraving of *c.*1620 (Coupe, pl. 139) where the finely dressed pope is contrasted with Christ riding on an ass.

5.3 *The candle is lighted, we cannot blow out, c.*1640. Luther is seated at a table surrounded by Reformers, including John Knox, William Perkins and John Wyclif; a cardinal, a devil, the pope and a monk attempt unsuccessfully to blow out the candle of Protestantism in the centre of the table.

Thirty Years War (1618–48). James I's worrying overtures to Spain included an attempt to arrange a marriage between the Prince of Wales and the sister of the King of Spain, and among the prints celebrating the failure of negotiations in 1623 are two broadsides illustrated with woodcuts welcoming the Prince's return from Spain (fig. 5.5).

Part of the propaganda against the Spanish marriage was *The Double Deliverance*, an engraving designed by Samuel Ward in 1621.[6] It was the first print to connect the Armada of 1588 with the Gunpowder Plot of 1605, presenting them as episodes in a continuing Roman Catholic conspiracy against English Protestant sovereignty. This was a high-quality print but it appeared in many cheaper copies and must have been well known.[7] Its imagery was simplified in a print by Jan Barra where the almost emblematic horseshoe formation of the Armada and the figure of Guy Fawkes approaching the cellar of Westminster Hall reappeared with a representation of the plague of 1625 – a warning from God that England should not slip back to the old religion.[8] The three-part image

A True Account of the Rise and Growth of the REFORMATION, or the Progress of the PROTESTANT RELIGION.

Setting forth the *Lives* and *Dying Speeches* of the *First* and most *Famous* Doctors of the *Protestant Church*, their constancy and stedfastness in the same to their Deaths and cruel Martyrdomes they suffered by those Bloody cruel Papists,

And now Printed and Published as a thankful Remembrance of God's goodness to all PROTESTANTS in these three Kingdoms of England, Scotland and Ireland, and necessary to be set up in every house and Family.

And recommended to all persons by these Reverend Divines, Mr. *W. I.* Mr. *R. B.* Mr. *N. V.*

That the Reader be not deceived by a Counterfeit sheet (full of many falshoods) in Imitation of this, The true sheet is only Printed and Sold by Joshua Conyers at the Black Raven in Duck Lane, 1680. 31.

5.4 *A True Account of the Rise and Growth of the Reformation*, 1680. This anti-Roman Catholic broadside, produced at a time of high anxiety over the likely succession to the throne of the Catholic James II, is illustrated by a crude woodcut version of the forty-year-old engraving, *The candle is lighted* (fig. 5.3).

The High and Mighty Prince Charles, Prince of Wales, &c.

The Manner of his Arriuall at the Spanish Court, the Magnificence of his Royall Entertainement there: His happy Returne, and hearty welcome, both to the King and Kingdome of England, the fifth of October, 1 6 2 3. Heere liuely and briefely deſcribed, together with certaine other delightfull paſſages, obſeruable in the whole Trauaile.

No longer let ſad dolours darke your eyes,
Nor longer feares your doubtfull hearts ſurprize,
Leaue gazing on each other, o're the Land,
As if the Countries ſtate were at a ſtand:
The ſolitary night is paſt away,
Succeeded by the glorious light of day,
Which brought the brightfull Sunne, againe to reare
His rayes aboue our Brittiſh Hemiſpheare;
That now the Land, which thirty weekes did mourne,
Dries her tear'd face, and finds her ioy returne.

His Departure, and Iourney.

This griefe did growe (without a fain'd pretence)
Vpon departure of our gracious Prince,
Whoſe often perils, mixt with trauaile-paine,
And oft diſtempers which he did ſuſtaine,
Both on the Sea, and that huge tract of way,
That in a hundred forty ᵃ ſtages lay,
While to, and through the very heart of France
He paſt, deſeru'dly doe his fame aduance.
In morning of the Spring he 'gan to goe,
And made it Winter here, which was not ſo;
Whoſe Winters viſiting vs now againe,
Makes vs new Spring of gladneſſe entertaine.
On Marche's ſeuenth day, to Spaine Courtly aire
Vnto Madrid was made his firſt repaire;
Where both our Kings ᵇ Embaſſadours, on knee,
With wonderment him welcom'd heartily,
With whom he priuately himſelfe repoſ'd
Till to that Monarch there, he was diſcloſ'd.

His Entertainement there.

His Comming knowne, the Maieſtie of Spaine,
That euer to his Highneſſe did maintaine
Royall reſpect, him graciouſly ſaluted,
And as his ᶜ Second Selfe the Prince reputed;
Yeelding large Quarter, and the Courtlieſt place,
With ſtore of Nobles to attend his Grace:
Who from all ᵈ coaſts (as their Lords will imported)
Eight hundred of the chiefeſt there reſorted.
Theſe ſtriuing, preſt with ſeruiceable loue,
Themſelues euen as his Liegemen ſtill to proue:
Deuiſing often ᵉ Maſques, Tilt, Tournament,
Barriers, Flights, Chace, each thing to cauſe content;
Sparing no coſt, expoſing (the greateſt treaſure)
Their perſons to aſſault (to ſhew him pleaſure)

Fierce ᶠ Bulls, vntam'd, vntide: nor was this all;
Spaines Soueraigne held himſelfe a ᵍ Feſtiuall,
To Honour Englands Heire, t'adorne which, were
The Queene, and faire Infanta preſent there.
Ne're Prince ſuch liking, ſo much grace accrewde,
Both of King, Nobles, Gentry, Multitude:
And this for ſixe moneths ſtay. But leauing theſe,
Haſte we to ſee 'em vpon, and paſt the Seas.

His Returne, Arriuall, and welcome.

Bidding the King, his Court, theſe ſports adieu,
T'embarke at Biſcay ſhore he ſtraite withdrew,
And waited long to meete a luckie wind,
At laſt, his wiſh was anſwered to his mind:
Heau'n proues propitious, winde his loue imparts,
Drawne by the prayers, driu'n by the ſighes, from hearts
Of thouſands here: So thence he forward ſet,
And Portſmouths Port, in ſeuen daies ſaile he ſet.
But being arriu'd, no tongue can halfe expreſſe
The rauiſht Countries wondrous ioyfulneſſe,
The Peoples clamour, Trumpets clangor, ſound
Of Drums, Fifes, Violls, Lutes, theſe did abound;
Loud Cannons thundring from the Caſtels, Towers,
And Ships, ſhooke Ayre and Earth, all to their powers,
Pourde healtĥs of wine for welcome; Bels were rung,
Bonefires were kindled, fire-workes each-where ſlung;
Yet's not enough high fires in ſtreets to frame,
Vnleſſe the fire of zeale your hearts enflame;
And that in Churches Pſalmes of thankes be ſinging,
As well as in the Steeples Bells a ringing.
Yee' haue pray'd, your prayer's heard; now this is done,
Laud God, and loue your King, and Kingdomes Sonne.

His arriuall at London, his welcome to the Court, with the generall Applauditẽs of all the People.

Yet louingly his louing mind he ſhewes
To London, where his Subiects loue beſtowes;
Some for meere ioy, burning their whole eſtate,
That Brittaines Prince might no; find them ingrate:
All ſhew'd their loues, all did forbeare to mourne,
When Englands Ioy, with ioy did ſafe returne.
Thus did he haſte to ſee his Fathers Court,
Where thouſand hearts with Ioy did free reſort,
To giue their beſt of welcomes: Englands Deare,
Was ne're more welcome; when their Heart was here,
That Heart, that dead did lay ſo many hearts,
When he from Brittany ſo freely parts,

Printed at London, 1 6 2 3.

Did with his ſight reuiue thoſe hearts againe,
Which his long abſence hath a long time ſlaine.
The Royall Cæſar of Great Brittaynes Ile,
Did entertaine his Sonne; a gracious ſmile,
And bleſſing he vpon his head doth powre,
Reioycing at that happy ioyfull houre.
Brittaines chiefe Deare did thus embrace his Deare,
Iuſt in the forme you ſee pourtraid here.
Then ſince all count theſe dayes the happy dayes,
To Him that makes man happy, be the Praiſe.

Theſe Notes, with their directory letters, are here inſerted, for the better explayning ſome of the Verſes, and Story.

ᵃ His Iourney by Land, conſiſted of 142 Stages, here in England, France, & Spaine; ſome of them containeſ ut 8 or 10, ſome 12 or 16 miles in length; ſo that the computation of the way that his Highneſſe rode Poſte amount to about 1100. miles.

ᵇ The Lord Digby, Earle of Briſtoll, Embaſſadour extraordinary for the Kings Maieſtie; and Sir Walter Aſton, Leiger there.

ᶜ For the King of Spaine appointed him haſte his Guard, and a moſt ſumptious Quarter in the Court, for his reſidence; as alſo cauſed him to ride in Triumph through Madrid.

ᵈ The Catholike King, becauſe other triumphes were preparing, ſent mandatory letters about, eſpecially to the Principall Nobility of Aragon, that they ſhould come and giue attendance at the Court, vpon the Princes pleaſure, becauſe they haue the reputation to be excellent men at Armes.

ᵉ Of which Maſques, the moſt magnificent, was on Eaſter day laſt, preſented by the Lord Admirall of Caſtile and Leon, in celebration of our moſt Illuſtrious Princes Arriuall there; where-in the King alſo was thought to haue beene an Actor.

ᶠ It hath bin, and is a cuſtome of that Countrey, at ſome great ſolemnities, for their Noblemen, as Dukes, Earles, Lords, and others of beſt note, to enter the liſts, and maintaine combate with Lances, Targets, Swords, and Darts, againſt looſe furious Bulls, in which they exerciſe their Courage and abilities, ſometimes not without danger; and as they merit, purchaſe eſtimation. This was performed at Whitſontide.

ᵍ That Feſtiuall before mentioned, was made by the King of Spaine at Madrid, the 21 of Auguſt laſt, 1623. to honour the Eſpouſall Treatie of Prince Charles, with the Lady Infanta Maria of Auſtria; and the maner was by darting with Canes, after the vſe there.

And this may ſuffice for a briefe, yet plaine deſcription of our Noble Princes ſudden Iourney thither, his Royall entertainment there, and moſt happy Returne hither, and wel-come home againe: To Gods glory, and the exceeding ioy and comfort of all true loyall hearted Subiects. FINIS.

5.5 *The High and Mighty Prince Charles, Prince of Wales*, 1623. This broadside celebrates the failure of plans for the future Charles I to marry the sister of the King of Spain

(*Facing page*) 5.6 *Monmouth's Saying*, 1683. The Duke of Monmouth, illegitimate son of Charles II, fled to Holland after the failure of the Rye House plot to assassinate Charles and the future James II. This ballad reports his promise to return to save England from Roman Catholicism.

became a symbol of the papist threat, repeated in prints responding to tragic accidents or plots for which Roman Catholics were rightly or wrongly blamed.[9] It was so recognizable that it needed no explanation and as late as 1683 it appeared in a simple woodcut illustrating *Monmouth's Saying*, a ballad supporting the Duke of Monmouth's claim to succeed Charles II (fig. 5.6).[10]

Anti-Roman Catholic propaganda in popular guises appears throughout the seventeenth century. A ballad of 1655 entitled *The true Portraiture of a prodigious Monster* (fig. 5.7) appears at first sight to be a straightforward account of the discovery of a strange creature in the Spanish mountains. It is given anti-papist significance in a postscript describing how the Roman Catholic hierarchy dreaded that the Last Judgement had arrived: 'yea, the very Pope himself trembled to hear this strange Report' for fear that this might be the 'Beast with seven heads' prophesied in the Book of Revelation.

A great rash of propagandist prints appeared from the late 1670s, when it became clear that the Roman Catholic James II was likely to succeed to the throne.[11] The output of just one publisher is illustrated by an advertisement appended in 1680 by Thomas Dawks to *Dr Otes his Vindication* – one of many broadsides and prints on the subject of Titus Oates's testimony of the alleged Popish Plot to assassinate Charles II and set up a Roman Catholic state in England:[12]

you may have Mr Bedloe's and Mr Dugdale's pictures, severally, thus with verses, declaring each of their reasons why they discovered this damnable, hellish, Popish plot: also you may have Sir Edmund Berry Godfrey's murder, most of the papists' cruelties in it, made visible, in a large copperplate, with a discourse thereon, to which is added Sir Edmund's character. Also a chronology of the rise and growth of Popery, when and who

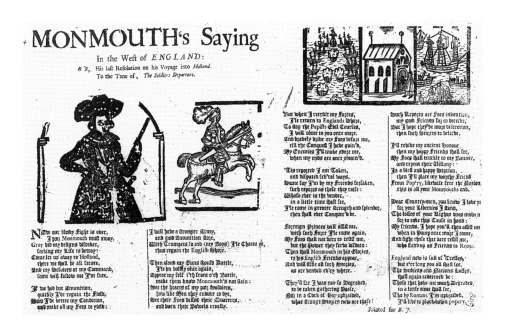

The true Portraiture of a prodigious *Monster*, taken in the *Mountains* of *Zardana*; The following Description whereof was sent to *Madrid*, Octob. 20. 1654. and from thence to *Don Olonzo de Cardines*, Ambassador for the King of *Spain*, now resident at *London*. Its stature was like that of a strong well set man, with 7 heads, the chief of them looking forward, with one eye in his fron; the other heads have each two eyes in their natural situation, the ears of an Ass; with its principal head it eates, drinks, and cryes with an extraordinary and terrible voyce; the other heads are also moved to and fro: It hath seven Arms and Hands of a Man, very strong in each of them; From the middle downward it is like a Satyr, with Goats feet, and cloven; it hath no distinction of Sex.
To the Tune of, Summer time.

Behold the Wonders of the Lord
In this same Creature pictur'd here,
Whose uncouth shape is full enough
To terrifie your hearts with fear.

The Picture which you here do see
Is of a Monster fierce and strange,
The which was taken in high Spain
As he about the Woods did range.

And after brought unto Madrid,
As a Present for to shew the King:
But when he did behold the same,
He counted it a miraculous thing.

Seven Heads in all this Monster hath,
And Nature did them so contrive,
That every head hath mouth and eyes,
And it's remaining still alive.

One head is bigger then any o'th rest.
Whose mouth for wideness doth exceed;
And that one head doth serve for all
The Monsters body for to feed.

So with one month sir heads are fed,
And all the Carkas in like sort;
The like was never known nor seen,
As they that saw him both report.

His eyes do goggle to and fro,
Like to great saucers as 'tis said;
And when he glows on any Folkes,
It makes their very hearts afraid.

His grinning teeth both sharp and long,
Like to a Mastiffs teeth appears;
And on his seven deformed heads
Grows fourteen long disguised ears.

The Second Part, To the same Tune.

Seven armes and hands he also hath,
With fingers well proportion'd all,
And on his Legs doth upright go,
Like to a man both strait and tall.

His Body from the Arm-pits down
Unto the knees over-grown with hair,
Is like unto a Satyre wilde.
Or else some ugly shag ge Bear.

The skin of him is Pistol proof,
As is for certain verifi'd
A sword can do his flesh no harm,
Hair grows so thick on every side.

His feet indeed are cloven feet,
Just in the manner of a Goat;
But of a mighty length and breadth,
Of which the people takes much note.

His voyce is extraordinary,
And terrible for men to hear;
For when it cryes it makes a noyse,
As if his throat would rend and tear.

But here the strangest wonder comes,
He never was known to speak at all;
But once before the King of Spain,
When he was present in the Hall.

Then in the Spanish Tongue he spake,
Quoth he, look to thy self O King,
The Superstition at the last
Not vengeance on thy head will bring.

As Germany hath been destroy'd,
By Famine, Fire, and the Sword;
So will it be with thee O King,
Except the mercies of the Lord.

Do thee reclaim from what thou art,
From Pride and foul Idolatry;
Those Nations that are now thy friends,
Shall then become thy Enemy,

Thy Mines of Silver and of Gold,
Shall quite be taken from thee away;

The English souldiers brave and bold
Shall afterwards the same insoy.

All Christian Princes are in Arms,
Against each others for to fight;
The bad against the good doth strive,
To overcome them with their might.

But now the Power of Rome must vail
The Triple Crown goes to decay;
Whereto the King made no Reply,
But that his head and went away.

Which being done, the Monster ceast
His word, and never spake no more:
Nor was it known by any one,
That ever he spake word before.

But in Madrid the Monster still
For certain doth remain alive,
And multitude of people comes,
Daily to see him they do strive.

Wherefore the King of Spain hath sent,
As by the subject may appear,
This News to his Ambassage,
Which now in London liveth here.

But to conclude, let none suppose,
Nor think this News to be a Lye;
For there are many Englishmen
That saw him, and will justifie

The same for truth which here is pen'd,
Being Eye-witness to this thing;
And was in presence when the Monster
Spake his speech unto the King.

Another Monster fierce and stout
Since this appear'd, hath been seen,
Like a red Dragon range about
The mighty Hils and Dales of Spain.

From whence these Monsters first did come
There is no man alive doth know:
But sure the Lord above doth some
Strange things to us by them foreshew.

The News of this Satyrical Monster being noysed abroad throughout all Spain, France, and Italy, made a desperate fear, and general distemper, amongst all the Popish Prelats, Cardinals, Jesuites, Monks and Fryers; yea, the very Pope himself trembled to hear this strange Report, There is a Prophesie in the 13. of the Revelation, of a great Red-Dragon, and a Beast with seven heads that should arise out of the Sea, that should continue 42 moneths, which was to come to pass before the great and terrible day of Judgment; which by the appearing of these strange Monsters is neer at hand now.

LONDON: Printed for *John Andrews*, at the White Lyon in the Old-Bayly. 1655.

brought in their superstitious devices: which may be had in 2 broad sheets joined with 52 figures, in copperplates, or in a pack of cards representing the rise, demonstration and discovery of the plot, with a book to explain each figure, &c. ...'[13]

Prints and broadsides followed a series of real and alleged plots and other events up to the accession of James II, which was followed by Oates's trial and punishment for perjury. The quality of the prints varied, and some engravings were copied in woodcut to allow for large editions (fig. 5.8).

Jesuits were seen as a particular threat, and Arthur Tooker's *A Jesuit Displaid* (fig. 5.9) would have had wide appeal both for its subject and for the manner in which it is portrayed, although as a large engraving it would not have been among the cheapest prints. The head of a Jesuit is treated as a composite figure made up of objects that the anti-Roman Catholic mind would take to be appropriate: Guy Fawkes's lantern, Judas's purse, and the tools of the trades with which the Jesuit might disguise himself – 'Gardner, Groome, Cooke, he's everything to all'.[14]

(Facing page)
5.7 *The true Portraiture of a prodigious Monster*, 1655. The ballad tells the story of a creature with seven heads, seven arms and the legs of a goat, found in the mountains of Spain and brought to London by the Spanish ambassador; an anti-papist postscript is added describing how the Roman Catholic hierarchy feared that this might be the 'Beast with seven heads' prophesied in the Book of Revelation. The same subject appears without the anti-papist gloss in an etching by William Faithorne. The image is based on an etching of 1578 of an 'horibile et maraviglioso mostro' by Giovanni Battista de Cavalieri; for other versions see Harms, VII, nos 112–14.

REWARD of DECEIT:

Being an Account of the Right Perfidious, and Perjury'd *TITUS OATES*; Who Recieved Sentence at the *Kings-Bench-Bar*, at *Westminster* the 16th day of May, 1685.

HERE STAND I FOR PERJURY.

O Cruel Fate! why art thou thus unkind,
So wavering and unconstant in thy Mind,
To turn (like weather-Cocks) with every Wind?
Did'st thou not once make Oates thy Favourite,
Thy only Darling, and thy dear Delight?
And mounted him upon thy Wings so high,
That he could almost touch the very Skie,
And now must Oates stand in the *Pillory*?
There to be Battered so with Rotten *Eggs*,
Both on the Face, the Body and the Legs,
That he will wish himself in *Hell* for Ease,
And Beg as Beggars do for Bread and Cheese,
That *Oates* might not be Thresh'd as Men do Pease.
And must he too (when once he has stood there)
Be sent to Ride upon the *Three-Leg'd-Mare*?
Zouns what's the meaning of it with a Pox?
Is that the way to pay his *Christmas-Box*?
Was he not once the *Saviour of the Nation*,
And must he be Contemn'd and out of Fashion?
Call'd *Perjur'd Rogue* and slighted be by all,
And toss'd about just like a Tennis-Ball.
What if he did Forswear himself a little,
Must his sweet Bum be rubb'd thus with a Nettle?
O fie! 'Tis not well done to Rob the Spittle.
But 'tis in vain I see to Mourn for *Oates*,
For if we Roar until we split our Throats,
We cannot help the poor distressed thing;
No hopes to get a Pardon of the King,
Therefore he must endure his Suffering.

Indeed (if to Lament would do him good)
Then we would Weep that's to be understood:
But, *my beloved Brethren in the Lord*,
That cannot keep him from a *Hempen-Cord*,
Or from his peeping through a *Two-inch-Board*.
And so 'tis needless that we Vex or Fret,
God's holy Will be done, we must Submit.
However let poor *Oates* be Brisk and Bonny
(Long as he Lives) he shall not want for Money,
For to his Hive we'll bring both Wax and Honey.
Yet (if he should be Hang'd and Die that way)
Oates will spring up again at Judgment Day,
Altho there will not be a bit of *Hay*.
But 'tis a great Disgrace that *O brave Oates*
(The Rampant Doctor of Religious *Plots*)
Is not (in state) Promoted up on High;
The just Reward of bloudy Perjury.
Yet he's no Coward, fearing to be Halter'd,
Unless of late his Courage should be Alter'd:
Fight Dog, fight Bear, he values not a Fig,
He always was and e'er will be a *Whigg*,
And stand up for the *Cause* we know full well,
Tho he were sure almost to go to *Hell*.
Therefore if he be Hang'd, and in a Cart
Carried to *Tyburn*, what cares he a Fart,
At last the Dearest Friends of all must Part.
And now Beloved Brother *Oates* adieu,
Altho this story looks a little Blue,
Yet what I Wrote of thee is very True.

LONDON, Printed by *George Groom*, at the Sign of the *Blue-Ball* in *Thames-street*, over against *Baynard's-Castle*. 1685.

5.8 *The Doctor Degraded; or, The Reward of Deceit*, 1685. After James II's accession Titus Oates was prosecuted for giving perjured evidence of Roman Catholic plots. A number of prints and broadsides record his trial and punishment (just as others had followed the Popish Plot and its ramifications since 1678) and this example with its woodcut illustration would have been intended for wide circulation. Oates suffered the pillory, whippings and imprisonment for four years as described in the text, but he was released when William and Mary took the throne in 1689 and enjoyed a substantial pension for the remainder of his life.

Anti-Roman Catholicism continued – although at a less extreme pitch – throughout the eighteenth century. A pair of illustrated broadsides on the Lisbon earthquake of 1755 (fig. 5.10) make it clear that the disaster was to be read as a punishment for Roman Catholicism and a warning to London, where there had been a small earthquake in 1750:

... thou hadst a warning not long since:
What hast thou done, amendments to evince?
Are playhouses neglected? Churches thronged?
Do thy courts right the helpless orphans, wronged?
Exemplary are thy chief magistrates?
Are balls exchanged for religious tracts?'

Each relaxation of the legal restrictions on Roman Catholics brought another spate of propaganda prints. As late as 1850 a particularly violent image headed 'No Popery!' and showing a British Bulldog as a butcher with a pope on his

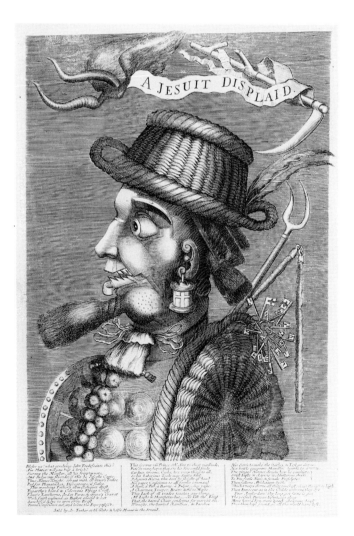

5.9 *A Jesuit Displaid*, *c*.1682. The head of a Jesuit is treated as a composite figure made up of objects – such as Guy Fawkes's lantern or Judas's purse – that the anti-Roman Catholic mind would take to be appropriate.

(*Facing page*)
5.10 *An Authentick View of the City of Lisbon in Portugal at the Time of the dreadful Earthquake, which entirely destroyed that City*, 1755. This broadside is a pair to another that shows the city of Lisbon and describes its appearance 'before its destruction by a dreadful earthquake on the 1st of November, 1755'.
The illustration to this sheet shows the earthquake taking place and the text describes the aftermath in a letter from an expatriate British resident. A verse presents the earthquake as a punishment to the Portuguese for following the Roman Catholic faith and exhorts Londoners to take the disaster as a warning to reform their sins.

An Authentick VIEW of the CITY of LISBON in Portugal, at the Time of the dreadful EARTHQUAKE, which entirely deſtroyed that City, on the 1ſt of *November*, 1755, and as it ended, drawn from the other Side the *Tagus*, by one of the beſt Artiſts for thoſe Things in that Country.

ENGLAND! be aw'd, now the Alarm is giv'n,
Nor dare provoke th' Artillery of Heav'n,
Who ſpares thee yet, tho' *Portugal*'s o'erthrown—
Ah! fear, from her Cataſtrophe, thy own!
The Throne and Palace ſunk! the Monarch ſav'd!
Mouſes, with their Inhabitants, ingrav'd!
Immenſe the Treaſure loſt!—Tremendous Hour!
Amazing Act!—of an Almighty Pow'r!
Canſt Thou, O Blind! this as a Judgment hold
For Sins in ſcarlet Capitals enroll'd?
Stay, from thy Lips, let no ſuch Cenſure fall;
Unleſs we all repent, we periſh all!

Be candid, *Brethren!* Had the Goſpel-Ray
Shone there, as here, in its full Blaze of Day;
Had former Kings renounc'd the Yoke of *Rome*,
And Ingratitude met deſerved Doom,
(Thoſe Bars to Truth) perhaps they had excell'd
In all that's Moral, all that's Sacred held.

Heav'n, oft before the fatal Bolt is hurl'd,
Gives timely Notice to an erring World;
Some leſſer Woes are Harbingers of Great:
O! *England!* hear! and dread approaching Fate!
While harmleſs Thunders, and while gentle Shocks

Still at thy Door for *Reformation* knocks,
Rouſe from thy ſtupid Lethargy of Sin,
Turn Penitent, and own the GOD within!
Or be aſſur'd, that the incenſed Pow'r
Will overtake thee in an evil Hour.

LONDON! thou hadſt a *Warning* not long ſince:
What haſt thou done, Amendment to evince?
Are Playhouſes neglected? Churches throng'd?
Do thy Courts right the helpleſs *Orphan*, wrong'd?
Exemplary are thy chief Magiſtrates?
Are Bulls exchang'd for Religious Treats?

Are Cards rejected for the Sacred Leaves?
Ill Books ſuppreſs'd, that poiſon half Mankind?
Calumnies baniſhed, and the Sweareres fin'd?
Examine well thy State, by Reaſon's Line,
And ſee it ſolid Piety be thine.

If ſuch thy preſent Caſe, with me, 'tis clear,
From flaming Earthquakes thou haſt nought to fear;
Supported by an All-ſufficient Hand!
Tho' *Rome* may fall, thy Gospel ſhall ſtand.

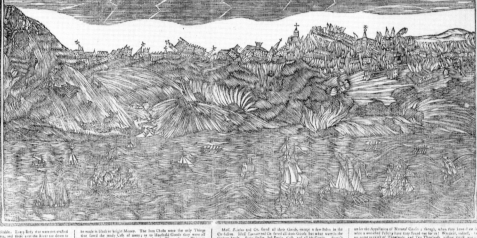

Extract of a Letter from Lisbon, dated Nov. 19.

SIR,

[The remainder of the page consists of a letter describing the Lisbon earthquake and a sermon, printed in multiple dense columns, largely illegible at this resolution.]

5.11 *No Popery!*, 1850.
This startling poster was
issued as an advertisement for
a collection of anti-Roman
Catholic prints published as
part of the furore against the
restoration of the Roman
Catholic hierarchy in England.
It came from the huge
collection of political prints
put together by Edward
Hawkins (1780–1867),
Keeper of Antiquities at the
British Museum. Hawkins was
notoriously anti-Catholic; in
1852 his catalogue of British
medals was suppressed by the
Trustees of the British
Museum because of passages
expressing his views in
extreme terms.

chopping block (fig. 5.11) was used to advertise a fold-out book of twenty-three
prints attacking the restoration of the Roman Catholic hierarchy in England.[15]
The boldness of the image links it to the popular woodcut tradition; the small
wood-engravings it advertises are much milder in appearance but no less uncom-
promising in their sentiments.

The repeal of anti-Roman Catholic legislation was just one of a series of
reforms of public life that had been enacted since the 1820s. The campaigns
leading to these reforms made great use of print propaganda. Popular imagery and
formats were appropriated in the causes both of reform and of the status quo in
a way that was much more carefully thought out than anything that had been
attempted in the earlier period.

In the 1790s English conservatives were deeply afraid that revolution might
spread from France and a number of voluntary organizations (albeit with tacit
government support) were set up to counter radicalism among the masses by
disseminating moralizing and 'loyal' texts.[16] The systematic use of popular prints
for propaganda was carried out most effectively by the Cheap Repository for

Moral and Religious Tracts run by the evangelical Hannah More from 1795 to 1798.[17] The Repository's neatly printed ballads and chapbooks, almost all written by Hannah More and signed 'Z', retell familiar stories emphasizing their moral content, or publish new ones, such as the chillingly condescending *The Riot: or, Half a Loaf is better than No Bread* (fig. 5.12) issued at a time when war with France was causing desperate food shortages. Cheap Repository Tracts used traditional formats, but their printing was too tidy and their ornament too genteel for them to pass as ordinary commercial products of the period.

Initially Cheap Repository Tracts were subsidized by subscriptions from wealthy supporters so that they could undercut their commercial equivalents – they were sold wholesale for as little as 6d. for twenty-four penny ballads – but sales were so high that the initiative was soon self-supporting: as many as two million publications were distributed in the first year. Popular print publishers were recruited into what must have been a lucrative market. The Bishop of

5.12 *The Riot; or, Half a Loaf is better than no Bread*, 1795. This example of the highly conservative publications of the Cheap Repository uses a genteel version of the popular ballad format to put the case against agrarian disturbances, aiming to convince young men of a moral imperative to maintain the status quo. It was published at the time of widespread food riots in response to the high cost of grain, and was also produced as a chapbook.

London had written to Hannah More in 1794 that he was keen for moralizing publications to be available in his diocese:

There is a central set of booksellers that are to the full as mischievous as your hawkers, pedlars and matchwomen in vending the vilest penny pamphlets to the poor people, and I am told it is incredible what fortunes they raise by this sort of traffic ... If therefore we gain any of these miscreants to our side, we shall have a most respectable set of booksellers to dispose of our works in town and country from the most eminent dealer in small wares in Paternoster Row to the vendor of cards and matches at Cowslip Green [More's home, near Bristol].

The Bishop had his way and the City publishers added the new material to their repertoire – although without ceasing to produce the publications that he condemned. The earliest Cheap Repository publications were printed by Samuel Hazard of Bath and John Marshall, successor to Richard Marshall of 4 Aldermary Churchyard (see pp. 56–61). Marshall proved, in Hannah More's words, to be 'selfish, tricking and disobliging from first to last'[18] and by the end of 1797 she had severed the connection with him; Marshall, however, published a further seventy-two Cheap Repository Tracts without authorization. John Evans of Smithfield (see pp. 61–2), Hatchard of Piccadilly and F. & C. Rivington were appointed as successors to Marshall with the right to reprint existing stock, and other publishers and booksellers as far afield as Dublin, and even Philadelphia, were drawn in as agents. As late as 1820 John Clare mentions Evans 'of Smithfield' and 'Pitts of Seven Dials' (see p. 62) 'singing their pennyworth of pennyances on the suppression of vice in brown and blue paper'.[19]

Large numbers of tracts were given away and there was a close connection with the growing Sunday School movement: Hannah More ran such schools in Somerset. It can be no coincidence that the chief promoter of the Sunday School movement was Robert Raikes (1735–1811), son of William Dicey's early partner (see p. 55) and his successor as proprietor of the *Gloucester Journal*.[20] Hannah More knew the Dicey family well and occasionally stayed with Thomas (son of Cluer) and his family at their house in Hampton, Middlesex. The new pious material therefore had access to the far-reaching network established by the newspaper proprietors in the 1720s.

The Cheap Repository was not the only source of conservative moralizing publications. In 1819 the Radical Francis Place (1771–1854) transcribed from memory a number of ballads that were well known in his childhood.[21] In an introductory note he described the rapid decline in numbers of ballad-sellers and the way in which 'bawdy songs, and those in praise of thieving and getting drunk were pushed out of existence ... such as even thirty-five years ago produced applause would now cause the singer to be rolled in the mud'. Place attributed much of the change in public attitude to the activities of the Association for Preserving Liberty and Property Against Republicans and Levellers, branches of which were set up all over the country in the winter of 1792–3 in response to fear that revolution might spread from France. The Association 'printed a large

number of what they called loyal songs, and gave them to ballad singers; if anyone was found singing any but loyal songs, he or she was carried before a magistrate'. A number of letters from members are preserved in the British Library, and one outlines the theory behind the initiative to publish 'loyal songs':

anything written in verse and especially to an old English tune ... made a more fixed impression on the minds of the younger and lower class of people, than any written in prose, which was often forgotten as soon as read ... By printing copies of the enclosed, as common ballads, and putting them in the hands of individuals, or by twenties in the hands of ballad singers who might sing them for the sake of selling them, I own I shall not be displeased to hear re-echoed by every little boy in the streets during the Christmas holidays – Long may Old England possess Good Cheer and Jollity, Liberty and Property and no Equality.[22]

Restrictions on ballads were not only applied in London. Thomas Bewick was an apprentice in Newcastle in the 1760s when printers of popular material flourished:

With the singing of [ballads], the streets of Newcastle were long greatly enlivened, and many market day visitors, as well as the town's people, were often highly gratified. What a cheerful lively time this appeared to me and many others. This state of things however, in time was changed, when public matters cast a surly gloom over the character of the whole country and these singing days, instead of being regulated by the magistrates, were, in their wisdom, totally put an end to.[23]

The poet John Clare (1793–1864) – who also loved traditional ballads and chapbooks – complained of the sort of material that replaced them:

I had a tract thrust into my hand the other day by a neighbour containing the dreadful end of an atheist who shot his own daughter for going to a methodist chapel – this is one of the white lies that are suffered to be hawked about the country to meet the superstitions of the unwary.[24]

Reformers and radicals also used popular forms. A tobacco wrapper in the form of a puzzle print (see pp. 29–31) given to visitors to the Horns tavern at Kennington in December 1792 reads: 'I am puzzled how to live while kingcraft may abuse my rights and tax the joys of day'.[25] A straightforward elegy became a political statement when it gave an account of the death of Queen Caroline – whose disastrous marriage to the future George IV and exclusion from his coronation had made her a Radical heroine (fig. 3.17). The execution broadside form was used in a mock dying speech of Thomas Paine published as part of the conservative attack on him after the publication of *The Rights of Man* in 1791,[26] and in 1814 in a very similar sheet announcing the hanging in Birmingham of Napoleon Bonaparte (fig. 5.13). Mock execution broadsides were also used for propaganda by those campaigning against the death penalty. As far afield as Stockton and Edinburgh broadsides were published at some date in the early nineteenth century describing the execution of nine-year-old Charles Elliot and fourteen other young men for stealing six handkerchiefs from a shop in Oxford Street, London, yet according to Gatrell there is no evidence for anyone younger

than fourteen years of age having been hanged in the whole of the nineteenth century.[27] In 1819 George Cruikshank used the familiar image of a row of men and women hanging from a gallows in his famous *Bank Restriction Note* (fig. 5.14).[28] Between 1805 and 1818 twenty per cent of executions were for forgery, and it was a crime that was all too close to home for printmakers (the well-known engraver William Wynne Ryland had been executed in 1783 for issuing a forged India bill). In 1832 a joyful reformer portrayed the Tory cabinet as a gang of criminals under a gallows in a broadside celebrating the passing of the great Reform Act (fig. 5.15).

Popular radical consciousness was stirred by one event of the early nineteenth century more than any other: Peterloo. Manchester was England's second largest city but had no Member of Parliament. Constituency boundaries remained unchanged from those of pre-industrial England, bearing no relation to contemporary patterns of population, and parliamentary seats were to a great extent in the hands of the hereditary élite. On 16 August 1819 a meeting was held in

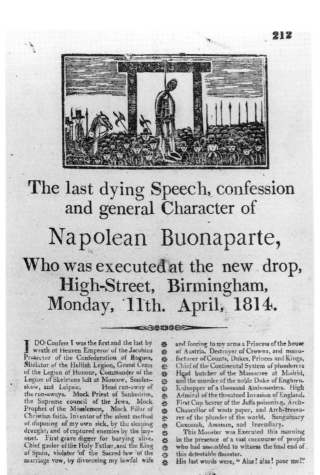

5.13 *The last dying Speech ... of Napolean Buonaparte*, 1814. This mock execution broadside was issued in celebration of Napoleon's abdication and exile to Elba on 11 April 1814.

(*Facing page*)
5.14 *Bank Restriction Note*, 1819. This mock banknote by George Cruikshank was published as part of the campaign to abolish capital punishment for forgery. Cruikshank has imitated the macabre inset rectangles of hooded hanging figures on execution broadsides (see figs 3.20, 4.32 and 4.33). Forgery ceased to be a capital crime in 1832.

St Peter's Field, Manchester, attended by some sixty thousand supporters of constitutional reform and the extension of the franchise. Local magistrates issued a warrant for the arrest of Henry 'Orator' Hunt and others addressing the meeting. The militia rode through the crowd to the hustings and, after arresting Hunt and thirty-four others, set about dispersing the assembly with the aid of a company of hussars. Within fifteen minutes fifteen people were dead and at least 420 injured. The event was ironically compared with the military victory four years earlier at Waterloo.

Prints of Peterloo appeared within days.[29] James Wroe, proprietor of the *Manchester Observer,* was a fierce advocate of reform and his press was a well-established weapon in the cause. He published not only newspapers but all sorts of printed ephemera – running the same sort of business that William Dicey had done in Northampton a hundred years earlier (see p. 55). In the charged atmosphere of post-French Revolution England the networks that distributed newspapers, chapbooks and patent medicines had become channels for political propaganda; Wroe was imprisoned for twelve months for his publications on the Peterloo massacre. Three years after Peterloo Lord Eldon was to complain that when he had been Attorney General in 1794 he:

never heard of wagons filled with seditious papers in order to be distributed through every village, to be scattered over the highways, to be introduced into cottages. Such things were formerly unknown; but there was now scarcely a village in the kingdom that had not its little shop, in which nothing was sold but blasphemy and sedition.[30]

A peep-show man (see figs 2.15 and 7.4) was arrested in Chudleigh, near Exeter, for exhibiting a print of Peterloo and 'in his description of it to the populace

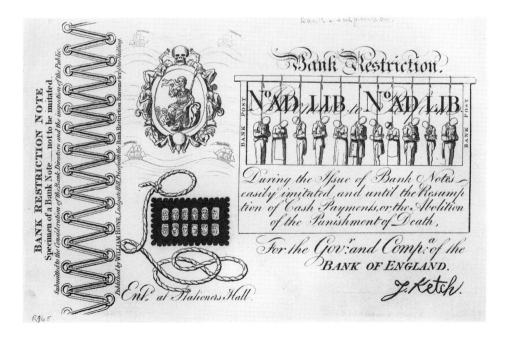

Desperate Condition of the Tory Gang.

5.15 *Desperate Condition of the Tory Gang*, 1832.
The defeated Tory leadership – the Duke of Wellington, Sir Robert Peel, Lord Ellenborough, the Earl of Eldon and the Duke of Cumberland – stand beneath a gallows with a verse rejoicing on the passage of the Reform Bill.

(Facing page)
5.16 *The Manchester Reform Meeting Dispersed by the Civil and Military Power*, 1819. This image of the 'Peterloo Massacre' is one of the best known of many prints showing the infamous military assault on a peaceful political meeting.

[making] use of seditious expressions'. The print was published by John Evans (see above), and the show man was also selling a 'loyal' sheet attacking Thomas Paine published by Evans on behalf of the Religious Tract Society.

The best known of the cheaper prints of Peterloo is a composition by John Slack printed on a large handkerchief of a type that was increasingly mass-produced by the growing Lancashire cotton industry (fig. 5.16). Slack emphasized the orderliness and respectability of the crowd of neatly dressed citizens, determined to counter accusations by conservative propagandists:

We had frequently been taunted by the press, with our ragged, dirty appearance, at these assemblages; with the confusion of our proceedings, and the mob-like crowds in which our numbers were mustered; and we determined that, for once at least these reflections should not be deserved, – that we would disarm the bitterness of our political opponents by a

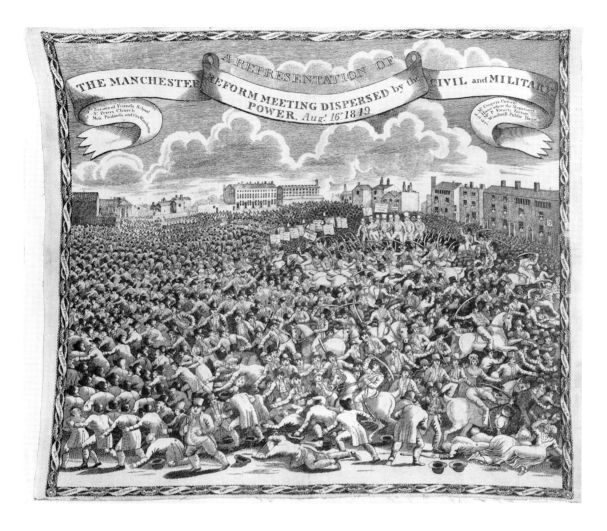

display of cleanliness, sobriety and decorum, such as we never before had exhibited. In short, we would deserve their respect by shewing that we respected ourselves, and knew how to exercise our rights of meeting, as it were well Englishmen always should do, – in a spirit of sober thoughtfulness.[31]

Among the political satires referring to Peterloo are a number by George Cruikshank, including *A Strong Proof of the Flourishing State of the Country* (BM Sat 13267) showing an oil painting of the massacre and another presenting the Cape of Good Hope as a Lubberland (see p. 122) – where the rocks are made of roast meat and the hailstones are plum puddings – to which the unemployed might emigrate. At this period Cruikshank was working closely with William Hone illustrating Radical shilling pamphlets that made use of traditional ballads and nursery rhymes. *The Political House that Jack Built* (fig. 5.17), published in December 1819, went through more than fifty editions and is said to have sold a hundred thousand copies. Peterloo was treated in another mock nursery rhyme of 1819, *Who killed Cock Robin?* (BM Sat 13341–5): 'These are the Manchester

"Great offices will have
Great talents."

**This is THE MAN—all shaven and shorn,
All cover'd with Orders—and all forlorn ;**

**A FREE BORN ENGLISHMAN !
THE ADMIRATION of the WORLD !!!
AND THE ENVY of SURROUNDING NATIONS !!!!!**

Sparrows, / Who kill'd poor Robins, with Bows and Arrows.' Twenty years later Thackeray remembered the 'grinning mechanics' at a print shop window 'who spelt the songs, and spoke them out for the benefit of the company'.[32] A hostile response to radical propaganda appeared in the *Annual Register*, 1821:

Newspapers, placards, pamphlets, and caricatures of the most filthy and odious description were exposed to sale in every street, alley, and lane of the metropolis, and circulated thence, though in less profusion, yet with great activity, to the most distant parts of the kingdom'.[33]

George Cruikshank also produced in 1819 new versions of *A Free Born Englishman* (fig. 5.18),[34] a man in fetters whose lips are padlocked together. The image had first appeared at the time of the Gagging Acts of 1795 designed to suppress opposition to the government: versions produced at that time included a token by Thomas Spence, a cheap etching by T. French[35] and an illustration to a ballad published by Jackson & Son, Birmingham,[36] as well as Cruikshank's own print.[37] The image of a man with his lips locked together – like the victim of some

medieval torture – is horrific enough on its own and the irony in the title is plain, but there would have been an added poignancy for a contemporary audience who would have recognized in the padlocked mouth a cruel attribute of the traditional 'Ideal Servant' who would betray none of his master's secrets.

A number of prints of the subject were related to a wall-painting of the 1580s in the kitchen lobby at Winchester College. Although there are literary sources going back to the fourteenth century, the wall-painting is likely to have been based on a now lost print of *The Portraiture of a Trusty Servant* registered with the Stationers' Company on 4 March 1577.[38] In 1662 Thomas Jenner advertised a print of the *Serving Man*, and in 1682 Narcissus Luttrell bought a broadside of *The Emblem of a Good Servant Explain'd* in which the servant's mouth is closed with a muzzle (fig. 5.19). The image was also known on the Continent, for instance, in a Polish broadsheet of 1655, *Wizerunk Slugi Wiernego* (The Good Serf) by the Monogrammist MK.[39]

In the early years of the nineteenth century the development of large typefaces allowed for the introduction of the poster in the modern sense of a notice designed to convey its message instantly rather than, like earlier proclamations, to be read

(*Facing page*)

5.17 *The Man* from *The Political House that Jack Built*, 1819. William Hone's satirical version of a well-known nursery rhyme, with illustrations by George Cruikshank, was immensely successful. 'The Man … all shaven and shorn' is the Prince Regent, described in the verse as the 'Dandy of Sixty'. Another illustration shows a printing press:

The Thing, that, in spite of new Acts
And attempts to restrain it, by Soldiers or Tax,
Will poison the Vermin,
That plunder the Wealth,
That lay in the House,
That Jack built.

5.18 *A Free Born Englishman!*, 1819. From the 1790s onwards restrictions such as had never been used before in England were imposed on the print trade. A number of versions appeared of a gagged and ragged Englishman; this powerful image by George Cruikshank was a response to the Seditious Meetings Prevention Act and the Blasphemous and Seditious Libels Act of 1819.

(*Right*) 5.19 *This Ages Rarity: or, The Emblem of a Good Servant Explain'd*, 1682. The ideal servant, portrayed with the useful attributes of a range of domestic animals, has his mouth muzzled so that he will not betray his master's secrets. Other versions of this image close the servant's mouth with a padlock. Annotations by Narcissus Luttrell show that he bought this broadside for 2d. on 26 May 1682.

at close quarters (fig. 5.20).[40] Poster designers took advantage of the bold style of popular woodcuts to make striking images for propagandist purposes. The earliest surviving use of political caricature at poster scale are two large woodcuts published during the bitter campaign for the election of the Chamberlain of the City of London in 1831 (figs 5.21 and 5.22). The subject of the attack is the Radical candidate Robert Waithman (1764–1833),[41] who is presented as *The Evil Genius* with cloven hoof and forked tail[42] and as *The Unrelenting Creditor* outside the debtors' gaol symbolized by a barred window in a stone wall through which pathetic faces plead. The Chamberlain acted as banker to the Corporation of London and had personal access to City funds. Waithman was beaten in the election by the Tory candidate Sir James Shaw, who subsequently lost £40,000 of the funds through imprudent investment.

INTELLIGENCE on the PEACE.

Printed for & Sold by CARINGTON BOWLES, at his Map & Print Warehouse, No 69 in St Pauls Church Yard, LONDON Published as the Act directs.

5.20 *Intelligence on the Peace*, 1783. The lamp-lighters, the cobbler, the Jewish old clothes dealer, the baker's man, the chimney-sweeper's boy and their friends are examining prints and broadsides telling of the end of the American War. Only the headings are legible; it was not until the nineteenth century that large type-faces allowed for posters in the modern sense that could be read at a distance.

5.21 *The Evil Genius in sack-cloth or, a Whiteman looking black*, 1831. This and the following print are among the earliest examples of the use of caricature in large political posters. The subject is the Radical Alderman and MP Robert Waithman (1764–1833) who was standing for the post of Chamberlain of the City of London. He is shown wearing the 'Orphan Coal Sack' as a reference to his reform of the administration of the Orphans' Fund which was supported by a duty on coals; funds had been diverted to profit certain aldermen, and Waithman's attack on corruption brought him enemies.

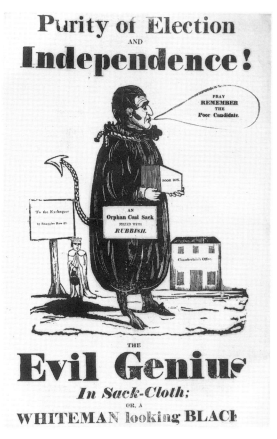

5.22 *The Unrelenting Creditor,* 1831. This print would have appeared at the same time as fig. 5.21 and alludes to Waithman's pursuit in 1816 of an insolvent debtor who owed his firm £3800.

THE POPULAR PRINT AND HIGH ART

High art – concerned with great names and elevated subject matter – has little to do with the commercial imperatives of the popular print in England. But publishers of popular prints consistently plundered high art for images on which to base their designs. They would have had no direct contact with great works in royal and aristocratic collections,[1] but the eighteenth century saw increasing numbers of reproductive prints that provided material for copyists at all levels of the print trade.

Raphael's cartoons for the Vatican tapestries had arrived in England in 1623 and were regarded as the greatest works of art in the country. Engravings after them appeared from the first decade of the eighteenth century onwards and they became so well known that they could be described in print catalogues simply

38 MAPS and PRINTS of different Sizes.

neatly coloured and pasted on Cloth, with a Roller and Ledge, is both a useful and handsome Ornament for a Hall. It measures near six Foot square. Price 1 *l.* 1 *s.*

2. *Geography Epitomiz'd.* Containing a Description of the Sun and Moon, Stars and Planets, of the Air and Meteors. Also an Explanation of the Terms of Geography, the Dimensions of the four Continents, their chief Kingdoms and Countries, the Longitude and Latitude of their capital Cities, the most remarkable Islands and Rivers. An Equation Table, shewing the Hours and Minutes of the Sun's Rising and Setting, *&c.* The whole is engraved in the neatest manner, and printed on a Sheet of Elephant Paper. Price 2 *s.*

3. A new and correct Map of the *Bay* and Harbour of *Dublin,* with a small Plan of the City. Neatly engraved, and printed on a Sheet of Elephant Paper. Price 1 *s.*

4. A Plan of the Town and Fortifications of *Gibraltar,* shewing the New Works made since the last Siege, for the better Security of that Fortress, and the Lines which the *Spaniards* have built before it. Exactly taken on the Spot in *May* 1731. Price 1 *s.*

5. A curious Print, done by Mr. *Hogarth,* about twenty Inches deep, and fifteen Inches wide; shewing the Reception of *Anna Bullen* by K. *Henry* VIII. when he became enamour'd of her. Price 2 *s.*

6. Eight different Prints of Hay-making, Gardening, Bird-catching, and other rural Employments. Each Print twenty-three Inches deep, and nineteen Inches wide. Price 6 *d.* each.

7. The *Tripple Plea,* or the Contest between a Lawyer, Physician, and Divine. Very neatly engraved by *George Bickham;* with a Copy of Verses at the bottom. Printed on half a Sheet of Demoy. Price 6 *d.*

8. The *Tea-Table,* neatly engraved, with a Copy of Verses at bottom, and printed on half a Sheet of Demoy. Price 6 *d.*

9. A Genealogical Print, shewing the Lineal Descent of the present Royal Family of *Great Britain,* from King *James* the First. Price 6 *d.*

10. The *King's Arms,* by *Stevenson.* Price 1 *s.*

11.

11. Directions for improving a *Kitchen Garden* for every Month of the Year. Price 6 *d.*

12. A neat *Pocket Globe,* three Inches diameter. Engraved by *Herman Moll* Geographer. Price 7 *s.* 6 *d.*

ROYAL SHEETS.

CHEAP PRINTS, each Printed on a Sheet of Royal Paper.

SETS.

1. Twelve Prints of the *Cæsars* or *Emperors* of *Rome* on Horseback, with an Account of their Lives.

2. Thirteen Prints of the *Apostles,* with St. *Paul* and St. *Matthias.* Each drawn at full length, with a distant View of the different Kinds of Martyrdom they suffered, and a short Account of their Lives at the bottom of each Plate.

3. The *Monarchs* of *England,* from *William* the Conqueror, to his present Majesty King *George* the IId, *&c.* with an Account when they were Crowned, how long they Reigned, *&c.* In six Prints.

4. The *History* of *King Charles* the Ist, in ten Prints; *viz.* 1. The King's Marriage. 2. *Hull* summon'd by the King. 3. The Revolt of the Fleet. 4. The King setting up his Standard by *Nottingham.* 5. *Naseby* Battle. 6. The King seized by Cornet *Joyce.* 7. The King's Escape from *Hampton* Court. 8. The Trial of the King. 9. The King taking Leave of his Children. 10. The Death of the King.

5. The *Cartons* of *Raphael Urbin* at *Hampton-Court,* in seven Prints; *viz.* 1. The miraculous Draught of Fishes. 2. *Christ's* Charge to *Peter.* 3. The lame Man healed by *Peter* and *John.* 4. The Death of *Ananias.* 5. *Elymas* the Sorcerer struck with Blindness. 6. *Paul* and *Barnabas* at *Lystra.* 7. *Paul* preaching at *Athens.*

6.

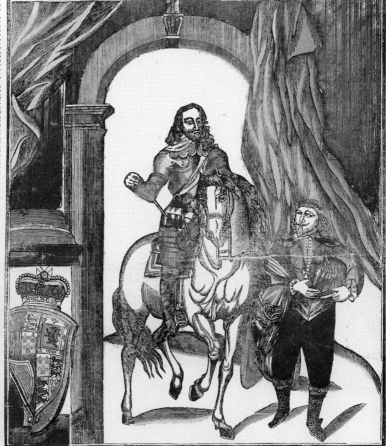

(*Facing page*) 6.1 Pages from *A Catalogue of Maps, Prints, Copy-Books, &c. From off Copper-Plates, Printed for John Bowles, at Mercers-Hall in Cheapside, London*, 1731. The 'Cheap Prints' listed on p. 39 include 'The Cartons [*sic*] of Raphael Urbin at Hampton-Court'.

(*Above*) 6.2 *The Portraiture of King Charles the First*, c.1745. Dicey's coarse copy of Van Dyck's fine painting accompanies an account of the abortive marriage negotiations between the future Charles I and the sister of Philip IV of Spain in 1623 (see fig. 5.5). The reason such a text appeared on an eighteenth-century print must have been as a reminder of the Catholic connections of the Stuart kings, especially topical at the time of the Jacobite Rebellion of 1745.

The popular print and high art 153

as 'the cartoons'. Once high-quality prints were selling well, the popular print publishers took them as models for their own publications. In the 1720s J. Farnell published one of the earliest surviving writing sheets with a set of small etchings of the cartoons in the borders (fig. 2.16). John Bowles listed four different sets in his catalogue of 1728 and versions in different sizes at different prices appear in subsequent catalogues (fig. 6.1). William and Cluer Dicey's 1754 catalogue included the cartoons in the form of engravings on 'cheap royal sheets', 'woodcut royals' and a sheet containing all seven cartoons.[2]

Van Dyck's beautiful equestrian portrait of Charles I appeared, through the intermediary of an engraving by Joseph Sympson the Younger of 1731,[3] as a crude hand-coloured woodcut on a broadside published by William Dicey and Company c.1745 (fig. 6.2 and front cover). Van Dyck's fine rendering of the King as the embodiment of elegance and power was quite irrelevant to Dicey. His

6.3 *The Crucifixion* after Peter Paul Rubens, 1631. Bolswert's fine print after Rubens's painting in Antwerp was known in England and was the source for a number of copies.

154 *The Popular Print in England*

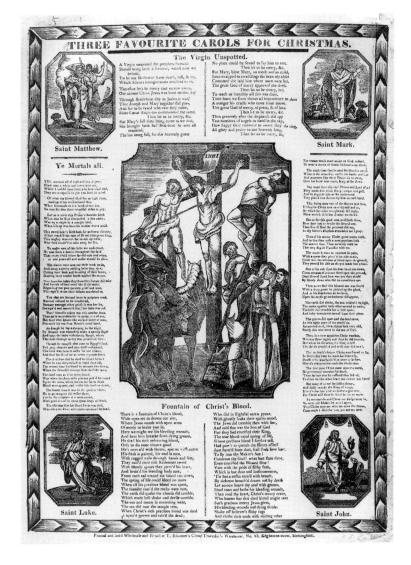

6.4 *Three Favourite Carols for Christmas*, c.1830–40.
The Crucifixion scene is based on a painting by Rubens (see fig. 6.3). The printmaker probably had no notion of his source and there would have been a series of intermediate prints between painting and woodcut. In 1823 William Hone lamented the passing of traditional carol sheets (see p. 19) but the style of this example suggests that it must date from later than that year.

woodcut is accompanied by a lengthy text describing the negotiations over Charles's proposed marriage with the sister of the King of Spain (see p. 132) and the broadside must have been intended to appeal to an anti-Jacobite audience. Charles I – great-grandfather of the Young Pretender who invaded England in 1745 – was presented not as the royal martyr but as a friend of Continental Roman Catholic powers, and an earlier example of Stuart treachery.

Other successful reproductions of paintings in the royal collection included Tintoretto's *Esther and Ahasuerus*, engraved by Simon Gribelin in 1712. The print was pirated on a larger scale for John Bowles.[4] A large woodcut version 'framed with deal but not glazed' was included in 1767 in the imaginary inventory of the cheap lodgings, in one of the 'dirtiest and meanest parts of town', of a clerk in a public office earning £50 a year.[5] The market for these cheap versions

6.5 *Painting*, from a series of prints of the Liberal Arts, *c.*1750, this impression *c.*1780. This series published by Carington Bowles's series is very close – though in reverse – to one by Henry Overton (fig. 2.22). One series is probably based on the other, but ultimately both derive from French compositions in the manner of Watteau.

of great paintings was as biblical illustrations or decoration. Purchasers of the Diceys' woodcuts were not concerned to have reproductions of works of high art: although the names of Raphael or Titian might appear – like famous brand names – in catalogues, most artists are unidentified and would have been irrelevant to both publisher and purchaser.

For religious subjects, where there was no native English tradition, the publishers' source for even the most lowly print would often be a reproduction of an Old Master: Rubens's great *Crucifixion* (*Le Coup de lance*) at Antwerp appeared in a woodcut version on a nineteenth-century Christmas carol sheet (figs 6.3 and 6.4). That Old Master paintings were so readily available as sources in the eighteenth and nineteenth centuries was due to the wide distribution of reproductive prints. Not only was there a succession of publishing projects to produce engravings of paintings in the great English collections, but prints from the continent of Europe were imported in vast numbers.[6] Most print publishers advertised foreign prints of some sort, and even a catalogue as down-market as the Diceys' of 1754 alluded to the fashion with an introductory note advertising that 'they are continually ... copying new sorts, from the various inventions of the best French, Dutch and Italian prints'.

Rather than commissioning a design, popular print publishers would normally

ask a printmaker to copy another print. After the passing of the Engravers'
Copyright Act in 1735 they were constrained for fourteen years from copying new
designs without permission, but topicality was of little concern at the lower end
of the market (see p. 88), and any inconvenience to the great City publishers –
infamous for their piracies of Hogarth and other ambitious printmakers – was
probably offset by the general growth in the print trade that the Act encouraged.
The cheapest prints rarely have dated publication lines; publishers would have
had no interest in claiming copyright of designs that were invariably already
second-hand. There was no premium on originality: motifs and entire compo-
sitions were copied indiscriminately. A high-selling print from one publisher
would be reproduced by another without hesitation. The Bowleses and Overtons,
in particular, often published very similar prints. Almost identical series of
the Liberal Arts portrayed as *fêtes champêtres* in the manner of Watteau were
published by both Carington Bowles and Henry Overton (figs 6.5 and 2.22). They
were clearly aimed at a middle-class audience, but a later set of extremely crude
versions of the same compositions would have found less discerning homes
(fig. 6.6).

Copies of one famous French print that would have found its market as a
curiosity was the virtuoso engraving by Claude Mellan representing the face
of Christ in one continuous line. It was used by writing masters as an example of

6.6 *Painting*, *c.*1800. This coarse hand-coloured etching must be based on either fig. 6.5
or 2.22.

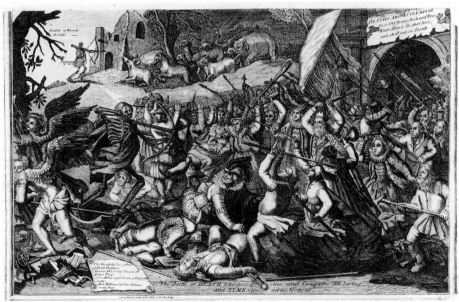

(*Top*) 6.7 *The Battle of Death and Time*, 1610. This print by David Vinckboons appeared in later states up to 1719.

(*Above*) 6.8 *The Battle of Death and Time*, c.1750. This composition is closely based on Vinckboons's prototype (fig. 6.7) and its allegorical approach to the inevitable triumph of Death must have seemed extremely old-fashioned by the time it was published in the age of Hogarthian naturalism.

(Left) 6.9 *Il Callotto resuscitato*, 1715. The elegantly distorted figures in etchings by Jacques Callot (1592–1635) were well known, but his name was also used as a generic term for humorous dwarfs.

(Right) 6.10 *The Twelve Months represented by Lilliputian Figures: January*, c.1720, this impression c.1740. This imitation of *Il Callotto resuscitato* (fig. 6.9) was probably published by one of the earlier members of the Bowles family (see pp. 51–2) and passed on to John Bowles who set up in business at the Black Horse, Cornhill, in 1733.

'striking' or 'command of hand' in order to advertise their skill. A copy appeared in Henry Overton's catalogue of 1717 (p. 17) as 'Our Saviour's head begun and finished with one stroke, very curious'; in his 1754 catalogue (p. 55) in the list of 'Demoy' sheets (10½ × 14 inches) where it is attributed to David Loggan and priced at 6d.; and in John Bowles's catalogue of 1764 as no. 142 in the list of 'Cheap prints, each printed on a sheet of royal paper … The head of our Saviour crowned with thorns, artificially represented by one single stroke of the graver, which formed from a point is continued waving round that point, without being crossed by other lines.'

Subjects of the type that appealed to a wide range of society could appear in

a succession of prints, steadily degenerating from fine works of art to cheap commercial products: see p.117 for the degeneration of the composition of a French etching of *c.*1560, *Le Caquet des femmes*, to *Tittle-Tattle*, a cheap print made from a damaged woodblock in mid-eighteenth-century London (pl. IIA). A composition by David Vinckboons of the struggle against Death and Time (fig. 6.7) published in 1610 (and in later states up to 1719) appeared on a larger scale in a print (fig. 6.8) published by William Herbert (1719–95), who advertised 'foreign prints chiefly collected from the works of the most celebrated artists'.[7] A genre of humorous dwarf figures appeared in Germany about 1604 in the first of several versions of *Il Callotto resuscitato* (taking the name of Jacques Callot but without any attempt to imitate the style of his dwarf figures; fig. 6.9). The series was plagiarized by John Bowles with figures such as Sir Jeffrey Jumble and Don Diego Surly-Phiz (fig. 6.10), and by Henry Overton with Mynheer van Squab, Sir Politick Fiery-Face and so on. By 1731 Bowles had also published what he called 'Liliputian subjects' in prints measuring three feet two inches by two feet; their popularity is attested by what he described as 'imperfect copies, and other indifferent pieces which bear the same general title with them'.[8] These 'pieces' might be the versions made by Thomas Taylor (fl. *c.*1710–26) in the form of a set of dancing masters and mistresses, which was itself copied in a set of crude woodcuts (figs 6.11 and 6.12).

High art provided sources for the popular print trade, but popular culture and popular imagery also impinged on the world of high art. Bosch, Bruegel and other Netherlandish painters used proverbs and popular symbolism, but their work was itself a source for popular print makers. A version of Bruegel's *The Land of Cockaigne* was published by Peter Stent *c.*1660 (fig. 4.54), and foolscap copies of his *Fat Kitchen* and *Lean Kitchen* appeared in Henry Overton's catalogue of 1717.

Painters whose subjects were peasants and tavern scenes have sometimes been thought to have been aiming at a popular market. Such themes occupy a low place in academic hierarchies of art, but they were certainly bought by the élite: Bosch was patronized by Philip the Handsome, Regent of the Netherlands; Bruegel by Cardinal Granvella in Brussels; Brouwer's Dutch boors enjoyed a market among the English aristocracy; Chardin's paintings of domestic servants found their way into the French royal collection; Goya used proverbs enacted by the poor of Madrid in designs for tapestries for the Spanish Bourbon court.

The English artist most often placed on the borderline between high and low art is Hogarth, and it is often assumed that his prints of London low life were bought

(*Facing page*) 6.11 *Dame Frowdella Doudykin and Sr Bacchus Suckbottle*, *c.*1720. This is one of a set of humorous dwarf dancing masters and mistresses with fanciful names that sum up their characters.

6.12 *Dame Frowdella Doudykin and Sr Bacchus Suckbottle*, *c.*1720. The engraved dwarf dancers shown in fig. 6.11 were popular enough for a woodcut version to be made.

Dame Frowdella Doudykin, *Dancing M.^{rs} to y^e* | S.^r Bacchus Suckbottle, *Tavern Dancing Mast.^r*
Country Shepherds & their merry Shepherdesses | to all True Toapers & merry Bottle Companions.

I teach both Sexes all their rural ayres, The Giddy World, I in a dance can show,
 And how to dance at Country wakes & fairs, From Justice Redface, to y^e Pale fac'd Beau;
Sometimes instruct 'em on y^e Wedding Night, But of all Drunkards, whether Rooks or Rakes,
 How things on both Sides may be manag'd right. The half pint Sot, y^e sneaking'st figure makes.

by people like the harlots and apprentices whom he depicted. This was far from the case. Hogarth achieved a high status by gaining the patronage of wealthy collectors; he did not target those who might treat prints as ephemera. His first major success, the six-print set of *A Harlot's Progress* in 1732, was expensive at one guinea; copies in different sizes were listed in Henry Overton's 1754 catalogue at 6s. and 12s. the set, still comparatively high prices. A print in the collection of George Clarke at Worcester College, Oxford, makes the point clearly: a good copy of Hogarth's *A Midnight Modern Conversation* published by John Clark and Bispham Dickinson,[9] only slightly smaller than the original, sold for 6d., while Hogarth's print sold for 5s. to advance subscribers and for 7s. 6d. after publication. A later two-sheet version of the subject was sold by John Bowles for 1s. 6d. (fig. 4.53).

Although Hogarth made some forays into the popular print market (see p. 65), his main contribution to the cheap end of the trade was in providing a rich source for printmakers of succeeding generations. Not only were cheaper copies made of entire compositions, but details were extracted and placed in other contexts. The background to his Gin Lane (fig. 6.13) appears in a far less bleak print bemoaning the fate of a man chained to a drunken wife (fig. 4.48), and an early-

6.13 *Gin Lane*, 1751. William Hogarth claimed to have a moral purpose in publishing this dreadful depiction of the effects of alcoholism, but, at 1s., it was a comparatively expensive print aimed at a respectable middle-class audience.
The poor – as the print announces – could be 'drunk for a penny / dead drunk for twopence'.

(*Facing page*)
6.14 *An Awful Warning to Blasphemers*, *c.*1820. This West Country broadside warning of the dangers of reading 'seditious and blasphemous books' is typical of the conservative versions of popular prints that were distributed in England in the period after the French Revolution (see Chapter Five).
The woodcut illustration uses elements from Hogarth's *Gin Lane* and *Beer Street* to stand as a generalized image of drunken disorderliness.

AN AWFUL
WARNING TO BLASPHEMERS

The Terrible Judgment of GOD manifested on Six Profane Young Men, at Brodney, in Somersetshire; who, through reading Seditious and Blasphemous Books, became converts to Infidelity—and, in the height of their Impiety, went into the Churchyard at Midnight, and made the horrible attempt of taking the Blessed Sacrament in the name of Satan, when the hand of Heaven stopped them in the midst of their hellish wickedness. To which are added a Sermon preached upon the occasion, and a suitable Copy of Verses.

"Behold, the Day cometh that shall burn as an Oven, and all that do wickedly, shall be as stubble; and the Day cometh that shall burn them up, and leave them neither root nor branch."

A WARNING TO BLASPHEMERS

I mean liv'd of late in Brodney town,
Six wild and wicked youths,
Who did deny God's holy word,
And all his wholesome truths.
The joys of Heaven they denied,
And punishments of Hell;
Declaring, when the body died,
The soul would die as well.

One night they had been drinking late,
'Till they could drink no more—
Blaspheming Heav'n at monstrous rate,
With horrid oaths they swore,
Into the churchyard they would go,
Though heav'n and earth might quake;
And there in Satan's cursed name
The sacrament they'd take.

Into the churchyard dark and drear
They carried bread and wine;
When, lo, a voice did strike their ear,
It was a voice divine—
"Mad youths, forbear! nor dare provoke
The wrath of Heaven above;
Tempt not the Lord—believe his word,
His mercies, and his love."

But heedless of the warning kind,
Which Heaven in pity sent,
So wicked were their hearts inclin'd,
And on destruction bent.
They only laugh'd, and curs'd, and swore,
Reviling all that's good;
To hear the oaths come from their mouths,
Would chill a Christian's blood.

But, mark ye, how the wrath of God
Pursued these wicked men,
They soon did feel his chast'ning rod,
Quick judgments followed them;
In the midst of their blasphemous deeds
He hurl'd them far and near,
Which fill'd their coward hearts with dread,
With trembling and fear.

Behold, how soon their wicked mirth
Was chang'd to dismal cries,
While lying prostrate on the earth,
Tears flowing from their eyes.
Mercy, mercy, they did exclaim,
And looking to the skies,
They did invoke that holy Name,
Which they had so despis'd.

Now, when the morning did appear,
The clergyman did go
To walk into the churchyard path,
As he was wont to do:
And there John Williams he espied,
And William Crosby too,
The blood all running from their eyes,
Their flesh all black and blue.

And near to them the other four,
All bruised o'er did lie;
Stephen Newell lamenting sore,
And William Jefferies,
Joseph Thomas, and Robert Lawson,
Lay in different parts,
Imploring Heaven's Almighty hand
To turn their harden'd hearts.

Now, may these lines a warning be,
To all both far and near,
To rev'rence Heaven's high Majesty,
His hallowed name to fear:
Ne'er to deny His blessed Word,
Nor take his name in vain;
But remember the end of these six young men,
Their sufferings and their shame.

I cannot think this account can be thought amiss of, when once it comes to be read over; since the world has come to such a wicked pass, and how old and young are so prone to sin and wickedness, that one can scarce walk in the streets without hearing the most horrid cursing and swearing, out of the mouths of hundreds—nay, the very children oftentimes blaspheming, and sinking their precious and immortal souls, in a most vile and desperate manner, even enough to bring down the King of Heaven from His throne, if God was so severe as to send his judgments so often as we call upon him for them. What then must we think will become of those who will believe in neither GOD nor Devil?—For I say there are such so hardened and blind in their hearts.

THE BLASPHEMERS PUNISHED.

At Brodney, in Somersetshire, lived the following personages, viz., John Williams, Henry Crosby, Stephen Newel, William Jefferies, Joseph Thomas, and Robert Lawson, six wicked and blasphemous young men, these young men lived very well in the world, and took pains to educate them in all godliness and sobriety; but they gave themselves up to wild courses of life, and followed all manner of wickedness, particularly in swearing, and blaspheming the name of the most High God. They had, by an habitual course of wickedness, so hardened themselves, that they taught each other to believe, that there was neither God nor Devil. And when they heard their parents talk of receiving the sacrament of the Lord's Supper, they said, they did not believe it signified any thing, and that it might as well be received in the name of the Devil, as in the blessed name of God, since they did not believe there was either one or the other.

But not long they continued in this wicked course of life, before the vengeance of the Almighty overtook them in their career—for one night last week, as they were all drinking together, at the sign of the Angel, in the said town, where they continued swearing and drinking till midnight, and being much intoxicated with liquor, and mad with wickedness, they conceived the horrid idea of carrying bread and wine into the churchyard, and there to take the sacrament in the cursed name of the Devil, when a loud and distinct voice pronounced these words:

"Oh! ye wicked and blasphemous young men, stop your hands, and proceed no farther in your wicked and desperate designs: consider there is a just and terrible God above, who will send down his just judgments upon you! Go, therefore,—turn and repent before it be too late."

Though they all distinctly heard the voice, yet they paid not the least regard to it, but went on with their wicked design. No sooner had they began, but there was heard the most astonishing cries and bellowings, accompanied with dismal groans, enough to melt a heart of stone, which struck such a dreadful surprise to the Rev. Mr. Simmons, and his family, who lived near the churchyard, that they could not lie in their beds. When Mr. Simmons got up to see what was the matter, he saw the bread a wine, but none of the people. Unable to guess what could have occasioned the extraordinary noise, he went to bed again.

Early the next morning, Mr. Simmons and his family went into the churchyard again, when they saw John Williams, and William Crosby, lying behind the churchyard wall, in a most deplorable condition, with blood running out of their mouths and ears.

Stephen Newell, William Jefferies, Joseph Thomas, and Robert Lawson, were found in different parts of the field adjoining to the churchyard, in the like miserable condition, to the great grief of their parents.

This remarkable and just judgment, we hope, will be a warning to all wicked persons;—the truth whereof may be attested by several people of good repute, who have desired that this affair might be printed and made public for the use and benefit of the rising generation.

A SERMON,

Preached on the Sunday following, upon this solemn occasion, by the Reverend Mr. Simmons.

Beloved Brethren,

This heinous sin will by many be taken for the sin against the Holy Ghost; but I will both shew you what is, and what is not that sin. I shall begin first with a description of this unpardonable sin, shewing what is not, and positively what is.

First. It is not every quenching of the motion of the spirit that is not the spirit.

Secondly. A man may commit many heinous and crying sins—a man may be an idolator, a whoremonger, a fornicator, a murderer, and work witchcraft and sin, with a very heavy hand, as Manasses did, and as Mary Magdalen, who had seven devils cast out of her, and yet by the mercy of God be pardoned, as they were.

Thirdly. A man may sin presumptuously against light and knowledge, and yet not commit this sin unto death; for St. Peter, when he denied Christ, he did it against great knowledge of Christ; and yet for all that, Christ looked upon him with a merciful eye. St. Paul, while fiercely prosecuting the believers of the word of God, was converted, and became a most zealous and powerful preacher.

Fourthly. It is not final unbelief, nor final impenitence that is the sin; and Christ himself hath said, that all manner of sin shall be forgiven unto man, except the sin against the Holy Ghost. But you are to take these words in the right sense and meaning; for, again, Christ said, he that sins against the Holy Ghost has no forgiveness, neither in this world, nor in that which is to come.

Thus I have shewn you what is not that unpardonable sin, and shall now show you positively what is the sin unto death. There are two sorts of people that cannot commit this sin.

First. A true believer cannot commit it.

Secondly. The grossly ignorant cannot commit it.

But there are some who have a light, and no grace: these are they who are liable to commit the sin against the Holy Ghost.

A HYMN FOR GRACE.

ALMIGHTY Lord! thou King of kings,
From whom all joy and comfort springs;
Hear, Sovereign Lord! enthron'd above,
And deign to shed thy bounteous love.

A worm, permitted, fain would pray,
And learn thy blessed will t'obey.
Teach me thy mercies for to sing,
In grateful song to thee, my King.

Bestow then, mighty God, thy grace,
And to a sinner show thy face,
That so I may with joy pursue
The road thy saints with comfort go.

Let gratitude my tongue employ,
And hymns of love be all its joy,
So be it, Lord! thy blessing give,
That I with thee may ever live.

CHRISTIAN SOLDIER.

BY faith enlisted am,
In the service of the Lamb;
Present pay from Him receive,
Peace of conscience he does give.
I'm a soldier, soon shall be
Happy in eternity.

What a captain have I got,
Is not mine a happy lot?
Therefore I will take the sword,
And fight for Jesus Christ my Lord:
I'm a soldier, soon shall be
Happy in eternity.

Come ye worldlings, come and list,
'Tis the voice of Jesus Christ;
Whosoever will may come,
Jesus Christ refuses none:
So a soldier you shall be
Happy in eternity.

Wicked men I need not fear.
Tho' they persecute me here;
Tho' they may the body kill,
Christ is King on Zion's hill:
I'm a soldier, soon shall be
Happy in eternity.

Jesus now my Captain is,
Conquest I can never miss;
Let the fiends of hell engage,
Threaten, fret, and foam, and rage:
I'm a soldier, soon shall be
Happy in eternity.

Unto those that faithful be,
'Till their blessed Lord they see;
It shall then be said, well done,
Enter thou and take thy crown:
I'm a soldier, soon shall be
Happy in eternity.

Brother soldiers still fight on,
Till the battle you have won,
The great Captain we have chose,
Never did a battle lose:
We're His soldiers, soon shall be
Happy in eternity.

Soon the triumph we shall share,
With our royal Captain there,
Soon the Conqueror's crown receive,
And with Him for ever live:
Who would not a soldier be
When ensur'd of victory?

We have almost gain'd the day,
Soon shall throw our arms away,
Every for most quickly yield,
See, they're flying o'er the field:
Fight a moment, and you'll be
Happy in eternity.

Devonport: Printed and Sold by ELIAS KEYS.

Sold also by B. STONE, Exeter;
A. BROWN, 27, Bristol Bridge, Bristol;
W. BURRIDGE, Truro;
J. PERROW, St. Austell, Cornwall;
And by S. REED, Newport, Monmouthshire.

(*Facing page*) 6.15 *The Wandering Jew: Or, the Shoemaker of Jerusalem*, c.1720. The 'Wandering Jew' was condemned never to rest after failing to help Christ on the way to Calvary. The image of a bearded man with a staff striding past a town appears in popular prints throughout Europe.

6.16 *The Wandering Jew's Chronicle*, 1674–80. The Wandering Jew's longevity gives him a privileged view of history and in this ballad he is able to characterize the reigns of successive monarchs from William I to Charles II. The illustration takes the form of a chronology of kings and queens.

(*Above*) 6.17 *L'Apôtre Jean Journet*, 1850. This lithograph by the great Realist painter Gustave Courbet imitates the broadside format and the motif of the Wandering Jew. Its subject is Jean Journet, an eccentric socialist; the ballad describes the many aspects of humanity that he has seen ('J'ai vu …'), and echoes the repetitive verses of *The Wandering Jew's Chronicle* ('I saw …').

nineteenth-century West Country moralizing broadside (fig. 6.14) uses a woodcut combining elements of both *Gin Lane* and *Beer Street*, the designer apparently unaware that Hogarth had portrayed beer as a healthy contrast to the deadly gin. Execution broadsides regularly used the scene of the Idle Apprentice's hanging even after the place of execution had moved from Tyburn to Newgate.[10]

A subject with appropriately widespread popularity is the Wandering Jew with his pack and staff (fig. 6.15) – condemned to wander forever after failing to give Christ a moment's rest on the way to crucifixion. The focus of attention is often not his cruelty to the suffering Christ but his longevity and the special view of history it allowed him. The ballad of the *Wandering Jew's Chronicle* (fig. 6.16) summarized the reigns of English monarchs from the Conquest 'When William, Duke of Normandy / With all his Normans gallantly, / This Kingdom did subdue'. In the British Library are versions, illustrated with a series of the heads of successive monarchs: the earliest was published in the 1670s by Coles, Vere, Wright and Clark, another with additional verses by J. White of Newcastle, *c.*1730, and another by William Dicey, *c.*1740.[11] The Wandering Jew emerges into high art in the work of Gustave Courbet (1819–77), whose interest in popular culture led him to take seriously the cheap prints produced in Epinal and other French cities in the middle of the nineteenth century (see pp. 216–18). In 1850 he imitated the broadside ballad format in a lithograph of Jean Journet, a well-known eccentric socialist, in the guise of the Wandering Jew, surrounded by simple verses telling of what he has seen throughout his life (fig. 6.17). In 1854 Courbet painted himself in the pose of the Wandering Jew in his famous painting *The Meeting*.[12]

CHAPTER SEVEN
THE MARKET FOR POPULAR PRINTS

The popular prints that survive are chiefly those that were purchased by collectors and kept in albums (see p. 192). They are exceptions to the rule. Collectors were the primary market for fine prints, but they were certainly not the buyers targeted by publishers of cheap prints. The vast majority of such prints were bought casually and treated carelessly. Paper, especially cheaply made paper, is fragile and survives only if looked after; prints bought as ephemera were soon destroyed and the few that survive by accident are in poor condition. There is little data on who owned which of the prints at the bottom end of the market. There are no catalogues or detailed inventories of prints on the walls of taverns, schoolrooms and cottages, as there are for collections in connoisseurs' libraries. Literary and visual records of prints show them in the settings for which they were intended, but such records are by no means concrete evidence and do not lend themselves to generalizations about the market as a whole.

More is to be gleaned from the study of the selling of a whole range of cheap manufactured goods that were increasingly available in England from the sixteenth century onwards. Much information on the lower end of the early consumer society has been brought to light in recent decades by social historians, in particular Margaret Spufford, whose work demonstrates the existence of a more complex and far-reaching market than might hitherto have been supposed. But before considering documentary evidence it is worth looking first at what prints themselves can reveal about the way in which they were sold.

In Hogarth's *March to Finchley* (1746), a young woman carries a basket laden with copies of the national anthem and portrait prints of the Duke of Cumberland. She would have bought a few dozen from a publisher at a discount rate and is selling them to the crowd that has gathered in Tottenham Court Road to cheer the militia as it sets off to defend London against the Jacobite army marching down from Scotland behind Bonnie Prince Charlie.[1] This is the sort of context in which many popular prints would have been sold. They were impulse buys or souvenirs, bought to commemorate national emergencies or joyous celebrations, or at local events like executions and fairs. Before the Reformation they would also have been bought at pilgrimage centres like Canterbury and Walsingham, as religious mementoes in the long-established tradition of pilgrim badges (fig. 4.1). Sellers could exploit atmospheres either of tension or of relaxation: they would sell portraits of leaders who would save the day, broadsides of criminals come to repentance and punishment, prints of coronations and

victory firework displays or, for those enjoying a rare holiday and with a few
pence to spend, amusing ballads and traditional tales with crude woodcuts. Such
prints could be a powerful expression of public feeling: in June 1659 – in the last
months of the Commonwealth – a satirical print of Richard Cromwell (pl. III) was
'cried by the women in the street' and the implied contempt was said to have made
Cromwell confine himself to his chamber.[2]

 Street sellers were among the poorest of the poor, and evidence about indi-
viduals is scanty, but some sort of picture of their lives is to be found in the
cheerless biographical accounts on execution broadsides. Elizabeth Price, who
was executed on 31 October 1712 aged 'about 37 Years' had earned her living
'picking up rags and cinders, ... selling fruit and oysters, crying hot-pudding and
gray-peas in the streets' before turning to burglary. In the same month Susan Perry
was whipped for committing a felony and on 13 March 1713 she was executed
for robbing and murdering a child; she was 'not above 22 Years old', had been

born at Greenwich and trained as a mantua-maker but could not find work in that trade so she 'betook herself to cry, sometimes newspapers, and at other times fruit, etc. about the streets'.[3]

London 'Cries' appear in prints from the early seventeenth century onwards,[4] and by the eighteenth century ballad- and broadside-sellers were commonly depicted. Rowlandson's disreputable 'chaunter' (fig. 7.1) is accompanied by a howling dog, making it clear that her voice was far from easy on the ear. Robert Seymour caricatured a family of caterwauling ballad-singers as a ragged group of cats and kittens (fig. 7.2). Some sellers were specialists: J. T. Smith recalled 'a noisy bow-legged ballad-singer' named Joseph Clinch, famous around 1790 for his song about Dick Whittington and his cat, who sold 'a coarse old wood-cut of the animal, with its history, and that of its master, printed in the back-ground' (fig. 7.3).[5] Some had more elaborate marketing devices like the peep- or raree-shows where prints were fitted into large boxes and viewed through a lens that enlarged them to life size (fig. 7.4). Showmen would carry the boxes from place to place on their backs.

In 1748, two years after the Jacobite invasion, Smollett indicated who might be the purchasers of such material: he had Roderick Random writing for the:

7.2 *Ballad Singers. Any thing for an honest living*, c.1830. Seymour's mocking caricature of a family of caterwauling ballad-singers indicates their very low status.

DRAWN AND ETCHED BY J.T.SMITH. DOMESTIC ARCHITECTURE. DRAWN IN JULY 1791

SOUTH EAST VIEW OF THE OLD HOUSE LATELY STANDING IN SWEEDON'S PASSAGE, GRUB STREET.

EXTERNAL SPECIMEN OF THE THE ABOVE, IS A SINGULARLY CURIOUS SPECIMEN, (IN LONDON) OF AN EXTERNAL WINDING STAIR CASE. THIS HOUSE WAS TAKEN DOWN
HEAVY TIMBER STYLE. IN MARCH 1805.

LONDON PUBLISHED AS THE ACT DIRECTS JAN.Y 20 1811, BY JOHN THOMAS SMITH N.18, GREAT MAY'S BUILDINGS S.T MARTINS LANE.

printers of halfpenny ballads, and other such occasional essays as are hawked about the streets ... my works were in great request among the most polite of the chairmen, draymen, hackney-coachmen, footmen, and servant-maids; nay I have enjoyed the pleasures of seeing my productions adorned with cuts, pasted upon the wall as ornaments in beer cellars and cobbler's stalls.'[6]

In the mid nineteenth century Mayhew gave more detailed accounts of the lives of poor traders than any predecessor. In about 1860 one of his collaborators interviewed a ballad-singer living in a lodging house in Drury Lane. The man could read but not write and earned 2s. to 2s. 6d. singing and selling ballads on a good night, but nothing on wet evenings. For many years he had sung all over London, in Hammersmith, Paddington, Marylebone, Somers Town, Camden Town, Whitecross Street, the City, Commercial Road and Whitechapel, and his favourite songs were *Gentle Annie*, *She's Reckoned a Good Hand at it*, *The Dandy Husband*, *The Week's Matrimony*, *The Old Woman's Sayings*, *John Bull and the Taxes*, *The Dark-eyed Sailor* and *The Female Cabin-boy*. He sometimes sang alone, sometimes with mate, and occasionally begged in Regent Street, Bond Street, Oxford Street or Holborn. He sometimes did odd jobs for money, but when times were hard he picked pockets for handkerchiefs.[7]

Mayhew was able to distinguish specialisms among sellers of what can broadly be called popular prints: 'the flying stationers, or standing and running patterers;

(*Facing page*)
7.3 *Domestic Architecture*, 1811. This illustration to *London*, one of J. T. Smith's anecdotal histories, shows a picturesque scene of urban decay drawn some twenty years before publication. The incidental interest is focused on Joseph Clinch, famous around 1790 for his song about Dick Whittington and his cat. He appears to be selling slip ballads from his basket but draws attention to himself with the image of the cat held aloft on a pole.

7.4 *Raree show* from *The Omnibus*, 1841. George Cruikshank's delicate design shows children looking at prints of exotic scenes through lenses in a peep- or raree-show.

The PRETTY MAID buying a LOVE SONG.

the long-song sellers; the wall-song sellers [or "pinners-up"; fig. 7.5]; the ballad-sellers; the vendors of play-bills, second editions of newspapers, backnumbers of periodicals and old books, almanacks, pocket books'.[8] Then there were:

the 'patterers', or the men who cry the last dying speeches, etc. in the street [fig. 1.1] ... those who help off their wares by long harangues in the public thoroughfares, are a separate class. These, to use their own term, are 'the aristocracy of the street-sellers' boasting that they live by their intellect ... the patterers are generally an educated class, and among them are some classical scholars, one clergyman, and many sons of gentlemen.[9]

At the other end of the street trading hierarchy were 'Screevers, or those who beg by screeving, that is, by written documents, setting forth imaginary causes of distress' (fig. 7.6).[10] Others who were little more than beggars were 'the sellers of flowers and songs [who] are chiefly boys and young girls. ... When the flower

season is over they sell songs – those familiar productions of Ryle [see p. 62], Catnach and company.' Mayhew's collaborator Andrew Halliday described a boy whom he had seen at intervals over ten years: at first the boy begged with his sister in public-house bars; later he carried pennyworths of flowers, or matches, or halfpenny sheets of songs; sang duets with his sister; sold fusees (a type of match); polished shoes; swept crossings; sold mackerel. Unconsciously echoing the accounts of the criminal careers of Elizabeth Price and Susan Perry 150 years earlier, Halliday pointed out that 'many who have such an introduction to life finish their course in a penal settlement'.[11]

A local antiquarian remembered similar traders in ballads and cheap prints in mid-nineteenth-century Carlisle:

7.6 *The Poor Widow and her Praying Boy* and *My Jesus*, c.1850. The begging note – 'Please to buy this of a poor family' – suggests that this sheet was used by one of the 'screevers' who, according to Mayhew, begged 'by written documents setting forth imaginary causes of distress'; the title of the first ballad would have lent itself to such a use.

The 'garlands' were run out of the market by the competition of the 'runners-up' and long-song-sellers. The pinners-up used to take possession of dead walls, or the fronts of unoccupied houses, on which to affix their wares, consisting of yard-long slips of new and popular songs, three slips a penny, while inside a huge open gingham umbrella they displayed a lot of cheap engravings [fig. 7.7]. A favourite pitch for runners-up during Carlisle fairs used to be the railings of the Nisi Prius Court, opposite the Lonsdale monument, an old blanket being thrown over the rails for the display of their stock in trade. The long-song sellers pasted three yards of songs together, and carried their wares about suspended from the top of a tall pole, crying 'Three yards a penny, songs, beautiful songs, newest songs.'[12]

Even after 1900 there were still railings festooned with song sheets for a half-penny in Farringdon Road, London, near one of the old centres of the popular print trade in Smithfield.[13]

The Carlisle traders probably included pedlars who travelled the country selling small goods at markets and fairs.[14] Many of these were far from the poverty-stricken quasi-beggars of the London streets. They were successful enough to threaten the trade of established shopkeepers, whose complaints – together with government desire to control the distribution of printed material –

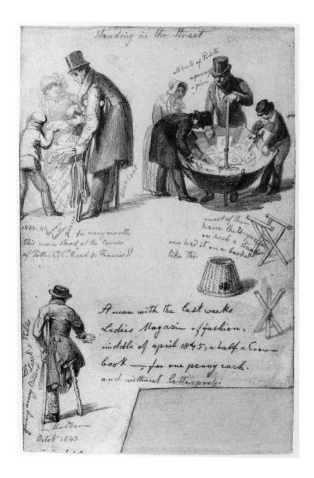

7.7 *Street vendors, including a man selling prints from an umbrella, c.1843.* Mayhew recorded seeing at the Saturday night and Sunday morning markets in London 'a man with an umbrella turned inside up and full of prints'. This drawing is one of George Scharf's sketches of London street life.

led to successive legislation to limit the activities of itinerant traders. As early as 1552 a licensing procedure was put into effect, and the 1597 Act against rogues, vagabonds and sturdy beggars included 'all pedlars and petty chapmen wandering abroad', providing for them to be whipped and returned to their place of birth. Such restrictions did not prevent itinerant trading: between 1682 and 1687 the Master of the King's Revels paid £5000 a year for the privilege of collecting licence fees. In the year 1697–8 two and a half thousand chapmen were licensed, some four hundred travelling on horseback, the remainder on foot. Many chapmen were respected clients of print publishers and stationers and were allowed to purchase goods on credit. Publishers' catalogues almost invariably advertised special prices for 'country chapmen', and wills frequently refer to debts owed by such clients.[15]

A number of publications from the seventeenth century onwards were designed to help itinerant tradesmen: broadsides in the Society of Antiquaries collection (Lemon 254 to 256) are laid out as tables, like those in modern road atlases, giving the distances between towns; in 1688 *The City and Country Chapman's Almanack* provided the useful function of listing dates of fairs and market days and detailing the post roads between them. A broadside of 1755 (fig. 4.41) combines a print of an extraordinary man with a useful note of market days and distances from London of towns on the road to Yarmouth.

The amount of printed material sold was enormous. The probate inventory of the publisher Charles Tias (d. 1664) lists reams (i.e. bundles of five hundred each) of 'pictures' and hundreds of titles of chapbooks and ballads: there were thirty-five thousand ballad sheets, more than nine thousand copies ready for sale of books under 6d. (most under 4d.) and a further eighty thousand awaiting binding. The most popular titles appear as broadsheets and as books in several formats.[16] Such figures give an indication of the scale of the trade in popular prints and cheap illustrated texts. The numbers sold by the leading publishers of the day must have been even higher.

The term 'chapman' could extend to small shopkeepers. Small towns would not have had specialist print shops but shops would have included prints in a wider range of goods. Laurie & Whittle's catalogue of 1794 included, among their cheaper prints, a section of 'quarto drolls ... well calculated for the shop windows of country booksellers and stationers ... the greatest variety of whimsical, satirical and burlesque subjects (but not political)'. Such shop window displays (fig. 1.2) served to encourage purchasers, but also brought prints to the attention of many people who could not have afforded to buy prints; at the same time they would have made some of the coarser products familiar to those who might have thought them beneath their dignity. J. P. Collier gave a number of hand-coloured woodcuts of traditional subjects to the Society of Antiquaries in 1854, describing them as 'familiar as being exhibited in the shop windows in the early portion of the present [century]'.[17] Laurie & Whittle's avoidance of political subject matter was evidently a personal choice: the radical William Hone

remembered Whittle's views – 'no change – church and state, you know! – no politics, you know! – I hate politics! There's the church, you know ..., and here am I, my boy! It's my sign, you know! No change, my boy!'.[18]

A country shopkeeper whose surviving papers have been published (see Willan) is Abraham Dent, who in 1774 inherited his father William Dent's shop in Kirkby Stephen, Westmorland.[19] Willan's study is illuminating in its account of the complex network of trade that by that time linked all parts of the country through the agencies of the carriers' wagons and, very importantly, bankers' letters of credit. Dent sold books, grocery, textiles, haberdashery, tobacco, medicines,[20] wine and beer and built up a large trade in locally knitted woollen stockings, of which he sold large numbers to the army during the American War of Independence and the Napoleonic Wars. He was supplied with paper, almanacs, magazines, books and, probably, newspapers by William Charnley of Newcastle on Tyne (for Emerson Charnley of Newcastle, see pp. 186–7).

Popular prints were bought in the street, at markets and fairs and in general stores, but this is not to say that the popular print was of interest only to those who could not appreciate more sophisticated work. David Landau and Peter Parshall raise the question of the market for the popular print in the Renaissance: 'Art for an uneducated public? Art for everybody, educated and uneducated alike?'[21] In England for the whole of the period dealt with in this book the second is the appropriate definition. Even after specialist popular print publishers emerged in the eighteenth century they did not necessarily serve a distinct market. Connoisseurs who enjoyed fine prints might also buy a print of a famous criminal or of an exotic beast they had seen in a tavern in Smithfield. If Catnach could sell impressions of an execution broadside to one in eight of the population (see pp. 97–8) he was not only serving the uneducated.

This chapter has so far concentrated on the very cheapest prints, but there was a range of prints above that level that nevertheless cannot be classified as fine art. Many such prints could be described as 'popular' in that purchasers were more interested in their subject matter than in their artistic merit. A catalogue of 1716 contains a list of the sort of prints that must have had a substantial market.[22] It also indicates one method by which prints were sold in the early years of the eighteenth century. It is transcribed here in full:

A large and curious collection of maps and prints, coloured and plain; fit for halls, chimney-pieces, staircases, closets, etc. which will be exposed to sale by way of auction; (or who bids most) on *Thursday the 22 of November 1716 at the Royal Oak in Briggate, Leeds beginning at four o'clock*

Conditions of Sale. I. He that bids most is the buyer. II. The goods to be delivered as they are sold, or the morning after; and the moneys to be paid on the delivery of the goods.

1 Map of the World. Coloured.
 Of Great Britain.
 Of North Britain.
 Of South Britain.
5 A fine Draught of the Elements.
 A Dutch Fancy.
 A Prospect of London. 2 Sheets.
 Of Westminster.
 Of Jerusalem.
10 Of St. John's College.
 Of the Castle and Gardens of
 Versailles.
 Of Blenheim House.
 A Set of the Roman Emperors.
 Of the Empresses.
15 Of the Evangelists.
 Of the Apostles. Large.
 Of Caesars. By Titian.
 Of Caesars on Horseback.
 An Epitome of Heraldry.
20 The Christian's Coat of Arms.
 Effigies of King George.
 Of the Prince of Wales.
 Of the Princess of Wales.
 Of Queen Anne.
25 Of Prince George.
 Of King William.
 Of Queen Mary.
 Of King James the II.
 Of King Charles the II.
30 Of King Charles the I.
 London Cries.
 A Set of the Seasons.
 Of the Times of the Day.
 Of the Senses.
35 Of the 12 Months.
 The Tent of Darius.
 A Dutch Droll.
 The Statue of Queen Anne.
 A Prospect of Buckingham House.
40 Epitomes of Heraldry. Coloured.
 A Draught of the Commandments. Large.
 Large Heads. By Vanderbank.
 Views of Noble Mens Seats in Scotland.
 Prospects of the Colleges in Oxford.
45 In Cambridge.
 A Draught of the Commandments. Small.
 Of Ships.
 The Mausoleum.
 Large Heads of Princes, &c. By Gulston.

50 Duke of Marlborough on Horseback.
 Prints in Optics.
 Lord Chief Justice Holt's Tomb.
 Cebetis Tabula.
 Figures of the Life of Christ.
55 Prospect of Trinity College.
 Of the Royal Palace at Kensington.
 Of the inside of Paul's Church.
 Of Chelsea Hospital.
 Of King's College Chapel.
60 Of Hampton Court.
 Maps of Europe.
 Of Asia.
 Of Africa.
 Of America.
65 Of Germany
 Of France.
 Of Spain.
 Of Holland.
 Of Flanders.
70 Of Sweden.
 Of Denmark.
 Of Turkey.
 Of England. With Tables.
 Of Scotland. With Tables.
75 Of the Roads in England.
 Of Yorkshire.
 Of Derbyshire.
 Of Nottinghamshire.
 Of Lincolnshire.
80 Caesars curiously Coloured.
 Fine Mezzotintos. Large.
 Fine Ditto. Small.
 A Prospect of Canaan.
 Of large Cities. 4 Sheets.
85 Plan of the Hemisphere.
 Merry Fancies.
 Theatrum Passionis.
 Pictures for Sashes. Plain.
 Ditto. Coloured.
90 A Prospect of Steeples of several
 Churches.
 Prints of fine Buildings.
 Maps of Ancient Geography.
 Scripture Stories. By Visscher.
 Largest Views of London.
95 Ditto. Coloured.
 The Battles of Constantine.
 A Set of Cartoons.
 A Quakers' Meeting. Coloured.

Flower Pots. Coloured.
100 Chimney-Pieces. Coloured.
Glorious Campaigns.
Coloured Medlies.
Dutch Fancies. By Landray.
Ditto. 2 Sheets.
105 Loves of Albain.
Effigies of Archbishop Sharp.
Of the present Archbishop of York.
A Large View of Oxford. 2 Sheets.
King George's Declaration. Coloured.
110 His Speech. Coloured.

Prospects of St. Pauls. Small.
Moll's best Maps.
French Prints on Royal Paper.
Large Sign Prints. By Reuben [sic].
115 Heads curiously Coloured.
Scripture Histories. Ditto.
117 Prospects of York Minster.

Large and small maps on cloth; finest Mezzotintos for painting on glass, and great variety of other sorts of maps and prints, too many to be particularized.

The time and place of the sale (shown above in italics) have been completed in manuscript, indicating that the same catalogue would have been used on a number of occasions. The auctioneer clearly acquired a stock of prints from a publisher and travelled from town to town selling them at auction. The inclusion of maps and views of Yorkshire, Derbyshire, Nottinghamshire and Lincolnshire, as well as London, Oxford, Cambridge and places of more general interest, indicates that this catalogue was to be used in towns in the Midlands and north of England.

The prints listed cover an extraordinary range, from *London Cries*, *Merry Fancies* and – no doubt scurrilous – *A Quakers' Meeting*,[23] to portraits of the then Archbishop of York and his predecessor, and prints after major paintings: the Raphael cartoons (see pp. 152–4), *The Tent of Darius* and *The Battles of Constantine* by Charles Le Brun and *Glorious Campaigns* after Louis Laguerre's wall paintings of battles of the Duke of Marlborough in Marlborough House. All these paintings had been engraved only recently for the first time and (whether or not what were being offered were the prime engravings) would have appealed to purchasers of some discrimination, but nevertheless no painters' names are given. Artists' names appear only when they identify specific examples of well-known subjects: Titian ('A set of Caesars'), Peter Vandrebanc ('Large Heads'),[24] Visscher ('Scripture Stories'), Landry ('Dutch Fancies') and Rubens ('Large Sign Prints'). Subjects and categories are familiar from print publishers' catalogues.[25] About one-sixth of the items in the catalogue are maps. About half of the prints in the list are either portraits or topographical subjects, while the remainder are divided among decorative 'fancies' and 'drolls', traditional series (such as the elements, senses, seasons, months and times of day),[26] secular and religious emblems, biblical narratives, reproductions of paintings, and military and naval subjects. Mezzotints are described as 'Large', 'Small' and 'for painting on glass' (see fig. 2.22) with no indication of subject matter. No medium is given for other prints, but it can be assumed that they would have been engravings and etchings since woodcuts would have been listed as such. 'French Prints' are included as a separate, unspecified category, although 'Dutch Fancies. By Landray' would have been imported from the Paris publishers Landry. Other items indicate uses for

Famous Boxing Match.

YESTERDAY morning, (Tuesday October 15th,) the attention of the milling amateurs and fancy of this town and neighbourhood, was directed to the field of sport, at Sutton Coldfield, to witness a contest between two young men, named Griffiths and Bayliss, the former an inhabitant of this Town, and the latter from Wednesbury, for a purse of £40. They were nearly of equal weight; but Bayliss had the advantage in heighth and reach.—The combatants set too at one o'clock, and after fighting two hundred &thirteen rounds in the space of four hours, (half minute time,) the battle was drawn, each party being so fully satisfied as to prevent the possibility of either rising in time to claim the victory !—Griffiths was the favourite at setting too, and in the second round drew first blood, in each of the eight first rounds, he brought the Wednesbury man down, which brought betting 6 to 4 in his favour. About the 160th round, however, betting became 20 to 1 against Griffiths; but in five or six rounds more, he reduced the betting to 5 to 4 in his favour.—The blows, even to the last round, were given with the most tremendous force, fully evincing the bottom of the combatants and their determined spirit. Tom Belcher was second to Griffiths and Millward, from Wednesbury, to Bayliss,—A number of the fancy tribe, from London were present, who had arrived a few days before to give a relish to this, perhaps as obstinate an effort of gluttony as any on the bruising record.—The spectators, it is thought, did not fall short of 10,000. Several coaches, and an immense number of vehicles of every description, horses, &c. &c. were upon the ground.

Three New Songs, Written on the Boxing Match, between Griffiths and Baylis,

For staunch and firm bottom there never was known
A contest more worthy of fame and renown,
Than one fought 'tween Griffiths and Baylis, of late,
On conquest both bent and for vict'ry elate.

Oc'ober the fifteenth, at one in the day,
Began this most bloody and terrible fray;
Determin'd they both were, on ent'ring the field,
To forfeit their lives before ever they'd yield.

Two hundred and thirteen hard rounds were display'd,
Not one nor the other e'er once seem'd afraid;
For more than four hours did the contest prevail,
And Vict'ry, o'er both, still held level her scale.

No shuffling nor tricks, nor moment's delay,
Of cowardice once gave the smallest display;
For half-minute rests were all the rests giv'n,
To such severe fighting the contest was driv'n,

The seconds and umpires, unable to say,
On which side the contest the victory lay,
Declar'd a drawn battle, as th' only sure road,
To stop the two heroes from shedding more blood.

May Birmingham and Wednesb'ry henceforth agree,
And friends their inhabitants evermore be;
When they meet, be they social and quiet inclin'd,
And give their old grievances all to the wind.

YOU jovial young fellows, wherever you be,
That boxing do love, give attention to me ;
October the 15th, two young fellows came,
On the Coldfield, near Sutton, to establish their fame.

These clever young men are very well known,
For they are the pride and boast of each town ;
One named Bayliss, from Wednesbury came,
The other from Birmingham, Griffiths by name.

The milling amateurs they flock'd thro' the town,
E'en the Lori's and Aaron's from London came down
Likewise Belcher and Millward to Birmingham came,
To second these boxers, and heighten their fame.

At the Coldfield arrived, as I do declare,
Each combatant stept forth with hearts void of
fear,
Exactly at one the fight did begin,
And such severe fighting sure never was seen.

During four hours fighting, each ne'er seem'd afraid,
But 213 hard rounds they display'd :
At half minute time they the battle sustain'd,
And their blows to the last with vigour maintain'd

The battle was fought for a purse forty-pound,
And severely they fought, yet would neither give
ground ;
Each man was good bottom ; with elated hearts,
They fought for the vict'ry, and well play'd their parts.

After very hard fighting the umphires they found,
They would neither give in : until the last round,
Each unable to come to the time as proposed,
They made a draw-main, so the battle was clos'd

COME all you bold champions,
I pray lend an ear,
And of a famous battle,
You very soon shall hear ;
Of two hardy champions,
Who fought from noon till dark
The battle it was fought by boys,
Near unto Sutton Park,
The ring was kept in good order,
For these fighters to play,
And for to set about their work,
They made not the least delay ;
Their spirits were so high
And their hearts so very sound,
The battle which they fought were
Two hundred & fourteen rounds
The fight was continued with
Good courage on each side,
And their bottom as good fighters
Sure better ne'er was try'd
Baylis was a stout young man,
As ever took the field ;
And Griffiths was determined,
That he would never yield.
In the whole of the battle,
Not a soul blow was found
The sum which they fought for
Was full forty pound ;
And such a hardy battle,
Sure no one ever knew,
For these two valiant champions
Were stout hearted and true.
So now to conclude my boys
And finish my song,
I speak in praise of both of them,
I'm sure it can't be wrong ;
Their friends did interfere,
And advis'd 'em to give in,
Which they did agree upon,
And neither did win.

7.8 *Famous Boxing Match, c.*1825. This broadside gives an account of a four-hour bare-knuckle contest at Sutton Coldfield, Warwickshire, where the famous pugilist Tom Belcher (1783–1854) acted as second to one of the protagonists, and there were said to be ten thousand spectators. The woodcut illustration is one of the crudest to have survived.

prints: 'Pictures for Sashes' (to be placed in windows), 'Chimney-Pieces' (to screen unused fireplaces) and 'Large Sign Prints' (to be coloured and varnished as signs outside business premises).

A note at the top of the title page, 'for Mr Thoresby', suggests that copies of the catalogue were sent to potential customers, in this case to Ralph Thoresby (1658–1725), the Leeds antiquarian. Thoresby's Diary[27] lacks the period from September 1714 to September 1719, but the type of print that interested him can be established from the 1713 edition of his *Musaeum Thoresbyanum*. As might be expected of an English antiquarian of the period, he considered only portraits worth noting in any detail.[28] The fact that the auctioneer sent a copy of his catalogue to Thoresby indicates that he expected to sell not only to dealers, or local chapmen, but also to private buyers. Sales of 'old' prints (as opposed to newly published material) became regular events from the 1680s onwards, and it was common practice for collectors to buy at auction as well as through printsellers.[29]

Leeds was not unusual in having prints of this middle-brow type for sale. In 1720 John Weale, a bookseller in Bedford, offered much the same sort of material:

variety of fine French, Dutch and English prints, viz. drolls of Ostade and Teniers, Elements of Albano, cartoons of Raphael d'Urbino, Theatrum Passionis after Rubens, all the cathedrals of England and Wales, hunting pieces, etc. French, for chimney-pieces, stair-cases, etc. Likewise stitched histories, garlands and ballads old and new, for pedlars and ballad-singers, wholesale and retail.[30]

Histories of print-collecting concentrate on wealthy connoisseurs who purchased the finest prints either by contemporary artists or Old Masters, and it is easy to forget that such prints represent only a tiny fraction of what was produced at any time. The remainder were not, however, an undifferentiated mass of coarse woodcuts and etchings. There were many levels of quality from skilled reproductions of fine paintings (fig. 1.4) to the cheapest broadsides with crude woodcut illustrations (fig. 7.8).

CHAPTER EIGHT
THE POPULAR PRINT AND ITS DEVELOPMENT IN ENGLAND

The small number of surviving sixteenth-century, let alone fifteenth-century, English prints makes generalizations about the early period difficult, but it is clear that there was as yet no separate class of popular print. Broadsides describing a malformed pig born in Germany in 1531 (fig. 3.1) or conjoined babies born in Oxfordshire in 1552 (pl.1) or the execution of the Babington plotters in 1586 (fig. 4.25) are far from sophisticated publications, but they were not ephemera produced for a mass market. Paper and printing technology were relatively new and still expensive. Such prints can be called popular in the inclusive sense of being of interest to a wide range of the populace, but they would not yet have sold in large numbers nor would they have been aimed exclusively at the poor rather than the wealthy or educated.

Sellers of printed material were rare in the earliest prints of English street-criers (fig. 8.1). Ballad-sellers were to become ubiquitous until the late nineteenth century, but they do not appear in an English print before Marcellus Laroon's *Cryes of London* of 1688 (fig. 8.2). In the early period prints were sold, like other comparatively expensive goods, in shops. In 1520 the bookseller John Dorne of Oxford sold ballads and Christmas carol sheets for a penny each.[1] A penny was not a negligible amount of money. By chance one of the rare records of sixteenth-century wages covers the city and county of Oxford and shows that carpenters and masons earned 6d. a day, and labourers 4d.[2] Although skilled craftsmen might from time to time have bought ballads costing one-sixth of a day's pay, most purchasers must have been further up the socio-economic scale. The price level that defines a print as cheap is disputable: Tessa Watt, in her study of cheap printed material from between 1550 and 1640, gave an upper limit of 6d., but that would include much that would have been known to the bulk of the population only at a distance.

Over the next two centuries prints dropped in price relatively if not absolutely. In the early nineteenth century mechanization of printing and papermaking brought about a real price cut. Ballads and large woodcuts still cost a penny, and there were plenty of engravings from copperplates to be had for 6d. But a penny was a much smaller proportion of income than it had been in John Dorne's day: by 1600 a craftsman in the south of England was earning 12d. a day, and by 1700 20d.; from around 1770 inflation took hold, and wages doubled in the next fifty years from 24d. to 48d. before standing still until the middle of the nineteenth century.[3] Popular print prices were within the budget of a large proportion of the

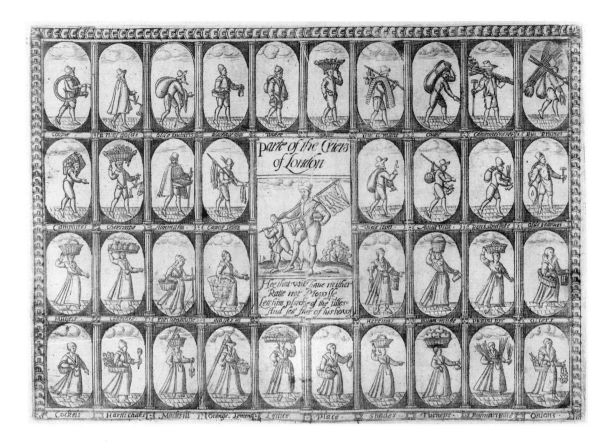

population of what was by 1700 a wealthy country. Even the cheapest prints, however, remained vastly more expensive in real terms than today's tabloid newspapers, which are their equivalent to a great extent in both function and subject matter.

The reduction in the price of prints was not just a function of technological progress. The quality of the cheapest prints deteriorated considerably as markets expanded and publishers began to specialize. Those aiming at the lower end of the market kept prices cheap by printing on rough paper from old blocks and worn copperplates. The same titles are listed in print publishers' catalogues for decades, the plates and blocks being reprinted as long as they would sell. Colouring at the cheaper end of the market was never careful, but until the late eighteenth century stencils provided a degree of uniformity between different impressions of the same print. By 1800 stencils had been abandoned by the cheapest publishers and they employed unskilled colourists to daub their prints with a few brush strokes of bright colours (for a particularly carelessly coloured example see fig. 6.14).

The development of the popular print in England can be illustrated by following the way in which one traditional motif was treated. The image of the *Stages of Life* was familiar from the medieval period in all types of visual

medium. It carries an element of *memento mori* in showing the inevitable progress from cradle to grave, but the iconography is elaborated by presenting each stage of life (there may be as few as four or as many as twelve) and its associated pitfalls; parallels are drawn with the four seasons, the seven planets, the twelve months and their associated humours, and sometimes each stage is given an appropriate animal. The most famous English example is a literary one: 'The Seven Ages of Man' recited by Jaques in Shakespeare's *As You Like It*.[4]

In the earliest prints figures – from infancy to old age – may stand in rows, or around a wheel of fortune,[5] but the arrangement of the *Stages of Life* on a series of ascending and descending steps – with the Fates, Hellfire or some other symbol of mortality beneath – was established in continental Europe by the middle of the sixteenth century (see fig. 11.4),[6] but the print trade in England lagged behind and large printed images were rare. The first record of what seems to have been a use of the Continental format in England was a print registered with the Stationers' Company on 22 January 1610 by Humphrey Lownes: *A Table of Man's Life, Laying Forth the Usual Estate of it, in Each Seven Years till the End of Ten Times Seven* (no impression is known). An early English example of the motif that does survive is a woodcut in the Pepys collection published in 1616 (fig. 8.3). Thomas

(*Facing page*)
8.1 *Parte of the Criers of London*, *c*.1660. This early sheet of the cries of London includes an almanack seller (second row, third from left) carrying his wares in a box suspended from his neck.

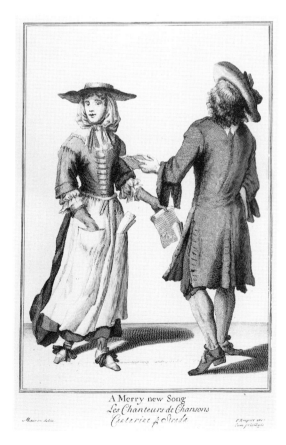

A Merry new Song
Les Chanteurs de Chansons

8.2 *A Merry New Song*, from *The Cryes of London*, 1689. This print after Marcellus Laroon (see Griffiths 1998, p. 260) appears to be the earliest depiction of the ballad-sellers who were so common on the streets of London from the seventeenth until the late nineteenth century.

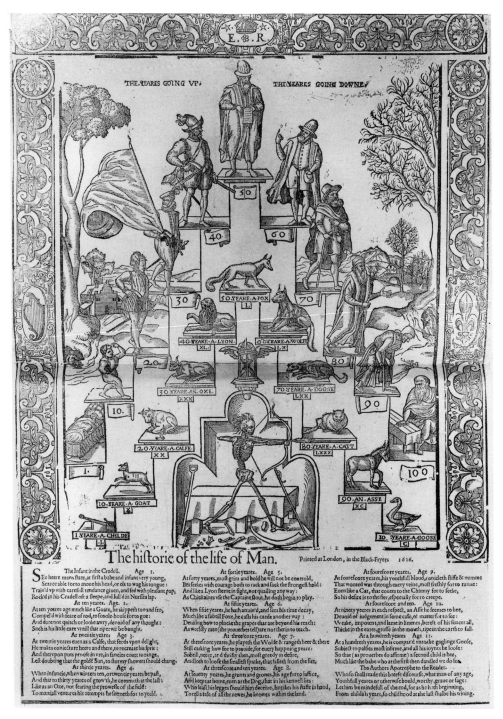

8.3 *The historie of the life of Man*, 1616. The familiar image of the ages of man arranged on a series of steps was already widespread throughout Europe in the sixteenth century, but this woodcut, in Samuel Pepys's collection, is the earliest English example to survive.

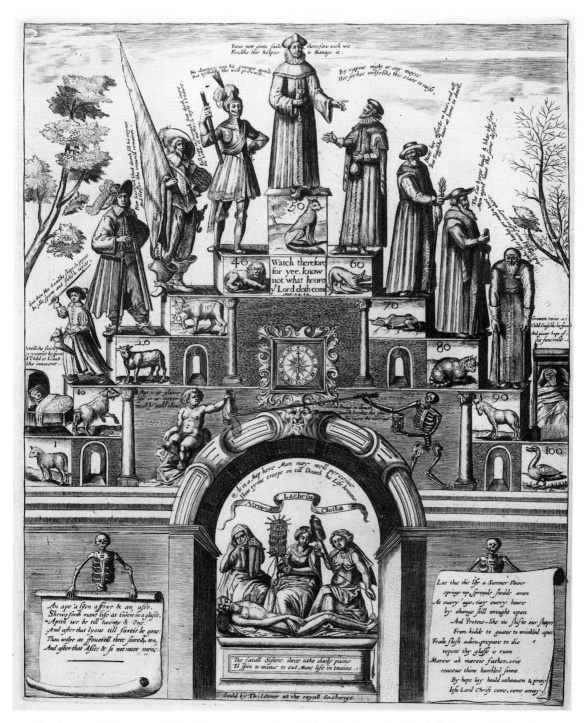

8.4 *The Stages of Life*, 1630s. This elaborate engraving with its allusion to the classical Fates would have been aimed at a prosperous and educated clientele. It appears in Thomas Jenner's catalogue of 1662, but the costume suggests that it was made some thirty years earlier.

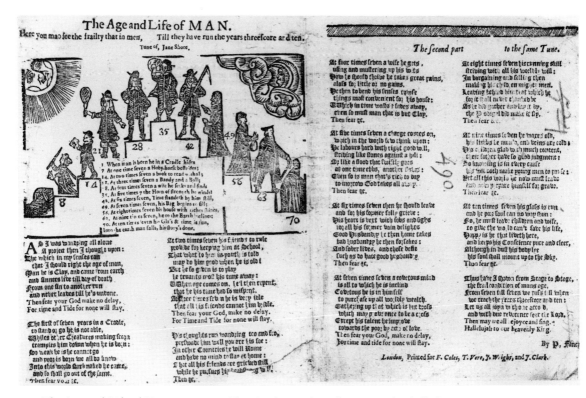

8.5 *The Age and Life of Man*, c.1674–80. The simple woodcut illustrating this ballad contrasts with the elaborate compositions shown in figs 8.3 and 8.4.

Jenner published an elaborate etching of the subject in the 1630s (fig. 8.4) and in 1655 Robert Walton, Jenner's rival, included in his catalogue 'One of once a man and twice a child, or the several ages of men and women, shewing their rising and falling, both of high and low, rich and poor, from the cradle to the grave'. These would have been relatively expensive prints, but by the late seventeenth century cheaper printed images were also widely available: most of the ballads in Pepys's collection and the broadsides collected by Narcissus Luttrell (see Chapter Nine) were illustrated. Simple woodcut versions of the traditional motif appear on a Pepys ballad, *The Age and Life of Man* (fig. 8.5), and in another late-seventeenth-century block which survived in the possession of the Newcastle printer Emerson Charnley until 1858 (fig. 8.6).

Charnley owned blocks that had belonged to a succession of publishers, dating back to the early eighteenth century, who had established Newcastle as a major centre for printing: John White; Thomas Saint; Thomas Angus; George Angus.[8] The loosening of the monopoly of the Stationers' Company (see Chapter Three) at the end of the seventeenth century had allowed printers to set up throughout the country. In 1700 the provincial market was small. There were only six towns outside London with populations over ten thousand: Birmingham, Bristol, Exeter, Newcastle, Norwich and York; of these the largest was Norwich with

a population of thirty thousand. The population of London was five hundred thousand, and about one-sixth of the total population lived there at some time in their lives. It was not until later in the eighteenth century that prints were produced in any numbers in provincial centres, but, as the commercial seaports and industrial towns grew into major cities, local jobbing printers moved on from producing letterheads and advertisements to publishing books and single-sheet prints. The cheaper end of the trade, however, was always content to regurgitate the work of competitors.

As the appreciation of fine prints developed in the eighteenth century, the trade divided between publishers who aimed at connoisseurs and those who produced images for an undiscriminating market. The latter were largely the old-established publishers in the City of London. Cheapness was their major selling point: Henry Overton's catalogue of 1754 offered 'maps, prints, copy-books, etc.' to 'all gentlemen, merchants, city and country shopkeepers, and chapmen ... at the lowest prices'. Subjects and themes were familiar favourites: among about two hundred 'Cheap Prints, each printed on a sheet of royal paper' were *The Several Stages of Man's Life*; *The World turned Upside Down*; *Lilliputian Humourists in Dwarf Figures*; *Thomas Brown, the Valiant Trooper*. In the same catalogue a list of 'upwards of one hundred and fifty different sorts of woodcuts, each printed on one sheet of fine royal paper ... either coloured, or plain' included, under 'Heads

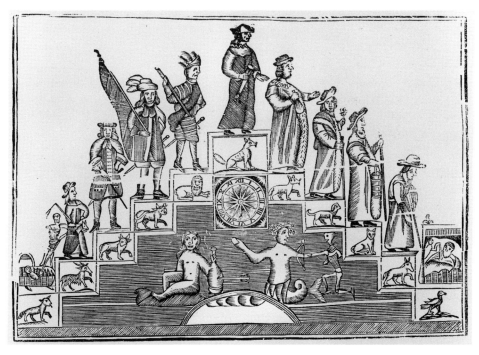

8.6 *The Stages of Life*, *c*.1700, this impression 1858. This print was made from a woodblock passed down through a succession of printers in Newcastle, one of the chief provincial centres of the trade.

of Illustrious Persons, etc.', *William, Duke of Cumberland*, and *Edward Bright, the Extraordinary Fat Man, late of Malden in Essex*, and, under 'Mixed Fancies Broadways', *The Cat's Castle* and *Youth and Age: or, The Stages of Man's Life*. William and Cluer Dicey's catalogue of the same year included the same range of subjects, with *The Various Ages and Degrees of Human Life, represented in twelve different stages from the birth to the grave* among over 350 'Copper Royal Sheets', and *The Stages of Man's Life, explaining the several Ages*, among 278 'Wood Royals'.

Woodcuts boomed in the middle of the eighteenth century. Thomas Bewick (1753–1828) remembered 'large blocks, with prints from them, so common to be seen, when I was a boy, in every cottage and farm house throughout the whole country'.[9] Even William Hogarth, who usually aimed at a more sophisticated level of printmaking, employed J. Bell in 1751 to make woodcuts after his prints (see p. 65) in order to reach a wider market. Topical satirical prints – whose lifespan

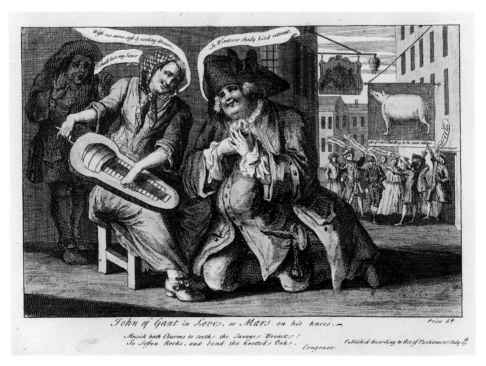

8.7 *John of Gant in Love, or Mars on his knees*, 1749. The Duke of Cumberland usually appeared in popular prints in the role of a military hero, but this sixpenny etching ridicules his liaison with a Savoyard hurdy-gurdy player.

(*Facing page*) 8.8 *John of Gant in Love; Or Mars on his Knees*, 1749. The mid eighteenth century saw a boom in the production of cheap woodcuts. This example is a copy of fig. 8.7 accompanied by an account of the affair of Cumberland and the Savoyard girl, introduced in disingenuous terms: 'we need not wonder at every trifling circumstance being turned to the disadvantage of this great man, in an age when scandal and detraction are at so high a pitch.'

Musick hath Charms to sooth the Savage Breast!
To soften Rocks, and bend the Knotted Oak.

Congreve.

LOVE is the noblest Frailty of Mind, says one of our famous English Poets; yet howsoever noble it may be generally thought, yet there are some particular Exceptions against it; and as a Proof of what I assert, I will only mention one Instance, and which is of Royal Authority.

King Charles II. was a Monarch, that wit out even the Shadow of Virtue, won the Hearts of his Subjects even to Adoration, was an Illustrious Exception to this Rule; he was neither noble nor nice in his Amours, Cinder Moll, or Doll the Oyster-wench, was as agreeable to him in his looser Hours, as a Countess or a Dutchess, and his Subjects were so far from being displeased at this merry Monarch's taste, that his odd and humorous Frolicks became the enlivening Discourse of every jocund Assembly.

But now, forsooth, we are grown so nice and so hysterical that if a great man, or a woman of Honour make a false step, scandal immediately sets up her foul-mouth'd Hallo too without Regard either to Person or Place. Thus it far'd with our Hero, whose Lowness is never enough to be admir'd; but Blessed be the poor in spirit for they shall see God.

And now good people we will give you an account of this wonderful affair that has made so much noise about town, and you shall have it without addition or diminution, just as Dame Scandal delivered it to the press by the Hands of common Fame, her sister.

This wonder-of-the-world being, as they tell ye, at Mother Duggie-Aries celebrating the Nocturnal Rites of Venus, Monsieur Maw-mouth the Marmot-man was call'd in with his Magick Lanthorn, to crown the Frolick, and his Dowdy Sister attended as Chief Musician. To hear with Melody and Art this adorable Dulcinea tickled her Gut-tub, and with what thrilling Notes she pour'd out the harmonious Song of Doodle doo, was ravishing to the Sense, and

the Hero unable to withstand such powerful Charms, fell captivated to the Ground, begging her to commiserate the Pangs of a hapless Lover.

You may very well imagine he did not meet with many Repulses from this Sun-burnt Dowdy, but crown'd his Wishes by an entire Resignation of her Charms. The Oddity of this Affair was the Occasion of a deal of Mirth, and nobody was offended but the Marmot-man, who was afraid of losing his Sister, and the Whores, who took it as a great Affront upon their Persons.

This is the whole Truth of this Remarkable Affair, and where is the great Wonder of a Gentleman's lying with a Ballad-singer? He may bring a great Monarch for a precedent, who did those things without any Rebuke.

But we need not wonder at every trifling Circumstance being turn'd to the disadvantage of this great Man, in an Age when scandal and detraction are at so high a Pitch. The Reader may perceive how difficult it is to oblige every one by the Example of Iphigenia; that dear, good-natur'd Nymph, who had nothing in View but to oblige the World with a Sight of her Charms, has thereby made herself the Jest of every dirty Porter and Shoe-black. Strange Ingratitude in a Christian Country.

This amazing Instance, how merry soever in itself, has displeas'd some part of the Town, especially the Female Sex; some of whom, whether in Jest or Earnest they best know, have been heard to say, Ay! We may well be slighted by Men of Fortune, when their superiors take up with Bunters, &c. who come from nobody knows where! And as the Ears of this great Man were tickled, and his Heart charm'd, on being serenaded with the MIDSUMMER WISH, 'tis not thought improper to insert it here,

THE

Midsummer Wish.

WAFT me some soft and cooling Breeze,
To Windsor's shady kind Retreat,
Where sylvan Streams, wide-spreading Trees,
Repel the Dog-star's raging Heat.
where tufted Grass, and mossy Beds,
Afford a rural calm Repose;
where woodbines hang their dewy Heads,
And fragrant Sweets around disclose.

Old oozy Thames that flows saft by,
Along the smiling Valley plays,
His glossy Surface chears the Eye,
As through the flow'ry Meads he strays;
His fertile Banks with herbage green,
His Vales with Golden Plenty swell,
where'er his purer Streams are seen,
The Gods of Health and Pleasure dwell.

Let me the clear and yielding wave
with naked Arm once more divide;
In thee my glowing Bosom leave,
And stem thy gentle rolling Tide;
Lay me, with Damask Roses crown'd,
Beneath some Ozier's dusky Shade,
where water-lillies paint the Ground,
And bubbling Springs refresh the Glade.

Let chaste Clarinda too be there,
with azure Mantle lightly dress'd,
Ye Nymphs bind up her silken Hair,
Ye Zephyrs fan her panting Breast;
Oh! haste away, fair Maid, and bring
Thy Muse, the only Friend to Love;
To thee alone my Muse will sing,
And warble through the Vocal Grove.

London: Printed in the Year 1749. According to Act of Parliament.

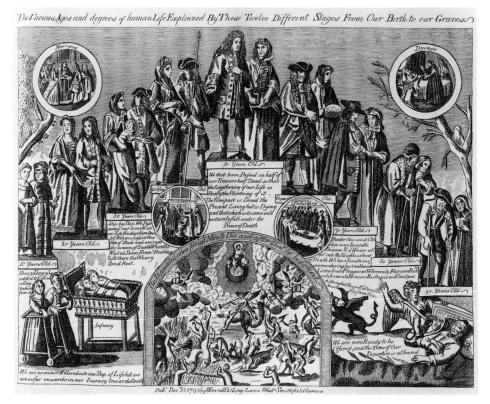

8.9 *The Various Ages and degrees of human Life Explained*, 1793. The traditional *Stages of Life* was a continuing staple of the popular print trade. The costumes shown in this print suggest that it was based on a design made some fifty years earlier.

would not normally have been long enough to benefit from the longevity of wood-blocks – were copied as woodcuts at this time. An example that, one imagines, would not have justified the (anonymous) publisher's efforts was a woodcut copied from an etching satirizing the Duke of Cumberland's liaison with a Savoyard hurdy-gurdy player in 1749 (figs. 8.7 and 8.8). Cumberland, clearly no longer universally honoured for his victory at Culloden three years earlier, had a number of printsellers arrested for selling a print on the same subject, and – no doubt in order to avoid the same fate – Hogarth seems never to have engraved his painting of the Savoyard girl.[10]

By the end of the century the old woodblocks used by the City publishers seem at last to have been abandoned. Their place was taken by copperplates etched with deeply bitten lines that would have produced tens of thousands of impressions, and that could easily be strengthened if they began to wear. John Evans of Smithfield, London, published a number of bold images of this type, including *The Various Ages and degrees of human Life, Explained by these Twelve Different Stages from our Birth to our Graves*, published in October 1793 (fig. 8.9),[11] as well as topical prints like *The Death of Marat at Paris Who was stabbed by*

Charlotte Corde of Caen Sunday July 14 1793 published on 21 October 1793 with *The Execution of Charlotte Corde at Paris July 17 1793* (fig. 3.16). By this time the political dimension of print publishing cannot be ignored (see Chapter Five). The popular print was a propaganda weapon, and Evans and others diversified by producing gentrified versions of popular prints for the Cheap Repository (see pp. 140–2).

James Catnach led the next development in the popular print trade. In 1813 he set up his press in Seven Dials in the West End of London and was largely responsible for reviving the popular woodcut (pl. IV). Seven Dials prints were not, like those of the City publishers, simply cheap versions of compositions aimed at a more discerning market. They were designed to be bold and eye-catching, combining short verses and texts with a number of separate woodcuts and decorative devices. Catnach replaced the rough and dingy paper that had become the norm for cheap prints with smooth white paper that took print well. This paper is extremely thin and so is easily damaged; although many Catnach prints survive, they can be only a small proportion of the millions that were produced. Some comparatively old blocks were still used, but new ones were cut or copied by the stereotyping process[12] to keep pace with the enormous demand for prints. Improvements in printing presses meant that they printed more evenly, and broadsides could be enlivened with a greater variety of typeface. Prints were normally brightly but carelessly coloured and much of this work would have been done by child labour, paid only a tiny sum per print. The tradition established in the seventeenth century of doubling retail prices for coloured prints remained, however, unchanged – '1d. plain, 2d. coloured' appears on many prints.

As the nineteenth century progressed, the print trade expanded enormously. By the 1850s the focus of popular imagery had moved to the illustrated newspapers with their elaborate wood-engravings employing large numbers of cutters to copy complex designs. In the 1870s photographic block-making began to take over from wood-engraving for illustrations. Lithography was the primary medium for single-sheet commercial prints, and the invention of chromolithography, above all, meant that colourful prints of all manner of subjects were readily available at low prices. The simple images of earlier popular woodcuts and cheap copperplates lost their original market and became material for self-conscious revivals of earlier styles (see Chapter Ten).

Traditional themes and subjects continued, however, in the mainstream of mass-produced images, although in different guises, and much of the material of today's tabloid newspapers descends directly from the broadsides of the early days of printing. In some areas little has changed beyond technique. The popularity of images of execution and violent crime has not diminished, the powerful still encourage the production of portraits of themselves, popular newspapers pay large sums of money for the rights to photographs of 'Siamese twins', and unfortunate whales washed up on beaches attract curiosity just as they have always done.

COLLECTORS AND HISTORIOGRAPHY

Most collections of popular prints have been put together in connection with some scholarly enterprise. Long before the popular print was identified as a distinct genre by scholars of the Romantic era, cheap prints were of interest as evidence of contemporary life or as examples of particular types of subject matter. From the late eighteenth century onwards, an urge to record what was seen as the authentic simplicity of the people led to the collection and publication of ballads. Collecting pushed up prices, and what had been produced as ephemera became treasured relics published in expensive limited edition facsimiles.

This chapter deals with some surviving collections and discusses the ways that collectors and scholars have approached their material. It is intended to serve also as a guide to the major collections of popular prints, but makes no claim to be comprehensive. For more detailed information on surviving collections the reader is directed to Williams. Few collections are fully catalogued, and popular printed imagery is not easily found; it is usually kept in libraries bound up with non-illustrated broadsides, ballads and other ephemera and catalogued, if at all, by title. Barwick lists collections according to categories including broadsides, ballads, chapbooks, crime/criminals, exhibitions, fairs, etc. The standard book catalogues of the period, STC, Wing and ESTC, list broadsides by title. They are also available, as the *English Short Title Catalogue 1473–1800*, on line through the Research Libraries Group (http://eureka.rlg.org/cgi-bin/zgate) and on a British Library CD-Rom.

The only Tudor collection of ballads and broadsides to remain intact is in the Huntington Library, San Marino, California (fig. 9.1). It was almost certainly part of the library of the Tollemache family at Helmingham Hall, Suffolk, before coming into the possession of an Ipswich postmaster named Fitch in the early nineteenth century. Fitch sold 149 broadsides to the satirical writer and book-collector George Daniel (1789–1864) who in turn sold them to Richard Heber (1773–1833). At Heber's posthumous sales they were bought by William Henry Miller, MP (1789–1848) and formed the basis of the major ballad and broadside collection at Britwell Court, Buckinghamshire. Britwell Court passed to Samuel Christy, who took the name Christie-Miller (1810–89), and subsequently to Wakefield Christy (Christie-Miller), who added to the library. It was dispersed in sales from 1910 to 1927.[1] The ballads are reproduced in facsimile in Collmann.

Several important seventeenth-century collections of English ephemera survive. George Thomason (d. 1666), a royalist bookseller based in the heart of the

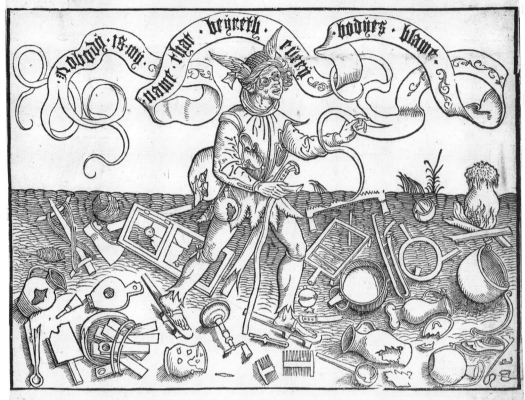

9.1 *The welspoken Nobody*, c.1550. This fine Reformation broadside follows a German prototype; for the figure of Nobody – who is always to blame – and the more common English version, see p. 47 and fig. 3.6.

London print trade at the Rose and Crown, St Paul's Churchyard, amassed a collection of twenty-three thousand English pamphlets, small books, newspapers and fugitive documents dating from 1640 to 1661 as evidence of life during the Civil War and Commonwealth.[2] His collection represents a high proportion of the total output of new material of the period, especially in London, although many Quaker tracts are absent. Thomason took pains to conceal the collection during the Civil War and eventually sent it for safe-keeping to Oxford, where it escaped destruction in the Great Fire of London. In 1761 it was bought from Thomason's descendants by George III; in the following year it was presented to the new British Museum (it is now in the British Library). It was catalogued by G. K. Fortescue in 1908. Photocopies are kept on open shelves in the Rare Book Room and a microfilm is available (Mic.B.58/246).

Anthony à Wood (1632–95), Oxford antiquarian, collected ballads, broadsides and pamphlets as part of his research into the histories of the university (published 1674), the town (published from his manuscript, 1889–99) and writers and bishops educated there (published 1691–2). His collection, now in the Bodleian Library, includes a series of almanacs for 1629–95, numerous chapbooks, nearly three hundred ballads and over five hundred broadsides. Also in the Bodleian Library are the large ballad collections of Richard Rawlinson (1690–1755) and Francis Douce (1757–1834), Keeper of Manuscripts at the British Museum. In addition to more than two hundred sixteenth- and seventeenth-century ballads, the Rawlinson collection includes 175 volumes of almanacs from 1607 to 1747; the Douce collection includes nearly nine hundred ballads from the seventeenth to the early nineteenth century as well as chapbooks and almanacs.

Samuel Pepys (1633–1703), naval official and diarist, left his library, with many caveats, to Magdalene College, Cambridge, where he had been a student. The library includes ten thousand prints and 1800 ballads, some of which date from the early seventeenth century (fig. 8.3; Pepys had acquired the collection of the antiquary John Selden (1584–1654)), and three volumes of 'Penny Merriments'. For catalogue see Bibliography.[3]

The collection of John Bagford (1650–1716), shoemaker and bibliophile, was intended for a projected history of printing. Most of it was acquired at his death by Robert Harley, Earl of Oxford (1661–1724), and was bought by Parliament for the new British Museum with the Harleian manuscripts in 1758. Bagford's manuscripts and printed books (3600 plus separate pages) are now in the British Library, but more than a thousand prints are dispersed among the collection of the Department of Prints and Drawings in the British Museum. Bagford collected many items which could be called popular prints, especially three volumes of ballads (British Library, C.40.m.9–11; photocopies on open shelves in the Rare Book Room), advertisements for quack medicines (British Library, Harl. 5931) and almanacs and prognostications (British Library, Harl. 5937). A list of the contents of the collection was compiled by A. W. Pollard, 1902–4.

The main activity of Narcissus Luttrell (1657–1732) appears to have been the

compilation of his daily chronicle of contemporary events, published in 1857 as *A Brief Historical Relation of State Affairs from September 1678 to April 1714*. He put together a large collection of contemporary elegies, ballads, proclamations and other broadsides; these carry annotations suggesting that they served as source material for the chronicle (fig. 5.19). A great part of the collection was bought from Luttrell's descendants in 1786 by the book-collector and antiquarian James Bindley (1737–1818); it was then in seven volumes. The collection was already well-known enough to be described by Walter Scott in his edition of Dryden (1808). At Bindley's posthumous sale in 1818 three volumes (lots 1125, 1126 and 1127) were bought by the Duke of Buckingham (1776–1839) for £550. He used many of the sheets for extra-illustrating his copy of Granger[4] which was broken up at the sale of his library at Stowe in 1849, at which the Department of Prints and Drawings of the British Museum bought much; the remaining Luttrell broadsides (mainly non-illustrated) that had not been used in the Buckingham Granger were acquired by the British Museum at the Stowe sale (now in the British Library, C.20.f.3–5; photocopies are on open shelves in the Rare Book Room). A further five volumes were sold at another Bindley sale in 1820 (lot 1028) and these are now distributed as follows: two volumes in the British Library,[5] and one each in the Clark Library, Los Angeles; the Huntington Library, San Marino; and the Newberry Library, Chicago.[6] Sheets dispersed from the Stowe Granger are easily identifiable from Luttrell's annotations (see fig. 5.19).

Sir Hans Sloane (1660–1753), physician and founder of the British Museum, included cheap prints – as well as very fine prints and drawings – in his volumes of specimens of natural history. Notable among the prints that might be called popular are the group of handbills, some illustrated, of exhibitions of exotic animals or human phenomena that he saw in London (see Chapter Four, n. 81). Sloane was left the library of William Courten (1642–1702) in which there was a volume of 'Monsters' including similar exotica. For an account of Sloane's print-collecting see *Landmarks*, pp. 21–42, 257–76.

The collection of about a thousand broadsides in the Society of Antiquaries, the earliest of which date from the beginning of the sixteenth century, is based on that of Charles Davis, a Holborn bookseller at whose sale in 1756 it was purchased by Thomas Hollis (1720–74) and given to the Antiquaries. Hollis spent a good deal of his considerable wealth in publishing and collecting books and medals, which he presented to a number of libraries, including those of the British Museum and Harvard University. His particular interest was in seventeenth-century republican literature. The Antiquaries' collection was catalogued by Robert Lemon in 1866.

The radical Francis Place (1771–1854) built up a large collection of pamphlets, broadsides and other material relating to the struggle for political reform in which he played a central role (British Library, see index to printed materials at Enquiry Desk; manuscripts are kept as Add. MSS 27789–859, 35142–54 and 36623–8; microfilms Mic.B.707 and 905). He transcribed a number of 'flash' ballads remembered from his youth (see pp. 142–3) which record a range of bawdy and

criminal subject matter and language that is very rare among the collections of more genteel scholars and bibliophiles.[7]

Place described the street ballad as a subversive instrument, but by his time scholars and collectors regarded popular prints of all sorts as products of a lost innocence – conservative rather than radical. They were associated with an idyllic rural life rather than with urban streets. The life of the poor became romanticized in the eyes of scholars and artists in England as elsewhere in Europe (see Chapter Eleven): in the 1780s Gainsborough began to paint shepherd boys and peasant girls on a scale previously confined to portraits of the aristocracy, and by the following decade there was a vogue for cottage scenes in the Royal Academy's exhibitions;[8] in 1786 the Duchess of Devonshire attended a masked ball dressed as a serving maid; in 1809 John Nash built Blaise Castle in a rustic style with bargeboarded gables and thatched roofs. Publications appeared of series of town or country 'types', their dress, customs and so on – W. H. Pyne, *Microcosm*, 1806, T. L. Busby, *Costume of the Lower Orders of London*, 1820 (fig. 9.2). These emerged from the 'cries' of earlier periods (see p. 169) that had been sanitized more directly by Francis Wheatley in his *Cries of London* of 1796, in which pretty girls in neat dresses sell their goods beside fine examples of civic architecture.

9.2 Title page to *Costume of the Lower Orders of London*, 1820. A collection of well-ordered working people is introduced by a broadside-seller displaying sheets bearing the title in English and French.

The type of popular print of most interest to collectors and scholars of this period was the ballad. Bishop Thomas Percy (1729–1811) had published *Reliques of Ancient Poetry* as early as 1765, but he considered that the ballads he had collected derived from medieval sources although he had bought a number from Dicey (see Chapter Six, n. 1). Following generations saw ballads as an example of the unspoilt culture that predated urban sophistication; in 1798 Wordsworth and Coleridge gave the title *Lyrical Ballads* to a collection of poems celebrating rural life. Ballads were admired for the honest simplicity of their language and music, but their status as artefacts inevitably rose as early examples became sought after by collectors. The Percy Society was founded in 1841 for the purpose of publishing early ballads.

The largest of the collections built up in the nineteenth century is still known by the name of its most famous owner as the Roxburghe Ballads. It consists of over two thousand ballads, mostly of the seventeenth century but some dating from as early as 1567 and as late as c.1790. Like any wide-ranging collection it is the result of the efforts of a succession of collectors. The core is three volumes of ballads assembled by John Bagford (see above) for Robert Harley, Earl of Oxford. These were added to by subsequent owners, James West (1704?–72), Major Thomas Pearson (1740–81) and the great bibliophile John Ker, 3rd Duke of Roxburghe (1740–1804). The sale of Roxburghe's magnificent library in 1812 prompted the setting up of the Roxburghe Club in order to publish high-quality reproductions of rare publications, including many that are relevant to the study of popular prints.[9] The ballads were bought by Benjamin Heywood Bright (d. 1843), who added a fourth volume mostly of seventeenth-century material. They were purchased by the British Museum for £560 5s. at the sale of Bright's library in 1845. The collection is now in the British Library (C.20.f.7–10; photocopies on open shelves in the Rare Book Room; microfilm, Mic.A.7526–7527). The collection was published, with reproductions of many of the woodblock illustrations, in parts, 1869–99.

Alexander Lindsay, 25th Earl of Crawford and 8th Earl of Balcarres (1812–80), devoted much of his life to building up a library representative of the literatures of all nations. The work was continued by his son and heir James Ludovic (1847–1913) who brought several new types of publications into the library, including broadsides and ballads, about 1400 of which dated from the seventeenth century. He presented a group of about sixty ballads to the British Museum in 1885 (now British Library). The major part of the library was broken up in the decades after his death, but the ballad collection remains intact and can be consulted by arrangement at the National Library of Scotland.[10]

Henry Huth (1815–78), a wealthy merchant banker, was renowned for his purchases of the finest books on the market. He was a member both of the Philobiblon Society and the Roxburghe Club. For the former he published *Ancient Ballads and Broadsides* (1867) from the collection he had purchased for £750 from George Daniel (see above; Daniel had himself published the collection

in 1856 as *An Elizabethan Garland*). A volume of sixty-nine Elizabethan and five later ballads was part of the bequest to the British Museum of Huth's son Alfred Henry Huth in 1903. It is kept in the British Library at pressmark Huth 50; there is a microfilm in the Department of Prints and Drawings, British Museum.

Fine publications of rarities were not the province only of wealthy amateurs. James Orchard Halliwell (later Halliwell-Phillipps, 1820–89)[11] was a brilliant and energetic scholar (elected to the Royal Society at the age of eighteen) whose interest moved from early mathematical and astronomical treatises to a more general interest in English history and Shakespeare in particular. Among quantities of reprints of antiquarian material – chiefly limited editions for anti-quarian clubs – he published twenty-one volumes of ballads and nursery rhymes for the Percy Society between 1841 and 1850. In 1852 he presented his collection of 3100 proclamations, broadsides, ballads and poems – mainly eighteenth-century – together with a catalogue (published 1851), to Chetham's Library, Manchester (fig. 9.3). Halliwell-Phillipps also put together a collection of 408 black-letter ballads which was purchased in 1856 by William Euing (1788–1874), insurance broker and underwriter, who left it as part of his library to Glasgow University. The Euing ballad collection was transcribed, with good reproductions of the illustrations, in 1971.

Another major area of collecting in the late eighteenth and early nineteenth centuries was the portrait print, and 'head-hunters' pursued popular examples with as much eagerness as fine works of art. Subjects included royalty and military and naval heroes, but a section of society defined in the British Museum's engraved portrait series as 'Class X – Phenomena, Convicts, etc.' is worth partic-ular consideration. The classification follows Granger and Bromley.[12] It includes, as examples of human phenomena, people of extraordinary height, weight or age, and those with physical malformations, criminals and members of the lower strata of society who had some claim to fame: Queen Victoria's friend, John Brown, and William Scivier, a porter at the gate of the British Museum, find their places beside notorious murderers, very fat children or the likes of Miss Hervey, the Albiness 'now exhibiting at Brookes's Original Menagerie, No. 242 Piccadilly' (see Chapter Four for examples of prints of such phenomena). The grouping was, no doubt, one of convenience explained by the fact that there were far fewer portraits of such types of people than of those of higher status. The rarity of such images made them sought after by collectors, and publishers exploited the demand by producing collections such as *The Wonderful Museum*, 1803, Caulfield's *Remarkable Persons*, 1819–20 (fig. 9.4), and J. Robins's *Fifty*

(*Facing page*) 9.3 *The Messenger of Mortality; or a dialogue between Death and the Lady*, early nineteenth century. James Halliwell-Phillipps described this print in his catalogue as 'a large and hideous woodcut'. Like several other prints from the north-east (it was printed in York) in the same volume it is signed in manuscript 'Jno Bell' and may have come from the collection of the Newcastle printer John Bell (1785–1860).

The MESSENGER of MORTALITY;

Or a DIALOGUE between DEATH and the LADY.

Vanity of vanities, all is vanity, Eccl. 1. 2.
Dust thou art, and unto dust thou shalt return, Gen. 3. 19.
Then shall the dust return to the earth as it was, and the spirit shall return unto God who gave it, Eccl. 12. 7.
She that liveth in pleasure, is dead while she liveth, 1 Tim 5.6.
O that they were wise, that they understood this; that they would consider their latter end, Deut. 32. 29.
For what is your life? it is even as a vapour, that appeareth for a little time, and then vanisheth away, James 4. 14

Tremble, ye women, that are at ease, Isa. 22. 11.
I have said to corruption, thou art my father; to the worm, thou art my mother and sister, Job 17. 14.
Like sleep they are laid in the grave, death shall feed upon them, their beauty shall consume in the grave the house appointed for all living. To be laid in the balance, they are all together lighter than vanity, Ps. 59. 14.
Job. 30.23 Ps. 62. 9.

Because the daughters of Zion are haughty, and walk with wanton eyes; the Lord will take away their ornaments, and instead of sweet smell there shall be stink, Isa. 3. 16, 18, 24.
One night Corinna was all gaiety in her spirits, all finery in her apparel, at a magnificent ball; the next night she lay an extended corpse, and ready to be mingled with the mouldering dead.—Hervey's Meditations.
In the midst of life we are in death.—Common Prayer.

Favour is deceitful and beauty is vain, Prov. 31. 30.
"How lov'd, how valued once, avails thee not,
To whom related, or by whom begot;
A heap of dust alone remains of thee;
'Tis all thou art, and all the proud must be.
Life how short! eternity how long!
Now get thee to my lady's table, and tell her, let her paint an inch thick, to this complexion she must come at last.—Shakespeare.

Your light is almost out.

Pride and Vanity submit to Death and Mortality.

DEATH.
FAIR Lady, lay your costly Robes aside,
No longer must you glory in your Pride,
Take Leave of all your carnal vain Delight
I'm come to summon you away this Night.

LADY.
What bold Attempt is this? pray let me know,
From whence you come, and whither I must go.
Shall I, who am a Lady, stoop or bow
To such a pale-faced Visage.—Who art Thou?

DEATH.
Do you not know me? Well, I'll tell you then
'Tis I that conquer all the Sons of Men;
No pitch of honour from my dart is free,
My name is Death, have you not heard of me.

LADY.
Yes, I have heard of thee, Time after Time,
But being in the glory of my Prime,
I did not think you would have call'd so soon
Why must my morning sun go down at noon.

DEATH.
Talk not of noon, you may as well be mute,
This is no time at all for to dispute,
Your riches, jewels, gold, and garments brave,
Your house and land, must all new Masters have.

LADY.
Are there not many bound in Prison strong,
In bitter grief of soul have languish'd long,

From all would find a grave, a place of rest
From all their grief, in which they are opprest,
Besides, there's many with their hoary head,
And palsy joints by which their joys are fled,
Release thou them whose Sorrows are so great,
But spare my Life to have a longer date.

DEATH.
Tho' they by age are full of grief and pain
Yet their appointed Time they must remain.

LADY.
My heart is cold, I tremble at the News,
Here's bags of gold, if thou wilt me excuse,
And seize on those (thus finish thou the strife)
On such as are weary of their life.

DEATH.
Tho' thy vain heart to riches was inclin'd,
Yet thou must die, and leave them all behind,
I come to none before my warrant's seal'd
And when it is, they must submit and yield
I take no bribe believe me, this is true,
Prepare yourself to go,—I come for you.

LADY.
Death, be not so severe, let me obtain
A little longer time to live and reign,
Fain would I stay, if thou my life wilt spare,
I have a Daughter beautiful and fair
I'd live to see her wed, whom I adore.
Grant me but this, and I will ask no more.

DEATH.
This is a slender frivolous excuse
I have you fast, and will not let you loose.
Leave her to Providence, for you must go
Along with me, whether you will or no.
I, Death, command Kings to leave their Crown
And at my feet they lay their sceptres down
If unto Kings this Favour I don't give
But cut them off, can you expect to live,
Beyond the limit of your time and space?
No, I must send you to another place.

LADY.
You learned doctors, now exert your skill,
And let not Death of me obtain his will,
Prepare your Cordials, let me comfort find,
My gold shall fly like chaff before the wind.

DEATH.
Forbear to call, their skill will never do,
They are but mortals here, as well as you.
I give the fatal wound, my Dart is sure
'Tis far beyond the Doctor's skill to cure.
How freely can you let your riches fly,
To purchase life rather than yield to die,
But while you flourish'd here in all your store,
You would not give one penny to the poor,
Tho' in God's name their suit to you did make,
You would not spare one penny for his sake
My Lord beheld wherein you did amiss,

And calls you hence to give account for this.

LADY.
Oh, heavy News! must I no longer stay,
How shall I stand in the great Judgment Day?
Down from her Eyes the crystal tears did flow,
She said, None knows what I do undergo.
Upon a bed of sorrow here I lie,
My carnal life makes me afraid to die.
My sins, alas, are many, gross, and foul,
Lord Jesus Christ have mercy on my soul.
Yet pardon, Lord, and pour a blessing down,
Then with a dying sigh her heart did break,
And did the pleasures of this world forsake.
Thus may we see the high and mighty fall,
For cruel death shews no respect at all,
To any one of high or low degree,
Great men submit to Death as well as we.
Tho' they are gay, their lives are but a span
A lump of clay, so vile a creature's man [care
Then happy those whom Christ hath made his
Die in the Lord, and fully blessed are.

The grave is the market place where all men meet,
If life was merchandise, that men could buy,
The rich would live and the poor would die.

Life is a blessing cannot be sold,
The ransom is too high;
Justice will ne'er be brib'd with gold,
That man may never die.

Carrall, Printer, Walmgate, York.

MISS MARY BLANDY.

Published by H.R.Young 36 Paternoster Row

9.4 *Mary Blandy*, from Caulfield's *Remarkable Persons*, 1819–20. The murderess Mary Blandy (see fig. 4.31) takes tea in her cell – shackles peeping out from beneath her elegant dress. Caulfield's four-volume publication of portraits and biographical accounts of famous criminals, phenomena and other curiosities cashed in on the rage for portrait-collecting, but his genteel reproductions have none of the vigour of the originals.

Wonderful Portraits, 1821; these contained reproductions of earlier portraits as well as new ones of contemporary subjects.

Portraiture is the only area of English popular prints that the Department of Prints and Drawings at the British Museum has collected systematically.[13] Portraits remained a major aspect of print-collecting until the early twentieth century, and the Museum was concerned to build up its holdings of all the classes of sitters listed in Granger's and Bromley's catalogues. In 1851 a group of over seven hundred portraits of 'Phenomena, etc.' was purchased from the dealer Evans; a number of these are reproduced in this book and can be identified by register numbers in the range 1851-3-8-18 to 1851-3-8-745. Another distinguished dealer, William Smith, presented the Museum in 1858 with a group of five woodcuts published in Aldermary Churchyard.

Many prints that can be called popular are included also in F. G. Stephens's catalogue of the British Museum's *Satirical* and *Political and Personal Subjects* before 1771 (published 1870–83). Their inclusion illustrates the difficulty of

defining different genres of print. Stephens – or more properly Edward Hawkins, whose collection formed the basis of the British Museum's holdings of satirical prints and whose notes Stephens used – subsumed into the genre a number of prints of the earlier period which had, in fact, no satirical content.[14] Entries in the British Museum catalogue of satirical prints are indicated in the checklist at the end of this book by the abbreviation 'BM Sat'.

There are few broadsides and fewer ballads in the Department of Prints and Drawings. Sheets with letterpress were considered to be the province of the old Department of Printed Books; its successor, the English Language Section of the British Library, continues to collect broadsides. The Library's collection is exceptionally rich, many of the earlier collections already discussed having found their way there.

Nineteenth-century popular prints are less difficult to find than those of earlier periods. Contemporary ballads were collected as continuations of the tradition. Sir Frederic Madden (1801–73), Keeper of Manuscripts at the British Museum, built up a collection of about 1600 eighteenth- and early nineteenth-century broadsides and ballads (with some earlier examples) that is now in Cambridge University Library; a large number are transcribed in Holloway and Black. The British Library has large holdings, mainly kept as collections. These include those of Sarah Sophia Banks (1744–1818), sister of the naturalist Joseph Banks (1743–1820), who collected large quantities of contemporary ephemera now divided between the British Library and the Department of Prints and Drawings in the British Museum (see User's Guide, pp. 81–4). The collection of Rev. Sabine Baring-Gould (1834–1924), folklorist and writer, best remembered as the author of *Onward Christian Soldiers*, is divided between the British Library and his family home, Killerton House, Exeter.

A letter from an affected young Victorian to a ballad-collector gives a first-hand account of the purchase of a ballad in the West End of London:

St John's Lodge 2.8.56

My dear Stevens

Passing through Albemarle Street last evening there was a fellow whose voice, though inferior in compass to Jenny Lind's, was a precious deal louder than mine or Parker's. He was delighting a ring of gardes-noir with a ballad which must have been written by Tennyson, Milman or Longfellow, – so I broke through the circle of unwashed and tendered a penny sterling, which procured the enclosed.

Now as this effusion – so redolent of loyalty, wit, poesy, sense, and judgement – might slip your ken, I solicit a berth for it in your tremendous collection

W. H. Smyth.[15]

Popular prints are also to be found in collections put together by those involved in the trade. A group of several hundred woodblocks descended through a succession of Newcastle printers; they were preserved from the early eighteenth to the mid nineteenth century as stock-in-trade, but then became collector's items

9.5 *The Famous History of the Valiant London Prentice*, 1711. The block, used here as the title page to a Newcastle chapbook, is close to the illustration to a ballad telling the same story published about thirty years earlier (fig. 4.23). The block was reprinted in 1858 with others from White's stock in Emerson Charnley's *Specimens of Early Wood Engravings* (see pp. 186–7). Charnley's collection also contained another version of the image.

and limited editions of impressions were made by Emerson Charnley in 1858 and William Dodd in 1862 (fig. 9.5). The collection of William S. Fortey (d. 1901), successor to Catnach, was purchased by George F. Wilson and presented to St Bride's Printing Library in 1953. The most important modern collection is the one assembled by John Johnson (1882–1955), Printer to the University of Oxford, and transferred from Oxford University Press to the Bodleian Library in 1968. Johnson had diligently collected ephemera that the Bodleian was eliminating from its collection early in the present century, including items from the collections of Bishop Percy (see above) and of Andrew White Tuer (see pp. 204–5). It is housed adjacent to Room 132 of the New Library and is arranged under some seven hundred headings of subjects and categories of material (a list is available).

In 1975 the Bodleian Library acquired the huge collection of musical material amassed by Walter Harding (1883–1973), a Chicago music-hall pianist and cinema organist; it contains about 15,000 street ballads and broadsides of the eighteenth and nineteenth centuries.

The graphic designer Maurice Rickards (1919–98) devoted many years to collecting all sorts of ephemeral printed material and compiling an encyclopedia of ephemera. His collection is housed in the Centre for Ephemera Studies at the University of Reading and his encyclopedia is to be published in due course by the British Library. The Ephemera Society that Rickards founded continues to encourage the collecting and study of printed and handwritten ephemera.

CHAPTER TEN
NOSTALGIC REVIVALS

Popular prints were published in England by small businessmen whose concerns were commercial. The printmakers they employed were required to produce woodcuts and cheap engravings that appealed to a wide market. Originality, style and quality of execution were of interest only if they increased sales. The world of the popular print and that of fine art met only at a distance: through reproductive prints that allowed great paintings to be used as models for cheap publications, or, conversely, through scholarly interpretations that imbued aspects of popular culture with romantic appeal for an educated audience. The prints resulting from this taste for the popular are the subject of this chapter.

Historians and collectors (see Chapter Nine) inevitably distanced popular prints from their commercial roots. They viewed such prints as documents to be studied or relics to be preserved rather than as consumer goods to be purchased in order to serve immediate needs. In Seven Dials and elsewhere popular prints continued into the second half of the nineteenth century to be published on what might be called a pre-industrial scale, but they were already being regarded as objects of nostalgia. Succeeding generations of printmakers treated popular prints as source material, self-consciously selected for its associations. Their polite interpretations have done much to distort later perceptions of popular prints. These new generations were a wholly different breed from the earlier anonymous craftsmen and the City entrepreneurs who employed them. They were the sons of professional men and industrialists for whom art was a vocation rather than a trade.

Much of the nostalgic interest in popular prints was associated with Newcastle, where the print trade had flourished in the eighteenth century and where Thomas Bewick's wood-engraving had raised the status of the medium. In 1858 the printer Emerson Charnley published a limited edition collection (twenty copies) of impressions from old woodblocks, many of them very crude indeed (see pp. 186–7, fig. 8.6). In the following year Joseph Crawhall (1821–96) published a limited edition of forty copies of *The Compleatest Angling Booke that ever was Writ*, the first of a series of books with similarly archaic titles decorated with Crawhall's own versions of seventeenth- and eighteenth-century woodcuts from ballads and chapbooks. He inherited the family rope-making business in Newcastle but was always more interested in the arts than in industry. He inaugurated annual art exhibitions in Newcastle in 1878, showing contemporary painting and in 1880 lending prints from his own collection by or after Parmigianino, Mantegna, Marcantonio Raimondi, Schongauer, Dürer, Ostade

and Jan Both. Crawhall was an executor of the will of Bewick's daughter Isabella, and in 1884 prepared a catalogue for the sale of Bewick's effects and inherited Bewick's own tools. After retiring from business in 1877 he worked closely with the publishers Tuer & Field at the Leadenhall Press in London, and most of his later books were published there. They are lavishly produced with carefully designed pages allowing plenty of space for his boldly decorative lettering and heavily outlined illustrations, usually based on recognizable prototypes and carefully coloured by hand (fig. 10.1); the paper is, however, in most cases acidic and now in poor condition.

Crawhall's books generally appeared in editions of varying qualities. *Izaak Walton: his Wallet Booke* (1885) – printed on hand-made paper, vellum-bound with silk pockets sewn inside the covers for 'Baccy', 'Hookes', 'Fysshe Tales I believe' (a small pocket) and 'Fysshe stories I don't believe' (a large pocket) – was published in five hundred copies at one guinea and one hundred copies on large paper at two guineas, the latter accompanied by one of Crawhall's engraved woodblocks. Some books appeared in cheaper lithographic editions. An example

10.1 Title page to *Chapbook Chaplets*, 1883. This volume is a compilation of Joseph Crawhall's book-illustrations and examples of lettering, all in his deliberately archaizing style.

is *Several Sovereigns for a Shilling*, a children's book of kings and queens from William the Conqueror to Victoria, jointly published by Hamilton, Adams & Company, London, and Mawson, Swan & Morgan, Newcastle, in 1886 at 1s. Crawhall and Tuer, however, had an eye on the collectors' market, and advertisements suggested that the value of their books would rise enormously: '*The Compleatest Angling Book that ever was Writ* First edition, 1858 (published at Two Guineas)... "We have seen a copy priced in a New York Bookseller's Catalogue at £30." – *Westwood's Bibliotheca Piscatoria*, 1861', and '*Crawhall's Chap-book Chaplets* ... "Published at twenty-five shillings, and in course of a few years will probably be worth as many pounds." – *The Paper and Printing Trades Journal*'.[1]

Andrew White Tuer (1838–1900) was brought up by his uncle, Andrew White, MP for Sunderland, and educated in Newcastle. In 1862 he went into partnership with Field, a London printer (d. 1891) and about six years later moved to Leadenhall Street. He had a great collection of eighteenth-century prints, especially those of Bartolozzi, on whom he published a monograph; ephemeral prints collected by Tuer are now in the Johnson collection at the Bodleian Library (see p. 202). Tuer wrote a number of popular antiquarian books. These include *London Cries*, 1883, with reproductions of prints of street criers by Bartolozzi, Crawhall, Cruikshank, Rowlandson and others; it sold at one guinea for the ordinary edition, two guineas for a large paper edition limited to 250 copies with signed proofs of twelve 'quaintly old fashioned and beautiful whole-page illustrations ... eminently adapted for separate framing', and four guineas for an edition of fifty large paper copies with the signed proofs printed on satin. In 1885 a small version of the book appeared as *Old London Street Cries*, priced at 1s.[2] Tuer's text consists mainly of lengthy quotations of the cries, and transcriptions of earlier accounts of street sellers. The Leadenhall Press also published books on popular prints by other authors in the same nostalgic vein such as John Ashton's *History of English Lotteries* (1893), based on examples of lottery advertisements and tickets, many of which were in Tuer's collection. In the first sentence of his *Humour, Wit and Satire of the Seventeenth Century* (1883) Ashton summed up the approach of the Tuer circle: 'Our forefathers delighted to call their country "Merrie England"; and so, in very truth, it was.'

The following generation of printmakers saw the popular print through the eyes of Crawhall and Tuer. William Nicholson (1872–1949) was the son of a wealthy MP and always disdainful of the conventional English art world. In 1893 he and James Pryde (1866–1941), styling themselves the Beggarstaff Brothers, joined in partnership in order to design posters. Their designs, with thick outlines surrounding areas of vivid colour, were modelled on Crawhall's illustrations, but they added an elegance, drawn from *art nouveau*, that took the end results even further away from their source in popular woodcuts. The fact that Nicholson was consciously recalling the woodcuts of Seven Dials, and before that of the City, is made clear in the subjects chosen for four sets of hand-coloured woodcuts he

made for William Heinemann after the partnership with Pryde had ceased: *An Alphabet*, 1898; *An Almanac of Twelve Sports*, 1898; *London Types* (thirteen plates), 1898 (fig. 10.2); and *Twelve portraits*, 1899. Each set was published in three versions: a deluxe edition in portfolio form printed from the original wood-cuts and hand-coloured by Nicholson himself, laid down on to backing sheets and signed by him; a library edition in book form on Japanese paper printed from lithographic transfers from the woodblocks with the colour printed litho-graphically; and a popular edition printed from the same lithographic stones, but on ordinary paper.

Nicholson's style was in turn echoed by the designer Claud Lovat Fraser (1890–1921)[3] who collected street broadsides and chapbooks and was also a great

2nd Impression.

PRICE—Twopence, plain.
Fourpence, coloured.

A SONG.

With love among the haycocks
We played at hide and seek ;

He shut his eyes and counted—
We hid among the hay—
Then he a haycock mounted,
And spied us where we lay ;

And O ! the merry laughter
Across the hayfield after !

RALPH HODGSON.

PRINTED BY A. T. STEVENS, OF 55 ST. MARTINS LANE, IN THE CITY OF
WESTMINSTER, FOR *FLYING FAME,* 45 ROLAND GARDENS,
LONDON, S.W., WHERE COPIES MAY BE HAD
FROM THE *SECRETARY.*

(*Facing page*)
10.2 *The Newsboy*, from
London Types, 1898. William
Nicholson's street vendor is a
direct descendant of ballad- and
broadside-sellers in prints going
back to the seventeenth century,
but the elegant composition is
wholly of the artist's own time.

10.3 *A Song*, 1913. Claud
Lovat Fraser recreated the
ballad form using twentieth-
century techniques and modern
poetry. His imprint 'Flying
Fame' took its name from a
popular seventeenth-century
ballad.

admirer of Crawhall's work. In 1913 Fraser and the poet Ralph Hodgson began to produce, under the imprint 'At the Sign of Flying Fame', what they described as modern versions of street ballads and chapbooks (fig. 10.3). Even such self-conscious revivals were printed by up-to-date technology: Fraser's bold outlines drawn with a reed pen were reproduced in line block; he added the colouring himself in bright inks.[4] He also designed a number of covers for *The Chapbook*, the monthly journal of Harold Munro's Poetry Bookshop.[5] The September 1920 issue has an article by Fraser on 'Old Broadside Ballads' and a cover design of a ballad-seller who is closer to Fraser's theatrical designs than to an eighteenth-century street (fig. 10.4). A similar sinister glamour was applied to the eighteenth-century low-life characters of *The Beggar's Opera* in Fraser's designs for the famous 1920 production by Nigel Playfair at the Lyric Theatre, Hammersmith.[6]

THE CHAPBOOK No 15
(A MONTHLY MISCELLANY) September 1920

OLD BROADSIDE BALLADS
Collected and Edited, with Reproductions
in facsimile, and Introduction by
C. LOVAT FRASER

ONE SHILLING AND SIXPENCE NET

10.4 *A ballad-seller*, cover to *The Chapbook*, September 1920. Claud Lovat Fraser's polished cover design could not be further away from the crude woodcut title-pages of the eighteenth-century chapbooks that gave their name to this literary journal.

10.5 Page from *Who killed Cock Robin?*, 1996.
This private press edition of a familiar nursery rhyme appeared in a chapbook format with well-designed type and fine wood-engravings by Enid Marx. Although using techniques familiar in popular prints, the care that has been lavished on its production and the intended market among collectors move it far away from its sources.

Who Killed Cock Robin?
I, said the sparrow,
With my bow and arrow,
I killed Cock Robin.

Who saw him die?
I, said the fly,
With my little eye,
I saw him die.

There were echoes of popular prints in the work of wood-engravers published by private presses between the wars and in the simple designs favoured by the Curwen Press,[7] but a conscious interest in the work that is the subject of this book returned only with the spirit of postwar nationalism and the 'new Elizabethan' era of the early 1950s. By then it was no longer obvious that the cheap printed material sold on the streets was the product of commercially minded entrepreneurs. Cheap prints merged in artistic consciousness with the folk art of fairground decoration, naive painting and such traditional crafts as scrimshaw and plaited corn dollies.[8] The artist and designer Enid Marx (1902–98) wrote about popular prints in this context and her collection of popular and folk art has been left to the Museum at Compton Verney, Warwickshire. Her carefully designed 'chapbook' of *Who Killed Cock Robin?* (fig. 10.5), printed in a limited edition on fine paper, epitomizes the twentieth-century view of the popular print as a collector's item – as far as can be from the tabloid newspapers that are its successors in function, if not in form.

THE CONTINENTAL
PERSPECTIVE

This final chapter looks at the popular print in England in comparison with its Continental equivalents. The popular print was 'discovered' simultaneously throughout Europe at the turn of the eighteenth to nineteenth centuries, and early woodcuts and contemporary catchpenny prints alike were seen as expressions of national character.[1] It is clear, however, that each country did not give such material the same attention. Extensive bodies of literature on popular prints exist in some countries, while in others – such as England – they have largely been ignored by scholars. Is this variation to be accounted for by national differences in popular print production? Or is it a function of differing intellectual interests?

Popular prints throughout Europe are distinctly similar in subject matter and there is little variation in style. Images of kings, cuckolds, criminals and freaks of nature are always to be found; every country has its land of cockaigne, the stages of life, Christ crucified (though not always the Virgin and saints), *memento mori* and the game of goose. Techniques do not vary: woodcuts provide long print-runs and have the practical advantage of allowing letterpress to be printed in the same operation as the image, but simple linear etchings are quick to produce and were also widespread. It is only in the high proportion of popular ballads as against images without text that the English popular print trade appears to have differed substantially from that of the Continent (see pp. 17–19).

Far fewer prints were published in England – at all levels – than in most other European countries and few popular prints survive from before the late eighteenth century. England tended to lag behind Continental developments, and the print trade can be seen as a provincial outpost. Woodcuts of both high and low quality appeared in Germany soon after 1400, and cheap images of saints were sold in huge numbers at pilgrim shrines and fairs. France, too, established a popular print industry at an early date: in 1455 – more than twenty years before the first print was printed in England (see p. 42) – printmakers in Toulouse set up a guild and established themselves as suppliers of playing-cards and images on paper in honour of various saints and confraternities ('ymagenas faytas de papier a honor de deverses sants et confrayrias') to much of the southern part of France, and similar simple prints coloured with stencils continued to be produced until the nineteenth century.[2]

Where the Reformation took hold, it destroyed the trade in woodcuts of Roman Catholic saints, but in Germany printmakers found a new Protestant market. Luther saw the value of prints as a means of evangelizing an unsophisticated

congregation: 'children and simple folk ... are more easily moved by pictures and images to recall divine history than through mere words or doctrines'. His *Passional Christi und Antichristi* (1521) was illustrated with unpretentious prints by Lucas Cranach that oppose the humility of Christ with the extravagance of the warrior pope (the 'Antichrist').[3] Anti-papist prints were also in demand in England: the text and simple woodcut illustrations of *Practica der Pfaffen* (Jakob Cammerlander, Strassburg, *c*.1535;[4] fig. 11.1), a series of apocalyptic prophecies demonstrating that the Reformation was foretold and that the papacy would fall, were used as the basis for Walter Lynne's *The beginning and endynge of all popery ... set forth out of hye Almayne into Englyshe* (1548; fig. 11.2).[5] The woodcuts were re-used (by now with worm-holes) in an edition of 1588 published by I. Charlewoode,[6] and one of the cuts (the pope with a wolf, a sword, a razor in his hand and the imperial crown at his feet) appeared a hundred years later as an illustration to a ballad entitled *The Pope's Pedigree*, printed for J. Conyers at the Black Raven in Holborn.[7] Another (in which a unicorn dislodges the papal tiara) was reinterpreted in a much coarser style as the title page to a 1615 edition of a

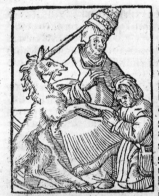

11.1 Page from *Practica der Pfaffen*, *c*.1535. The simple woodcuts illustrating this German anti-Roman Catholic text were deliberately designed to be easily understood by those who might not readily grasp the meaning of the text: here a unicorn, symbol of innocence, dislodges the triple tiara of a corrupt pope.

book published by W. White under the title *A Nunnes Prophesie, or The fall of Friers; Contayning the downefall of the Pope, by the Unicorne of the West* (fig. 11.3).[8]

But most surviving sixteenth-century single-sheet prints – not least those by Luther's friend Cranach – are elaborate compositions drawing on complex iconographic conventions. They would have been expensive, and few can be called popular in any sense other than that they dealt with subjects that would have had wide interest. Broadsides satirizing hen-pecked husbands, corrupt clergy and so on, with songs by Hans Sachs, the Nuremberg shoemaker-poet, and woodcut illustrations by Erhard Schön,[9] would have been bought by a literate middle-class audience and are far superior in quality to the street ballads of later periods. Subjects that were later identified only with cheap print production appear at this period in high-quality prints in all media (fig. 11.4). Woodcut was given equal status with engraving. In 1515 Dürer, the master of both techniques, made a woodcut broadside of an exotic creature – his famous rhinoceros. Among the

11.2 Page from *The beginninge and endinge of all popery*, 1548, an English version of fig. 11.1.

11.3 Title page to
A Nunnes Prophesie, 1615.
This crude version of figs
11.1 and 11.2 demonstrates
the decline in the English
woodcut by the beginning
of the seventeenth century.

finest prints produced in France in the second half of the sixteenth century were the large woodcuts published by a group of *imagiers* in the rue Montorgueil, Paris. Their style was based on that of the mannerist decorators of the château of Fontainebleau earlier in the century, with elaborate frames designed as part of the print. Biblical scenes and the lives of saints were common subjects, but others are similar to those of popular prints produced in England and elsewhere: allegories, patriotic scenes, social satires, instructive subjects (anatomical prints (fig. 11.5), costumes, birds, flowers, games), prodigious births, maps, *memento mori*, portraits of the king, prints after Raphael.[10]

The print trade was international, and rue Montorgueil prints were made for export with blank cartouches to be printed in other languages. Gyles Godet, who settled in England in 1547,[11] published series on the Prodigal Son and Sts Paul and Joseph after designs made for him by François Gence in the rue Montorgueil. He was related to Prigent Godet, who was in business there as a printer in 1571, and the woodcuts he published in England compare well with Continental publications (see figs 3.2, 3.3 and 11.5).

11.4 *The Stages of Life*, 1540. This fine large woodcut designed by Jorg Breu the Younger of Augsburg is one of the earliest to depict the Stages of Life in a series of steps; a number of later English versions are illustrated in Chapter Eight.

In the seventeenth century the middle range of print publishing developed with a combination of engraving and etching as the usual medium. Print-publishing dynasties were established that were to last in many cases for more than a hundred years. The focus of the Parisian print trade (fig. 11.6) was in the area around the Sorbonne – especially the rue Saint Jacques. The best-known names are Basset, Bonnart, Chéreau, Jollain, Lagniet, Landry, Langlois, Larmessin and Mariette. Prints from Antwerp (established as a great centre of engraving in the sixteenth century by publishers such as Cock, Galle and de Jode, and after the city fell to Spain in 1585 by émigrés such as Crispijn de Passe[12]) were exported throughout Europe and found a market not only among collectors but also as models for the work of all manner of craftsmen.[13] Huge numbers of prints were in circulation, and as well as high-quality engravings publishers sold cheap copies or prints from worn plates or damaged woodblocks. The middle-market London print shops of Peter Stent and Robert Walton (see pp. 48–50) would have had their equivalents in every European city.

The eighteenth century saw the emergence of woodcuts of popular subjects deliberately made to sell cheaply. Many French provincial cities had thriving print-publishing trades. The accounts of André-Sébasten Barc (1736–1811), a little-known publisher of Chartres, demonstrate the scale on which such businesses operated. His best-selling subjects sold in huge numbers: forty thousand images of Christ, ten thousand of the Wandering Jew.[14] In Amsterdam the print shops of de Groot, Kannewet and Lootsman sold large woodcuts with stencilled colouring (the equivalent of Dicey's 'royal' sheets; see p. 59) of amusing and moralizing subjects aimed largely at children.[15]

In England popular prints were sold by ballad-singers who 'chaunted' in the streets with a basket or pocket full of songs, and by peep-show men with large

11.5 *The Anatomie of the Inwarde Partes of Man and Woman*, c.1559. Such prints were probably aimed at barber-surgeons who needed rudimentary anatomical knowledge to be able to bleed patients safely. A series of flaps can be lifted to reveal the internal organs. The print was registered by Gyles Godet in London in 1563 but may have been cut in France.

boxes in which were prints that could be viewed through a magnifying lens (figs 2.15 and 7.4). In Continental countries another type of vendor was also common: the *bänkelsänger* or *chanteur de cantiques*. The singer would perform, usually from an improvised stage, in front of a screen or board to which were attached coloured prints; as the ballad was sung an assistant would follow the sequence of events by pointing to each print in turn (fig. 11.7). In the Musée Départemental d'Art Ancien et Contemporain, Epinal, is the box of a *chanteur de cantiques* containing a carved figure of the suffering Christ with prints attached to the doors.[16] These performances continued into recent times – for examples as late as 1968 see Eichler and Wynen.

The most successful centre for popular print production was Epinal in eastern France. The brightly coloured prints produced by the firm of Pellerin in par-

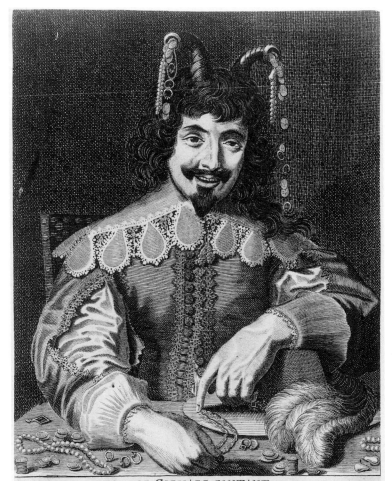

LE CORNARD CONTANT.

Malore le poinct dhonneur que lon osiametant. Par elles la Fortune á mis dans ma maison Puis que par leur vertu lō charme les malheu
Je prefere les biens à l'humaine prudence. Vne felicitè sans mesure et sans bornes , O qui pour mon repos elles m'estouentbian diies
Et de tous les mortels ie suis le plus contant. Et ma femme scait bien sue niy pas rayson Et quinitant le cerf ie verseroie des pleurs.
Diuoir dosus le front deux cornes dabondāe. De porter du respect à de si belles cornes. Sil falloit oui m adunt de les auoir perdues.

11.6 *Le Cornard Contant, c.*1650. The cuckold was an international figure of fun and this anonymous seventeenth-century French example served as a model for an English print (fig. 4.46).

(*Facing page*)
11.7 *Bänkelsänger,* 1740. The pedlar drums up custom by recounting the story told in his prints. This print by C. W. E. Dietrich apes the style of Rembrandt a century earlier.

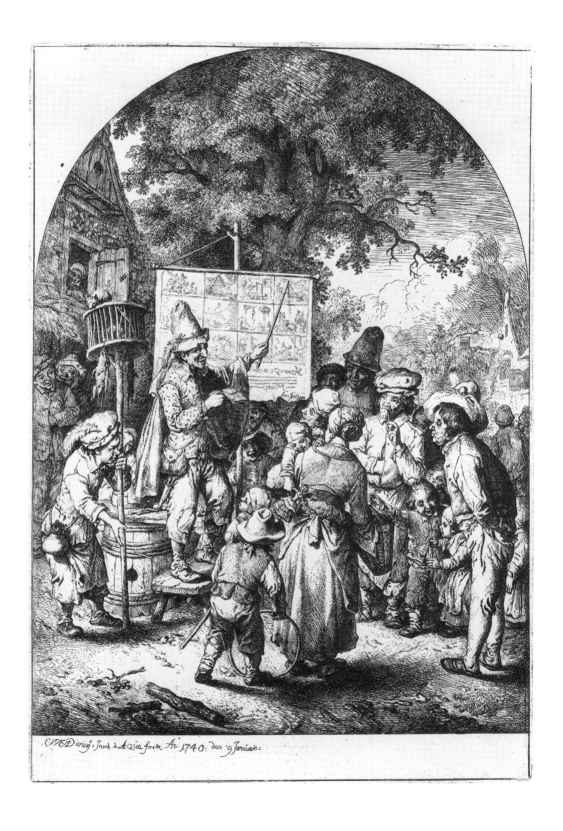

ticular are so well known that the term *imagerie d'Epinal* is often used in France as a generic description for popular prints. In the middle of the nineteenth century, while Catnach and the other Seven Dials printers succumbed to new technology and the rise of the illustrated newspaper, Nicolas Pellerin expanded his business. When he took over from his father, Jean-Charles, in 1822 he inherited 221 woodblocks and 7750 large and 36,500 small printed sheets; by 1846 he was producing more than three million prints a year. These figures are comparable with the output of the Catnach firm, but while Catnach made a fortune and retired at the age of forty-five (see p. 62) Pellerin moved on into mass production on a modern scale. He took up lithography in 1850, and later zincography and chromolithography, and the firm embraced the worldwide market for instructive prints for children. Prints were sold as far afield as the newly settled American Midwest (fig. 11.8). In 1887 Pellerin produced 790 different images, in 1889 1441 and in 1914 almost two thousand – with up to half a million impressions of each print.[17]

The scale of Continental popular print production was always greater than that of England, but it was not different in its nature. The fact that English popular prints have received comparatively little scholarly attention must lie in the way that the popular print has been perceived by later scholars.

In Germany the study of popular woodcuts, especially early examples, has been assimilated into the study of woodcuts generally, and benefits from the high reputation of the German Renaissance woodcut. Prints produced as propaganda for the Reformation – expressing both simple and highly complex ideas – have been categorized as popular although a large proportion of them must have been aimed at a sophisticated audience. Collectors were active at an early stage: the collection of broadsides of prodigies assembled by Johann Jakob Wick (1522–88), a Protestant pastor in Zürich, survives in twenty-three volumes in the Zentralbibliothek, Zürich.[18]

German woodcuts have been the subject of much systematic study, and there have long been series of reproductions on which to base scholarly research. The earliest was H. A. von Derschau's publication in 1808 of a large series of impressions from old woodblocks in his possession. Between 1899 and 1942 Paul Heitz published one hundred volumes of facsimiles of fifteenth-century single-sheet prints. Between 1923 and 1930 Max Geisburg published thirty-seven loose-leaf portfolios of facsimiles of German single-sheet woodcuts of the first half of the sixteenth century; these were reissued in four volumes by W. L. Strauss, 1974–5. In 1975 Strauss published German woodcuts of the second half of the sixteenth century, and Dorothy Alexander continued the series up to 1700 (1977). Collections of German broadsides of the sixteenth and seventeenth centuries are being published in a continuing series by Wolfgang Harms. German political broadsides of the seventeenth century are being published in a continuing chronological series by Roger Paas. Other useful recent texts are Bartrum, Coupe, Moxey and Scribner.

The land of Cocagne is a country which you cannot find on any map. It is the paradise of good children.

The boys always ride on rocking horses and byciefes and they never meet a stone on the road.

Water does not flow through the rivers, but sweet milk which the boys drink as they glide over in their little boats.

The little girls are always playing battle door and shuttle lock and never grow tired.

The houses are made of ginger bread and cakes so that if you are hungry you can eat the walls without breaking your teeth.

Every afternoon there is a *Punch and Judy* show where the most beautiful pieces you can imagine are played.

There are no schools there. Lessons are given in the country and any hour that the children wish.

Their books are so amusing and interesting that they cannot lay them aside: they are full of beautiful colored pictures.

It never rains in Cocagne. The sun is never too warm and they can play all day without growing tired.

From morning till night they run around in the shade of large oak trees.

The girls also run where they please without tearing their dresses, as there are neither thorns nor brambles.

Lunch is always waiting. They can have what they wish. All kinds of sweet meats and delicaeyes are there.

In the evening they all sing and dance together. Their feet do not become cold for the grass is never damp.

In the central building which is made of ice cream there is a large skating ring free for all.

At night they go into the parlor to play on the piano and sing the latest songs.

After the concert they enter the ball room and dance until midnight when they retire and prepare for the next day.

Imagerie d'Epinal. — Pellerin, imp.-edit.

"Printed expressly for the Humoristic Publishing Co, Kansas City, Mo."

11.8 *The Land of Cockaigne*, c.1880. In the late nineteenth century the dream-world of Bruegel's drunkards (pp. 120–22 and fig. 11.9) was domesticated to become a children's fantasy. Pellerin printed sheets in eastern France for the American Midwest.

Imagerie populaire was first brought to the attention of French scholars and artists by J. F. F. Husson, known as Champfleury, who began to write on popular culture in the journal *Le National* in 1850 and over succeeding years published series of articles on popular songs of the French provinces, ancient and modern caricature, patriotic pottery under the Revolution, and so on. With his book *Histoire de l'imagerie populaire* (1869) he hoped to encourage French artists to turn for inspiration to what he saw as the naive but vigorous work of provincial printmakers rather than the mediocrity of the Salon (for Champfleury's influence on Courbet see p. 166). Popular prints were seen, not as in England as an anti-quarian interest, but as a vital source for future development.

An interest in cheap prints in France can be traced back as far as the great seventeenth-century collector Michel de Marolles, who was said to have bought prints in the street as well as from the leading dealers and engravers of the day. His collection of 123,000 prints in 527 volumes was bought by Louis XIV in 1667 and is now in the Bibliothèque Nationale. Popular prints are also to be found in the large collection of prints on French history left to the nation in 1863 by Michel Hennin. In 1915 Henri Vivarez, founder of the historical society Le Vieux Papier, bequeathed to the Bibliothèque Nationale his collection of peep-show views and other popular prints, particularly from Epinal.

A general survey of popular prints by Duchartre and Saulnier in 1925 was followed by a number of publications on regional publishing which combined to make popular prints accessible for further scholarship.[19] The Musée National des Arts et Traditions Populaires, founded in 1936, takes an ethnographic approach to pre-industrial France, showing objects connected with agriculture, primitive forms of manufacture and religious practices, as well as housing, costume and the visual and performing arts. Many regional museums in France also have collections of popular prints.

A touring exhibition of over three hundred popular prints – *Cinq Siècles d'Imagerie Française* – was organized in 1973 (it was shown as *French Popular Imagery* at the Hayward Gallery, London, in 1974).[20] Its scale and prestige were unlike any imaginable English equivalent: a team of curators headed by Jean Adhémar, *conservateur en chef* of the Cabinet d'Estampes at the Bibliothèque Nationale and doyen of French print history, and an organizing committee of politicians and senior government officials. Two volumes of a complete illus-trated catalogue of the French national collection have so far appeared, under the editorship of Nicole Garnier.

A series of facsimiles of Netherlandish woodcuts of the first half of the sixteenth century were published by Wouter Nijhoff between 1931 and 1939. In the Netherlands popular prints tend to be subsumed into the study of genre subjects in prints and in paintings. Scenes from everyday life, whether or not with moral-izing undertones, have been favourite subjects since before the Reformation, and important early collections of prints often had sections devoted to such material, among which are prints that can be called popular (fig. 11.9).[21] An album of

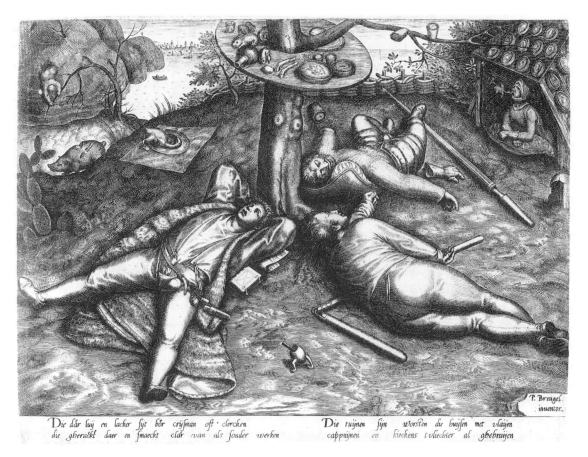

Die dâr luij en lacker syt bôr crijsman oft · clercken
die gheraёkt daer en smaeckt clâr van als sonder werken

Die ruijnen sijn worsten die huijsen met vlaijen
cappuijnen en kieckens t vliechier al ghebruijen

11.9 *The Land of Cockaygne*, 1567. This fine engraving by Jan van der Heyden after Peter Bruegel is based on his painting in the Staatsgemäldesammlungen, Munich.

'Grotessen' dated 1637 assembled by Pieter Spiering Silfvercrona (d. 1652) is now in the Rijksprentenkabinet, Amsterdam,[22] and a group of *snakerij* (drolleries) in the collection of Johannes Thysius (1621–53) is at Leiden University. In the 'Paper Museum' of the Roman collector Cassiano dal Pozzo (1588–1657) was a volume of Dutch genre prints (Royal collection, Windsor).[23] Popular prints appear also in important nineteenth-century collections of Dutch historical prints put together by Frederik Muller (Rijksprentenkabinet, Amsterdam), Abraham van Stolk (Rotterdam) and Simon van Gijn (Dordrecht). François Gerard Waller, one of the major benefactors of the Rijksprentenkabinet and a collector of Old Master drawings and prints as well as popular material, presented his collection of 7600 popular and children's prints in 1923. This great resource has allowed for systematic study of the popular print in the nineteenth-century Netherlands.[24]

An even larger resource is the collection of four hundred thousand secular popular prints from Italy and other countries presented to the Comune of Milan in 1927 by Achille Bertarelli (1863–1938). It has been housed ever since in the

Castello Sforzesco and is arranged by subject according to a complicated system devised by Bertarelli himself. This arrangement has lent itself to iconographic studies, rather than to studies of cultural history.[25]

While large numbers of English popular prints survive, especially from the nineteenth century, they are distributed within larger collections and there is no general catalogue – and few institutional catalogues – to serve as the basis for further scholarship.[26] Russia was even later in developing a print industry than England,[27] but Rovinsky's massive mid-nineteenth-century catalogue of popular prints gave them status and accessibility, and the *lubok* (fig. 11.10) is far better known than the English popular print. Rovinsky was a serious print scholar, well known for his catalogue of Rembrandt's prints, and his catalogue of popular prints was produced to an extremely high standard with five thousand excellent reproductions.[28] His work on popular prints coincided with the end of the tradition; the harsh censorship of Nicholas I destroyed the print trade, and the monasteries that produced 'paper icons' closed down. Artists of the early twentieth century rediscovered the *lubok*: Kandinsky reproduced examples in his *Blaue Reiter Almanach* (Munich 1912) and the combination of peasant life and the supernatural also influenced Marc Chagall, Natalya Gontcharova (fig. 11.11) and Mikhail Larionov. English popular prints await such a renaissance.

(*Facing page*)
11.10 *The Cat's Funeral*, *c.*1850. This is a later version of a highly popular subject among Russian popular prints (for an earlier version see Burke, fig. 10). It is based on the funeral in 1725 of Peter the Great.

11.11 *Bal Banal*, 1924. Natalya Gontcharova used a stylized image of women in peasant costume to illustrate a poster in the form of a traditional broadside. The art world of Paris is to be present at a ball where the aim will be to appear not exotic or elegant, but as banal and commonplace as possible.

NOTES

CHAPTER 1

1 For a wide-ranging discussion of the notion of popular culture as 'discovered' in the Romantic period see Burke, pp. 3–22.

2 See Griffiths 1996 for printmaking techniques.

3 Advertised in the *London Evening Post*, 18 March 1740 (information from Timothy Clayton).

4 A 'wood royal' (i.e., a woodcut measuring about 500 × 400 mm) of 'King Charles I on horseback' appeared as no. 253 on p. 76 of the 1764 catalogue of Cluer Dicey and Richard Marshall (see pp. 56–9); this is very likely to be a later impression of William Dicey's print reproduced here. The wholesale price list included in the same catalogue listed 'Wood Royals, plain, 26 to the quire' at 1s. 2d. a quire plain and 1s. 4d. coloured; retail prices can be assumed to have been double wholesale prices.

5 See figs 8.3 to 8.5.

6 R. Paulson, *Popular and Polite Art in the Age of Hogarth and Fielding*, Notre Dame, Indiana, 1979, p. x.

CHAPTER 2

1 On 4 August 1626 Thomas Pavier's widow assigned to Brewster and Bird her late husband's rights 'in any sorts of ballads ... and his interest and title to any pictures and ... tables'; rights in 'pictures' were reassigned to John Wright on 13 June 1642 (quoted in Blagden 1954). Both the terms 'pictures' and 'tables' could be used to refer to large woodcuts.

2 See pp. 42–3.

3 Watt, pp. 349–56.

4 Watt, p. 42.

5 See also J. van der Waals, 'The print collection of Samuel Pepys', *Print Quarterly*, I, 1984, pp. 236–57.

6 I. Walton, *The Compleat Angler*, 1653, The Third Day.

7 J. Swift, *Baucis and Philemon*, 1709.

8 T. Holcroft, *Memoirs*, I, 1816, p. 135; for an account of King Charles's rules see Martin.

9 G. Smith, *The Country Lovers*, 1770. For further literary references to ballads see Martin. For Fair Rosamond see fig. 2.3 and p. 114. The ballad of Chevy Chase concerns an episode in the medieval feud between the Percy and Douglas families across the English-Scottish border.

10 For an account of the development of literacy and its social and political context see L. Stone, 'Literacy and education in England, 1640–1900', *Past and Present*, XLII, February 1969, pp. 69–139.

11 See pp. 42–3.

12 The Court of Star Chamber consisted of members of the King's (or Queen's) Council who sat as a court in a room at Westminster decorated with stars. The rules of procedure of the court made it a powerful instrument of governmental control. Under James I and Charles I its powers were abused and it was abolished in 1641.

13 For ballads registered after the decree of 1586 see Arber.

14 Watt, pp. 39–73.

15 See Blagden 1954 for a clear account of the history of the ballad partnership (which sometimes has been confused with the English Stock, an organization run by the Stationers' Company to exploit its monopoly over certain particularly profitable material). Blagden's analysis of the changing membership of the partnership allows the dating of ballads published between 1655 and 1692. Thackeray's list is preserved with the Bagford ballads (British Library, C.40.m.10/2); the same list was appended to a partnership agreement between Thackeray, John Millet and Alexander Milbourn dated 18 January 1689 (Pepys, II.ii, pp. 177–82; facsimile, V, pp. 439–54).

16 W. Hone, *Ancient Mysteries Described*, 1823, pp. 97–103. Hone listed several dozen 'old carols', among which were some that are still well-known: *Hark! The Herald Angels Sing*, *The Holly and the Ivy* and *While Shepherds Watched their Flocks by Night*.

17 Thomas, pp. 347 ff.

18 Lilly was a friend of Elias Ashmole, and his library, letters and other papers are in the Bodleian Library, Oxford.

19 Thomas, pp. 347–55.

20 F. Dahl, *A Bibliography of English Corantos and Periodical Newsbooks 1620–42*, 1952. The authorities were anxious about any potential channel for Puritan propaganda and between 1632 and 1638 the Star Chamber forbade the printing of foreign news.

21 *The London Gazette* was named after the Venetian newspaper founded in the mid sixteenth century and itself named after the gazetta, the small coin that was the price of the paper or perhaps the price paid for reading a copy.

22 Griffiths 1998, pp. 280–2.

23 P. Lorrain, *The Ordinary of Newgate his Account of the Behaviour, Confessions, and Last Speeches of the Malefactors that were Executed at Tyburn*, 1703–1718 (British Library, 1852.d.4).

24 Advertisements might sometimes stray from the pious tone of the accounts. For instance, on 28 January 1708 an advertisement appeared for *Bumography: or, A Touch at the Lady's Tail's, Being a Lampoon privately Dispers'd at Tunbridge-Wells*, 1707, by a Water-Drinker.

25 Hogarth showed such a sheet – the triple tree clearly visible – in the final painting of his *Marriage A-la-Mode* series of 1743 (National Gallery).

26 Trade card of Thomas Kaygill, British Museum, Heal 100.45.

27 For a bibliography of *Newgate Calendars* up to 1811, see L. B. Faller, *Turned to Account: The Forms and Functions of Criminal Biography in Late Seventeenth- and Early Eighteenth-century England*, Cambridge 1987.

28 There is a group of plague broadsides in the British Library, 816.m.9.

29 There is a collection of eighteenth-century bellmen's sheets in the Public Library, Canterbury.

30 J. Larwood and J. C. Hotten, *History of Signboards*, 1866 (revised edition 1951), and A. Heal, *Sign Boards of Old London Shops*, 1957.

31 *User's Guide*, pp. 174–6, and A. Heal, *London Tradesmen's Cards of the XVIII Century*, London, 1925.

32 The full potential of wood-engraving was realized only in the work of Thomas Bewick (1753–1828). See Griffiths 1996, pp. 22–7, for an account of the technique and its history.

33 British Library, Bagford 5947/36.

34 Trade card, Banks 59.17, c.1710. Bedbury had earlier issued another trade card (Banks 100.34) with similar wording. The middle-market printmaker Sutton Nicholls (fl. 1700–40) also listed 'Tobacco-marks' among a wide range of types of prints he would engrave 'on Wood or Metal' (Heal 59.113). Thomas Willson advertised that he would print 'Tobacco Marks' and other ephemera; his trade card shows a copperplate rolling press (Heal 59.179, c.1720).

35 The advertisement is appended to an unillustrated broadside entitled *England's Over-Joy at the Duke of Monmouth's Return* (British Library, C.20.f.3/91). See pp. 135–6 for another advertisement by Dawks.

36 Griffiths 1998, pp. 283–4.

37 Reproduced in P. Thornton, *Authentic Decor: The Domestic Interior 1620–1920*, 1993 (paperback edition), p. 77.

38 Spufford 1981, pp. 91–110.

39 John Bewick wrote to his brother, the famous wood-engraver Thomas Bewick, that he found it hard to devise a way of representing some proverbs in the form of everyday scenes. His prints were not, however, the first representation of proverbs in England: a late-seventeenth-century set, possibly at least in part designed by Francis Barlow, appeared in the form of a pack of playing cards (British Museum, Willshire E.204). I am grateful to Nigel Tattersfield for information on this publication that will appear in his forthcoming book on John Bewick.

40 Locke was closely connected with the Shaftesbury family and was tutor to both the 3rd and 4th Earls. On 29 August 1712 Thomas Micklethwayte wrote from England to his cousin the 3rd Earl in Naples and told him that his two-and-a-half-year-old son, Lord Anthony Ashley Cooper, was 'mightily diverted with Mr Locke's playthings and begins to know the letters upon them' (S. O'Connell, 'Lord Shaftesbury in Naples 1711–1712', The Walpole Society, LIV, 1988, p. 178).

41 Sold at Christie's, 23 June 1993.

42 Roscoe J223(2). Similar books were published by P. Norbury of Brentford (*A Pretty Lottery Book for Children*, c.1770, British Library, Ch.810/103) and W. Charnley of Newcastle (*A New Lottery Book of Birds and Beasts for Children*, 1771, British Library, Ch.770/16). I am grateful to Barry McKay for drawing my attention to these books.

43 Trade card of Thomas Kaygill, British Museum, Heal 100.45.

44 The word does not appear in the Oxford English Dictionary with this use, but children's prints of the same type were known by similar names throughout Europe until the twentieth century.

45 Roscoe and Brimmell (p. xv) describe how this game was turned into a method of selling prints by girls on the streets of Glasgow who used to pester passers-by with cries of 'Dab, dab, dab at the picture-book'.

46 The first lottery was set up under Elizabeth I. Lotteries became an important source of public funds during the eighteenth century, but they were notoriously corrupt and were abolished in 1826.

47 A number of handbills, especially those of T. Bish, are reproduced in Ashton 1893.

48 Sold at Sotheby's, 9–10 December 1985.

49 Catalogue of the print publishers Sayer & Bennet, 1775, p. 127. Six Harlequinades were sold at Sotheby's, 6–7 June 1991, lots 178–83.

50 Sotheby's, 6–7 June 1991, lot 182.

51 See Speaight, pp. 46–50, for a discussion as to whether West or J. K. Green was actually the first to publish toy theatre prints.

52 Interview in *The Morning Chronicle*, quoted in K. Fawdry (ed.), *Toy Theatre*, 1980, pp. 21–3.

53 *The Magazine of Art*, April 1884.

54 O. Goldsmith, *The Citizen of the World*, 1762. See also letter to Henry Goldsmith, 13 January 1759, quoted in Martin.

55 See pp. 80–3 for the popularity of portraits of Cumberland. Sets of the seasons, the months, the times of day, the liberal arts and so on were long-established features of the print market at all levels (see Griffiths 1998, pp. 307–13).

56 O. Goldsmith, *The Deserted Village*, 1770.

57 Luttrell collection, Newberry Library, Chicago.

58 Bartrum, pp. 97–8.

59 C. J. Kaldenbach, 'Perspective views', *Print Quarterly*, II, 1985, pp. 87–104.

60 Griffiths 1998, p. 196.

61 M. Braun-Ronsdorf, *The History of the Handkerchief*, Leigh-on-Sea, 1967.

CHAPTER 3

1 S. O'Connell and D. Paisey, 'This Horryble Monster: an Anglo-German broadside of 1531', *Print Quarterly*, XVI, March 1999.

2 The situation in London may be compared with that in Nuremberg where there was no guild system and Dürer developed his remarkable skills as a printmaker in an open market where he could sell his work freely (see Bartrum, p. 9). See Griffiths 1998 for the slow growth of the upper end of the print trade in the seventeenth century.

3 I am grateful to Malcolm Jones for passing on the results of his research in the Stationers' Registers and STC.

4 See Arber, I, p. 272, and Watt, pp. 354–6.

5 British Library, Huth 50/28.

6 A. Carlino, '"Know thyself": anatomical figures in early modern Europe', *RES. Anthropology and Aesthetics*, XXVII, 1995, pp. 53–69.

7 IFF, II, pp. 331–3.

8 R. Lloyd, *A Briefe Discourse of the ... Actes and Conquests of the Nine Worthies*, 1584.

9 Watt (pp. 190–1) agrees, somewhat hesitantly, with the suggestion in STC (13851) that the block had passed to a Paul Boulenger, but the evidence is scant.

10 Godet's woodcuts registered 1562 to 1568 and Thomas Warren's of 1656 are listed in Watt, pp. 354–6.

11 Griffiths 1998, pp. 30–1.

12 Lemon 177 'Printed by E. Allde for H. G. [Henry Gosson] and are to be sold by Edward Wright', and Lemon 204 'Printed at London by Edward Allde for John Wright'.

13 *The Tempest*, Act III, scene ii. The connection with Shakespeare was reciprocal, for in 1603 Trundle published a pirated copy of *Hamlet*.

14 For an exhaustive account of the motif see Calmann.

15 Watt, p. 359.

16 Lemon 143, 210, 232, 239 and 243. See Johnson 1986 for an account of Trundle's career and publications.

17 Globe dated Stent's first catalogue to 1653 but the date has since been revised to 1654 (see Griffiths 1998, p. 123).

18 *The Cat's Castle*, clearly from the same group (and acquired by the British Museum in 1953 with *Lubberland*), does not appear in any of the known advertisements issued by Stent or Overton; the print may have been one of the 'such like; fifty sorts' listed as 'Sorts of Pictures of Stories' in 1662 and 1673 (Globe, p. 185). *The Contented Cuckold* and *Lubberland* are listed by Globe as his nos 452 and 471. None of the impressions reproduced here had been located by Globe.

19 For references to these and other print publishers' catalogues see Griffiths 1984. See Griffiths 1998 for the upper end of the seventeenth-century print trade.

20 Oxford, Bodleian Library, Gough Maps 46, f. 169.

21 Globe, p. 7. See Griffiths 1998, p. 17, for routes by which the stock plates of the major seventeenth-century print publishers descended.

22 J. Gay, *Trivia*, 1716.

23 T. Brown, *Works*, II, 1729, p. 236 (quoted in Rostenberg, p. 81).

24 The following information on the Bowles family is based on D. Hodson, *Country Atlases of the British Isles*, Tewin 1984, I, pp. 186–91.

25 A group of 163 prints published by Bowles and Carver, mostly of the type described as 'lotteries' (see pp. 33–4, fig. 2.15) were reproduced, actual size, in Old English Cuts.

26 For a thorough study of the upper end of the eighteenth-century print trade see Clayton.

27 A Dicey woodcut satire on the South Sea Bubble (BM Sat 1626; Roxburghe, III, 855) has printed on the verso a ballad entitled *Roger's Delight: or, The West Country Christening and Gossiping* with a woodcut illustration.

28 This major series had been jointly published by Henry Overton and Thomas Bowles in 1717 (Clayton, pp. 55–6).

29 More recently a number of articles have been published by Gilles Duval on aspects of the Diceys' production; see *Factotum*, 1992, pp. 9–11, and 1995, pp. 13–18, with further references.

30 Raikes moved to Gloucester in 1722 to set up *The Gloucester Journal* and the partnership was dissolved in 1725. The Dicey name appeared on *The Northampton Mercury* until 1885.

31 Roxburghe, III, 855. In 1721 Dicey placed an advertisement in the *Northampton Mercury* (p. 311) for subscriptions for a print of Peterborough Cathedral. The advertisement gives another impressive list of respectable retail outlets where subscriptions could be taken: 'at Mrs Standish's Coffee house and at Mr Little's at the White Hart in Peterborough; at Mr Fowler's, Bookseller, in Northampton; at [Dicey's] Printing Office there; and by the men that carry this news ... Mr Wilson, Bookseller, in Boston; Mr Jonathan Sisson, Mathematical Instrument-maker, at the corner of Beaufort Buildings in the Strand, London; Mr Smith, Bookseller, in Daventry; Mr Ratton, Bookseller, in Market-Harborough, and at his shops in Kettering and Lutterworth; Mr Gibson, Bookseller, in Wisbech; Mr Lot Mael, Draper, in Spalding; Mr Blyth, at the Black Swan in Stamford; Mr Dexter at the Queen's Head in Thrapson; Mr James at the Three Horse-shoes in Huntingdon; Mr Bunning at the Swan in Uppingham; Mr Hartwell, at the Angel in Wellingborough'. I am grateful to Timothy Clayton for this reference.

32 John Cluer, whose wife, Elizabeth, was the sister of William Dicey, buried a son named Dicey Cluer at St Mary-le-Bow on 6 November 1713. It is likely that the boy died in infancy and that he and Cluer Dicey (whose

date of birth is unknown) were born at about the same time.

33 In the event the purchase fell through.

34 Cluer seems already to have owned a one-third share in the Pectoral Drops while the widow of their inventor and patenter Benjamin Okell owned a further third share (*The Northampton Mercury*, 13 January 1755; I have to thank Timothy Clayton for generously giving me copies of his notes from this newspaper).

35 Unidentified press-cutting annotated 1724 for *Daffey's Elixir Warehouse and the French Hungary Water Warehouse at Cluer's Printing Office* (Heal collection). Daffy's Elixir, or the Elixir Salutis, was said to have been originated about 1660 by the Rev. Thomas Daffy of Redmile in the Vale of Belvoir; it was manufactured by various members of his family and the recipe was published by Anthony Daffy (C. J. S. Thompson, *The Quacks of Old London*, 1928, p. 255).

36 British Library, 11621.c.1/45.

37 F. Pottle (ed.), *Boswell's London Journal 1761–3*, 1950, p. 299. Boswell's collection of Dicey chapbooks is now in Harvard University Library.

38 The dates printed on the covers of these catalogues are unreliable: the catalogue dated 1754 includes portraits of George III and Queen Charlotte (married 1761) and a view of the battle of Zorndorf (1763). In spite of such lapses, print publishers' catalogues give invaluable evidence about what was being produced; see Griffiths 1984.

39 The rate books show that Cluer Dicey 'and Company' continued to occupy two houses in Bow Churchyard until at least 1766. Further archival research would doubtless yield more information about the interrelationships of City publishers.

40 John Marshall & Company also traded at 17 Queen Street, Cheapside.

41 Woodcuts measuring approximately 450 × 400 mm.

42 The Dicey Warehouse occupied a large site on the corner of Bow Lane and Bow Churchyard and the lease probably referred to the existing premises.

43 See Bindman 1989 for an account of the English response to the French Revolution as seen in prints.

44 British Museum, 1992-6-20-3 (1–20).

45 John Catnach published illustrations by Bewick (see Hindley 1878, pp. 6–15). See Isaac for an account of the career of another north-eastern publisher, William Davison of Alnwick. Like Cluer and the Diceys, Davison sold medicines as well as prints and books.

46 See Shepard, 1969 pp. 73–7.

47 Clayton, pp. 10 and 288, n. 35.

48 Clayton, pp. 223 and 305, n. 65.

49 Bewick, p. 192.

50 Trade card for Isaac Bedbury, British Museum, Banks 59.17. Tillet was a coarse cloth used to wrap bales of fabric during shipping. It was stamped with a woodcut device identifying the owner. A block of a man's head from the reign of George II (1727–60) used for printing

on tillet bales survives in the Royal Albert Memorial Museum, Exeter. The mezzotinter Isaac Beckett began his career as an apprentice to a calico-printer and tillet-painter (Vertue, I, pp. 42–3).

51 Steevens noted that he had acquired from Hodson a print in his Hogarth collection (Lewis-Walpole Library, Farmington, Connecticut, vol. I, annotation on f. 3). There are woodcut illustrations signed Hodgson (*sic*) in J. Hawkins, *A General History of the Practice and Science of Music*, 1776.

52 'RM' was discovered by Barry McKay, who has brought to light much information on the Cumbrian print trade at the end of the eighteenth century (see Bibliography).

53 An American popular printmaker of the period whose name survives is Pompey Fleet, a slave owned by a publisher in Boston. An example of his work is identified by the initials 'PF' on a coarse woodcut on the title page to *The Prodigal Daughter*, c.1769 (Harvard University; I am grateful to Marjorie Cohn for this information).

54 The other prints of this type were the series *Industry and Idleness* (1747) and *Beer Street* and *Gin Lane* (1751).

55 For reproductions see Bindman 1997, pp. 145 and 147.

56 William Sale (*Samuel Richardson: Master Printer*, New York, 1950, p. 348) suggested that Bell was responsible for a group of book illustrations signed 'I.B.' in James Thomson, *A Poem sacred to the memory of Sir Isaac Newton*, 2nd edn, 1727; Daniel Waterland, *The nature, obligation, and efficacy of the Christian Sacraments*, 1730; Joseph Massie, *A Letter to Bourchier Cleeve*, 1757. The signature on these woodcuts differs from that on other prints and the quality is not so high; it is possible that they are the work of Isaac Bedbury.

57 British Museum, 1886-12-8-1043.

58 The Newbery woodcuts are listed in Roscoe: J219(2); J280(2); J308(8); J309(4) and (5); J348(6).

CHAPTER 4

1 I have to thank Malcolm Jones for drawing my attention to many of the references in this chapter. He has been particularly generous in passing on the results of his study of the Stationers' Registers which has gleaned information on the earliest publication of many prints which have been lost or which survive only in later impressions.

2 Pepys's categories are as follows: 'Devotion and Morality, History – True and Fabulous, Tragedy – vizt. Murders, Executions, Judgements of God, etc., State and Times, Love – Pleasant, Love – Unfortunate, Marriage, Cuckoldry, etc., Sea Love, Gallantry and Actions, Drinking and Good Fellowshipp, Humour, Frollicks, etc. mixt.'. For catalogues of the collection see Bibliography.

3 See C. Dodgson, *Woodcuts of the XV Century*, I, 1934. STC lists two additional indulgences (14077.14a and 14077.23). Another type of indulgence was aimed specifically at the relatively wealthy and so cannot properly be called popular. These indulgences were designed to raise funds for the repair and embellishment of churches and other religious foundations. Any illustration is incidental to the text describing the worthy

project and the rewards to be secured by those who contributed.

4 Religion and politics are inextricably linked, but I have attempted to separate prints expressing and encouraging morality and devotion (to use Pepys's terminology) from those which sought to bolster the Protestant faith with reminders of the threat of Roman Catholicism. The latter are discussed in Chapter Five, see also p. 89.

5 Granger, p. 74. A broadside of *Old Mr Dod's Sayings* entered the British Museum, Department of Prints and Drawings for the sake of the small woodcut portrait of John Dod (1868-6-12-1196); another version published by Thomas Norris and Joseph Marshall in 1721 was with Grosvenor Prints in 1995.

6 See Martin and Bindman 1986.

7 The earliest versions of the letters of Christ and Agbarus (Abgar) are in the *Ecclesiastical History* of Eusebius (*c.*260–*c.*340); there is a ninth-century Anglo-Saxon manuscript in the British Library (Royal MS 2A XXX, ff. 12v–13). An early-fifteenth-century English manuscript of the Epistle of Lentulus (British Library, Harley MS 2472, ff. 37–8) is a Latin translation of a much earlier Greek original. See M. Jones (ed.), *Fake? The Art of Deception*, exhibition catalogue, British Museum, 1990, pp. 79–80.

8 There are entries in the Stationers' Registers for prints of the Ten Commandments registered by John Wolf (14 May 1594) and John Pindley (27 April 1612). A four-sheet print in the British Museum (1876-7-8-2000) of Moses and Aaron supporting the tablets of the commandments was published by Laurie & Whittle (fl. 1794–1812) but appears in the 1717 catalogue of their predecessor Henry Overton.

9 Watt, pp. 244–50, figs 49 and 47. The broadsides are both in the Huntington Library, San Marino, California (RB 18343 and 18319). What is probably a version of *Some Fyne Gloves ...* was licensed by the Stationers' Company to William Welby on 30 July 1614 under the title *A Handfull of Doctrine or the Groundes of Religion in the Forme of a Hand*.

10 The many versions of the so-called *Soldier's Bible* are outlined in E. M. Wilson, 'The Tale of the Religious Card Player', *Folklore*, C, 1939, pp. 263–72.

11 For the survival of some aspects of traditional imagery see Watt, pp. 174–7.

12 Matthew, VII, 13–14.

13 The composition is found throughout Europe; there is even a popular nineteenth-century Russian version (British Museum, 1938-9-1-2). Prints of *Broad and Narrow Way* were still to be found on schoolroom walls at the beginning of the twentieth century (Eliza Clarke, b.1893, speaking on *Ian Hislop's School Rules*, Channel 4, 7 September 1997). A third 'way' was sometimes added, by which the foolish would proceed to Hell while thinking they were heading towards Heaven (see, for example, *Les 3 Chemins de l'Eternité*, published by Pellerin of Epinal, *c.*1800, reproduced in Martin and Huin, no. 50.

14 Revelation, XXII, 2. Sophisticated compositions like *The Tree of Man's Life*, engraved by John Goddard *c.*1634

(Griffiths 1998, pp. 148–51, no. 93), take the emblematic approach to a degree of intellectual and aesthetic complexity that is far beyond the realm of the popular print; a closely related print entitled *A Laurel of Metaphysicke* (Yale University, Beinecke Library) was entered in the Stationers' Register on 16 January 1638 to William Hope.

15 Revelation, XXI, 2.

16 Written descriptions of the long-lost painting inspired many versions in the Renaissance period and later; see Samuel C. Chew, *The Pilgrimage of Life*, New Haven and London, 1962, and R. Schleier, *Tabula Cebetis*, Berlin, 1973.

17 M-H 1481.

18 Prints by Wierix and contemporary Netherlandish engravers were well known in Britain; see Griffiths 1998.

19 What is apparently the earliest version of the print (New York, Pierpont Morgan Library, Peel collection, reproduced in P. J. Korshin, *Typologies in England 1650–1820*, Princeton, 1982) shows the Tree without the figure of Christ. For other versions see BM Sat 771, 4570 and 4571. For a discussion of the popularity of the image and its use by William Blake see Bindman 1986.

20 Kirkham's painting was based on a version of the iconography devised by the German Pietist Charlotte Reihlen (1805–68); see J. M. Massing, 'The Broad and Narrow Way: from German Pietists to English open-air preachers', *Print Quarterly*, V, 1988, pp. 258–67.

21 A third version (Oxford, Bodleian Library, Douce collection W.1.2 (13)) is reproduced in Kunzle, pl. 10-1.

22 Grinding or milling provided similar metaphors; see P. Huys, *Molen en molenaar te kijk gesteld*, Gent, 1996. Later Continental and surviving British examples of emblematic mills are usually light-hearted fantasies of old people being ground young: a crude woodcut showing such a scene forms the frontispiece to *The Merry Dutch Miller*, 1672 (British Library, 12316.a.43), a chapbook whose title page announces that it 'may serve to pass away an hour in a cold winter night, without any great offence, by a good fire side'; John Bowles's catalogue of 1749 included on p. 23 'The Wonderful Youth-restoring Mill for grinding old men and women young, representing all ranks of people, pressing to be ground, in order to recover their youth'; the image also appears on transfer-printed teapots produced by Wedgwood (D. Drakard, *Printed English Pottery: History and Humour in the Reign of George III 1760–1820*, 1992). The image is translated into political satires; for instance, James Gillray showed William Pitt grinding John Bull, the taxpayer, into money (BM Sat 8654).

23 The 'horn of suretyship' appears in an engraving published by C. J. Visscher, *Versinteer ghy beghint*, which is probably the source for English versions on the title page to F. Kirkman, *The Unlucky Citizen*, 1673, and as an illustration to a late seventeenth-century ballad entitled *The Extravagant Youth: or, An Emblem of Prodigality* (Wing E3934). The image is also referred to in Ben Jonson's *Eastward Ho* (Act I, scene i): 'I had the horn of suretyship ever before my eyes. You all know the device of

the horn where the young fellow slips in at the butts-end and comes squeezed out at the buckle.' I am grateful to Malcolm Jones for elucidating the meaning of this emblem.

24 Pepys, II, 72 and III, 71.

25 See BM Sat 6903, and British Museum, 'Caricatures', III, ff. 62–3.

26 S. Lines, *A Few Incidents in the Life of Samuel Lines*, Senior, 1862, p. 10.

27 STC 14898.5 to 14900.

28 See Watt, pp. 174–7.

29 Watt, fig. 25. The broadside was republished in the late seventeenth century by W. Thackeray (British Library, 816.m.22/12) and William Hone described an impression published in 1701 by J. Bradford in Little Britain (*Ancient Mysteries Described*, 1823, pp. 102–3).

30 I have to thank Mr K. H. Rogers for this reference.

31 F. Engels, *The Condition of the Working Class in England*, 1845; English translation, paperback edition, Harmondsworth, 1987, p. 71.

32 Bewick, p. 193.

33 *A New Song* and *England's Glory*, Sheffield: Printed by Francis Lister, near the Shambles, 1746 (British Library, Roxburghe, III, 789). A more up-market print (sold at '3d. Plain', and probably 6d. coloured) designed to be inserted into a watch-case has a small circular portrait of Cumberland surrounded by a verse reading 'William! the Princely Youth, with Transport see. He chains th'Oppressor, sets th'Oppressed free. Hail Friend of Albion, and of Liberty!' (reproduced in Griffiths 1996, p. 155).

34 For lists of Godet's and Warren's prints see Watt, pp. 353–5.

35 See also p. 131.

36 Griffiths 1997, pp. 224–7, figs 152–3.

37 British Museum, 1882-8-12-459.

38 Griffiths 1997, pp. 220–1, 294–6, figs 148 and 205.

39 *The Honourable and Truly Brave William Blakeney Esqr. late Governor of Minorca*, published by Henry Overton, c.1756, engraving with etching (British Museum, 1997-12-7-1) (reproduced in Clayton, p. 106).

40 Bewick, pp. 192–3.

41 A verse beneath a cheap engraving of Haddock (British Museum, 1868-8-8-1639) gives a flavour of the appeal of naval exploits: 'Britons the valiant Haddock here behold! / Who Spain will scourge, and fill with Indian gold / The pockets of each honest tar that fights; / For England's laws, her liberties and rights.'

42 Although he made his fortune through trade with America, Coram's fame is based on his role as a philanthropist in setting up the Foundling Hospital.

43 See Clayton, pp. 150–1, and fig. 165.

44 The symmetrical image appears, for instance, on a late-seventeenth-century ballad published by William Olney (Bagford, II, 110, and Roxburghe, III, 747) and in

chapbooks published in Newcastle (see fig. 9.5) and Whitehaven (McKay, pp. 69–70, fig. 2). The naturalistic version appears in the frontispiece to *The Famous History of the Valiant London Prentice*, Printed and Sold in Bow Churchyard, London, c.1780 (British Library, 1076.l.4/6, another edition 12315.aaa.6/13), and *The History of the London 'Prentice*, Printed by J. Turner, c.1820 (British Library, 11621.b.26/4).

45 The first edition of Foxe in 1554 was not illustrated.

46 For recent studies of Foxe see D. Loades (ed.), *John Foxe and the English Reformation*, 1997; see also Aston, pp. 172–5, and Watt, pp. 158–9. Eirwen Nicholson lists sixty-one derivations published between 1660 and 1837 (Loades, *John Foxe*, pp. 172–7).

47 Impression in the British Museum, FH 31.

48 Lemon 55, 77, 83 and 84. All were printed in London: 55 by John Awdely 'dwelling by great St Bartholomews'; 77 and 83 by Richard Jones who, in the former case, gave his address as 'dwelling near Holborn Bridge'; 84 by Thomas Purfoote for Edward White.

49 Chicago, Newberry Library, Luttrell collection.

50 Roxburghe, III, 33.

51 A version of the block (showing a murder in a forest) also appeared on the title page to *Natures Cruell Step-Dames*, 1637 (Folger Shakespeare Library, Washington, D.C.).

52 Bagford, II, 73–4.

53 Letter to Horace Mann, 18 October 1750.

54 *The exact Effigies, Life and Character of Christopher Layer, Esq*, 1723. Printed by F. Clifton, Waterman's Lane, Blackfriars, London (British Museum, 1851-3-8-417). See DNB for an account of Layer's life and conspiracies.

55 For George White's mezzotint after Thornhill's prison portrait of the young robber see Bindman 1997, p. 130, no. 73.

56 J. Harrison after W. Chamberlain, *Richard Parker*, etching, 1797. Published by J. Harrison & Co., York (British Museum, 1868-8-8-13519).

57 The Whole Life and Adventures of Miss Davis (British Library, 1077.g.36/2). For another portrait of Mary Blandy see fig. 9.4.

58 See Kunzle, pp. 193, 195–6.

59 British Library, 1077.g.36/29.

60 Bowman was the last woman to be burnt at the stake. She was executed outside Newgate prison in 1789 'for High Treason, in feloniously and traitorously counter-feiting the Silver Coin of the Realm' (British Library, 1077.g.36/28).

61 *The Last Dying Speech and Confession of John Pallett*, 1823. Bodleian Library, John Johnson Collection, Broadsides, Murder and Execution, III. See Gatrell, pp. 166–7; this study is to be recommended, among other reasons, for its use of execution broadsides and other prints as evidence for attitudes to public execution.

62 The notorious trial of James Rush was also exploited by other publishers: *The Norwich Mercury* advertised an 'Extraordinary' edition to be published immediately after the trial with verbatim reports and a number of wood-

engravings by 'first-rate artists' showing the building where the crime took place, Rush himself, his disguise and facsimiles of his handwriting. For a group of such material see Johnson collection, Broadsides, Murder and Execution, IV.

63 For an account of the Mannings' execution, and the responses to it of Charles Dickens and James Leech, see Gatrell, pp. 605–7.

64 Johnson collection, Broadsides, Murder and Execution, II, III and IV.

65 It was not only illustrations that were unreliable: the crimes of Sarah Malcolm, remembered from Hogarth's portrait of 1733, are described in another of Marshall's broadsides (Johnson collection, Broadsides, Murder and Execution, III) where the account is accurate in every detail except for the date of her execution, which is said to have taken place in 1816. Marshall was clearly cashing in on the popularity of execution broadsides by recycling an old story that he assumed his audience would have forgotten.

66 See woodcut illustration to a broadside of the execution of Henry Fauntleroy, 1824 (British Library, 1875.d.7/18).

67 A portfolio labelled 'Broadsides, Murder and Execution, Large' in the Johnson collection contains the Thompson etching together with variants of the composition in an etching of the execution of William Cundle and John Smith in 1812, published by John Pitts, as well as in woodcuts illustrating broadsides of the executions of Samuel Wright in 1863 and Louis Bordier in 1867. For Despard see Thompson, pp. 521–8.

68 On 4 February 1998 the London *Evening Standard* reported the execution on the previous day of Karla Faye Tucker in Huntsville, Texas. The account contained all the traditional elements: a description of the crime and the culprit's behaviour while awaiting execution; the repentant 'last statement'; her final meal; her clothing and hairstyle; details of the execution itself; her last words; and the reaction of the crowd gathered outside the prison.

69 *The Tempest*, 1611–12, Act II, scene ii. Shakespeare refers on other occasions to the fascination with what he called 'monsters': Macbeth was threatened with the fate of living 'to be the show and gaze o' the time: / ... as our rarer monsters are, / Painted upon a pole, and underwrit, / *Here may you see the tyrant*' (*Macbeth*, 1605–6, Act V, scene viii), and Autolycus, the archetypal pedlar, sold a 'ballad, of a fish that appeared upon the coast on Wednesday the fourscore of April, forty thousand fathom above water' (*The Winter's Tale*, 1610–11, Act IV, scene iii). Sketches by the German immigrant artist George Scharf demonstrate that similar tastes were still to be exploited in London in the middle of the nineteenth century: in March 1843 Scharf drew a mobile sideshow in Oxford Street, carrying advertisements for 'a boy born without Arms and hands', 'An enormous Fat Women' (*sic*) and 'The smallest man in the World'; in 1845 he recorded a cart in Upper St Martin's Lane with 'just arrived from Egypt ... a Monster Alligator'; and in 1855 Wombwell's Royal Menagerie at Smithfield with banners showing an elephant, lions and a zebra (reproduced in P. Jackson, *Scharf's London*, London, 1987, pp. 38–9).

70 Peter Parshall discusses such beliefs in a forthcoming essay in F. Carey (ed.), *The Apocalypse and the Shape of Things to Come*, exhibition catalogue, British Museum, 1999.

71 Archbishop Laud feared that a portrait in his study had fallen to the floor as a sign of God's displeasure; the antiquarian Ralph Thoresby wrote in his diary in 1682 that he was 'not ignorant that such meteors proceed from natural causes yet are frequently also the presages of imminent calamities' (Thomas, pp. 104–6).

72 Another impression in the Wick collection, Zentralbibliothek, Zürich (to be included in a forthcoming volume of Harms), is missing the upper woodcut of the front view of the twins, but retains lettering that is missing from the British Museum impression: a heading above the lower woodcut reads, 'The backe partes of the ii chyldren.'; the main text continues '... of the Kinges Maiesties booke. / Imprinted at London by Jhon Daye dwellynge over Aldersgate beneth S. Martyns'.

73 See Watt, pp. 251–3. The 'monstrous creatures' were all in the Huth collection, now divided between the British Library and the Huntington Library.

74 Roxburghe, III, 216–17. Conjoined twins and other malformed people were not only depicted in cheap prints. Many examples appear in high-quality early prints: conjoined twins born in Trebizond who were reared at the Sultan's expense (Monogrammist NA.DAT, reproduced in A. M. Hind, *Early Italian Engraving*, V, 1948, pl. 851); a man with a smaller figure growing out of his torso (Marcantonio Raimondi, Bartsch, XIV, 334.446); a one-eyed baby (Giulio Sanuto, Bartsch, XV, 500.3). An earthenware sgraffito dish of 1680 commemorates the birth of conjoined twins in Donyatt, Somerset (Taunton Museum; reproduced in M. Lambert and E. Marx, *English Popular Art*, 1951, pl. 27).

75 Interest in Parr was widespread and continued for an appropriately long time: his portrait was published all over Europe and he was often referred to as the 'Old, old, very old man'. Public houses named after him survive in London in Upper Street, Islington, Blythe Road, Hammersmith and elsewhere.

76 London: Printed by Peter Lillicrap for William Crooke at the sign of the three Bibles on Ludgate Hill, next Fleet Bridge, 1664 (British Museum, 1851-3-8-299). See Altick for a thorough account of exhibitions in London of remarkable people and animals of all sorts.

77 British Museum, 1914-5-20-490.

78 'Siamese twins' remain an acceptable fascination: the BBC Horizon programme devoted editions in 1995 and 1997 to operations to separate Dao and Duan, born in Thailand in 1990; *The Daily Mail* purchased exclusive rights to the first picture of Chloe and Nicole Astbury, born on 14 September 1995; on 26 December 1997 *The Daily Telegraph* devoted half a page to a photograph of Niamhe and Aoife Varley, who had been separated six months earlier.

79 Exotic visitors, human and animal, seem to have enjoyed a particular vogue in the early 1680s (Griffiths 1998, pp. 255–6).

80 British Library, N.Tab.2026/25 (formerly 551.d.18). Distinguished British Museum scholars continued to be

interested in the bizarre: the journal (unpublished manuscript, Bodleian Library) of Sir Frederic Madden, Keeper of Manuscripts, records that in May 1832 he visited the 'Scotch Youth' aged eight with double sight, in February 1833 he saw the 'Fat Boy' at the Royal Society, and in May 1833 the 'Exhibition of Wonderful Fleas' in Regent Street.

81 A collection of advertisements for exhibitions put together by Hans Sloane remains in a volume in the British Library (N.Tab.2026.25). One of them (f. 49) reads: 'This is to give notice to all gentlemen, ladies, and others, that there is arrived at this place a little wild man born in St. David's Straights, aged 27 years; he is 34 inches high, straight, very well proportioned, and clothed in the proper dress of his country: he had the honour to be shown to their Royal Highnesses the Prince and Princess of Orange, and their court at the Hague, to their great admiration. The like of this wild man having never been seen in Europe, is now to be seen at the Mitre and Rummer at Charing-Cross, from 10 o'clock in the morning to 1 in the afternoon; and from 2 in the afternoon to 8 at night. He has been shown twice before the Royal Family and Sir Hans Sloane.'

82 J. Hunter (ed.), *The Diary of Ralph Thoresby*, 1830, p. 259.

83 British Museum, 1914-5-20-698. The description of the orang-utan as the 'wild-Man of the Woods' recalls both the mythical 'greenmen' or 'woodwoses' covered in hair who were believed to have lived in the forests of medieval Europe, and stories of children brought up by animals from Romulus and Remus to Peter the Wild Boy, and later Mowgli and Tarzan. Peter 'the Wild Boy' (1712–85) was found in a forest near Hamelin in Germany in 1725 and brought up in England under the protection of George I. His arrival caused a great stir, and in 1726 Jonathan Swift wrote a satirical pamphlet entitled *It Cannot Rain but it Pours: or, London Strewed with Rarities, Being an Account of … the Wonderful Wild Man*.

84 Handbills in the British Library, LR 301.h.5/19aa and 15aa. The bills are part of the collection of Sarah Sophia Banks (see Bibliography).

85 A photograph in *The Independent*, 19 November 1994, showing a whale on the beach near Koksijde, Belgium, surrounded by a crowd of onlookers, is reminiscent of prints of the same subject by Jacob Matham, 1598 (Hollstein 317) and Jan Saenredam, 1601 (Hollstein 121).

86 See Altick, pp. 253–4, figs 78–9.

87 Byrne/O'Brien is the subject of a recent novel by Hilary Mantel, *The Irish Giant*, 1998.

88 British Museum, 1851-3-8-378. An etching of Joy entitled *The English Sampson* was advertised by John Nutt in *The Post Boy*, 14–16 December 1699. The fact that Nutt went to the expense of advertising takes the print beyond the realm of the cheapest prints, and the composition has pretensions beyond those of the average popular publication: Joy is shown with a lion's skin – like Hercules rather than Samson – in an elegant oval portrait surrounded by depictions of his feats of strength and agility.

89 There are prints of Morrell, Inglefield and other disabled artists in the collection of engraved portraits in the British Museum. The Mouth and Foot Painting Artists' Christmas cards still provide a major part of the income of many artists without hands.

90 J. G. Garratt and B. Robertson, *The Four Indian Kings*, Ottawa, 1985, pp. 3–5, 139–52.

91 For an account of Sartje's life and the indignities to which she was subjected both in England and France, see Altick, pp. 268–72. She provided material for satirical print-makers: see BM Sat 11577–11580, 11602, 14449.

92 The illustration is taken from a photograph sent to the British Museum in 1952 by the late Heinrich Schwarz, then Curator at Rhode Island School of Design, later at the Davison Art Center, Wesleyan University, Connecticut. Neither institution has been able to trace the woodcut.

93 The sign appeared outside a shop near St Giles-in-the-Fields, London, in Hogarth's *Noon*, 1738; in 1764 it was published as the trade card of Joseph Pitcher, oil and colourman, in the same area (Heal 89.113).

94 See V. Alford, 'Rough music or charivari', *Folklore*, CXX, 1959, pp. 505–18.

95 The well-known image of venerable philosophers beguiled by ruthless young women was used to illustrate a pamphlet telling the story of the fraudulent activities of Judith Phillips who was sentenced in 1594 to be whipped through the city of London (*The Brideling, Sadling and Ryding, of a Rich Churle in Hampshire, by the Subtill Practise of one Judeth Philips, a Professed Cunning Woman, or Fortune Teller*, 1595, printed at London by T. C. and sold by William Barley, at his shop in Newgate Market, near Christ Church. Huntington Library, San Marino, California; for an account of Phillips's career see Thomas, pp. 732–4).

96 See Coupe, pp. 145–6. The monsters parallel the sixteenth-century German pairing of the fat fool-eater and the starving giant who only eats men who are masters in their own homes (Bartrum, pp. 95–6, no. 83).

97 'O noble wyves, ful of heigh prudence, / Lat noon humylitee youre tonge naille, / Ne lat no clerk have cause or diligence / To write of yow a storie of swich mervaille / As of Grisildis pacient and kynde, / Lest Chichevache, yow swelwe in hire entraille!' (G. Chaucer, *Patient Grisell: The Clerk of Oxenford's Tale*, in *The Canterbury Tales*, c.1387).

98 In a print by Renold Elstrack of c.1620, see Hind, II, pp. 210–13, and S. O'Connell, 'The Peel collection in New York', *Print Quarterly*, XV, March 1998, pp. 66–7 (with reproduction).

99 The laws prescribing burning of witches remained on the statute books until 1736. For German anti-women prints see Moxey.

100 There are other versions in the Hennin collection (Bibliothèque Nationale, Paris) and in the Thys collection (Leiden). I am grateful to Malcolm Jones for pointing out the pun in the French title and for further information on this print.

101 In a number of early impressions of his engraving *Evening* (1738) William Hogarth printed the hands of the cuckolded husband in blue in order to identify him as a dyer.

102 See p. 32.

103 Roxburghe, III, 176–7, and Pepys, I, 404–5.

104 British Library, C.22.f.6/66. The use of this block can be followed in ballads in the Pepys collection (Pepys, IV, 103, 129 and 143). A copy of the same cuckold alone appears on *The Poor Contented Cuckold*, 1689 (Pepys, IV, 133).

105 An impression of the etching is in the Library of Congress, Washington, D.C., and an impression of the woodcut, entitled *O Rare Show: or, The Fumblers Club* in the British Library (Cup 21.g.34/62). Costumes and the style of the etching point to a date no later than the middle of the seventeenth century, but it has been suggested that the print was later adapted as a satire on the birth in 1688 of James II's son, the Old Pretender (R. P. Maccubbin and M. Hamilton-Phillips (eds), *The Age of William III and Mary II*, exhibition catalogue, Williamsburg, Virginia, 1989).

106 No. 32 in Carington Bowles's catalogue of 1786, p. 93.

107 Lewis-Walpole Library, Farmington, Connecticut, 735.7.19.1.

108 Pepys, IV, 65.

109 Yale University, Bienecke Library, Broadsides By 6/1700.

110 The iconography of *Fair Rosamond* was used by Hogarth as the basis for *Henry VIII and Anne Boleyn*, c.1728–9, also showing a mistress treated sympathetically in relation to the rejected queen.

111 BM Sat 7095.

112 BM Sat 4500.

113 BM Sat 3775. For seventeenth-century prints on the same theme aimed at a more sophisticated audience see Griffiths 1998, pp. 261–2.

114 BM Sat 6764 and 6765.

115 See E. D'Oench, *Copper into Gold: Prints by John Raphael Smith*, London and New Haven, 1999.

116 Figures composed of objects have always appealed to popular taste. The most famous examples of the genre are the sixteenth-century Milanese painter Giuseppe Arcimboldo's bizarre heads made up of vegetables and other materials.

117 This series of composite figures representing trades (BM Sat 2469–72) also includes a Barber whose genitals are represented by a pair of scissors and a razor strop.

118 Cambridge University Library, Madden collection, reproduced in S. Shesgreen, *The Criers and Hawkers of London*, Aldershot, 1990, p. 18, fig. 16.

119 Reproduced in Hind, III, pl. 211.

120 Pepys, III, 294, and 6, 257, 280 and 288.

121 Pepys, III, 71; Roxburghe, II, 453.

122 British Library, C.22.f.6/57.

123 Pepys, Prints and Drawings, London and Westminster, Chapter IX, 442.

124 IFF, XVIc prints, p. 194, Bibliothèque Nationale, Tf. 2, fol. 49.

125 The etching appears in R. Pennington, *Wenceslas Hollar*, 1982, as no. 596, and the British Museum has impressions both as a single sheet and illustrating a broadside entitled *Schaw Platz*. Another broadside with the same title and a very similar etched illustration was published by Peter Aubry in Strasburg between 1609 and 1628 (Harms, I, 145).

126 Roxburghe, III, 64–5 and 806–7; Pepys, II, 66; Manchester, Chetham's Library, Halliwell-Phillipps collection.

127 A late seventeenth-century etching, *The Wanton Head-dressers Coat of Arms* (Library of Congress, Washington), uses the popular device of an imaginary heraldic device. A mask and *fontange* form the crest, a length of cloth the shield and supporters are a rake with a goat and a cunning bawd with a fox at her side and a baby in a basket; the motto suggests that the milliner's shop is used to conceal prostitution: 'Keep a Shop for Countenance / Kiss with Beaus for Maintenance.'

128 Pepys, IV, 365.

129 The late-eighteenth-century fashion for huge powdered wigs was satirized at all levels of print publishing: Carington Bowles's cheap mezzotint droll, *Slight of Hand by a Monkey – or the Lady's Head Unloaded* (BM Sat 4546), in which a fashionable young lady is exposed as bald beneath her towering wig, was copied as an even coarser print for Davison of Alnwick (British Museum, 1991-6-15-67). Men who indulged a taste for fashionable clothes were similarly disapproved of, and a group of prints appeared in northern Europe around 1629 satirizing 'Monsieur A-la-Mode'; only one English version has been traced (*The Funeral Obsequies of Sir All-in-New-Fashions*, published by Thomas Geele, Oxford, Bodleian Library, Douce collection). Prints of the 1770s showing 'macaronis' dressed in exaggerated fashions treat both sexes with equal ridicule (for a number of examples see BM Sat V, p. 821).

130 BM Sat 1696.

131 Elements of this world appear in the Utopia described in Hugh Platt's *Flowres of Philosophie* (1572?): 'a house all tiled with tart, / The walls whereof with custard crusts / Are made by wondrous art. / The posts be all of cinnamon / and ginger jointly joined, / And wafers cover all the floor / where every stranger dined ... These pigs came in their petitoes / with long knives at their waist, / With shrieking voice they cried aloud / come eat us both in haste.'

132 The earliest known visual appearance of the subject is in a woodcut by Erhard Schön illustrating a broadsheet of Hans Sachs of c.1530 (Geisberg 1193). For a general account of the subject see G. Cocchiara, *Il Paese di Cuccagna*, Turin, 1956, and Malcolm Jones's forthcoming article 'The Land of Cockaigne' in *Garland Encyclopedia of Medieval Folklore*.

133 *An Invitation to Lubberland* (Roxburghe, II, 226), dating from the late seventeenth century, described how 'in every town / Hot roasted pigs will meet ye, / They in the streets run up and down, / still crying out, come and eat me ... / The rivers run with claret fine, / the brooks with rich canary / The ponds with other sorts of wine, / to make your hearts full merry: / Nay, more than this,

you may behold / the fountains flow with brandy, / The rocks are like refined gold / the hills are sugar candy.' A mid-eighteenth-century chapbook entitled *The History of Lawrence Lazy* (printed and sold at No. 4, Aldermary Churchyard; British Library, 12315.aaa.6/6) tells the story of the Governor of Lubberland Castle and his wife Katherine Sloth and their son Lob-lie-by-the-fire. In the 1960s Burl Ives sang of 'The Big Rock Candy Mountain', and more recently a Brazilian chapbook or *cordel* by Manoel Camilo dos Santos described the *Journey to Sao Sarué*: 'There I saw rivers of milk, / and fences of roast meat. / There were lakes of pure honey, / and others filled with cream, / reservoirs of port wine / and mountains of stewing steak' (translated by M. Dineen, *Brazilian Popular Prints*, 1995).

134 See Griffiths 1998.

135 See, for instance, a print after Isaak Ostade, *Singers at a window*, etching, c.1640 (Lewis-Walpole Library, Farmington, Connecticut), where verses celebrate the joys of a simple life: 'From cares that man is never free, / Who sets his heart upon his riches: / Has house on land or ship at sea, / Or too much money in his breeches. / Shipwrecks and thieves disturb his thoughts, / With great perplexities he labours: / While I, who ne'er was worth two groats / Sing and make merry with my neighbour'. A companion print with a similar image (after Isaak Ostade, Bartsch 19) adds a misogynist gloss with verses extolling the contentment resulting from singing rather than contending with a shrewish, unfaithful wife.

136 Bindman 1997, nos 6–9.

137 Wing J1116. The block was a popular one and appeared on a number of the ballad partners' publications.

138 The moral appears on the frontispiece to a set of prints by Paul van Somer published with the title *Nil Placet* (Nothing Pleases; British Museum, 1977.u.1237).

139 For an Italian version see N. Turner, 'Some drawings by Giuseppe Caletti, called il Cremonese', *Scritti di storia dell'arte in onore di Federico Zeri*, 1984, II, pp. 681–8. On 8 March 1637 a pamphlet entitled *Wee be seaven* by the popular writer John Taylor was entered in the Stationers' Register by Mr Purstow – no extant copy has been recorded but it is likely that there was an image on the title page.

140 See R. Chartier, 'The World Turned Upside-Down', in *Cultural History: Between Practices and Representations* (trans. L. G. Cochrane), Cambridge, 1988, pp. 115–26.

141 See, for instance, Georg Pencz, Hollstein 141.

142 Anthropomorphized cats, rats and mice are staples of popular imagery. See fig. 11.10 for a Russian example; a dead cat surrounded by apprehensive mice appears on one of the embroidered flags of the Asafo, the warrior group of the Fante people of Ghana (P. Adler and N. Barnard, *Asafo! African Flags of the Fante*, exhibition catalogue, Royal Festival Hall, London, 1992, no. 137). 'The Cat and the Fiddle', a gentler evocation of the same role-reversal, appears in the form of a large cat playing for dancing mice on an English Delftware dish of c.1730 (Sotheby's, 15 April 1997, lot 158; I am grateful to Judy Rudoe for drawing my attention to this dish).

143 The inventory in the Colombina Library, Seville, of this extraordinary collection was brought to light by David Landau in a paper given at a conference on *The Collecting of Prints and Drawings in Europe c.1550–1800*, at the National Gallery, 20–21 June 1997. There is a nineteenth-century copy of the inventory in the British Museum (Department of Prints and Drawings, Pp. 6.45) where the impression of *Una batalla de gatos y ratones* is listed on p. 450, and *Muchos ratones que pelean contra muchos gatones* on p. 452.

144 Gotha, Museen der Stadt, inv. 40.56 (reproduced in N. Sato *et al.*, *Der Deutsche Holzschnitt der Reformationszeit aus dem Besitz des Schlossmuseums/ Museen der Stadt Gotha*, exhibition catalogue, National Museum of Western Art, Tokyo, 1995, no. 40).

145 Subsequent Continental versions include: a sixteenth-century Dutch woodcut (an impression of the right-hand half published in 1800 by S. and W. Koene of Amsterdam (Atlas van Stolk, Rotterdam) is reproduced in Meyer 1970, fig. 96); an Italian woodcut of c.1600 (British Museum, 1947-3-19-54; the sheet is damaged and includes only the left-hand part of the composition); *La Grande et Merveilleuse Bataille d'entre les Chats et les Rats* published by Leonard Odet of Lyon in 1610 (Paris, Bibliothèque Nationale, Hennin collection); *Der Thier und Jage Krieg*, a broadside published by Paulus Fursten in Nuremberg in 1652 (British Museum, 1880-7-10-516) which is clearly based on the composition although it shows a variety of animals and birds attacking men in a castle; a board game of 1690 by Giuseppe Maria Mitelli in which cats attack the rat's castle; and *Le Fort des Chats assiegé*, an eighteenth-century French print (Paris, Bibliothèque Nationale, Hennin collection).

146 The subject is not listed in Globe. There is a very similar print of about the same date in the Library of Congress, Washington, D.C.

147 British Museum, 1862-10-11-552; Old English Cuts, p. 64; Lewis-Walpole Library, Farmington, Connecticut (information from Vic Gatrell).

148 See R. Paulson, *Popular and Polite Art in the Age of Hogarth and Fielding*, Notre Dame, Indiana, 1979, p. 6, for an account of successive Gin Acts from the 1730s to 1750s.

149 Henry Mayhew, *London Labour and London Poor*, I, 1861, p. 25.

150 Reid 2713.

CHAPTER 5

1 Watt, pp. 150–9.

2 See p. 81 and relevant footnotes.

3 A Dutch version published by Cornelis Danckert is lettered 'na de copy van Londen' ('after the version from London') but no prime source has yet been discovered. For discussions of the image see W. Hofmann, *Luther und die Folgen für die Kunst*, exhibition catalogue, Hamburger Kunsthalle, 1984; Harms, II, no. 123; and E. Molland, 'Reformasjonens Fedre eller "Lysestaken"', *Aust-Agder Arv*, Stockholm, 1971–2. Versions not

referred to in these sources include paintings at Hertford College, Oxford, and in the Museum Catharijne Convent, Utrecht, and a Delft dish celebrating the marriage of Jan van Dieninge and Jannetie van Wynbergen, 1692 (British Museum, MLA 1891,2-24,3). I am grateful to Malcolm Jones, Tanja Kootte and David Gaimster for help with this note.

4 Although Roman Catholicism was the main religious target of English satirical printmakers and propagandists, other groups were also attacked. There were many seventeenth- and eighteenth-century prints mocking Quakers, and in the eighteenth century many anti-Methodist prints.

Anti-semitism is implicit in many religious prints, most notably as far as the cheap end of the market is concerned in the title given to many depictions of the scene of Christ before Caiaphas, *The Bloody Sentence of the Jews against Jesus Christ our Saviour*. A woodcut of the subject was licensed by the Stationers' Company to Francis Leach on 12 March 1656; it may be significant that the publication of this print coincided with the ending of the five-hundred-year exclusion of Jews from Britain. The subject was published by all the major cheap print publishers of the late eighteenth century: Dicey & Marshall (1764 catalogue; impression in the British Museum, 1871-11-11-520); John Bowles (1764 catalogue; two sizes); Carington Bowles (1768 catalogue); G. Thompson (impression dated 1794 in the Lennox-Boyd collection); John Evans (1793, British Museum, 1992-6-20-3(11)). A contemporary copy in the Museum of Early Southern Decorative Arts, Winston-Salem, North Carolina, is signed Frederick Kemmelmeyer, Baltimore (information from Brad Rauschenberg). There are a number of Continental prints with similar compositions and titles: Adriaen Collaert after Maerten de Vos (Hollstein 1147); an anonymous woodcut and an engraving by Isaac Brun of Strassburg, both after Ambrosius Francken (Hollstein 1 and 3); Phillip Thomassinus after Claude Deruet, 1617 (impression dated 1649, British Museum, 1869-4-10-2498); an anonymous late-seventeenth-century Italian woodcut (Modena, no. 153). Specifically anti-semitic prints were published at the time of bills in the 1830s to remove legal restrictions on Jews (see fig. 5.11 for an anti-papist print published at a time of relaxation of anti-Roman Catholic laws). For anti-semitism in British prints more generally, see F. Felsenstein and S. Liberman Mintz, *The Jew as Other: A century of English caricature 1730–1830*, exhibition catalogue, Jewish Theological Seminary of America, New York, 1995.

Racial prejudice underlies many prints of exotic visitors to England and becomes explicit from the late eighteenth century onwards in prints relating to slavery and its abolition. A casual prejudice that was doubtless a continuing part of the English viewpoint is, however, betrayed in a ballad that appeared in a number of versions from the late seventeenth to the early nineteenth century: *A Lamentable Ballad of the Tragical End of a Gallant Lord and a Vertuous Lady, with the Untimely End of their Two Children, Wickedly Performed by a Heathenish Blackamoor their Servant* is illustrated with a crude woodcut of a large black man hurling members of his master's family from the battlements of a castle.

5 Lemon 132–4.

6 For a reproduction and a full account of the print and its impact see Griffiths 1998, pp. 152–4.

7 The 1820 catalogue of books for sale of the great Radical propagandist William Hone includes as no. 1097 this print, or a version, described as 'Spayne and Rome defeated. A foreign print' priced at £2 12s. 6d.

8 Jan Barra, *To the Glory of God in Thankfull Remembrance of our Three Great Deliverances*, Printed at London by Isaac Jaggard, for Michael Sparke, dwelling in Green-Arbour, and there to be sold, 1627 (Lemon 266; Hind, III, 101.13).

9 Other uses of the motif include BM Sat 13 and 45.

10 Pepys, II, 241.

11 See Griffiths 1998, pp. 280–305.

12 For a full account see J. Kenyon, *The Popish Plot*, 1972.

13 See p. 31 for another advertisement by Thomas Dawks, and a discussion of the way the same prints were published in different formats.

14 This anti-Jesuit print was probably published during the Popish Plot period of 1678. Tooker's address is given as the Globe and Half Moon in the Strand. Two later addresses are known: on 27 June 1681 he announced in *The London Gazette* that he had moved from the Globe near Salisbury House (off Fleet Street) to the Royal Hand and Globe, at the corner of St Martin's Lane near Charing Cross.

15 *No Popery! A Protestant Roland for a Popish Oliver by Anti-Guy*, 1850 (British Library, 3938.a.4).

16 See Bindman 1989 for English reactions to the French Revolution; societies set up to disseminate anti-radical imagery are discussed on pp. 33–6, 117–22.

17 For a full account of the Cheap Repository Tracts and a bibliography of publications see Spinney.

18 Letter to Zachary Macaulay, September 1797, quoted in Spinney, p. 305.

19 Letter from John Clare to his publisher John Taylor, 20 March 1821 (Northampton MS. 32, letter 50, quoted in Deacon, pp. 33–4).

20 The connection between publishers in Gloucester and London is further illustrated by the fact that Mary Raikes, daughter of Dicey's partner, married Francis, son of John Newbery. Francis Newbery eventually specialized in medicines and his shop in St Paul's Churchyard survived until 1900.

21 British Library, Add. MSS 27825, f. 144.

22 British Library, Add. MSS 16922, f. 45.

23 Bewick, p. 41.

24 Peterborough Museum, Clare MS A45, p. 5, quoted in Deacon, p. 33.

25 Letters to the Association for Preserving Liberty and Property Against Republicans and Levellers complain of radical propaganda in the form of prints on tobacco wrappers. The example mentioned is inserted at the front

of British Library, Add. MSS 16922, which contains a number of such letters. The wrapper is reproduced in Bindman 1989, p. 118.

26 See Bindman 1989, pp. 19–21, fig. 55, and, for other anti-Paine imagery, pp. 106–13.

27 Undated broadsides printed by Appleton of Stockton, and John Sanders of Edinburgh (reprinted by J. K. Pollock), Johnson collection, Broadsides, Murder and Execution, III. See Gatrell, p. 4.

28 An earlier mock banknote (BM Sat 10734) was produced by Luffman of 377 Strand, London, on 23 May 1807 (later reissued by S. W. Fores) to celebrate the election to Parliament of the Radicals Francis Burdett and Samuel Romilly; it promised to pay the bearer 2d. when all the electors of the country voted for the Radical cause. Fores also issued a note promising to pay Master Bonaparte 2d. when 'the Gallic flag shall triumph over the British' (Lemon Add. 13). For other mock banknotes see BM Sat 11424, 11431, 11432 and 11447.

29 The following account is based on Donald. Other articles in the special issue of *Manchester Region History Review* (III, 1, 1989) on Peterloo are also to be recommended.

30 Hansard, XLI, 27 December 1819, quoted in Wickwar, p. 135.

31 S. Bamford, *Passages in the Life of a Radical*, new edn 1967, II, p. 177 (quoted in Donald, p. 23).

32 W. M. Thackeray, 'An essay on the genius of George Cruikshank', *Westminster Review*, LXVI, 1840 (quoted in Donald, p. 28).

33 *Annual Register*, 1821, p. 60, quoted in Wickwar, pp. 180–1.

34 BM Sat 13287; for Cruikshank's versions of the image and contemporary derivations see R. L. Patten, *George Cruikshank's Life, Times, and Art*, I, pp. 154–5 and 443, notes 13–17.

35 BM Sat 8710; see Bindman 1989, pp. 193–4, 198–202, nos 197 and 206k.

36 Two copies in the Bodleian Library: Harding B11/909 and Firth c.12(436).

37 BM Sat 8711; it is possible that this print dates from later than 1795.

38 The print was registered by Henry Bamford to whom it had been sold by William Hoskins (the Winchester painting was made at the instigation of John Hoskins, who may have been his nephew); in 1578 the licence was assigned to Richard Jones.

39 K. Kruzel, 'The print collection of the Polish Academy of Sciences', *Print Quarterly*, XI, 1994, p. 165, fig. 92. A French sixteenth-century woodcut of *Le Bon Serviteur* shows the same type of figure with ass's ears, stag's hooves and a pig's snout, but without a padlock or muzzle (Bibliothèque Nationale, Hennin 1123, reproduced in *The French Renaissance in Prints*, exhibition catalogue, Los Angeles, New York and Paris, 1995, no. 150). The verse accompanying *The Welspoken Nobody*, c.1550 (fig. 9.1), describes how his mouth 'with locke was sparred' until God set him free to speak. A woman whose lips are padlocked appears in a print by Anton Woensam of c.1525 (she also has horse's hooves to show her sure-footedness as the *Good Servant* has a stag's hooves for speed); a modern Mexican postcard shows an old woman with a padlocked mouth (M. Warner, *From the Beast to the Blonde*, 1994, p. 34, pl. 14).

40 See N. Gray, *Nineteenth-century Ornamented Types and Title Pages*, 1938, M. Rickards, *Posters of Protest and Revolution*, 1970, and M. Rickards, *The Public Notice, an Illustrated History*, Newton Abbot, 1973.

41 Election meetings were reported in *The Times*, 15 January – 3 February 1831.

42 *The Evil Genius* is based on BM Sat 14244, published in 1821, in which the figure of Waithman follows an etching by Richard Dighton of July 1818 (BM Sat 13024).

CHAPTER 6

1 Thomas Percy, Bishop of Dromore (see p. 195), described a visit to Dicey's Printing Office in Bow Churchyard in terms that make it clear how unusual it was for someone of such elevated status to come into contact with publishers of popular prints.

2 For details of catalogues see Griffiths 1984. For an account of prints after the Raphael Cartoons, see Clayton, pp. 49–52, figs 55–9.

3 Reproduced in Clayton, p. 67. Sympson's engraving is in the opposite direction to both the original painting and the woodcut and therefore would have been copied from the former, and in the latter, without the printmaker having to concern himself with problems of reversal. The same minor details, such as the roulettes on the king's spurs, are omitted in Sympson's engraving and Dicey's woodcut. Other engravings after the painting include Bernard Baron's of 1741. The horse and rider in Pierre Lombart's 'Headless Horseman' were based on the same painting (see Griffiths 1998, no. 117).

4 Reproduced in Clayton, p. 80.

5 *Considerations on the Expediency of Raising at this Time of Dearth the Wages of Servants that are Not Domestic, Particularly Clerks in Public Offices*, 1767, pp. 6–7 (quoted in M. D. George, *London Life in the Eighteenth Century*, paperback edn, Harmondsworth, 1992, pp. 101 and 341, n. 87).

6 See Clayton (especially pp. 25–48, 66–74 and 169–80) for a comprehensive account of the reproductive print in eighteenth-century England.

7 For Herbert see Clayton, p. 108.

8 See G. G. Bauer and H. Verfordern, *Barocke Zwergenkarikaturen von Callot bis Chodowiecki*, exhibition catalogue, Salzburg, 1991, and John Bowles's catalogue of 1731, p. 20; there is a series of Overton's versions in the British Museum (167.a.25).

9 Reproduced in Clayton, p. 87, fig. 98. The Worcester College print is significant because Clarke died in 1736 and so it can be dated to within three years of the original.

10 See Gretton, p. 50, fig. 18, for a wood-engraving showing the crowd from the Idle Apprentice's hanging used on a broadside published by John Pitts for the execution of J. Newton in 1823.

11 Roxburghe, III, 47, 732 and 733.

12 Courbet's interest in popular prints (which was not unusual for the time) is discussed by Meyer Schapiro, 'Courbet and Popular Imagery', *Journal of the Warburg and Courtauld Institutes*, IV, 1940/1, pp. 164–219. Schapiro suggests that the composition of *The Burial at Ornans* has elements of the traditional *Stages of Life* (see Chapter Eight) and that Courbet's abandoning of chiaroscuro in favour of flatter areas of colour may have been part of a search for a more direct approach to his subjects influenced by the simplicity of popular prints.

Chapter 7

1 See pp. 82–3 for Bewick's recollection of the lasting popularity of portraits of Cumberland.

2 The note of how the woodcut of Richard Cromwell was sold appears in a contemporary letter to William Clarke in the library at Worcester College, Oxford, that has recently been translated from shorthand by Frances Henderson (*New material from the Clarke manuscripts: political and official correspondence and news sent and received by the army headquarters in Scotland, 1651–1660*, Oxford D.Phil. thesis, 1998, p. 476, no. 31.112). Cromwell's reaction to the print and other signs of growing unpopularity was reported by the pseudonymous W. Greene or Mr Miles in a letter of 24 June 1659 to Edward Nicholas, Charles II's Secretary of State, in exile: 'Cromwell is vendible here with an owl's head pictured and many other circumstances of contempt, and confined to his chamber for fear of street bailiffs' (G. F. Warner (ed.), *The Nicholas Papers*, IV (Royal Historical Society, Camden, Third Series, XXXI), 1920, pp. 160–1).

3 P. Lorrain, *The Ordinary of Newgate his Account of the Behaviour, Confessions, and Last Speeches of the Malefactors that were Executed at Tyburn*, 1703–18 (British Library, 1852.d.4).

4 See Beall, pp. 107–200. Sean Shesgreen is in the process of compiling a listing of all London Cries; copies of a preliminary listing are in the Print Room of the Guildhall Library, London, and the Lewis-Walpole Library, Farmington, Connecticut.

5 J. T. Smith, *London*, 1810, p. 43.

6 T. Smollett, *Roderick Random*, 1748.

7 Mayhew, Extra Vol., p. 30.

8 Mayhew, I, p. 3.

9 Mayhew, I, pp. 6–7.

10 Mayhew, Extra vol., p. 24.

11 Mayhew, Extra vol., p. 439.

12 R. Ferguson, 'On the collection of chap-books in the Bibliotheca Jacksoniana in Tullie House, Carlisle', *Transactions of the Cumberland and Westmorland Antiquarian and Archaeological Society*, Old Series, XIV, 1, 1896, pp. 5–6. I am grateful to Barry McKay for this reference.

13 C. Lovat Fraser, 'Old broadside ballads', *The Chapbook*, no. 15, London, September 1920.

14 See Spufford 1984 for the development of the network of pedlars and chapmen in the seventeenth century.

15 For credit arrangements between publishers and chapmen see Spufford 1984, pp. 69–83.

16 Spufford 1981, pp. 91–110; see also Thomas Dawks's advertisements for Popish Plot prints in several formats (pp. 31 and 135–6).

17 *Proceedings of the Society of Antiquaries*, 30 March 1854, quoted in Lemon, p. 147.

18 Hone's memoir of James Whittle is quoted in J. Wardroper, *The World of William Hone*, 1997, p. 162.

19 Kirkby Stephen had a population of 1141 in 1801, but customers would have been found among nearly 1400 residents of surrounding villages within the same parish, and among those who came to town for the weekly market and the fairs held twice a year.

20 Daffy's Elixir (see p. 56) was sold for 1s. 3d. a bottle: a broadsheet advertising the Elixir and other patent medicines, including Bateman's Pectoral Drops, survives among the Dent papers (Willan, pp. 17–18, illustrations facing pp. 18–19).

21 D. Landau and P. Parshall, *The Renaissance Print*, London and New Haven, 1994, p. 219.

22 British Museum, Department of Prints and Drawings, SC.A.1.1.

23 See Griffiths 1998, pp. 262–3.

24 See Griffiths 1998, pp. 220–2, 295–6.

25 Many of the titles listed appear in Henry Overton's catalogue of 1717 which is the nearest in date of surviving print publishers' catalogues, but publishers' stocks were similar and it is by no means certain that Overton was the auctioneer's supplier.

26 See Griffiths 1998, pp. 307–13.

27 R. Thoresby, *Diary* (ed. J. Hunter), 1830.

28 R. Thoresby, *Museum Thoresbyanum*, 1713, pp. 492–6; among other 'Prints, Histories, Maps, &c.' Thoresby described only prints with personal connections: 'some Prospects betwixt Rome and Naples, both delineated and etched by ... John Evelyn Esq; who presented them to me with his Picture engraved by the noted Nanteuil, and are not to be met with, save in private Hands'. He also owned copperplates by Hollar and Francis Place, and drawings by Hollar and by local professional and amateur artists: William Kent, Thomas Kirke, William Lodge, Thomas Marsh and Francis Place.

29 I am grateful to Diana Dethloff for information on early auctions of prints. For an account of the development of art auctioneering in England see Ian Pears, *The Discovery of Painting*, New Haven and London, 1988, pp. 57–67.

30 *Northampton Mercury*, 1720, p. 382. I am grateful to Timothy Clayton for this reference.

CHAPTER 8

1 F. Madan, 'The daily ledger of John Dorne, 1520', *Collectanea*, 1st Series, part 3, pp. 73–177. The ledger does not record whether the ballads were illustrated.

2 H. Phelps Brown and S. V. Hopkins, *A Perspective of Wages and Prices*, London and New York, 1981, p. 8.

3 Phelps Brown and Hopkins, *Wages and Prices*, pp. 11–12.

4 William Shakespeare, *As You Like It*, Act II, scene vii. I am grateful to Malcolm Jones for giving me access to his file on *The Stages of Life* which is my source for many of the following references. See also Griffiths 1978, p. 308, for mid-seventeenth-century sets of 'The Four Ages of Man'.

5 For a row of figures see Schreiber 1881 (1482, British Museum, 1872-6-8-351), and for figures on a wheel of fortune Schreiber ii, 1883 (c.1490, British Library IC.35).

6 Other early versions include: Cornelis Anthonisz., c.1540; Cristofano Bertelli, c.1550/60; Niccolo Nelli, c.1580; Giuseppe Maria Mitelli 180. See also Kunzle, pp. 205, 288, 384.

7 See Griffiths 1998, p. 148, no. 92.

8 A number of these blocks are now in the collection of McGill University, Montreal; see C. Heppner, 'A collection of woodblocks and related material at McGill University', *The Book Collector*, XXXV, 1986, pp. 53–66.

9 Bewick, p. 192.

10 For a full account of the affair and the prints satirizing it, see E. Einberg, 'Music for Mars, or the Case of the Duke's Lost Sword', *The Huntington Library Quarterly*, LVI, 1993, pp. 181–9.

11 *The Stages of Life* remained a popular subject and has a truly international currency: Goya adapted it for a tapestry cartoon, *La Boda* (Museo del Prado, Madrid; see V. Chan, 'New light on Goya's tapestry cartoon: La Boda', *Gazette des Beaux-Arts*, 6e, CI, 1983, pp. 33–6); in New York in 1850 Currier and Ives published lithographs of the traditional motif in male and female versions; in 1884 Walter Crane painted it as *The Bridge of Life*; Jewish versions with Hebrew text were published in chromo-lithography by Fuld & Co., New York, c.1900 (J. Darquenne, *Cartorama*, Krombach, Germany, March 1997, nos 62 and 65); and in Thailand popular versions were still for sale on the streets in the early 1990s (British Museum, OA 1991-10-22-0114; I have to thank Richard Blurton for this information.) The *Guardian* newspaper followed the traditional composition in a mock Victorian version, 'The (Insurance) Ages of Man', on 26 February 1998.

12 Stereotypes were metal casts made from woodblocks in order to produce additional printing surfaces. The process was invented in the late 1820s and was superseded ten years later by electrotyping which used electrolysis to copy woodblocks.

CHAPTER 9

1 For items now in the British Library, see *British Museum Quarterly*, I, 1926, pp. 47–8.

2 Information on collections is based on Williams, supplemented by biographical information from the DNB.

3 See also J. van der Waals, 'The print collection of Samuel Pepys', *Print Quarterly*, I, 1984, pp. 236–57.

4 The practice of adding extra illustrations to books ('grangerizing') enjoyed an enormous vogue in the late eighteenth and early nineteenth centuries, and many prints were extracted from earlier collectors' volumes for the purpose (see M. Pointon, *Hanging the Head*, London and New Haven, 1993, pp. 66–78).

5 British Library, C.122.i.5. See J. M. Osborn, 'Reflections on Narcissus Luttrell', *The Book Collector*, VI, 1957, pp. 15–27.

6 Photocopies in British Library, Cup.407.ee.15.

7 See Gatrell, pp. 123–55.

8 J. Barrell, *The Dark Side of the Landscape*, Cambridge, 1980, pp. 20–1.

9 Publications continue; the Roxburghe Club will shortly be producing a facsimile of Thomas Trevilian's *Great Book*, a series of naive copies of prints.

10 For an account of the building up of the Library see N. Barker, *Bibliotheca Lindesiana*, 1977.

11 He took the name Halliwell-Phillips in 1867 on the death of his wife's father, the antiquary Sir Thomas Phillipps, whose magnificent collection of Old Master drawings came to the British Museum in 1946 through the generosity of Count Antoine Seilern.

12 Class I is Royalty; Classes II to VIII (from nobility down to the professional classes) contain only male sitters; Class IX contains noble and 'other' female sitters in two sub-sections; Class X and the separate classifications of 'Theatricals' and 'Foreigners in England' contain both sexes.

13 More recent attempts to collect popular prints have been frustrated by the dearth of material on the market, though there are many recent acquisitions among the illustrations in this book.

14 M. D. George, who continued the catalogue up to 1832 (published 1935–54), had a much clearer view of what constituted what she called *Personal and Political Satires*.

15 British Library, 11621.k.4, between ff. 221 and 222; the ballad referred to is apparently the next one in the volume, 'Gallant Cambridge jumping over Prince Albert'.

CHAPTER 10

1 The advertisements appear in a similar volume entitled *Olde ffrendes wyth newe Faces*, published in 1883.

2 Reprinted by the Scolar Press, London, 1978.

3 Fraser's early death was partly caused by the after-effects of gas attacks during the First World War. Forty drawings and designs are reproduced with a biographical memoir by his widow in *Claud Lovat Fraser*, exhibition catalogue, Victoria and Albert Museum, 1969.

4 In 1915 Harold Munro took over the production of Flying Fame.

5 Similarly nostalgic interests are apparent in *The American Chapbook* (twelve issues, 1904–5) in which Will Bradley used ornaments derived from the work of Crawhall (see C. P. Hornung, *Will Bradley: His Graphic Art*, New York, 1974).

6 It was the success of this revival that inspired Bertolt Brecht to write *The Threepenny Opera*, and its most famous song, 'Mack the Knife', was inspired by execution

ballads that were still sung at fairs in Germany (Lotte Lenya, 'That was a Time!', *Theatre Arts*, May 1956, reprinted as the foreword to the Black Cat edition of *The Threepenny Opera*, New York, 1964).

7 See P. Gilmour, *Artists at Curwen*, exhibition catalogue, Tate Gallery, 1977.

8 See N. Carrington, *Popular Art in Britain*, 1944; M. Lambert and E. Marx, *English Popular and Traditional Art*, 1946 and *English Popular Art*, 1951; B. Jones, *The Unsophisticated Arts*, 1951; G. Fletcher, *Popular Art in England*, 1962.

CHAPTER 11

1 See p. 9 and Burke, pp. 3–22.

2 Hayward, pp. 85–7.

3 Bartrum, pp. 177–8, cat. 181; Scribner, pp. 150–3, figs 119–26.

4 The artist responsible for the simple woodcuts in Cammerlander's publication has not been identified; the book is not listed in H. Röttinger, 'Die Holzschnitte der Druckerei des Jakob Cammerlander in Strassburg', *Gutenberg Jahrbuch*, 1936, pp. 125–40. The text of *Practica der Pfaffen* is close to that of Andreas Osiander, *Eyn wunderliche Weyssagung von dem Bapstum* with woodcuts by Erhard Schön (1527; British Library, 3906.bb.40), but the illustrations are quite different. The apocalyptic prophecies are reinterpretations of those attributed to Joachim of Fiore (*Joachimi abbatis Vaticinia*, Bologna 1515; British Library 3836.b.37). See Scribner, pp. 142–7, figs 108–13.

5 British Library (3932.dd.29) and Huntington Library, San Marino.

6 British Library, C.25.c.16/2.

7 Euing 280; Roxburghe, II, 256 (without the publication line).

8 British Library, C.25.c.16/3. I am grateful to Malcolm Jones for drawing my attention to this sequence of images, and to David Paisey for information on early German illustrated books.

9 See Bartrum, nos 83 and 84.

10 For a history of print production in the rue Montorgueil see Adhémar 1954. The main collections of surviving prints from the rue Montorgueil are in the Bibliothèque Nationale: there are prints in three albums in the Cabinet d'Estampes (E d 5 g; Tf 1; AA3), one of which is a reference album assembled *c*.1580, and another an album from the Marolles collection entitled *Les Vieux Maitres en bois*; in the Reserve des Imprimés is an album of late sixteenth-century prints and pamphlets attacking Henri III that were assembled by Pierre de l'Estoile (1546–1611; La 25 6). The title given to this volume is instructive: *Les Belles Figures et Drolleries de la Ligue* [the Catholic League, one of the factions opposed to the king], *avec les peintures, placcars et affiches injurieuses et diffamatoires contre la mémoire et honneur du seu Roy ... imprimées, criées, preschées et vendues publiquement à Paris, par tous les endroits et quarrefours de la ville, l'an 1589*. The description of political prints being sold in the streets

indicates that such propaganda was widely distributed. In 1594 Henri IV ordered all documents relating to the wars of the Catholic League to be burnt, and very few other examples of such material survive.

11 See pp. 43–5.

12 For de Passe see Griffiths 1998, pp. 39–41. Jan van der Stock's excellent study of printmaking in Antwerp up to 1585 arrived too late for his findings to be included in this book.

13 For the use of prints as models for the decorative arts in England, see A. Wells-Cole, *Art and Decoration in Elizabethan and Jacobean England: the influence of Continental prints, 1558–1625*, New Haven and London, 1997, and N. Barker's forthcoming Roxburghe Club edition of Thomas Trevilian's *Great Book*.

14 Hayward, pp. 100–2.

15 For an account of Dutch popular prints, especially those aimed at children, see Centsprenten.

16 A photograph of the box is reproduced in J. M. Massing, 'Images d'Epinal', review of Martin and Huin, *Print Quarterly*, XIV, 1997, pp. 208–11, fig. 127.

17 For the history of the Pellerin firm and many illustrations of their work see Martin and Huin.

18 See Harms, VII.

19 See Adhémar 1968 for bibliography.

20 The catalogue provides a succinct survey of French popular prints (see Bibliography under Hayward).

21 The classification of certain subjects as 'genre' was a nineteenth-century invention that begs as many questions of definition as the term 'popular'. For a discussion of the Dutch taste for such subjects see de Jongh and Luijten.

22 For '1637 albums' see J. van Gelder and I. Jost, *Jan de Bisschop and his Icones and Paradigmata*, Doornspijk, 1985, pp. 200ff.

23 See A. Griffiths, 'Cassiano's Print Collection', in N. Turner (ed.), *The Paper Museum of Cassiano dal Pozzo*, exhibition catalogue, British Museum, 1993, pp. 245–59.

24 The standard work on Dutch popular prints is Meyer. For Waller's collection see Centsprenten.

25 Giuseppe Cocchiara's studies of the Land of Cockaigne, the World turned upside down, and other popular subjects were based on the Bertarelli collections. Several hundred prints from the collection are reproduced in Rigoli, which is arranged according to the order of the collection.

26 A computerized catalogue of the collection of Catnach prints at St Bride's Printing Library, London, will shortly make that collection more readily available to scholars.

27 Among the earliest survivals is a calendar of *c*.1628 in the Bodleian Library with twelve hand-coloured woodcuts by Pamva Berynda of Kiev.

28 For accounts of Russian popular prints see Duchartre and Sytova.

ABBREVIATIONS AND BIBLIOGRAPHY

The bibliography lists basic print catalogues as well as other publications on which I have drawn heavily and which I recommend for further reading. Place of publication is London unless otherwise stated.

Abbreviations may also refer to collections of prints (such as Sarah Banks's trade cards in the British Museum) where there is no published catalogue but items are arranged according to a numbered index.

ADHÉMAR 1954 J. Adhémar, 'La rue Montorgueil et la formation d'un groupe d'imagiers parisiens au XVIe siècle', *Le Vieux Papier*, Fascicule 167, XXI, April 1954, pp. 25–34

ADHÉMAR 1968 J. Adhémar, *Imagerie Populaire Français*, Milan, 1968

ALEXANDER D. Alexander, *The German Single-Leaf Woodcut 1600–1700*, New York, 1977

ALTICK R. D. Altick, *The Shows of London*, Cambridge, Massachusetts and London, 1978

ARBER E. Arber (ed.), *A Transcript of the Registers of the Company of Stationers of London 1554–1640*, 1875–94, and *A Transcript of the Registers of the Company of Stationers of London 1640–1708*, 1913–14

ASHTON 1882 J. Ashton, *Chapbooks of the Eighteenth Century*, 1882 (references are to the 1990 reprint)

ASHTON 1883 J. Ashton, *Humour, Wit and Satire of the Seventeenth Century*, 1883

ASHTON 1893 J. Ashton, *A History of English Lotteries*, 1893

ASTON M. Aston, *The King's Bedpost: Reformation and Iconography in a Tudor Group Portrait*, Cambridge, 1993

BAGFORD Ballads collected by John Bagford in the British Library (C.40.m.9–11)

BANKS Trade cards chiefly from the collection of Sarah Sophia Banks in the Department of Prints and Drawings, British Museum (see *User's Guide*, pp. 174–5)

BARTRUM G. Bartrum, *German Renaissance Prints 1490–1550*, exhibition catalogue, British Museum, 1995

BARTSCH A. Bartsch, *Le Peintre-Graveur*, Vienna, 1803–21

BARWICK G. F. Barwick, *The ASLIB Directory: a guide to sources of specialized information in Great Britain and Ireland*, 1928

BASTELAER R. van Bastelaer, *Les Estampes de Peter Bruegel l'Ancien*, Brussels, 1908 (translated and revised by S. Fargo Gilchrist as *The Prints of Peter Bruegel the Elder*, San Francisco, 1992)

BEALL K. Beall, *Cries and Itinerant Trades*, Hamburg, 1975

BENNETT H. S. Bennett, *English Books and Readers 1475–1557*, Cambridge, 1969

BERTARELLI A. Bertarelli, *Le incisioni di Giuseppe Maria Mitelli*, Milan, 1940

BEWICK I. Bain (ed.), *A Memoir of Thomas Bewick written by himself*, Oxford, 1975 (references are to the paperback edn, 1979)

BINDMAN 1986 D. Bindman, 'William Blake and Popular Religious Imagery', *Burlington Magazine*, CXXVIII, 1986, pp. 712–18

BINDMAN 1989 D. Bindman, *The Shadow of the Guillotine: Britain and the French Revolution*, exhibition catalogue, British Museum, 1989

BINDMAN 1997 D. Bindman, *Hogarth and his Times: serious comedy*, exhibition catalogue, British Museum, 1997

BLAGDEN 1954 C. Blagden, 'Notes on the ballad market in the second half of the seventeenth century', *Studies in Bibliography*, VI, 1954, pp. 161–80

BLAGDEN 1960 C. Blagden, *The Stationers' Company: A History, 1403–1959*, Stanford, California, 1960

BM SAT *Catalogue of Personal and Political Satires in the British Museum*, 1870–1954 (vols I–V by F. G. Stephens; VI–XI by M. D. George)

BOSANQUET E. F. Bosanquet, *English Printed Almanacks and Prognostications to 1600*, 1917

BROMLEY H. Bromley, *A Catalogue of Engraved British Portraits from Egbert the Great to the Present Time*, 1793

BRÜCKNER Brückner, *Populäre Druckgraphik Europas: Deutschland*, Munich, 1969

BURKE P. Burke, *Popular Culture in Early Modern Europe*, 1978, revised 1994 (references are to the 1994 edn, Aldershot and Brookfield, Vermont)

CALMANN G. Calmann, 'The Picture of Nobody: an iconographical study', *Journal of the Warburg and Courtauld Institutes*, XXIII, 1960, pp. 60–104

CAPP B. Capp, *Astrology and the Popular Press: English Almanacs 1500–1800*, 1979

CENTSPRENTEN C. F. van Veen, *Centsprenten*, exhibition catalogue, Rijksmuseum, Amsterdam, 1976

CHAMPFLEURY Champfleury (J. F. F. Husson), *Histoire de l'imagerie populaire*, Paris, 1869

CHARNLEY *Specimens of Early Wood Engraving being Impressions of Wood-cuts from the Collection of Mr.* [Emerson] *Charnley*, Newcastle, 1858

CLAYTON T. Clayton, *The English Print 1688–1802*, London and New Haven, 1997

COLLMAN H. Collmann, *Ballads and Broadsides, chiefly of the Elizabethan period ... at Britwell Court, Buckinghamshire*, Roxburghe Club, Oxford, 1912

COUPE W. A. Coupe, *The German Illustrated Broadsheet in the Seventeenth Century*, Baden-Baden, 1966

DEACON G. Deacon, *John Clare and the Folk Tradition*, 1983

DE JONGH and LUIJTEN E. de Jongh and G. Luijten, *The Mirror of Everyday Life: Genreprints in the Netherlands 1550–1700*, exhibition catalogue, Rijksmuseum, Amsterdam, 1997

DERSCHAU H. A. von Derschau, *Holzschnitte alter deutscher Meister*, Gotha, 1808–16

DNB *The Dictionary of National Biography*, 1885–1949

DODD *Specimens of Early Wood Engraving being Impressions of Wood-cuts in the Possession of the Publisher* [William Dodd], Newcastle, 1862

DONALD D. Donald, 'The power of print: graphic images of Peterloo', *Manchester Region History Review*, II, 1, 1989, pp. 21–30

DUCHARTRE P. L. Duchartre, *L'imagerie populaire Russe*, Paris, 1961

DUCHARTRE and SAULNIER P. L. Duchartre and R. Saulnier, *L'imagerie Populaire: les images de toutes les provinces français du XV siècle au Second Empire*, 1925

EBSWORTH J. W. Ebsworth, *Bagford Ballads*, 1876–80

EICHLER and WYNEN U. Eichler and A. M. Wynen, *Bänkelsang und Moritat*, exhibition catalogue, Staatsgalerie Stuttgart, 1975

ESTC *English Short Title Catalogue 1473–1800*, the combined STC, Wing and Eighteenth-century Short Title Catalogue (which it supersedes) on-line through the Research Libraries Group (*http://eureka.rlg.org/cgi-bin/zgate*) and on CD-ROM (London: British Library, 1998)

EUING *The Euing Collection of English Broadside Ballads* (introduction by J. Holloway), Glasgow, 1971

GARNIER N. Garnier (ed.), *L'imagerie populaire française*, Paris, 1990 (continuing)

GATRELL V. A. C. Gatrell, *The Hanging Tree: Execution and the English People 1770–1868*, Oxford, 1994

GEISBERG M. Geisberg, *Der deutsche Einblatt-Holzschnitt in der ersten Halfte des 16. Jahrhunderts*, Munich, 1923–30 (revised and illustrated edn by W. L. Strauss, New York, 1974)

GLOBE A. Globe, *Peter Stent: London Printseller, circa 1642–1665*, 1985

GRANGER J. Granger, *A Biographical History of England ... adapted to a Methodical Catalogue of Engraved British Heads*, 1769

GRETTON T. Gretton, *Murders and Moralities: English Catchpenny Prints 1800–1860*, 1980

GRIFFITHS 1984 A. Griffiths, 'A checklist of catalogues of British print publishers', *Print Quarterly*, I, 1984, pp. 4–22

GRIFFITHS 1996 A. Griffiths, *Prints and Printmaking: an introduction to the history and techniques*, 2nd edn, 1996

GRIFFITHS 1998 A. Griffiths, *The Print in Stuart Britain*, exhibition catalogue, British Museum, 1998

HARMS W. Harms, *Deutsche illustrierte Flugblätter des 16 und 17 Jahrhunderts*, Tübingen, 1985 (continuing)

HAYWARD *French Popular Imagery*, exhibition catalogue, Arts Council of Great Britain, Hayward Gallery, London, 1974

HEAL Trade cards bequeathed to the British Museum by Ambrose Heal (1872–1959) (see *User's Guide*, pp. 174–5)

HEITZ P. Heitz, *Einblattdrucke des Fünfzehnten Jahrhunderts*, Strassburg, 1899–1942

HENNIN M. Hennin, *Inventaire de la collection d'estampes relatives à l'histoire de France, leguée en 1863 à la Bibliothèque Nationale par Michel Hennin* (ed. G. Duplessis), Paris, 1877–82

HIND A. M. Hind, *Engraving in England*, Cambridge, 1952–64 (vol. III, compiled from Hind's notes by M. Corbett and M. Norton)

HINDLEY 1871 C. Hindley, *Curiosities of Street Literature*, 1871

HINDLEY 1878 C. Hindley, *The Life and Times of James Catnach*, 1878 (reprinted Welwyn Garden City, 1970)

HOLLOWAY and BLACK J. Holloway and J. Black (eds), *Later English Broadside Ballads* (2 vols), 1975–9

HOLLSTEIN 1949 F. W. H. Hollstein, *Dutch and Flemish Etchings, Engravings and Woodcuts, c.1450–1700*, Amsterdam, 1949 (continuing)

HOLLSTEIN 1954 F. W. H. Hollstein, *German Engravings, Etchings and Woodcuts, c.1400–1700*, Amsterdam, 1954 (continuing)

IFF *Inventaire du Fonds Français*, Bibliothèque Nationale, Paris, 1930 (continuing)

ISAAC P. Isaac, *William Davison's Specimens of Cast-metal ornaments and wood types, introduced with an account of his activities as pharmacist and printer in Alnwick, 1780–1858*, 1990

JOHNSON John Johnson Collection, Bodleian Library, Oxford University (there is no published catalogue and references are to the portfolios in which the collection is arranged)

JOHNSON 1986 G. D. Johnson, 'John Trundle and the book-trade 1603–1626', *Studies in Bibliography*, XXXIX, 1986, pp. 177–99

KUNZLE D. Kunzle, *The Early Comic Strip*, Berkeley, California, 1973

LANDMARKS A. Griffiths (ed.), *Landmarks in Print Collecting*, exhibition catalogue, British Museum, 1996

LEMON R. Lemon, *A Collection of Printed Broadsides in the possession of the Society of Antiquaries*, 1866

LINK J. F. Link, *Monographie der von ... C. W. E. Dietrich radirten, geschabten und in Holz geschnitten malerischen Vorstellungen*, Berlin, 1846

LUBORSKY and INGRAM R. S. Luborsky and E. M. Ingram, *A Guide to English Illustrated Books, 1536–1604*, forthcoming

LUTTRELL Broadsides from Narcissus Luttrell's collection in the British Library (C.20.f.3–5)

MANN S. Mann, *Collecting English Playing-Cards*, 1978 (republished 1984)

MARTIN M. Martin, 'The case of the missing woodcuts', *Print Quarterly*, IV, 1987, pp. 342–61

MARTIN and HUIN D. Martin and B. Huin, *Imagerie d'Epinal*, exhibition catalogue, Quebec, 1995

MASSING A. Massing, 'From print to painting, the technique of glass transfer painting', in *Print Quarterly*, VI, 1989, pp. 383–93

MAYHEW H. Mayhew, *London Labour and the London Poor*, 1861–2

McKAY B. McKay, 'Three Cumbrian chapbook printers: the Dunns of Whitehaven, Ann Bell and Anthony Soulby of Penrith', in P. Isaac and B. McKay (eds), *Images and Texts: their production and distribution in the eighteenth and nineteenth centuries*, Winchester and Newcastle, 1997, pp. 65–87

MEYER 1962 M. de Meyer, *De Volks- en Kinderprint in de Nederlanden*, Antwerp, 1962

MEYER 1970 M. de Meyer, *Volksprenten in de Nederlanden, 1400–1900*, Antwerp, 1970

M-H M. Mauquoy-Hendrickx, *Les Estampes des Wierix*, Brussels, 1978–83

MODENA *Quattro secoli di stampa nell'Italia settentrionale: i legni incisi della Galleria Estense*, exhibition catalogue, Modena, 1986

MOXEY K. Moxey, *Peasants, Warriors and Wives: popular imagery in the Reformation*, Chicago and London, 1989

NEUBERG 1969 V. E. Neuberg, 'The Diceys and the Chapbook Trade', in *The Library*, 5th series, XXIV, 1969, pp. 219–31

NEUBERG 1977 V. E. Neuberg, *Popular Literature: a history and guide*, 1977

NIJHOFF W. Nijhoff, *Nederlandsche Houtsneden 1500–1550*, s'Gravenhage, 1931–9

OLD ENGLISH CUTS *Old English Cuts and Illustrations for Artists and Craftspeople: Bowles and Carver*, New York, 1970 (also published as *Catchpenny Prints: 163 popular engravings from the eighteenth century*, New York, 1970)

PAAS J. R. Paas, *The German Political Broadsheet 1600–1700*, Wiesbaden, 1985 (continuing)

PAULSON R. Paulson, *Hogarth's Graphic Works*, 3rd edn, 1989

PEPYS R. Latham (gen. ed.), *Catalogue of the Pepys Library at Magdalene College, Cambridge*, Cambridge, 1978–94 (the volumes of most relevance to the study of popular prints are: II, H. Weinstein (ed.), Ballads, 1992–4; III.i, A. W. Aspital (ed.), Prints and Drawings, General, 1980; III.ii, E. Chamberlain (ed.), Portraits, 1994; the Pepys ballads were published in 1987 in five facsimile vols under the editorship of W. G. Day)

PLOMER H. R. Plomer, *Wynkyn de Worde and his contemporaries*, 1925

POLLARD A. W. Pollard, 'Rough List of the contents of the Bagford collection', *Transactions of the Bibliographical Society*, VII, 1902–4, pp. 143–59

REID G. W. Reid, *A Descriptive Catalogue of the Works of George Cruikshank*, 1871

RIGOLI A. Rigoli et al., *Fuoco Acqua Cielo Terra: Stampe popolari profane della Civica Raccolta Achille Bertarelli*, Vigevano, 1995

RÖTTINGER H. Röttinger, 'Das Holzschnittwerk Jörg Breu des Jüngeren', *Mitteilungen der Gesellschaft für vervielfältigende Kunst*, Vienna, 1909, pp. 1ff

ROSCOE S. Roscoe, *John Newbery and his Successors 1740–1814: a bibliography*, Wormley, 1973

ROSCOE and BRIMMELL S. Roscoe and R. A. Brimmell, *James Lumsden & Son of Glasgow: their juvenile books and chapbooks*, Pinner, 1981

ROSTENBERG L. Rostenberg, *English Publishers in the Graphic Arts, 1599–1700*, New York, 1963

ROVINSKY D. Rovinsky, *Russkiye narodnyye kartinki*, St Petersburg, 1881–93

ROXBURGHE Collection known as the Roxburghe Ballads, British Library (C.20.f.7–10), which was published with editorial notes by J. W. Ebsworth and C. Hindley in parts, 1869–99, with reproductions of many of the woodblock illustrations

SCRIBNER R. W. Scribner, *For the Sake of Simple Folk: popular propaganda for the German Reformation*, Cambridge, 1981

SHEPARD 1962 L. Shepard, *The Broadside Ballad: a study in origins and meaning*, London, 1962 (reprinted Hatboro, Pennsylvania and Wakefield, 1978)

SHEPARD 1969 L. Shepard, *John Pitts, Ballad Printer, of Seven Dials, London 1765–1844*, Pinner, 1969

SHEPARD 1973 L. Shepard, *The History of Street Literature*, Newton Abbot, 1973

SPEAIGHT G. Speaight, *Juvenile Drama: the history of the English toy theatre*, 1946

SPINNEY G. H. Spinney, 'Cheap Repository Tracts: Hazard and Marshall Edition', in *The Library*, 4th Series, XX, 1939, pp. 295–340

SPUFFORD 1981 M. Spufford, *Small Books and Pleasant Histories*, 1981

SPUFFORD 1984 M. Spufford, *The Great Reclothing of Rural England*, 1984

STC A. W. Pollard and G. R. Redgrave, *A Short-Title Catalogue of Books printed in England, Scotland, Ireland, Wales and British America 1475–1640*, 2nd edn by K. F. Pantzer, 1976–91

STRAUSS W. L. Strauss, *The German Single-Leaf Woodcut 1550–1600*, New York, 1975

SYTOVA A. Sytova, *The Lubok: Russian folk pictures seventeenth to nineteenth century*, Leningrad, 1984

THOMAS K. Thomas, *Religion and the Decline of Magic*, 1971 (references are to the paperback edn, Harmondsworth, 1991)

THOMPSON E. P. Thompson, *The Making of the English Working Class*, paperback edn, Harmondsworth, 1991

USER'S GUIDE A. Griffiths and R. Williams, *The Department of Prints and Drawings: A User's Guide*, 1987

VERTUE G. Vertue, *Notebooks*, I–VI (Walpole Society), Oxford, 1930–52

WATT T. Watt, *Cheap Print and Popular Piety 1550–1640*, Cambridge, 1991 (references are to the 1996 paperback edn)

WICKWAR W. H. Wickwar, *The Struggle for the Freedom of the Press*, 1928

WILLAN T. S. Willan, *An Eighteenth-Century Shopkeeper: Abraham Dent of Kirkby Stephen*, Manchester, 1970

WILLIAMS M. I. Williams (ed.), *Directory of Rare Book and Special Collections*, 1985

WILLSHIRE W. H. Willshire, *A Descriptive Catalogue of Playing and Other Cards in the British Museum*, 1876

WING D. Wing, *Short-Title Catalogue of Books printed in England, Scotland and Ireland 1641–1700*, 2nd edn, New York, 1982–98, also on CD-ROM (Chadwyck-Healey, 1997)

AUTHOR'S ACKNOWLEDGEMENTS

My principal thanks are due to Antony Griffiths, who suggested this book and the exhibition that coincides with its publication. He has been, as always, a generous guide; I have to thank him particularly for patiently reading drafts of the text, and for his help in planning the content and arrangement of the exhibition. Nicolas Barker kindly read a draft of the entire text and clarified aspects of the history of English printing. Malcolm Jones read and commented on a draft of Chapter Four, and has been especially helpful in passing on his knowledge of medieval and early modern iconography. So much of what I have to say on that subject has been learnt from him that it has been impossible to acknowledge every reference. Ralph Hyde and John Berry kindly read drafts of Chapters Two and Three and made very helpful comments. Jonathan King's keen interest in popular prints has been a great encouragement and his gifts to the Museum (especially of the prints reproduced in figs 5.21 and 5.22) are much appreciated. David Paisey has generously shared his knowledge of early German printing, and broadsides in particular. Colleagues in the Department of Prints and Drawings have been greatly encouraging over the last few years: they have remained consistently alert for examples of popular imagery, have conscientiously brought them to my attention, and have shown kind interest in my own 'discoveries'.

Colleagues in the British Library, John Goldfinch, Mervyn Jannetta and Giles Mandlebrote, have led me to many popular prints in that collection. Until 1973 what is now the English Language Section of the British Library was part of the Printed Books Department of the British Museum and English popular prints that were accompanied by letterpress were normally housed there, while those where the image predominates were allocated to the Department of Prints and Drawings. The result is that, in order to show the range of English popular prints, a good deal of material from the British Library has had to be included in this book, and I have to thank the staff of the Rare Book Room and the Reprographic Department for patiently dealing with many requests. I am also grateful to colleagues in libraries and museums in this country and in the United States who have helped in my search for popular prints over a number of years. I am indebted, more immediately, for photographs provided at very short notice by the staff of Chetham's Library, Manchester; the Huntington Library, San Marino, California; Pepys Library, Cambridge; the Society of Antiquaries of London and Worcester College, Oxford.

The survival of cheap prints is particularly dependent on the care with which they have been preserved, and the names of collectors are noted in the Checklist. The British Museum Society kindly purchased for the Museum the prints illustrated in figs 2.22 and 6.6. Other prints were purchased by the Trustees or presented to the Museum by donors over the past 250 years. A number of print dealers and booksellers have helped by informing me of popular prints that have come their way: I am particularly grateful to Norman Blackburn, Barbara Cavanagh of Motley Books, Andrew Edmunds, Anthony Heath, Joslyn McDiarmid of Grosvenor Prints, and Barry McKay, who has also shared his knowledge of Cumbrian publishers and whose work I refer to in the body of the text.

Among the many other friends, colleagues and scholars whom I have to thank for help of various kinds are: Brian Allen, Margaret Aston, Rosemary Baker, Carmen Bambach, Richard Blurton, Tim Clayton, Cecie Clement, Marjorie Cohn, Judith Colton, Nick Cooper, Diana Dethloff, Ellen D'Oench, Diana Donald, Frances Dunkels, Gilles Duval, Elizabeth Einberg, Barrie Evans, Mark Evans, Angela Fell, Alexandra Franklin, Mireille Galinou, Vic Gatrell, Gianni Giachin, Richard Godfrey, Jessica Harrison-Hall, Kasha Jenkinson, Alain Kahn, Michael Kitson, Vivien Knight, Steve Kopper, Julie Anne Lambert, Tom Lange, Christopher Lennox-Boyd, Beth Linton, Ger Luijten, Annie Lyles, Liz Miller, Jane Munro,

David Nolta, Frederick, Mary and Maureen
O'Connell, Steven Parissien, Michael Powell, Simone
Rebelo, Jane Roberts, Bruce Robertson, Amanda
Robinson, Jirka Rohan, Judy Rudoe, Henrietta Ryan,
William Shupbach, Tom Smith, Lindsay Stainton, Joan
Sussler, Tanya Szrajber, Nigel Tattersfield, Nicholas
Turner, Sally Wallace, the Weddup family, Helen
Weinstein and Stephanie Wiles.

The immediate preparation of the book has relied on
the co-operation of a number of colleagues to whom
I am very grateful: Julia Nurse has dealt efficiently
with a great number of time-consuming practical
matters; Tom Cochrane, Lisa Bliss, Ivor Kerslake, Bill
Lewis and Barbara Winter have produced excellent
photographs in a very short time; Nina Shandloff and
Emma Way of British Museum Press have been
patient and encouraging; James Shurmer's enthusiasm
for the subject is a bonus in addition to his talent as a
designer; John Banks edited my text with great care.

The exhibition that opens as this book is published
makes further demands on others. We are grateful to
the British Library Board, the Society of Antiquaries of
London, the Trustees of the Victoria and Albert
Museum, Worcester College, Oxford, and a number of
private owners for lending material in their collections.
Colleagues in these institutions, especially Mervyn
Jannetta, Anne Rose, Bernard Nurse, Susan Lambert
and Joanna Parker, have kindly dealt with the
administration of loans at far less notice than they
should have been given. Janice Reading has dealt with
the receipt of loans with an efficiency that it is all too
easy to take for granted. Gillian Roy, Heather
Norville-Day and the Department of Conservation
team – Christina Angelo, Caroline Barry, Jenny
Bescoby, David Green, Victoria de Korda, Joanna
Kosek, Dylan Owen, Jane Pickles, Annette Pinto,
Jude Rayner, Alice Rugheimer and Helen Sharp – have
dealt cheerfully with the problems of making these
often fragile prints exhibitable. And I am confident
that in the final stages Charlie Collinson's visual
sensitivity and calm attention to detail will take a great
deal of the anxiety out of trying to create a serious
exhibition in a venerable museum from a mass of
disparate material that was originally intended for a
short life on a tavern or cottage wall.

CHECKLIST OF ILLUSTRATIONS

Prints are anonymous, published in London and in the collection of the Department of Prints and Drawings at the British Museum unless otherwise stated. Measurements, height by width in millimetres, are those of the plate mark in the case of intaglio prints, and otherwise of the printed surface including text.

1.1 *Street criers*, *c*.1835
Drawn by George Scharf
(1788–1860)
Graphite, 229 × 138 mm
1862-6-14-348

1.2 *A crowd outside a print shop*, 1790
Watercolour, 374 × 530 mm
1878-5-11-654

1.3 *Sawney in the Boghouse*, *c*.1745
Hand-coloured etching,
241 × 191 mm
BM Sat 2678
1868-8-8-12385, Hawkins collection

1.4 *The Hen Peckt Husband*, 1768
After Philip Dawe (fl. 1760–82); published by John Smith and Robert Sayer
Etching and engraving,
373 × 280 mm
1869-2-13-9

1.5 *Saint George, the Chief Champion of England*, *c*.1750
Published in Aldermary Churchyard
Hand-coloured woodcut and letterpress, 503 × 380 mm
1858-12-9-3, Presented by William Smith

2.1 *The Holy Virgin Mary*, *c*.1840
Published by Taylor & Smith
Hand-coloured woodcut and letterpress, 494 × 362 mm
1989-7-22-21, Renier collection

2.2 *The Four Indian Kings*, *c*.1820
Published by John Pitts
Woodcut and letterpress,
193 × 340 mm
1992-7-25-132, Presented by David Bindman

2.3 Title page to *A Garland of New Songs*, early nineteenth century
Printed by J. Marshall, Newcastle on Tyne
Woodcut and letterpress,
126 × 72 mm
1993-7-25-30

2.4 *The Champion*, *c*.1825
Printed by M. Birt
Woodcut and letterpress,
687 × 149 mm
1928-12-10-396, Presented by Miss A. E. Hewett

2.5 *Moore's General Almanack for 1835*, 1834
Published by E. Lloyd
Wood-engraving and letterpress,
555 × 441 mm
1868-8-8-12995, Hawkins collection

2.6 *An Elegy for Prince Rupert*, 1682
Published by Langly Curtis
Woodcut and letterpress,
350 × 276 mm
British Library, Luttrell Elegies 129

2.7 *London's Loud Cryes to the Lord by Prayer*, 1665
Printed by I. Mabb for K. Burton and R. Gilberson
Woodcut and letterpress,
450 × 350 mm
British Library, 816.m.9/26

2.8 *A Copy of Verses presented by Isaac Ragg, Bell-man*, 1683
Printed by William Downing
Woodcut and letterpress,
407 × 305 mm
British Library, Luttrell Broadsides, II, 50

2.9 *The Lamp-lighter's Poem*, *c*.1800
Printed at 81 Shoe Lane, Fleet Street
Woodcut and letterpress,
465 × 354 mm
1872-6-8-545, Anderdon collection

2.10 *Advertisement for J. Russel's Elixtrated Spirit of Scurvy-Grass*, *c*.1665
Woodcut and letterpress,
200 × 149 mm (cropped)
Wellcome Institute Library, Patent Medicines, Bf.39(a)

2.11 *Tobacco wrapper*, *c*.1760
Cut by J. Bell
Woodcut and letterpress,
50 × 79 mm
Banks 117.20, Franks collection

2.12 *Trade card of George Wildey*, *c*.1720
Cut and printed by John Cluer
Woodcut and letterpress,
253 × 201 mm
Banks 100.115
Y.5-267, Sarah Banks collection

2.13 *Proverbs Illustrated by Pictures from Real Life*, 1790
Cut by John Bewick (1760–95); published by John Trusler
Wood-engraving and letterpress, 435 × 530 mm (trimmed)
1995-2-26-7

2.14 *A New Book of all Sorts of Beasts*, c.1660, this impression c.1670
First published by Peter Stent, later by John Overton
Engraving, 168 × 255 mm
1972.u.30 157.b.21/40

2.15 *Lottery sheet*, c.1750, this impression c.1800
Published by Bowles and Carver
Etching, 251 × 173 mm
1858-4-17-8, Presented by John Fillinham

2.16 *Writing sheet: The Seven Cartons* [sic], c.1729
After Raphael (1483–1520)
Etching and engraving with manuscript, 400 × 325 mm
1996-7-13-1

2.17 *Turn-up: The Magic Egg or Birth of Harlequin*, 1771
Published by William Tringham
Etching, 348 × 155 mm (open)
1878-12-14-277

2.18 *William Barrymore as Hamet Abdulcrim in El Hyder*, 1823
Published by William West
Etching, 246 × 175 mm (cropped)
1886-5-13-767 168*.a.2/69

2.19 *The Royal and Entertaining Game of the Goose*, c.1800
Published by John Lumsden & Son, Glasgow
Hand-coloured engraving, varnished and mounted in a mahogany frame backed with green baize, 480 × 360 mm (excluding frame)
1893-3-31-131, Presented by Lady Charlotte Schreiber

2.20 *A George on Horseback*, c.1710
Engraved by John Harris (fl. c.1686–1739) after S. H.; published by Henry Overton
Engraving, 700 × 100 mm
1902-10-18-78

2.21 *The Lord Mayor's Mansion House, London*, 1751
Engraved by Paul Fourdrinier (1698–1758) after Samuel Wale (1720–86); published by John Bowles
Etching and engraving, 407 × 260 mm
Crace XXI, 42, 104
1880-11-13-3619

2.22 *Painting*, from a series of allegories of the arts, c.1750
Published by Henry Overton
Glass print, 253 × 355 mm
1998-1-18-2, Presented by the British Museum Society

3.1 *This Horryble Monster*, 1531
Published by Niclas Meldeman, Nuremberg, and Peter Treveris, Southwark (ornament blocks made for Wynkyn de Worde, c.1522)
Hand-coloured woodcut and letterpress, 240 × 314 mm
Sloane 5220-12 (1928-3-10-96)

3.2 *A genealogy of the Kings of England: Henry VII to Mary I*, 1562
Published by Gyles Godet
Hand-coloured woodcut, 378 × 570 mm (section illustrated)
British Library, G.6456

3.3 *The good Hows-holder*, 1564–5, this impression 1607
First published by Gyles Godet, later printed in Blackfriars
Woodcut and letterpress, 485 × 367 mm
E.6-38, Sloane collection

3.4 *The image of the lyfe of man ... by Apelles*, c.1560, this impression 1656
Published by Thomas Warren
Woodcut and letterpress, 930 × 1562 mm
E.4-34.37, Sloane collection

3.5 *Fill Gut, & Pinch belly*, 1620
Printed at London by Edward Allde for Henry Gosson
Woodcut and letterpress, 370 × 475 mm
Society of Antiquaries, Lemon 175

3.6 *No-Body his Complaint*, 1652
Published by B. Alsop
Woodcut and letterpress, 128 × 772 mm
British Library, Thomason Tracts, E.1351/5

3.7 *The Cats Castle besieged and stormed by the Rats*, c.1660, this impression after 1665
Published by Peter Stent, later by John Overton
Engraving, 215 × 292 mm
1953-4-11-70, Bequeathed by E. H. W. Meyerstein

3.8 *Lucipher's new Row-Barge*, 1721
Engraving, 309 × 193 mm
BM Sat 1714
1868-8-8-3498

3.9 *The Happy Marriage*, c.1690, this impression c.1750
Published at 4 Aldermary Churchyard
Woodcut and letterpress, 419 × 495 mm
1872-12-14-383

3.10 *Search the World, you'll seldom see, Handsomer Folks than We Three*, c.1795
Published by Bowles and Carver
Hand-coloured mezzotint, 344 × 247 mm
BM Sat 4542
1861-7-2-104; Caricatures, I, 104

3.11 *An Hymn To be sung at St Clement Eastcheap*, 1714
Printed by John Cluer
Woodcut and letterpress, 292 × 145 mm
1937-4-24-2, Presented by Major H. R. M. Howard

3.12 *Trade card of William &*
Cluer Dicey, 1736–56
Published by William and Cluer
Dicey
Etching and engraving,
204 × 152 mm
Heal 59.56

3.13 *The Cruel Treatment of*
the Slaves in the West Indies,
1793
Published by John Marshall
Etching, 250 × 340 mm
Private collection

3.14 *The Glory of Man's*
Redemption, *c*.1714–24
Published in Aldermary
Churchyard
Woodcut and letterpress,
412 × 274 mm
1858-12-9-4, Presented by
William Smith

3.15 *Miss Fanny Murray* and
The Careless Maid, *c*.1760
Published by Cluer Dicey and
Richard Marshall
Woodcut and letterpress,
428 × 534 mm
British Library

3.16 *The Death of Marat* and *The*
Execution of Charlotte Corday,
1793
Published by John Evans
Etching, 371 × 470 mm
1992-6-20-3(9)

3.17 *An Elegy to the Memory*
of Queen Caroline of England,
1821
Published by John Pitts
Woodcut and letterpress,
466 × 325 mm
1993-12-12-39, Renier collection

3.18 *The Perpetual Almanack*,
c.1813
Published by James Catnach
Letterpress and woodcut,
340 × 222 mm
1994-7-24-2

3.19 *Life in London; or, the*
Sprees of Tom and Jerry, 1822
Published by James Catnach
Woodcut and letterpress,
460 × 345 mm
1997-2-23-2

3.20 *Trial, Sentence, and*
Execution of W. G. Youngman,
1860
Published by William Fortey at the
Catnach Press
Woodcut and letterpress,
464 × 348 mm
1993-6-19-13

4.1 *Indulgence with* Christ as the
Man of Sorrows, *c*.1490
Hand-coloured woodcut,
110 × 65 mm
Schreiber 869
1857-5-20-26

4.2 *A Letter written by Jesus*
Christ, *c*.1840
Published by R. Bond, Plymouth
Woodcut and letterpress,
468 × 342 mm
1952-4-17-1, Presented by
Vera Blackhall

4.3 *The Young-Man's Conquest*
Over the Powers of Darkness,
1684
Woodcut and letterpress,
460 × 300 mm
Published by Joshua Conyers
British Library, Luttrell Broadsides,
II, 134

4.4 *Saint Bernard's Vision*, *c*.1700,
this impression *c*.1750
Published at 4 Aldermary
Churchyard
Hand-coloured woodcut and
letterpress, 510 × 363 mm
1858-12-9-2, Presented by
William Smith

4.5 *A Plan of the Road from the*
City of Destruction to the
Coelestial City, *c*.1800
Etched by W. Jeffreys
Hand-coloured etching,
190 × 242 mm
1975.u.1140, Bequeathed by
Eliza Cruikshank

4.6 *An Epitome of Gospel*
Mystery, *c*.1700
Engraved by John Pryer (fl. *c*.1700);
published by Joseph Marshall
Etching and engraving,
550 × 430 mm
British Library, 1897.c.19/44

4.7 *The Tree of Life*, *c*.1750,
this impression *c*.1800
Published by Bowles and Carver
Hand-coloured etching,
354 × 250 mm
BM Sat 4571
1868-8-8-4624, Hawkins collection

4.8 *The Tree of Life*, *c*.1825
Published by James Catnach
Hand-coloured woodcut and
letterpress, 490 × 352 mm
1992-1-25-32, Presented by
Antony Griffiths

4.9 *The Prodigal Son Sifted*,
c.1700, this impression *c*.1750
Published in Aldermary
Churchyard
Hand-coloured woodcut and
letterpress, 416 × 545 mm
BM Sat 1407
1858-12-9-5, Presented by
William Smith

4.10 *The Prodigal Sifted*, 1677,
this impression *c*.1740
First published by Robert Walton,
later by William Dicey
Engraving, 191 × 304 mm
1870-10-8-2897

4.11 *Keep within Compass*,
c.1790
Etching, 249 × 160 mm
1970-4-3-2, Presented by the
City Record Office, Coventry

4.12 *Our Lord's Passover*,
c.1750
Published in Aldermary
Churchyard
Hand-coloured woodcut and
letterpress, 415 × 511 mm
1858-12-9-1, Presented by
William Smith

4.13 *Flight into Egypt*, c.1810
Published by P. and P. Gally
Hand-coloured etching,
100 × 152 mm
1949-4-11-2256, Bequeathed by
Campbell Dodgson

4.14 *A cottage interior* (detail),
1883
Photographed by A. E. Emslie
(1848–1918)
Albumen print, 151 × 202 mm
Victoria and Albert Museum,
E.882-1994

4.15 *Cobler's Hall*, c.1750,
this impression c.1800
Published by Bowles and Carver
Etching and engraving,
378 × 520 mm
1875-8-14-2465, Presented by
John Deffett Francis

4.16 *A Loyal Song*, 1746
Published by Henry Overton
Etching and engraving with
letterpress, 360 × 505 mm
(plate mark, 357 × 235 mm)
British Library, Cup.21.g.34(41)

4.17 *The Royall Line of Kings,
Queenes, and Princes*, c.1613
Woodcut and letterpress,
475 × 370 mm
Society of Antiquaries, Lemon 132

4.18 *Sir Thomas Fairfax*,
1646
Published by Francis Leach
Woodcut and letterpress,
380 × 453 mm (cropped)
1933-12-20-1, Presented by
Major R. H. M. Howard

4.19 *The Famous Ship Victory*,
1744
Woodcut and letterpress,
413 × 523 mm
1992-6-20-15

4.20 *Captain Thomas Coram*
(1668?–1751), after 1740
After William Hogarth
(1697–1764)
Woodcut, 314 × 266 mm
1938-4-29-5

4.21 *The Ark Royal*, c.1588
Woodcut, 494 × 740 mm
1874-8-8-1367, Wicklow collection

4.22 *The Glorious Victory ... on
June the 1*, 1794
Etching and engraving,
571 × 1035 mm
1869-7-10-139

4.23 *The Honour of a London
Prentice*, 1690s
Published by William Onley
Woodcut and letterpress,
185 × 275 mm
British Library, Roxburghe Ballads,
III, 747

4.24 *The Ten first Persecutions of
the Primitive Church*, 1570, this
impression 1632
Printed by A. I. and F. K. and R. Y.
Woodcut and letterpress,
416 × 865 mm
1867-10-12-776

4.25 *A proper newe Ballad,
declaring the substaunce of all the
late pretended Treasons against the
Queenes Majestie*, 1586
Printed by Thomas Purfoote for
Edward White
Woodcut and letterpress,
450 × 294 mm
Society of Antiquaries, Lemon 84

4.26 *The Disobedient Son and
Cruel Husband*, c.1700
Woodcut and letterpress,
290 × 178 mm
British Library, Roxburghe Ballads,
III, 788

4.27 *The Execution of Lord
Lovat*, 1747
Woodcut and letterpress,
275 × 165 mm
1997-2-23-1

4.28 *Henry Rogers*, 1735
Published by A. Groth
Etching and engraving,
322 × 214 mm
1851-3-8-564

4.29 *Matthew Henderson*, 1746
J. Grimstone after B. Jackson
Etching and engraving,
324 × 210 mm
1953-4-11-51, Bequeathed by
E. H. W. Meyerstein

4.30 *Captain James Lowry*, 1752
Published by R. Bennett
Etching, 345 × 243 mm
1851-3-8-422

4.31 *The Female Parricide*
(Mary Blandy), 1752
Woodcut and letterpress,
550 × 420 mm
1851-3-8-61

4.32 *Execution of James Garside
and Joseph Mosley*, 1834
Printed by Smeeton
Woodcut and letterpress,
450 × 300 mm
Private collection

4.33 *Life, Trial, and Execution of
Christian Sattler*, 1858
Woodcut and letterpress,
450 × 338 mm
1990-6-23-15

4.34 *The Three Wonders of this
Age*, 1636
Engraved by George Glover
(fl. 1634–52); published by
M. Sparke Junior
Etching and engraving and
letterpress, 462 × 375 mm
Hind III, 250.68
P.3-358

4.35 *Angelina Melius and Santiago
de los Santos*, c.1820
Hand-coloured etching,
468 × 299 mm
1871-8-12-4209

4.36 *Three Wonderful
Phoenomena*, 1787
Woodcut and letterpress,
277 × 132 mm
1914-5-20-668, Joseph Banks
collection

4.37 *Hartebeest*, 1702
Woodcut and letterpress,
144 × 86 mm
1914-5-20-691, Joseph Banks
collection

4.38 *The Whale at Blackwall Dock*, c.1690
Etched and published by John Drapentier (fl. 1674–1713)
Etching, 242 × 310 mm
Z.1-163, Probably Sloane collection

4.39 *Bernardo Gigli*, mid eighteenth century
Hand-coloured etching, 343 × 237 mm
1914-5-20-663

4.40 *Jacob Powell*, c.1754
Engraved by Charles Spooner (1717–67) after David Ogborne (fl. 1752–62); published by T. Swan
Etching, 352 × 249 mm
1851-3-8-532

4.41 *The Suffolk Wonder* (Christopher Bullock), 1755
Woodcut and letterpress, 358 × 280 mm
1851-3-8-63

4.42 *The Four Indian Kings*, 1710
After John Verelst (c.1648–1734)
Etching, 336 × 252 mm
1851-3-8-376

4.43 *A Good Housewife*, c.1600, this impression c.1750
Hand-coloured woodcut, 480 × 350 mm
Formerly collection of Heinrich Schwarz

4.44 *The Happy Marriage* and *The Unhappy Marriage*, c.1690
Published by John King
Etching, 271 × 362 mm (cropped)
1906-8-23-4, Presented by Alfred Bowditch

4.45 *The Jolly Widdower*, c.1690
Published by J. Blare
Woodcut and letterpress, 190 × 302 mm (entire sheet)
Pepys Ballads, IV, 102

4.46 *The Contented Cuckold*, c.1660, this impression c.1670
Published by Peter Stent, later by John Overton
Etching, 254 × 185 mm
1996-6-8-1

4.47 *The Dyers Destiny*, c.1690
Published by J. Blare
Woodcut and letterpress, 185 × 290 mm (cut into two parts)
British Library, Roxburghe Ballads, II, 120

4.48 *Wedlock*, c.1751
Published at 414 Oxford Street
Etching, 310 × 238 mm
1992-10-3-23

4.49 *Moll Handy*, c.1750, this impression c.1800
Etched by George Bickham (1705–58); probably first published by Thomas Bowles II, this impression by Bowles and Carver
Hand-coloured etching, 321 × 189 mm
BM Sat 2472
1935-5-22-2(5); Caricatures, II, 5

4.50 *Love in a Mist*, late seventeenth century
Published by Jonah Deacon
Woodcut and letterpress, 186 × 315 mm
British Library, C.22.f.6(57)

4.51 *The Feather'd Fair in a Fright*, 1779
After John Collet (1725–80); published by Carington Bowles
Etching, 520 × 372 mm
BM Sat 5621
1875-8-14-2463, Presented by John Deffett Francis

4.52 *John Bull running down Crinoline*, c.1850
Published by H. J. Carter
Hand-coloured lithograph, 240 × 230 mm
1998-7-12-6

4.53 *A Midnight Modern Conversation*, c.1733
After William Hogarth (1697–1764); printed and sold by John Bowles
Etching and engraving, 570 × 870 mm (cropped)
1860-6-23-80

4.54 *The Mapp of Lubberland*, c.1660, this impression c.1670
Probably first published by Peter Stent, later by John Overton
Engraving, 195 × 274 mm
1953-4-11-69, Bequeathed by E. H. W. Meyerstein

4.55 *The Old Man, his Son and his Ass*, 1793
Published by John Evans
Etching, 370 × 475 mm
1992-6-20-3(6)

4.56 *The Seven Oddities*, c.1820
After Cornelis Dusart (1660–1704); published by J. Sherratt
Lithograph, 277 × 178 mm
1872-10-12-5091

4.57 *The World Turned Upside-Down*, c.1790
Published by John Evans
Etching, 370 × 471 mm
1992-6-20-3(8)

4.58 *A Looking-Glasse for a Drunkard*, 1652
Printed for J. D. and sold by George Wilford
Etching and letterpress, 400 × 320 mm
British Library, Thomason Tracts, 669.f.16/59

4.59 *The Vices of the Gin Shop*, c.1833
Published by J. V. Quick
Woodcut and letterpress, 480 × 352 mm
1996-9-29-19, Presented by Antony Griffiths

4.60 *A Grand View of the Times*, 1833
Published by J. V. Quick
Woodcut and letterpress, 483 × 350 mm
1993-12-12-42, Renier collection

4.61 *The Bottle*: Plate V, *Cold, misery and want destroy their youngest child*, 1847
Etched by George Cruikshank (1792–1878)
Glyphograph, 217 × 325 mm
Reid 2714
1978.u.324, Bequeathed by Eliza Cruikshank

5.1 *The Poysonous Tree*, c.1580
Woodcut and letterpress,
530 × 360 mm
1916-2-12-2

5.2 *The pope on horseback*,
c.1620
Hand-coloured woodcut and
letterpress, 238 × 200 mm
(cropped)
1860-4-14-271

5.3 *The candle is lighted, we
cannot blow out*, c.1640
Published by Thomas Jenner
Etching, 260 × 373 mm
1907-3-26-31, Halle collection

5.4 *The Rise and Growth of the
Reformation*, 1680
Published by Joshua Conyers
Woodcut and letterpress,
410 × 300 mm
BM Sat 1096
British Library, 816.m.22/36

5.5 *The High and Mighty Prince
Charles, Prince of Wales*, 1623
Woodcut and letterpress,
470 × 370 mm
Society of Antiquaries, Lemon 203

5.6 *Monmouth's Saying*, 1683
Published by B. J.
Woodcut and letterpress,
200 × 320 mm (entire sheet)
Pepys Ballads, II, 241

5.7 *The true Portraiture of a
prodigious Monster*, 1655
Published by John Andrews
Woodcut and letterpress,
240 × 290 mm
British Library, Thomason Tracts,
669.f.19/81

5.8 *The Doctor Degraded; or,
The Reward of Deceit*, 1685
Printed by George Groom
Woodcut and letterpress,
414 × 243 mm
BM Sat 1134
1868-8-8-3304, Hawkins collection

5.9 *A Jesuit Displaid*, c.1682
Published by Arthur Tooker
Etching, 448 × 308 mm
1983-10-1-11

5.10 *An Authentick View of the
City of Lisbon*, 1755
Published by William and Cluer
Dicey, London and Northampton
Woodcut and letterpress,
540 × 432 mm
British Library, Cup.21.g.34/63

5.11 *No Popery!*, 1850
Woodcut and letterpress on
prepared paper, 717 × 475 mm
1868-8-8-9593, Hawkins collection

5.12 *The Riot; or, Half a Loaf is
better than No Bread*, 1795
Published for the Cheap Repository
for Religious and Moral Tracts by
John Marshall and R. White,
London, and Samuel Hazard, Bath
Woodcut and letterpress,
387 × 212 mm
1994-6-19-12

5.13 *The last dying Speech,
confession and general Character of
Napolean Buonaparte*, 1814
Published by H. Wadsworth,
Birmingham
Woodcut and letterpress,
212 × 136 mm
1997-2-23-3

5.14 *Bank Restriction Note*,
1819
Etched by George Cruikshank
(1792–1878); published by
William Hone
Etching, 118 × 176 mm
Reid 965; BM Sat 13198
1978.u.955, Bequeathed by
Eliza Cruikshank

5.15 *Desperate Condition of the
Tory Gang*, 1832
Published by G. Drake
Woodcut and letterpress,
456 × 350 mm
BM Sat 17134
1993-12-12-41, Renier collection

5.16 *The Manchester Reform
Meeting*, 1819
Designed by John Slack
(fl. c.1803–28)
Etching printed on linen,
510 × 594 mm
1893-1-6-39

5.17 *The Man* from *The Political
House that Jack Built*, 1819
Designed by George Cruikshank
(1792–1878); published by William
Hone
Wood-engraving, 162 × 100 mm
BM Sat 13299
1865-11-11-395 184.a.1(4),
Maskelyne collection

5.18 *A Free Born Englishman*,
1819
George Cruikshank (1792–1878)
Hand-coloured lithograph,
344 × 241 mm
Reid 228; BM Sat 13287a
1865-11-11-2136, Maskelyne
collection

5.19 *This Ages Rarity*, 1682
Etching and engraving,
461 × 298 mm
BM Sat 1120
1849-3-15-85, Luttrell collection

5.20 *Intelligence on the Peace*,
1783
Probably after Robert Dighton
(1752–1814); published by
Carington Bowles
Hand-coloured mezzotint,
349 × 250 mm
BM Sat 6351
Caricatures, I, 53

5.21 *The Evil Genius*, 1831
After Richard Dighton
(1795–1880)
Woodcut and letterpress,
747 × 455 mm
1993-4-4-6, Presented by
Jonathan King

5.22 *The Unrelenting Creditor*,
1831
Woodcut and letterpress,
497 × 767 mm
1993-4-4-5, Presented by
Jonathan King

6.1 *Catalogue of John Bowles*,
1731, open at pp. 38–9
Letterpress, 170 × 203 mm
1936-9-30-3 E.2.15

6.2 *The Portraiture of King Charles the First on Horseback*, c.1745
After Anthony van Dyck (1691–1741); published by William Dicey & Company, London and Northampton
Hand-coloured woodcut and letterpress, 580 × 434 mm
1864-10-8-205

6.3 *The Crucifixion: 'Le Coup de lance'*, 1631
Boethius à Bolswert (c.1580–1633) after Peter Paul Rubens (1577–1640)
Engraving, 604 × 432 mm
Rooses 296
1891-4-14-647

6.4 *Three Favourite Carols for Christmas*, c.1830–40
Published by T. Bloomer, Birmingham
Woodcut and letterpress, 487 × 355 mm
1989-7-22-18, Renier collection

6.5 *Painting*, from a series of allegories of the arts, c.1750, this impression c.1780
Probably first published by Thomas Bowles II, later by Carington Bowles
Etching, 251 × 352 mm
1856-3-8-96

6.6 *Painting*, c.1800
Hand-coloured etching, 235 × 333 mm
1998-1-18-3, Presented by the British Museum Society

6.7 *The Battle of Death and Time*, 1610
Designed by David Vinckboons (1576–c.1633); published by Boethius à Bolswert
Etching and engraving, 275 × 375 mm
Hollstein 10 (Vinckboons), 313 (Bolswert)
1935-5-29-89

6.8 *The Battle of Death and Time*, c.1750
Published by William Herbert (1719–95)
Etching and engraving, 380 × 611 mm
1872-6-8-57

6.9 *Il Callotto resuscitato*, 1715
Published in Germany, probably Augsburg
Etching, 298 × 183 mm
1938-6-17-12(2) 159*.b.9

6.10 *The Twelve Months represented by Lilliputian Figures: January*, c.1720, this impression c.1740
Published by John Bowles
Etching, 258 × 152 mm
1874-2-14-1

6.11 *Dame Frowdella Doudykin and Sr Bacchus Suckbottle*, c.1720
Published by Thomas Taylor
Etching and engraving, 174 × 200 mm
J.7-22, Sarah Banks collection

6.12 *Dame Frowdella Doudykin and Sr Bacchus Suckbottle*, c.1720
Woodcut, 88 × 175 mm
1995-9-30-94(2), Presented by Jonathan King

6.13 *Gin Lane*, 1751
Engraved and published by William Hogarth (1697–1764)
Etching and engraving, 387 × 322 mm
Paulson 186
S.2-122

6.14 *An Awful Warning to Blasphemers*, c.1820
Published by Elias Keys, Devonport; sold by R. Stone, Exeter, A. Brown, Bristol, W. Burridge, Truro, J. Perrow, St Austell, and S. Reed, Newport, Monmouthshire
Hand-coloured woodcut and letterpress, 468 × 338 mm
1989-7-22-25, Renier collection

6.15 *The Wandering Jew*, c.1720
Published by John Cluer
Woodcut and letterpress, 182 × 270 mm (cut into two parts)
British Library, Roxburghe Ballads, III, 718–19

6.16 *The Wandering Jew's Chronicle*, 1674–80
Published by Francis Coles, Thomas Vere, John Wright and John Clarke
Woodcut and letterpress, 212 × 304 mm
British Library, Roxburghe Ballads, III, 47

6.17 *L'Apôtre Jean Journet*, 1850
Gustave Courbet (1819–77); printed by Vien, Paris
Lithograph, 390 × 300 mm
1920-5-12-41

7.1 *Cries of London No. 3: Last dying speech and Confession*, 1799
After Thomas Rowlandson (1756–1827); published by Rudolph Ackermann
Hand-coloured etching, 334 × 261 mm
BM Sat 9476
Caricatures, X, 130

7.2 *Ballad Singers*, c.1830
Designed by Robert Seymour (1798–1836); printed by Graf & Soret; published by W. Spooner
Lithograph, 208 × 264 mm
1982.u.839

7.3 *Ancient Topography of London*: Plate 20, *Domestic Architecture*, 1811
Etched and published by J. T. Smith (1766–1833)
Etching, 302 × 240 mm
1853-6-11-110 172.c.5

7.4 *Raree show* from *The Omnibus*, 1841
Designed by George Cruikshank (1792–1878)
Wood-engraving, annotated and signed by the artist, 60 × 63 mm
Reid 3955
1978.u.538, Bequeathed by Eliza Cruikshank

7.5 *The Pretty Maid buying a Love Song, c.1785*
After Henry Walton
(*c*.1746–1814); published by Carington Bowles
Hand-coloured mezzotint, 350 × 250 mm
Caricatures, II, 74

7.6 *The Poor Widow and her Praying Boy* and *My Jesus, c.1850*
Printed by S. Cooper, Chesterfield
Woodcut and letterpress, 254 × 181 mm
1995-11-5-1

7.7 *Street vendors, including a man selling prints from an umbrella, c.1843*
Drawn by George Scharf (1786–1860)
Graphite, 193 × 129 mm
1862-6-14-910

7.8 *Famous Boxing Match, c.1825*
Woodcut and letterpress, 340 × 225 mm
1994-5-15-14

8.1 *Parte of the Criers of London, c.1660*
Etching, 181 × 271 mm
Hind III, 367, 82
1843-3-11-280

8.2 *The Cryes of London*: Plate 25, *A Merry New Song*, 1689
Etched by John Savage (fl. 1683–1700) after Marcellus Laroon (1648/9 or 1653–1702); published by Pierce Tempest
Etching, 240 × 153 mm
Griffiths 1998, 180
1972.u.370 170*.a.10, Probably Sloane collection

8.3 *The historie of the life of Man*, 1616
Woodcut and letterpress, 500 × 358 mm
Pepys Library, Aspital 443

8.4 *The Stages of Life*, 1630s
Published by Thomas Jenner
Engraving, 395 × 329 mm
BM Sat 796; Griffiths 1998, 92
1862-5-17-190

8.5 *The Age and Life of Man, c.1674–80*
Published by Francis Coles, Thomas Vere, John Wright and John Clarke
Woodcut and letterpress, 208 × 312 mm (entire sheet)
Pepys Ballads, II, 32

8.6 *The Stages of Life, c.1700*, this impression 1858
Published by Emerson Charnley, Newcastle-upon-Tyne
Woodcut, 166 × 250 mm
British Library, 1267.g.17

8.7 *John of Gant in Love*, 1749
Hand-coloured etching, 235 × 327 mm
BM Sat 3037
J.1-63, Sarah Banks collection

8.8 *John of Gant in Love*, 1749
Woodcut and letterpress, 435 × 304 mm
BM Sat 3038
1868-8-8-12399, Hawkins collection

8.9 *The Various Ages and degrees of human Life Explained*, 1793
Published by John Evans
Etching, 373 × 472 mm
1992-6-20-3(13)

9.1 *The welspoken Nobody, c.1550*
Possibly published by S. Mierdman
Woodcut and letterpress, 365 × 275 mm
STC 18599
Huntington Library, San Marino, RB18323

9.2 Title page to *Costume of the Lower Orders of London*, 1820
Etched by Thomas Lord Busby (fl. *c*.1804–39)
Hand-coloured etching, 105 × 110 mm
1896-5-11-74

9.3 *The Messenger of Mortality*, early nineteenth century
Published by Carrall, York
Hand-coloured woodcut and letterpress, 365 × 480 mm
Chetham's Library, Manchester, Halliwell 902

9.4 *Miss Mary Blandy, a convict*, from James Caulfield's *Remarkable Persons*, 1820
Published by H. R. Young
Etching, 250 × 157 mm
1864-6-11-267 298.b.7

9.5 Title page to *The Famous History of the Valiant London Prentice*, 1711
Published by J. White, Newcastle-upon-Tyne
Woodcut and letterpress, 138 × 74 mm
British Library, 12612.b.15/1

10.1 Title page to *Chapbook Chaplets*, 1883
Designed by Joseph Crawhall (1821–96); published by Field & Tuer, Simpkin, Marshall & Co., and Hamilton, Adams & Co., London, and Scribner & Welford, New York
Hand-coloured woodcut and letterpress, 221 × 145 mm
1992-6-20-30 249.b.29

10.2 *The Newsboy*, from *London Types*, 1898
Designed by William Nicholson (1872–1949); published by William Heinemann
Hand-coloured woodcut, 255 × 230 mm
1992-7-25-77(10) 180*.a.9, Presented by Reed International

10.3 *A Song*, 1913
Claud Lovat Fraser (1890–1921); printed by A. T. Stevens for Flying Fame
Hand-coloured line block, 245 × 107 mm
1996-3-23-3

10.4 Cover to *The Chapbook*,
September 1920
Claud Lovat Fraser (1890–1921);
published by the Poetry Bookshop
Line block and letterpress,
219 × 175 mm
British Library, Cup.400.b.2

10.5 Page from *Who killed Cock
Robin?*, 1996
Designed by Enid Marx (1902–98);
published by the Incline Press,
Oldham
Woodcut and letterpress,
65 × 55 mm
1997-11-2-8

11.1 Page from *Practica der
Pfaffen*, c.1535
Published by Jakob Cammerlander,
Strassburg
Woodcut and letterpress,
182 × 145 mm
British Library, 1226.a.69

11.2 Page from *The Beginning
and Ending of all Popery*, 1548
Printed by John Herforde for
Walter Lynne
Woodcut and letterpress,
190 × 130 mm
British Library, 3932.dd.29

11.3 Title page to *A Nunnes
Prophesie*, 1615
Printed by W. White and sold by
E. Marchant
Woodcut and letterpress,
173 × 125 mm
British Library, C.25.c.16

11.4 *The Stages of Life*, 1540
Jorg Breu the Younger
(c.1510–47)
Woodcut, 489 × 665 mm
Röttinger 63
1927-6-14-181

11.5 *The Anatomie of the Inwarde
Partes of Man and Woman*,
c.1559
Cut by R. S.; published by Gyles
Godet
Hand-coloured woodcut and
letterpress, 422 × 412 mm
1860-4-14-264

11.6 *Le Cornard Contant*, c.1650
Anonymous French
Etching, 296 × 212 mm
1873-7-12-28

11.7 *Bänkelsänger*, 1740
Etched by Christian Wilhelm Ernst
Dietrich (1779–1847)
Etching, 263 × 186 mm
Link 74
1854-10-20-247

11.8 *The Land of Cockaigne*,
c.1880
Printed by Pellerin & Cie, Epinal,
France, for the Humoristic
Publishing Company, Kansas City,
Missouri
Hand-coloured process block,
365 × 260 mm
1997-2-23-11

11.9 *The Land of Cockaygne*,
1567
Engraved by Jan van der Heyden
(1637–1712) after Pieter Bruegel
(c.1520/30–69); published by
Hieronymus Cock
Engraving, 204 × 277 mm
Van Bastelaer 147 bis
1866-4-7-21, Presented by
Lady Inglis

11.10 *The Cat's Funeral*, c.1850
Anonymous Russian
Hand-coloured etching,
362 × 565 mm
1934-4-2-21, Purchased through
the H. L. Florence Fund

11.11 *Bal Banal*, 1924
Natalya Gontcharova (1881–1962);
published in Paris
Line block and letterpress,
610 × 182 mm
1999-2-28-1

COLOUR PLATES

I *Conjoined twins born in
Middleton Stoney*, 1552
Published by John Day
Hand-coloured woodcut and
letterpress, 415 × 245 mm
(cropped)
Sloane 5259-227 (1928-3-10-102)

IIA *Tittle-Tattle*, c.1600,
this impression c.1750
Perhaps first published in the
Netherlands, later in Aldermary
Churchyard
Hand-coloured woodcut and
letterpress, 404 × 507 mm
BM Sat 61
1973.u.216

IIB *Pilgrim's Progress*, 1813
Published by John Pitts
Hand-coloured etching,
378 × 490 mm
David Bindman

III *His Highness Hoo, Hoo, Hoo*,
1659
Hand-coloured woodcut with
spangles, 489 × 369 mm
The Provost and Fellows of
Worcester College, Oxford
(Clarke collection)

IV *The Stages of Life*, c.1830
Hand-coloured woodcut and
letterpress, 476 × 340 mm
Published by James Catnach
1992-1-25-31, Presented by
Antony Griffiths

FRONTISPIECE
Robin o'Green of Burnley, 1780
Mezzotint and etching,
254 × 202 mm
Engraved and published by John
Robinson
1851-3-8-315

FRONT COVER
Detail of fig. 6.2

BACK COVER
Adam and Eve in Paradise,
1815
Published by John Evans and Son
Hand-coloured etching,
354 × 464 mm
1998-10-4-1

INDEX

Aldermary Churchyard 14, 58–9, 80, 200; figs 1.5, 3.9, 3.14, 4.4, 4.9, 4.12, colour plate IIA
Allde, Edward 47; fig. 3.5
almanacs 18, 21–2; figs 2.5, 3.18, 8.1
Andrews, Henry 22
anamorphic prints 38–40; fig. 2.20
Anne, Queen 85, 108
Antiquaries, Society of 195; figs 3.5, 4.17, 4.25, 5.5
anti-Roman Catholicism 89, 114, 129–40, 155, 211–12; figs 4.17, 4.24–4.25, 4.52, 5.1–5.11, 11.1–11.3
anti-semitism 234 (ch. 5, n. 4)
Association for Preserving Liberty and Property against Republicans and Levellers 142–3

Bagford, John 194, 197
ballads 17–19, 112–17, 171, 181, 192–8, 201, 212; figs 2.2–2.4, 4.15–4.16, 4.23, 4.25–4.26, 4.45, 4.47, 4.50, 5.6–5.7, 5.12, 6.15–6.17, 7.2–7.3, 7.5–7.6, 10.3
ballad partners 18, 224 (ch. 2, n. 15)
ballad-singers (and sellers) 167–74, 201, 215–16; frontispiece, figs 1.1, 7.2–7.3, 7.5, 8.2, 10.4, 11.7
Banks, Joseph figs 4.36–4.37
Banks, Sarah Sophia 29, 201; figs 2.12, 6.11, 8.7
Baring-Gould, Sabine 201
Bedbury, Isaac 31, 65
Bell, J. 65, 188; fig. 2.11
bellmen's sheets 27, 51; fig. 2.8
Bennett, John 51, 54
Benyon, Francis 60
Bertarelli, Achille 221–2
Bewick, John 32, 225 (ch. 2, n. 39); fig. 2.13
Bewick, Thomas 62, 64–5, 82, 88, 143, 188, 204; figs 4.15, 4.19

biblical subjects 80; figs 3.14, 4.12–4.13
Bindley, James 195
Blandy, Mary 94; figs 4.31, 9.4
board games 38; fig. 2.19
Boswell, James 56
Bowles, Carington 33, 40, 51–2, 53, 64, 157, 232 (ch. 4, n. 129), 234 (ch. 5, n. 4); figs 4.51, 5.20, 6.5, 7.5
Bowles, (Henry) Carington II 51, 53, 226 (ch. 3, n. 25); figs 3.10, 4.7, 4.15, 4.49
Bowles, John 52, 53, 155, 159, 160, 234 (ch. 5, n. 4); figs 2.21, 4.54, 6.1, 6.10
Bowles, Thomas I 51
Bowles, Thomas II 51–2; figs 4.49, 6.5
Britwell Court 192
Broad and Narrow Way 72, 228 (ch. 4, n. 13); figs 4.3–4.4, 4.6–4.8
Bruegel, Pieter 122, 160; figs 4.53, 11.9
Buckingham, Duke of 195
Bunyan, John 72; fig. 4.5, colour plate IIB

Callot figures 160; figs 2.15, 6.9–6.12
Candle is lighted 129–31, 233 (ch. 5, n. 3); figs 5.3–5.4
Caroline, Queen 143; fig. 3.17
Carver, Samuel 52, 53, 226 (ch. 3, n. 25); figs 3.10, 4.7, 4.15, 4.49
Cassiano dal Pozzo 221
Catnach, James 62, 97–8, 191, 202; figs 3.18–3.20, colour plate IV
cats 123–4, 187, 233 (ch. 4, nn. 142–7); figs 3.7, 11.10
censorship 22, 42, 55, 148–9, 224 (ch. 2, n. 20); fig. 5.18
Champfleury 218–20
chapbooks 21, 96–7; figs 9.5, 10.1, 10.4–10.5

chapmen 175–6, 236 (ch. 7, nn. 14–15)
Charles I (also referred to as Prince of Wales) 132, 154–5; figs 5.5, 6.2
Charnley, Emerson 186, 203; figs 8.6, 9.5
Cheap Repository for Moral and Religious Tracts 140–2, 146, 234 (ch. 5, n. 17); fig. 5.12
children's prints 32–8, 225 (ch. 2, nn. 40, 42, 44); figs 2.13–2.18
Christmas sheets see bellmen's sheets and writing sheets
Clare, John 142, 143
Clarke, George 162
Cluer, John 55–6, 226–7 (ch. 3, nn. 32, 34); figs 2.11, 3.11
Cobb, Thomas 55
Collet, John 64
Colon, Hernandez 124
Coram, Thomas 88; fig. 4.20
Courbet, Gustave 166; fig. 6.17
Courten, William 195
Crawhall, Joseph 203–5; fig. 10.1
criminal portraits 93–4, 96; figs 4.28–4.30
Cromwell, Richard 122, 168, 236 (ch. 7, n. 2); colour plate III
Cruikshank, George 126, 144, 147; figs 4.5, 4.61, 5.14, 5.17–5.18, 7.4
cuckoldry 109–14, 231 (ch. 4, nn. 100–1); figs 1.4, 3.5, 4.46–4.47, 11.6
Cumberland, Duke of 38, 82–3, 88, 167, 187, 190, 229 (ch. 4, n. 33), 237 (ch. 8, n. 10); figs 4.15–4.16, 8.7–8.8

Daniel, George 192, 198
Davis, Charles 195
Dawks, Thomas 31, 135–7
Dent, Abraham 176
Dicey, Cluer 12, 53, 55–60, 154, 156, 188, 196, 227 (ch. 3, nn. 38–9, 42), 234 (ch. 5, n. 4), 235

(ch. 6, n. 1); figs 3.9, 3.12, 3.15,
5.10
Dicey, Robert 60
Dicey, Thomas 60, 142
Dicey, William 12, 55–6, 154, 156,
166, 188, 226–7 (ch. 3, nn. 31, 38);
figs 3.12, 5.10, 6.2
Dighton, Robert 64
Dorne, John 19
Douce, Francis 194
drunkenness 126, 162; figs 4.48,
4.53–4.54, 4.58–4.61
Dürer, Albrecht 212; fig. 4.24

elegies 26–7; figs 2.6, 3.17
Elizabeth I 84, 91; fig. 4.25
Elizabeth of Bohemia 84, 131;
fig. 4.17
Epinal 166, 216–18; fig. 11.8
Euing, William 198
Evans, John 61, 142, 146, 190, 234
(ch. 5, n. 4); figs 3.16, 4.55, 4.57,
8.9
Evans, Thomas 61
execution broadsides 22–4, 26, 47,
89–90, 92–3, 97–8, 143, 168–9,
172, 230 (ch. 4, n. 65), 236 (ch. 7,
n. 3); figs 1.1, 3.20, 4.25, 4.27,
4.31–4.33, 5.13–5.15, 7.1

Fair Rosamond 18, 114, 232
(ch. 4, n. 110); fig. 2.3
Fairfax, Thomas fig. 4.18
fashion 117–19, 232 (ch. 4, n. 129);
figs 4.51–4.52
Fawkes, Guy 132; fig. 5.9
Fortey, William 62, 202; fig. 3.20
Foxe, John 89, 129; fig. 4.24
Fraser, Claud Lovat 206–8; figs
10.3–10.4

genealogies 44, 47; fig. 3.2
George IV (also referred to as Prince
of Wales and Prince Regent) 143;
figs 3.17, 4.36, 5.17
glass prints 40–1; fig. 2.22
Glover, George 102; fig. 4.34
Godet, Gyles 43, 84, 213; figs
3.2–3.3, 11.5
Gosson, Henry fig. 3.5
Grant, Charles Jameson fig. 2.5

Halliwell-Phillipps, James Orchard
198; fig. 9.3
Heal, Ambrose 29
handkerchiefs 41; fig. 5.16
Harding, Walter 202

Harley, Robert, Earl of Oxford 194,
197
Hawkins, Edward 201; figs 2.5, 4.7,
5.8, 5.11, 8.8
Hazard, Samuel 142; fig. 5.12
Heber, Richard 192
Hennin, Michel 220, 233 (ch. 4,
n. 145)
Hodson 65, 227 (ch. 3, n. 51)
Hogarth, William 51, 52, 65, 83,
88, 98, 111, 122, 126, 160–7,
188, 225 (ch. 2, n. 25); figs 4.20,
4.48, 4.54, 4.60, 6.13–6.14
Hollis, Thomas 195
Hone, William 19, 147–9, 175, 236
(ch. 7, n. 18); figs 5.17, 6.4
horn of suretyship 74, 228 (ch. 4,
n. 23)
Horsemonger Lane Gaol 98, 230
(ch. 4, n. 67); figs 3.20, 4.32
Hottentot Venus (Sartje Bartmann)
108, 231 (ch. 4, n. 91)
Huth, Henry 197–8

Ideal Servant 149, 235 (ch. 5, n. 39);
fig. 5.19
Indian Kings (Iroquois sachems)
figs 2.3, 4.42

Jacobite Rebellion 82–3, 155, 167;
figs 1.3, 4.15–4.16, 4.27, 6.2
James II 135–6; figs 5.4, 5.6, 5.8
Johnson, John 202

Keep within Compass 77, 80;
fig. 4.11
King Charles's Rules 18, 38

Land of Cockayne (Lubberland)
120–2, 160, 232 (ch. 4, n. 131),
232 (ch. 4, nn. 132–3); figs 4.53,
11.8–11.9, colour plate III
Lamp-lighters' sheets fig. 2.9
Laurie, Robert 51, 54, 175
Laurie, Robert Holmes 51
Lindsay, Alexander, Earl of
Crawford and Balcarres 197
Locke, John 32
lotteries (children's prints) 33, 225
(ch. 2, nn. 44–5); fig. 2.15
Lovat, Simon Fraser, Lord 83;
fig. 4.27
Luttrell, Narcissus 22, 91–2, 195;
figs 2.6, 2.8, 4.3, 5.19

Madden, Frederic 201
Marolles, Michel de 220

marriage 109–19; figs 3.8–3.9,
4.43–4.48
Marshall, John 58, 61, 142;
figs 3.13, 5.12
Marshall, Richard 53, 56, 58–60,
234 (ch. 5, n. 4); figs 3.9, 3.15
Marx, Enid 209; fig. 10.5
Mayhew, Henry 126, 171–3
medicines 55–6, 176, 227 (ch. 3,
nn. 34–5, 45), 234 (ch. 5, n. 20),
236 (ch. 7, n. 20); fig. 2.10
Meldeman, Niclas 42; fig. 3.1
mezzotints 52–5, 178, 232
(ch. 4, n. 129); frontispiece,
figs 2.22, 3.10, 5.20, 7.5
Milbourne, Robert 102
Miller, William Henry 192
mills 228 (ch. 4, n. 22)
Mitelli, Giuseppe Maria 38, 233
(ch. 4, n. 145)
Monmouth and Buccleuch, James
Scott, Duke of fig. 5.6
More, Hannah 141–2; fig. 5.12
murder 91–2, 94; figs 4.26,
4.28–4.29

Napoleon 143; fig. 5.13
naval subjects 88, 94, 229 (ch. 4,
n. 41); figs 4.19, 4.21–4.22, 4.30
Newbery, John 32, 65, 234 (ch. 5,
n. 20)
Newgate 93–4, 98, 166; fig. 4.33
newspapers 22, 55, 60, 65, 169, 224
(ch. 2, n. 21)
Nicholson, William 205; fig. 10.2
Nobody 47; figs 3.6, 9.1

Oates, Titus 135–6; fig. 5.8
Overton, Henry I 33, 51, 85, 122,
157–9, 236 (ch. 7, n. 25); figs 2.20,
2.22, 4.16, 6.5
Overton, Henry II 51, 54, 187
Overton, John 48–51, 112, 124;
figs 2.14, 3.7, 4.46, 4.53
Overton, Mary 51
Overton, Philip 54

Paine, Thomas 143, 146
Paris, rue Montorgueil 44, 213, 238
(ch. 11, n. 10)
Paul, James 62
peep-shows 145–6, 169, 220;
figs 2.15, 7.4
Pepys, Samuel 17–18, 31, 68, 194,
227 (ch. 4, n. 2); figs 4.45, 4.47,
5.6, 8.3, 8.5
Percy, Bishop Thomas 197, 202

Peterloo 144–8; fig. 5.16
Pilgrim's Progress 72; fig. 4.5,
 colour plate IIB
Pitts, John 62, 142; figs 2.2, 3.17,
 colour plate IIB
Place, Francis 142–3, 195–6
playing cards 38, 210
Pollock, Benjamin 37
posters 149–50; figs 5.20–5.22
Prodigal Sifted 72, 74, 76–7;
 figs 4.9–4.10
prodigies 98–108, 135, 198–200,
 230 (ch. 4, nn. 69, 74), 231
 (ch. 4, nn. 81, 83, 88); figs 3.1,
 4.34–4.36, 4.39–4.41, 5.7,
 colour plate I
prostitution 114, 232 (ch. 4, n. 127)

Raikes, Robert 55, 142, 226
 (ch. 3, n. 30), 234 (ch. 5, n. 20)
Raphael 12, 152–4, 178, 180;
 figs 2.16, 6.1
Rawlinson, Richard 194
religious subjects 16–17, 68–80;
 figs 2.1, 3.18, 4.1–4.14, colour
 plate IIB
Rickards, Maurice 202
R.M. (printmaker) 65, 227 (ch. 3,
 n. 52)
Rowlandson, Thomas fig. 7.1
Roxburghe Ballads 197; figs 4.23,
 4.26, 6.15–6.16
Rubens, Peter Paul 156, 178;
 figs 6.3–6.4
Rupert, Prince fig. 2.6
Ryle, Ann 62

Sachs, Hans 212
Sayer, Robert 36, 51, 54

Scharf, George figs 1.1, 7.7
sex 113–14, 116, 119; figs 4.49–4.50
Skimmington 110–11
Slack, John 146; fig. 5.16
slavery 227 (ch. 3, n. 53), 234
 (ch. 5, n. 4); fig. 3.13
Sloane, Hans 104, 195; figs 3.3–3.4,
 4.38, 8.2
Smith, Benjamin fig. 1.4
Smith, William 200; figs 1.5, 4.4,
 4.9, 4.12
Spanish Armada 88, 132–5, 234
 (ch. 5, nn. 6–10); figs 4.21, 5.6
Stages of Life 187–8, 190, 237
 (ch. 8, n. 11); figs 8.3–8.6, 8.9,
 11.5, colour plate IV
Stationers' Company 16, 18, 21–2,
 42–3
Stent, Peter 48–50, 124; figs 2.14,
 3.7, 4.46, 4.53
street criers (including print-sellers)
 168–9, 177–8, 181, 196, 205, 236
 (ch. 7, n. 4); frontispiece, figs 1.1,
 7.1–7.3, 7.5–7.7, 8.1–8.2, 10.4,
 11.7, colour plate III

Taylor, Thomas 160; fig. 6.11
Thomason, George 22, 192–4;
 figs 3.6, 4.58, 5.7
Thompson, G. 61
Thoresby, Ralph 104, 180, 236
 (ch. 7, nn. 27–8)
Thysius, Johannes 221
Tias, Charles 32, 175
tobacco wrappers 29, 31, 143, 225
 (ch. 2, n. 34); fig. 2.11
trade cards 29; figs 2.12, 3.12
Tree of Life 72, 228 (ch. 4, nn. 14,
 19–20); figs 4.6–4.8

Treveris, Peter 42; fig. 3.1
Trundle, John 47
Trusler, John 32; fig. 2.13
toy theatres 36–8; fig. 2.18
Tuer, Andrew White 202, 204–5
turn-ups 36; fig. 2.17

Valiant 'Prentice 88, 229 (ch. 4,
 n. 44); figs 4.23, 9.5
Van Dyck, Anthony 12, 154;
 fig. 6.2
Vivarez, Henri 220
vue d'optiques 40; fig. 2.21

Waithman, Robert figs 5.21–5.22
Waller, François Gerard 221
Walton, Robert 50, 89
Wandering Jew 166, 215; figs
 6.15–6.17
Warren, Thomas 45, 84
West, William 37
Westbrooke, Richard 85
We three (and We are seven) 122,
 233 (ch. 4, n. 139); figs 3.10,
 4.56
Whittle, James 51, 175
Wick, Johann Jakob 218
Wilkinson, Robert 52
women 47, 109–11, 114, 117–19,
 231 (ch. 4, nn. 95–7), 232 (ch. 4,
 n. 125); figs 3.5, 3.15, 4.43, 4.45,
 4.49, 4.51–4.52, colour plate IIA
Wood, Anthony à 194
World-turned-upside-down 122–3;
 fig. 4.57
writing sheets 34, 36; fig. 2.16
Wroe, James 145